CUBA AND REVOLUTIONARY LATIN AMERICA

About the author

Dirk Kruijt is professor emeritus of development studies in the Faculty of Social Sciences, Utrecht University. A sociologist turned anthropologist, he has undertaken research on entrepreneurs and the labour class, ethnicity and exclusion, and military dictatorship and guerrilla movements, and has conducted fieldwork in many Latin American and Caribbean countries. His previous oral history books are about the Revolutionary Government of the Armed Forces of Velasco Alvarado in Peru and the guerrilla movements in Central America.

CUBA AND REVOLUTIONARY LATIN AMERICA

AN ORAL HISTORY

DIRK KRUIJT

ZED
Zed Books
LONDON

Cuba and Revolutionary Latin America: An Oral History was first published in 2017 by Zed Books Ltd, The Foundry, 17 Oval Way, London SE11 5RR, UK.

www.zedbooks.net

Typeset in Sabon by Lumina Datamatics Ltd.
Index by John Barker
Cover design by Keith Dodd
Cover photo © Martin Roemers/Panos Pictures

A catalogue record for this book is available from the British Library.

ISBN 978-1-78360-803-4 hb
ISBN 978-1-78360-802-7 pb
ISBN 978-1-78360-804-1 pdf
ISBN 978-1-78360-805-8 epub
ISBN 978-1-78360-806-5 mobi

CONTENTS

· ·

ACKNOWLEDGEMENTS

· · · · · · · · · · · · · · · · · · · ·

The genesis of this book dates back to the mid-1980s. It was then that I began to write about the leftist-nationalist Revolutionary Government of the Armed Forces of General Velasco Alvarado, president of Peru between 1968 and 1975. By interviewing nearly all of his military and civilian advisers, I discovered that many of the progressive Velasquistas had ties with Cuba; some of them showed me photos with Fidel Castro or souvenirs they had received (in some cases Kalashnikovs). During my second research project on revolutionary generations – the Central American guerrilla leadership – I became aware of their intense relationship with Cuba and the importance of the presence and influence of the representatives of the Departamento América, a Cuban institution whose history is the heart of this book. This time I write about the Cuban revolutionary generation. Over decades they decisively influenced nearly all guerrilla organizations and rebellious movements in Latin America and the Caribbean (with the exceptions of the macabre Shining Path movement in Peru and the Mexican guerrilla movements).

I conducted many interviews in Cuba and afterwards in Colombia and Central America. I owe a debt of gratitude to the roughly seventy interviewees in Cuba. They enthusiastically participated in interview sessions that always took several hours, sometimes several days or more. They patiently amended, rewrote or corrected the written text of various versions. I have the same feelings of appreciation with respect to the twenty interviewees, former guerrilla representatives

and peace negotiators, in Colombia, El Salvador, Guatemala and Nicaragua; sometimes they were reinterviewed after years but they always found the time to reflect on their decisions in the past.

I also used existing interviews that were published in testimonial publications in Cuba or all other countries where Cuba supported insurgent movements. The fieldwork in Cuba was funded by a grant from the Netherlands' inter-university science foundation NOW. Utrecht University sponsored my other field trips. In a more summary version, the Cuban interviews were published as Bell Lara, Caram León, Kruijt and López García (2013) and Suárez Salazar and Kruijt (2015). The first series of interviews refer to the Cuban insurgency generation; the second refers to the functionaries of the Departamento América and other Cuban internationalists.

Delia López, Tania Caram and José Bell were excellent colleagues who not only introduced me to the history and society of Cuba during the 1950s and 1960s, but also provided me with insights into Cuba's history and the Cuban academic culture. With them I conducted interviews about Cuba's insurgency veterans over the course of two years. Tania Caram transcribed the taped interviews. With Luis Suárez and Alberto Cabrera I interviewed Cuba's internationalists, and Alberto's wife Martha Morales transcribed the taped versions. They became friends and guides during the three years that we collaborated. I was most hospitably received as a house guest by both Tony López and his wife Joaquina Cruz; I learned much about the idiosyncrasies of life in Cuba. Half of the interviews were conducted in the small apartment above their house.

Kees Koonings (CEDLA Amsterdam and Utrecht University) read the entire manuscript twice and I am very grateful for his comments and suggestions. Eduardo Rey Tristan (Universidade de Santiago de Compostela) also commented in detail on most of the chapters. Sergio Acosta (Radio Nederland Worldwide), Eric Hendriks (Peking University), Edelberto Torres-Rivas (FLACSO and UNDP Guatemala) and the late Menno Vellinga (University of Florida at Gainesville and Utrecht University) commented on previous versions of the chapters. I am indebted to Alberto Martín (Instituto Mora Mexico City), Carlos Figueroa (BUAP Mexico), Arturo Taracena (UNAM Mérida) and Mario Vázquez (UNAM Mexico City) for their extensive comments on a

proto-draft of Chapter 4, which I reviewed with them during a large discussion session at the Instituto Mora in Mexico. Luis Eduardo Celis (Corporación Nuevo Arco Iris Bogotá) was the liaison with nearly all persons interviewed in Colombia.

I had the good fortune of consulting the libraries of the Casa de las Américas in Havana and the Widener Library of Harvard University. I spent a couple of months researching at the magnificent library of the Ibero-Amerikanisches Institut in Berlin.

With Edwin Koopmans (VPRO Public Radio and TV in the Netherlands) I recorded a radio documentary about the members of the Cuban guerrilla and urban insurgency between 1953 and 1959.

The Cuban ambassador to The Hague, Zelmys Maria Domínguez Cortina, and the Netherlands' ambassadors to Havana, Ronald Muyzert and Norbert Braakhuis, were very helpful.

Jennie Levitt was so kind as to proofread the entire manuscript meticulously; the quality of the manuscript improved enormously.

I also express my thanks to the staff of Zed Books, especially Kika Sroka-Miller, the editor.

Havana and Utrecht, July 2016

SELECT ACRONYMS AND ABBREVIATIONS

· ·

AJR	Asociación de Jóvenes Rebeldes (Cuba)
ALBA	Alianza Bolivariana para los Pueblos de Nuestra América (Bolivarian Alliance for the People of Our America)
ALN	Ação Libertadora Nacional (Action for National Liberation) (Brazil)
BRAC	Buró para la Represión de las Actividades Comunistas (Bureau of Repression of Communist Activities) (Cuba)
CDR	Comités de Defensa de la Revolución (Committees for the Defence of the Revolution) (Cuba)
CEA	Centro de Estudios de América (Centre of the Study of the Americas) (Cuba)
CELAM	Consejo Episcopal Latinoamericano (Latin American Episcopal Council)
CIA	Central Intelligence Agency (United States)
COMECON	Council for Mutual Economic Assistance (Socialist Bloc)
CPUSTAL	Congreso Permanente de Unidad Sindical de los Trabajadores de América Latina (Permanent Congress of Workers' Labour Unity of Latin America)

CTC	Central de Trabajadores de Cuba (Unitary Organization of Cuban Workers)
CUC	Peso Cubano Convertible (Cuban Convertible Peso)
DEA	Drug Enforcement Administration (United States)
DEU	Directorio Estudiantil Universitario (University Students' Directorate) (Cuba)
DGI	Dirección General de Inteligencia (Directorate General of Intelligence) (MININT)
DGLN	Dirección General de Liberación Nacional (Directorate General of National Liberation) (MININT)
DIER	Departamento de Investigaciones del Ejército Rebelde (Department of Investigation of the Rebel Army) (Cuba)
DOE	Dirección de Operaciones Especiales (Direction of Special Forces/Special Operations) (Cuba)
DR	Directorio Revolucionario Estudiantil, also mentioned as Directorio Revolucionario 13 de Marzo ([Student] Revolutionary Directorate of 13 March) (Cuba)
DSE	Departamento de Seguridad del Estado (Department of State Security) (Cuba)
ECLAC	Economic Commission of Latin America and the Caribbean
EGP	Ejército Guerrillero de los Pobres (Guerrilla Army of the Poor) (Guatemala)
ELAM	Escuela Latinoamericana de Ciencias Médicas (Medical School for Latin American Students) (Cuba)

ELN	Ejército de Liberación Nacional (National Liberation Army) (Bolivia/Colombia/Peru)
EPL	Ejército Popular de Liberación (Popular Liberation Army) (Colombia)
ERP	Ejército Revolucionario del Pueblo (Revolutionary People's Army) (Argentina)
FAR	Fuerzas Armadas Revolucionarias (Revolutionary Armed Forces) (Argentina/Cuba)
FAR	Fuerzas Armadas Rebeldes (Rebel Armed Forces) (Guatemala)
FARC-EP or FARC	Fuerzas Armadas Rebeldes de Colombia – Ejército Popular (Rebel Armed Forces of Colombia – People's Army) (Colombia)
FBI	Federal Bureau of Investigation (United States)
FEDIM	Federación Democrática Internacional de Mujeres (International Democratic Federation of Women)
FEU	Federación Estudiantil Universitaria (University Students' Federation) (Cuba)
FLACSO	Facultad Latinoamericana de Ciencias Sociales (Latin American Faculty of Social Sciences)
FMC	Federación de Mujeres Cubanas (Federation of Cuban Women)
FMLN	Frente Farabundo Martí para la Liberación Nacional (Farabundo Martí Front for National Liberation) (El Salvador)
FPL	Fuerzas Populares de Liberación Nacional (People's National Liberation Forces) Farabundo Martí (El Salvador)

FPMR	Frente Patriótico Manuel Rodríguez (Patriotic Front Manuel Rodríguez) (Chile)
FSLN	Frente Sandinista de Liberación Nacional (Sandinista Front for National Liberation) (Nicaragua)
FUMEC	Federación Universal de Estudiantes Cristianos (Universal Federation of Christian Students)
GDR	German Democratic Republic
ICAIC	Instituto Cubano del Arte y la Industria Cinematográficos (Cuban Institute of Art and Film Industry)
ICAP	Instituto Cubano de Amistad con los Pueblos (Cuban Institute for Friendship with the Peoples)
ICRT	Instituto Cubano de Radio y Televisión (Cuban Institute of Radio and TV)
ISRI	Instituto Superior de Relaciones Internacionales (Diplomatic Staff School) (Cuba)
ITT	International Telephone and Telegraph Company
JUCEPLAN	Junta Central de Planificación (National Planning Board) (Cuba)
KGB	Committee for State Security of the USSR
Komsomol	Communist Youth of the USSR
M-14	Movimiento 14 de Mayo (Movement of 14 May) (Paraguay)
M-19	Movimiento 19 de Abril (Movement of 19 April) (Colombia)
M 26-7	Movimiento 26 de Julio (Movement of 26 July) (Cuba)
MEC	Movimiento Estudiantil Cristiano (Christian Students' Movement) (Cuba)

MINFAR	Ministerio de las Fuerzas Armadas Revolucionarias (Ministry of Defence) (Cuba)
MININT	Ministerio del Interior (Ministry of the Interior) (Cuba)
MINREX	Ministerio de Relaciones Exteriores (Ministry of Foreign Affairs) (Cuba)
MINSAP	Ministerio de Salud Pública (Ministry of Public Health) (Cuba)
MINTER	Ministerio del Interior (Nicaragua)
MIR	Movimiento de Izquierda Revolucionaria (Revolutionary Movement of the Left) (Chile/Peru/Venezuela)
MLN–T	Movimiento de Liberación Nacional–Tupamaros (National Liberation Movement–Tupamaros) (Uruguay)
MNR	Movimiento Nacional Revolucionario (National Revolutionary Movement) (Cuba)
MNR	Movimento Nacionalista Revolucionário (Nationalist Revolutionary Movement) (Brazil)
MRO	Movimiento Revolucionario Oriental (Revolutionary Movement of the East) (Uruguay)
MRTA	Movimiento Revolucionario Tupac Amaru (Revolutionary Movement Tupac Amaru) (Peru)
NCO	non-commissioned officer
NO-AL	Movimiento de los Países No Aliados (Movement of Non-Aligned Countries)
OAS	Organization of American States (Organización de Estados Americanos)

OLAS	Organización Latinoamericana de Solidaridad (Latin American Solidarity Organization)
ORI	Organizaciones Revolucionarias Integradas (Integrated Revolutionary Organizations) (Cuba)
ORPA	Organización del Pueblo en Armas (People's Armed Organization) (Guatemala)
OSPAAAL	Organización de Solidaridad con los Pueblos de Asia, África y América Latina (Organization of Solidarity with the Peoples of Asia, Africa and Latin America)
PCC	Partido Comunista Colombiano (Colombian Communist Party)
PCC	Partido Comunista de Cuba (Communist Party of Cuba)
PCCh	Partido Comunista de Chile (Chilean Communist Party)
PDVSA	Petroleros de Venezuela SA (Venezuela's state-owned oil company)
PGT	Partido Guatemalteco del Trabajo (Guatemalan Workers' [Communist] Party)
PRI	Partido Revolucionario Institucional (Institutional Revolutionary Party) (Mexico)
PRT	Partido Revolucionario de los Trabajadores (Revolutionary Workers' Party) (Colombia)
PRT-ERP	Partido Revolucionario de los Trabajadores – Ejército Revolucionario del Pueblo (Revolutionary Party of the Workers – Revolutionary People's Army) (Argentina)

PSCh	Partido Socialista de Chile (Socialist Party of Chile)
PSP	Partido Socialista Popular (Popular Socialist Party) (Cuba)
SIM	Servicio de Inteligencia Militar (Military Intelligence Service) (Cuba)
UJC	Unión de Jóvenes Comunistas (Union of Young Communists) (Cuba)
UNAM	Universidad Nacional Autónoma de México (National Autonomous University of Mexico)
UNDP	United Nations Development Programme
UNESCO	United Nations Educational, Scientific and Cultural Organization
URNG	Unión Revolucionaria Nacional Guatemalteca (Guatemalan National Revolutionary Unity)
USSR	Union of Socialist Soviet Republics
VMT	Vice-Ministerio Técnico (Technical Vice-Ministry) (MININT)

CHAPTER 1

.

Revolutionaries

The Cuban revolutionary generation

I always I wanted to be a spy and a diplomat. Once, before the Revolution, I had said that to my father but he told me I was speaking rubbish. A poor, black boy born in Ciego de Ávila, how could you become a diplomat? A spy? [...] My paternal grandfather had been executed by the Spanish colonial government on allegations of conspiracy; my maternal grandparents had participated in the War of Independence [...] I joined the Revolution through the student movement linked to the 26th of July Movement [Movimiento 26 de Julio or M 26-7, led by Fidel Castro]. Really, there was a good relationship among the revolutionary organizations in the insurgency against the Batista regime: demonstrations, events, declarations, distribution of pamphlets. I was one of the organizers of the funeral of young Ricky Pérez German, a member of the Rebel Army [Ejército Rebelde, the guerrilla arm of M 26-7], who had fallen in combat. He had been a student of the [local] Institute of Secondary Education. I was also involved in the funeral of Raúl Cervantes, whose cousins were my classmates and who was a member of the Student Revolutionary Directorate [Directorio Revolucionario Estudiantil, DR, another rebel movement that afterwards merged with M 26-7] [...].[1]

In a nutshell, this is the start of the career of a young revolutionary student who participated in the insurgency campaign of Cuba's revolutionary movements – the M 26-7 and the DR – against dictator Batista and who, afterwards, also took part in rebellions and leftist movements across the Caribbean and Latin America. In the 1970s he

became a liaison officer with the Caribbean left and, in the 1980s, the first Cuban ambassador to Surinam. There were hundreds, then thousands, of rebels like him who would transform Cuba and influence the course of revolutions in Latin America and the Caribbean island-states.

Two successive age cohorts, which constitute Cuba's revolutionary generation, have left their mark on Cuba. The first cohort participated in the insurrection from 1953 through 1958 against the dictatorship of General Batista. They operated with the support of the majority of the Cuban population. After the victory in January 1959, this generation radicalized in a swift transition towards socialism, immediately before the Bay of Pigs invasion in 1962. The succeeding age cohort is that of the younger members of the two rebel organizations (M 26-7 and DR) and of the adolescent youth who was too young to participate in the guerrilla campaigns or the urban resistance movements. Afterwards, in the early 1960s, they joined the Cuban literacy and public health campaigns. They also participated in the efforts to support and disseminate similar revolutions abroad: in Latin America, the Caribbean, and central and southern Africa. If the first generation cohort is that of the revolutionary combatants and their supporters, the second is constituted of revolutionary internationalists and passionate *fidelistas* (named after their leader, Fidel Castro) who were in many ways inspired by the iconic figure of Che Guevara.

The two Cuban revolutionary generations had an enormous influence on nearly all Latin American guerrilla leaders. The first generation served as a glorified example; as will be demonstrated in the subsequent chapters, the second generation provided the revolutionary movements with liaison officers, advisers and caretakers.

The relevance of the study

This study is centred on Cuba, but it has an explicit comparative perspective. Firstly, this is an analysis of the trajectory of the revolutionary generation that shaped the Cuban Revolution. I will describe and illustrate the evolution of the Cuban Revolution through the eyes and voices of its participants, from 1953 to the present. Secondly, Cuba's revolutionaries themselves are also an object of study. What

happened to its members? What made them insurgents? What made them socialists? What made them internationalists? Thirdly, the comparative element is highlighted in the central theme of this book: Cuba's internationalism in Latin America in the consecutive phases of its relationship with the Caribbean and the Latin American region as a whole.

This book traces the influence of Cuba's revolutionary generation in Latin America and the Caribbean from 1959 until the first decade of the twenty-first century. It differs from other studies in the sense that it is the first systematic analysis of the internationalization of the Cuban Revolution in Latin America and the Caribbean. As far as I know, the following issues were never deeply examined: the organization of this internationalizing process, the objectives and perspectives of the leaders who formulated the strategy and tactics, the institutional structures that implemented the policies, or the relationships of Cuba with friendly or hostile governments and military dictatorships. This study is a reconstruction of Cuba's involvement with the region, largely based on oral history, interviews with the (retired) members of an elite organization that functioned as the 'eyes and ears of Fidel' – the Departamento América – that implemented Cuba's policy with respect to the region, especially regarding the left and the armed left, Latin America's rebels, guerrilleros and revolutionaries. The analysis is enriched with complementary interviews in Colombia and Central America. It also draws on both testimonial publications and historical narratives of most of the numerous revolutionary movements in the region, particularly with respect to the experiences and consequences of Cuba's involvement.

This book is not a general history of the Cuban Revolution. I will, of course, follow the evolution of Cuba's economy, society and political system. The majority of the chapters, however, are related to Cuba's support of Latin America's revolutions and rebel movements.

During the Cold War, military dictatorships had replaced civilian governments in many countries of the region. Counter-insurgency was a favoured strategy of the ruling military administrations. Official propaganda accused the emergence of any resistance movement, rebellion, armed struggle – or even strike, protest march or mass demonstration – of being the result of a sinister plot masterminded

by Cuban agents. In reality, Cuba supported most opposition movements, moderate and insurrectional, against dictatorship and military juntas. Cuba trained, advised, comforted and nurtured the numerous rebellion movements that came to the island for support. In Latin America and the Caribbean, political changes emerged across many democratically elected centre-left and leftist governments in the 1990s and 2000s. As I will emphasize in the final chapter of this text, this transformation is at least in part a legacy of Cuba's internationalism and development assistance.

I will make frequent reference to roughly seventy interviews with members of the revolutionary generation. Additionally, I make use of about twenty interviews with former guerrilla representatives in Colombia, El Salvador, Guatemala and Nicaragua. I also thoroughly consulted published resources about nearly all guerrilla movements that were supported by Cuba. With respect to Cuba itself, there is an abundant number of biographical studies on Che Guevara. Fidel Castro had the custom of letting himself be interviewed periodically by biographers as well. There are also biographies of Raúl Castro and Camilo Cienfuegos. Vilma Espín, Melba Hernández, Celia Sánchez and Haydée Santamaría are the four women always mentioned as outstanding participants in the insurgency.[2] Nevertheless, it is clear that the revolutionary generation was much more extensive than the famous few who lived in the limelight.

The Cuban Revolution was a source of inspiration for many other revolutionary movements in Latin America and the Caribbean. The second cohort – the Cuban internationalists – provided assistance in many ways: as special envoys, confidential liaisons, trusted advisers, diplomatic overseers, military instructors and medical specialists. Between the 1960s and the 1990s, an elite group of high-level political observers and counsellors worked as diplomats or as undercover agents. They maintained direct relationships with Latin American and Caribbean revolutionary movements. They also maintained frequent contact with other political organizations, entrepreneurial associations, labour unions, journalists and academic scholars. They belonged to the Departamento América, an organization under the charismatic leadership of Manuel Piñeiro – a close personal friend and confidant of Fidel Castro and Che Guevara, and one of Raúl Castro's

comandantes during the insurgency against Batista. The Departamento América had several institutional predecessors, starting with the Vice-Ministerio Técnico (VMT, Technical Vice-Ministry) of the Ministerio del Interior (MININT, Ministry of the Interior). In 1971 the VMT split into the Dirección General de Inteligencia (DGI, Directorate General of Intelligence) and the Dirección General de Liberación Nacional (DGLN, Directorate General of National Liberation), also incorporated into the MININT.[3] In 1975 the Departamento América, successor entity of the DGLN, was transferred to the Comité Central of the Partido Comunista de Cuba (PCC, Communist Party of Cuba). All these organizational structures were in fact the successive informal elite departments that conducted Cuba's secret foreign relations under the direct supervision of, and access to, Fidel Castro. Official Cuban sources have always been discreet about information regarding the members and activities of the Departamento. Most of the chapters of this book are dedicated to their close contacts with the armed left and with progressive political parties and social movements in Latin America and the Caribbean.

Methodology and data

For practical reasons I will follow the revolutionary generation until the end of the first decade of this century, a period roughly coinciding with the end of the administration of Fidel Castro and the maturing of the Bolivarian Revolution of Hugo Chávez in Venezuela. In order to portray the Cuban revolutionaries – the national combatants and the internationalists – in a more coherent and realistic manner, I will draw from two primary sources. A first round of thirty interviews was arranged with members of the national combatants, from 1953 to 1962. The interviews consisted of the life stories and testimonies of men and women who fought as young people in the guerrilla movement in the Sierra Madre and in the urban resistance groups. They carried out tasks of dissemination of information, organized public demonstrations against the Batista regime, prepared surprise attacks and spectacular assaults (avoiding collateral civilian victims), transported arms and money, and/or were affiliates and day-to-day supporters of the guerrilla forces in the Sierra.[4] These interviews were

conducted between March and October 2011.The respondents were selected with the assistance of the Asociación de Combatientes de la Revolución Cubana (Association of Combatants of the Cuban Revolution). All interviews were taped and transcribed, then reordered in a more chronological and thematic structure. All respondents had the opportunity to review the text at least once to make alterations and improvements.

Between October 2011 and March 2013, a second cycle of interviews was organized among the members of the Departamento América. All twenty-four interviewed members of the Departmento (who were already retired at the time of the interview) were officers at home and diplomats abroad during a considerable part of their careers. In addition, fourteen interviews with other significant persons of the 'extended institutional family' of the Departmento were conducted, covering the more 'civilian component' of Cuba's internationalism and development assistance.[5] The interviewees also reviewed and corrected their transcriptions.[6] The Appendix provides the essential biographical and career data of the respondents directly quoted in this book.

I also draw from other interview sources: recent testimonial publications based on interviews with key figures of the armed left and guerrilleros trained in Cuba. These include persons from Argentina, Bolivia, Brazil, Chile, Mexico, Peru, Uruguay and Venezuela. I also reviewed my own interviews with guerrilla leaders in Central America[7] and made interview updates in Colombia, Central America and Mexico. These new interviews in Colombia and Central America were conducted between 2010 and 2015. Most interviews were taped and transcribed; in cases where they were not, I took detailed notes while interviewing. I explicitly compare and contrast the memories and experiences of these former guerrilla members with those of the Cuban interviewees.

Structure of the book

Chapter 2 will establish the historical context of Cuba, the largest and most populated of the Caribbean island-states. Already charted during Columbus's first voyage to the Americas, it was also one of the first territories to be colonized by Spain. However, it was the last colony that sought independence – it remained under Spanish

dominance until 1898, when it was occupied by the United States. Cuba was formally declared independent in 1902; however, it was only recently, after the Cuban Revolution, that the dependent dominion status evaporated.

In this chapter I will also discuss the legacy of the colonial and twentieth-century economy and society up until the 1950s. I will discuss the reverence for the heroes of the three unsuccessful independence wars in the last decades of the nineteenth century, as well as the inclination to rebellion in decades prior to the Cuban Revolution. I will also examine the modernization of the country under American control, the political culture that surfaced during the five decades of the American protectorate, the significance of the student movements of the twentieth century, and the extensive periods of dictatorship and the periodic instances of upheaval in which the students were always present. The last dictator was President-General Batista, against whom various insurgent movements rebelled. I will briefly trace the 'when' and 'why' of the guerrilla movements in the Sierra Madre and how the urban underground could finally triumph on 1 January 1959.

Chapter 3 provides a portrait of the revolutionary generation that participated in the insurrection between 1953 and 1959, the group that constituted the Cuban Revolution. Here I will make significant reference to the interviews with the combatants in the mountainous eastern region (Sierra Madre) and the vital rebellions of the urban underground in the flat regions of the country (Llano), where associated rebel groups operated.[8] I will review the history of the insurgency against Batista through the eyes of its very participants. The second part of this chapter covers the principal events and episodes during the three decisive years after January 1959. It was the phase of transition towards socialism and the implementation of the most important revolutionary reforms. The analysis consists of the evolution of the 'government of lawyers' to a revolutionary government-cum-party structure of (mainly) former guerrilla combatants as well as the (uncomfortable) merger of the insurgent movements with the existing Communist (Socialist) Party. The rapidly deteriorating relations with the United States, the approach to the Soviet Union and the planning (or non-planning) of Cuba's economy as well as that of the restructuring of its society – as seen through the eyes of the combatants – is

reserved for the end of the chapter. The failed American invasion at the Bay of Pigs (Playa Girón) and the Missile Crisis were events that consolidated Cuba's trajectory towards socialism.

With the advantage of hindsight and the use of fresh, new, detailed information in the interviews with Cuba's internationalists, there is an opportunity to nuance and balance the interpretation of Cuba's influence in the Latin American guerrilla movements. Chapters 4 through 6 are dedicated to the examination of Cuba's official and unofficial foreign policy, especially with regard to the support of the armed and non-armed left in the region. Following my own interests and that of many of the interviewees, I cover in detail Cuba's relations with Mexico, Central America, Panama and the Andean countries of Bolivia, Chile, Colombia and Peru. I also follow Cuba's involvement with the revolutionary governments in Granada, Guyana and Jamaica, and the first government period of Colonel Bouterse in Surinam. In lesser detail I analyse Cuba's relations with Argentina, Brazil, Ecuador, Paraguay and Uruguay. What were Cuba's general and more ad hoc, primary and secondary objectives? Who designed the overall strategy? How was the executing organization embedded? Here I sketch a political portrait of Cuba's spymaster, Manuel Piñeiro, and the functioning of his elite organization, the Departamento América.

Chapter 4 is a study of Cuba's involvement with nearly all insurgent movements in Latin America during the 1960s, through the Departamento América and its prior structures. Cuba became a leading country within the Movement of Non-Aligned Countries (NO-AL, Movimiento de los Países No Aliados). The island became a refuge for persecuted intellectuals and politicians in the western hemisphere. With the exception of Mexico, all Latin American countries ruptured diplomatic relations after the US embargo in 1962. Part of the chapter is dedicated to the creation and operative style of the Departamento América and its leadership, along with the infiltration of the oppositional Miami-based anti-Castro organizations and even of the American security apparatus (and vice versa). It also describes the good technical but politically strained relationship with its counterpart organizations in the Soviet Union and the eastern European socialist countries. In addition, it touches on the rivalry between the Cubans and the Soviets about the control of and influence over Latin

American communist parties, and specifically the guerrilla and resistant underground movements during the first years of Latin America's dictatorships. The greater part of the chapter is dedicated to Cuba's support of the guerrilla movements of that period.

Chapter 5 covers the decades of the 1970s and 1980s: years of more pragmatic support, always emphasizing unity of action and organization among the various, sometimes conflicting, guerrilla movements. At the same time, contact with all non-armed resistance movements against military dictatorship was maintained. This is also the period of Liberation Theology, the Dependency Theory of the Social Sciences, the Allende government and the governments of progressive nationalist-leftist militaries in Peru (General Velasco Alvarado), Panama (General Torrijos Herrera) and during a short period in Bolivia (Generals Alfredo Obando and Juan José Torres) and Ecuador (General Rodriguez Lara). The Caribbean also saw the emergence of progressive governments, such as that of Jamaica (Prime Minister Manley), Grenada (Prime Minister Bishop) and Guyana. At the same time, Cuba slowly but surely re-established diplomatic relations with many Latin American and Caribbean countries. Cuba's reputation as a Third World leader increased hugely after its military involvement in Angola. In the western hemisphere, Cuba's support for revolutionary movements continued.

In the case of countries suffering from repressive dictatorships, it provided military training and advice, provision of medical services, publication facilities, and rest and relaxation for the leadership and the wounded or crippled guerrilla combatants. In the case of countries where official diplomatic relations existed, support was restricted to 'humanitarian support', which was sometimes broadly interpreted. Cuba supported neither the Mexican guerrilla movements of the 1960s and 1970s, nor the Zapatista Army for National Liberation (Ejército Zapatista de Liberación Nacional, EZLN) that formed in 1994. Mexico never had interrupted diplomatic relations with Cuba and was its loyal supporter for decades. The Cubans detested the actions of the Peruvian (officially Maoist) guerrilla of Shining Path, a movement that was also never acknowledged by the Chinese government. Central America became a region of Cuban attention. Special mention is reserved for the support of Sandinista Nicaragua in the 1980s. Cuban aid also included (sometimes very substantial) support

in matters of defence and security as well as medical support and assistance in literacy campaigns. This period ended with the implosion of the Soviet Union and the disappearance of all communist governments in eastern Europe.

Chapter 6 covers the decades of the 1990s and the 2000s. Cuba maintained its socialist character but without the economic support of its former allies. Internally this meant the beginning of the 'special period', which officially lasted only a couple of years but had long-term consequences which persist to the present day. This period entailed coping with an economy of enforced austerity. The relations with the United States did not improve until December 2014, when the re-establishment of diplomatic relations was announced after decades of negotiation. Cuba intensified relations with Venezuela after the electoral victory of Hugo Chávez and the start of the so-called Bolivarian Revolution. In 2004 Cuba and Venezuela signed the ALBA covenant (Alianza Bolivariana para los Pueblos de Nuestra América, Bolivarian Alliance for the People of Our America), a formal agreement that covered the exchange of medical and educational services (Cuba) and petroleum (Venezuela). ALBA was subsequently joined by Bolivia (2006), Nicaragua (2007), Ecuador (2009) and some smaller Caribbean states – Antigua and Barbuda, Dominica, St Vincent and the Grenadines and St Lucia.

Where Cuba in previous decades had supported guerrilla warfare and rebellion by the armed left, peace facilitation (Central America, Colombia) became the new hallmark of Cuba's foreign policy in the region. In the case of El Salvador, after two years of formal negotiations, a peace agreement was reached between the national government and the guerrilla movement FMLN (Frente Farabundo Martí para la Liberación Nacional, or the Farabundo Martí Front for National Liberation). Cuban leaders, especially Fidel Castro himself, advised for years on how to begin to negotiate a political solution. Even more clearly in the case of Guatemala, Cuba acted successfully in offering its good offices. Formal peace negotiations between the government and guerrilla umbrella URNG (Unidad Revolucionaria Nacional Guatemalteca, Guatemalan National Revolutionary Unity) had started in 1991. Parallel to the official negotiations, informal dialogues had evolved between guerrilla leaders and representatives of

the army. In March 1996 an army delegation of over twenty officers and the entire guerrilla leadership departed for Cuba, where a cease-fire and a personal reconciliation were reached. In December 1996 the formal peace agreements were signed. During the years of the Guatemalan peace negotiations Cuba had established a rapport with Norway, a country that had also offered its good offices. In the case of Colombia, Cuban envoys had maintained good relations with M-19 and the smaller guerrilla organizations that opted for peace and disarmament in 1989. Simultaneously, it had sustained relations with the (*guevarista*) ELN and somewhat more distant relations with the FARC. In the period from 1998 until 2002, when the FARC was based in the demilitarized zone of Caguán, Cuban emissaries participated in preparations for formal peace negotiations. Between 2003 and 2007 the Colombian government and the ELN negotiated in Havana. In 2010, again in tandem with Norway, Cuba facilitated the first rounds of peace negotiations with the FARC. These negotiations have persisted in Havana up to the present to the extent that several partial agreements have been reached, even the crucial agreement on ceasefire and disarmament, and a formal peace accord is expected later in 2016.

CHAPTER 2

.

Historical context

Introduction

In 2011 I interviewed Antonio Llibre Artigas, who was seventy-nine years old at the time. During the insurgency against dictator Batista he had been Fidel Castro's aide-de camp in the Sierra Maestra. After 1959 he had become a lawyer and political scientist. He also served as a high-ranking diplomat in Algeria, a vital link between Cuba and the African world. Afterwards he furthered his diplomatic career in several European countries; he acted as one of the advisers to the head of the delegation of COMECON (Council for Mutual Economic Assistance) and negotiated the crucial membership of Cuba in 1972. After the first interview he invited me to come back to his office two days later. I asked him to describe the common traits of his colleagues, especially the influences and inspirations characteristic of the revolutionary gen eration of the 1950s.[1] He nodded his head, grabbed a bottle of rum, served two small glasses and said: 'That will take some time.'

To my surprise he did not begin with the rebellions and the nineteenth-century wars of independence against Spain. Instead, he rattled off a long and detailed series of quotations of successive American presidents about how convenient it would be to dominate, annex or incorporate Cuba. Effectively, Cuba's history is not only closely related to the Caribbean and Latin America, but also intimately connected to the historic and strategic interests of Spain and the United States. In this chapter I will contextualize colonial and post-colonial Cuba. I will pay special attention to the question of why Cuba did *not* follow the path to independence of so many other countries in Latin America: by way of war. Most of this chapter is dedicated to the period from circa 1860 to 1959, a century of civil strife and wars of independence. Cuba's complex relations with colonial and post-colonial Spain, the

American intervention in the Spanish-American War (1898–1902)
and Cuba's formal independence under American supervision will be
analysed. The final two sections of this chapter will map out various
revolts, ending with the insurgency campaign of Fidel Castro. My aim
is to distil the historical ingredients of the collective conscience that
moulded the revolutionary generation.

Colonial Cuba

Cuba had already been visited by Columbus during his first two
voyages in 1492 and 1494, but the first Spanish settlement was estab-
lished on the neighbouring island of La Española (or Hispaniola, the
present day two-state island of Haiti and the Dominican Republic). In
1510 an expedition was sent to (much larger) Cuba to conquer and
settle the island. The resistance of the indigenous peoples (Taínos,
Caribs) was quickly overcome; they disappeared in history. The
conquerors, however, did not find much gold; agriculture became
the main economic activity, exploiting the labour of imported black
slaves. Yet neither agriculture nor the farmers prospered. Zanetti
remarks that the exodus to Mexico, Florida and Central America
'threatened to condemn the largest [colony] of the Antilles to the con-
dition of a "useless island" – an expression already used for some of
their smaller neighbours'.[2] The tide turned in 1561 when the system
of annual colonial fleets was established. Convoys had sailed from
Spain to the transfer ports of the viceroyalties of Peru and Mexico; the
return fleet was assembled in Havana.

 Cuba became a paradise for European pirates. French, British and
Dutch buccaneers intercepted vessels and sometimes captured (most
of) the entire fleet. Smuggling, contraband and piracy were endemic
in the sixteenth and seventeenth centuries. In several instances these
three countries assaulted Havana and occupied smaller or larger parts
of the island. As European maritime competitors of Spain, they tried
to establish empires in the Americas. The British and the French suc-
cessfully founded settlements in the northern landmass (present-day
Canada and the United States). Great Britain, France and the Netherlands
also competed in the West Indies (the Caribbean) and in South America.
The three Guianas changed hands among the British, the French and

the Dutch. The French colonized the western part of La Española; in 1697 Spain officially ceded St-Domingue (Haiti). Remarkably, both French St-Domingue and British Jamaica, and even the small Dutch Antillean islands, developed sugar plantations that did substantially better than the Spanish possessions in the Caribbean.[3]

Leather, tobacco and sugar became the major Cuban exports during the first two centuries of colonialism. Tobacco became a monopoly of the Spanish Crown. Since 1520, sugar cane was already being imported from La Española. Cuba was not a densely populated country.[4] In 1544, the island had a population smaller than 7,000; in 1607 there were 20,000 inhabitants and in 1700 there were scarcely 50,000. A significant portion was established in Havana.[5] Common-law marriages with indigenous and black slave women were customary; mestizo and mulato descendants formed a new population segment of 'free mestizos', 'free mulatos' and 'free blacks'. Land tenure was an important ingredient of colonial elite membership. Old families of the traditional elite were inclined to form a select oligarchy, which permitted marriages only with aristocratic Spanish administrators and officers. White or 'lightly coloured' free professionals, military subaltern officers, teachers, doctors, lawyers and engineers constituted a tiny middle class. Lower-middle-class citizens performed services or worked as artisans or constructors; here all colour nuances could be observed. Commercial agriculture, especially tobacco cultivation, generated a class segment of small landholders and rural tenants.

Tempests of rebellion and independence swept over the Americas in the second half of the eighteenth century. The first successful rebellion was that of the thirteen American colonies, confederated into the United States of America. But after independence the new state emerged as another imperial power in competition with the older European colonial countries. Restlessly, the new country brought other territories under its domain by force, by buying colonial possessions from France, Spain and Russia, or by conquest from Mexico.[6] The emerging continental power was also attracted to opportunities to conquer or annex territories in the Caribbean and the Pacific which belonged to Spain. They also had their eyes on land-ends that belonged to Colombia and formally independent countries in Central America.

The independence of the former North American colonies also reverberated in most Spanish colonies in the Americas. During the Napoleonic Wars in Europe, Spain and Portugal were overrun by French armies, and the weakness of the two Iberian powers evoked even more sympathy for, and interest in, independence efforts. As a result, great patriotic leaders of national independence emerged across Latin America: Hidalgo in Mexico, De Miranda and Bolivar in Venezuela, Santander in Colombia, O'Higgins in Chile, and De San Martin in Argentina.[7] The last two decisive battles against the Spanish armies in the Americas were fought in Peru, in 1821 and 1824. In 1823 the countries of the Central American isthmus declared independence from Spain, then from Mexico. The independence of Brazil was actually a matter of dynastic arrangements, when the Portuguese Cortes forced the king – governing from Brazil during the Napoleonic years – to return to Lisbon. His son Pedro acclaimed himself Brazil's first emperor in 1822.

The intriguing question remains why Cuba, which was the most important Spanish colony in the Caribbean in the early nineteenth century, did not declare independence but opted for the status quo. Cuban historians mention the effects of the Haitian slave rebellion and the killing of plantation holders in 1804, and the harsh and repressive Spanish regime in Cuba during the decades of the Wars of Independence. But even the Dominican Republic, which suffered much more from the Haitian rebellion, gained independence in 1821. André Gunder Frank coined the term *Lumpenbourgeoisie* to typify the Latin American class of merchants, industrialists and plantation holders as an elite that refused to perform its 'historical mission' to support national independence and implant national capitalism. Instead they assumed the more comfortable position of intermediary between foreign colonial powers, subordinated to their foreign masters. If that is indeed the case, then the Cuban elite were one of the first examples of *Lumpenbourgeoisie*. There were tiny efforts to proclaim independence from Spain in 1811, 1812 and 1823. The most important voice of independence and for abolition of slavery came from the Cuban priest Félix Varela, during his exile in the United States. Bolivar had ideas about an expedition to liberate Puerto Rico and afterwards Cuba, but the dissolution of Gran Colombia in 1830 impeded further action.[8]

The Cuban colonial economy and society remained as stratified as they were during the eighteenth century. A process of land and wealth concentration took place in the mid-1880s.[9] Slavery became even more important in that period. In the first decades of the nineteenth century, however, slave trade was forbidden, first by Britain and then by the United States. An appalling fact is that, of the roughly 565,000 slaves imported into Cuba from 1512 to 1865, about 425,000 (or 75 per cent) were imported in the nineteenth century.[10] Eventually, in 1886, a Spanish royal decree formally abolished slavery in Cuba. With only free labour at hand, the Cuban sugar plantations were transformed into enormous and fully mechanized *centrales* (capital-intensive sugar mills) in the 1880s and 1890s. What is remarkable is the fact that, between 1878 and 1895, about 300,000 Spanish contract labourers migrated to Cuba to join the workforce in the sugar industry; most migrants remained and became permanent inhabitants of Cuba.[11] At that point the sugar economy was already primarily dependent on its exports to the United States, not to Spain.

The colonial ties with Spain were not appreciated by all members of the Cuban elite. Both equal rights and incorporation as a Spanish overseas province were denied; Cuba was a dependent colony with certain privileges reserved for the rich and the powerful. Frustrated by the Spanish monarchy, elite segments initiated a discussion about alternatives: annexation or incorporation by the United States. American presidents and politicians had expressed their interest in Cuba since the early nineteenth century:[12] President Jefferson considered annexation in 1809, and Madison contacted the wealthy Cuban plantation owners for the same reason. Secretary of State John Quincy Adams predicted that, over the course of time, Cuba would fall as ripe fruit into American hands. After the American annexation of Texas in 1845, influential Cuban landowning families founded the 'Club of Havana' in an effort to encourage the purchase of Cuba from Spain by the United States. In vain, President Polk offered 100 million dollars to the Spanish Crown. In 1854 President Pierce increased the offer to 130 million; it was also rejected.[13] Cuban and American supporters of annexation organized, as in the case of Nicaragua, to 'filibuster' expeditions to Cuba that involved several hundred adventurers in the 1840s and 1850s.[14] Their efforts failed. American abolitionists suspected

that a future annexation of Cuba would increase the number of slave states. In the aftermath of the American Civil War, the annexation debate lost impetus. However, when Cuban independence movements acquired momentum again in the 1860s, American interests in Cuban internal affairs increased as well.

Cuba's wars of independence

In 1865, reform-minded Cuban and Puerto Rican envoys to Madrid discussed the necessity of political, social and economic trans- formations. They were specifically concerned with the countries' relationships with Spain in terms of the abolition of slavery, labour reforms and improvements of the terms of trade and taxation.[15] Several angry debates ensued, and the reform efforts failed. Both colonies, Puerto Rico and Cuba, proclaimed independence in 1868. The insurgency in Puerto Rico was rapidly repressed. The Cuban revolt resulted in three successive insurrections: the Ten Years' War (1868–78), the Little War (or Guerra Chiquita, 1878–80) and the War of 1895–98 (sometimes confusingly called the War for Independence, which developed into the Spanish-American War of 1898). Formally, Cuba's independence was declared in 1902, not by Spain but by the United States, whose armed forces intervened in the last months of the third Cuban-Spanish War of Liberation.[16]

In September 1868 an insurrection in Madrid resulted in the exile of the Spanish queen Isabella. Revolution in the Spanish capital led to rebellion in the country's Caribbean colonies. In October 1868, the local Cuban landowner Carlos Manuel de Céspedes freed his slaves and declared both independence and the abolition of slavery. The Cuban revolt, originally started in the east – the Oriente province – spread promptly to other provinces. During this war and the subsequent rebellion campaigns, many former slaves joined the revo- lutionary movement as soldiers called 'mambis'.[17] In 1874, however, the Spanish Republic was overthrown by a military government that initiated a campaign of harsh repression in Spain and its colonies. Eventually, the rebellion concluded in a pact, the so-called Pact of Zanjón of 1878. During the Ten Years' War Spain sent in roughly 210,000 soldiers, at least 50,000 of whom died.[18] During the first

War of Independence, Dominican-born general Máximo Gómez and Cuban-born generals Maceo and Calixto García acquired fame.[19]

The Pact of Zanjón of 1878 transformed the latent anti-colonial and ethnic conflict into another rebellion, the Guerra Chiquita of 1878, 1879 and 1880. In fact, this rebellion was initiated by General Maceo and the thousands of soldiers under his command, who refused to recognize a peace agreement without independence and the abolition of slavery. During the conflict there was a clash between (white) General Calixto García and (black) General Maceo. Their dispute divided the revolutionary soldiers, and the new Spanish captain-general Polovieja suppressed the revolt in the Oriente. As a result, most revolutionary leaders went into exile.[20]

During the Guerra Chiquita a young national revolutionary hero, José Martí, ascended to fame.[21] Martí, born in 1853 to Spanish immigrants, had been exiled to Spain at the age of sixteen. A lawyer and prolific journalist, he returned to Cuba in 1878 under the provisions of the Pact of Zanjón. The following year he was deported to Spain again and escaped to the United States, where he spent a considerable part of his life. There, in exile, he founded the Partido Revolucionario Cubano (PRC, Cuban Revolutionary Party), recruiting its first members from the pool of Cuban exiles.[22] Nuclei of rebellion rapidly formed in Cuba and the United States. As delegate of his party he convinced General Máximo Gómez (and other revolutionary generals like Maceo) to take up arms once again. By the end of 1894, three ships with armed revolutionaries sailed from Florida to Cuba. At the same time, another rebellion erupted in the Philippines, Spain's last Asian colony.

Santiago de Cuba once again became the principal stronghold of the Cuban rebellion. Spain sent in an army of 200,000 enlisted men and officers for 'pacification', which was in reality a bloody counter-insurgency campaign that employed the use of concentration camps.[23] The guerrilla forces were on the defensive, but the Spanish counter-insurgency operations had only limited success. In early 1898, the Spanish government offered self-rule and amnesty to all Cuban prisoners in Spanish jails. This reform programme had ended the war in the Philippines, but the Cuban Liberation Army refused to lay down arms.

At this point, the United States stepped in. A mysterious explosion aboard the US battleship *Maine* in the harbour of Havana, resulting in the death of more than 250 American servicemen, was seen as a *casus belli*. The United States declared war on Spain. Between May and August 1898, the US Navy destroyed the Spanish fleet and occupied Manila after its desertion by the majority of Philippine soldiers. In August 1898, Puerto Rico was also occupied by an American invasion force of 15,000 men.[24] In Cuba the US Navy routed the Spanish fleet into the Bay of Santiago de Cuba and invaded the island with a force of 15,000 soldiers.[25] They defeated the Spanish army in a six-week campaign. The Americans prevented the Cuban Liberation Army from formally taking over Santiago. At the signing of the Treaty of Paris in December 1898, only the American and the Spanish government were represented. The Cuban rebel leadership was not even invited, a fact that has always been remembered with bitterness. As a result, Spain ceded its Caribbean and Pacific possessions (Cuba, the Philippines and Puerto Rico) to the United States.[26]

Cuba's supervised independence

Between 1898 and 1902, Cuba was occupied by the American army. The United States established 'in effect, a military dictatorship. The Spanish captain-general was replaced by an American general'.[27] More American soldiers were sent in to enforce the occupation. The majority of the officials of the Spanish public sector were re-employed. Americanized former Cuban exiles, white and wealthy, returned to the island; American entrepreneurs and businessmen joined them. They were followed by Protestant missionaries; churches and schools were founded by Methodists, Baptists and especially Presbyterians. At the same time, the Roman Catholic Church opted for reinforcing its ties with Spain.[28]

The US military governor also created a new security force, disbanding the Cuban rebel army of 33,000 soldiers and prohibiting Martí's Partido Revolucionario Cubano (PRC). A paramilitary Guardia Rural was established, incorporating a number of former rebel combatants. Unsurprisingly, the officer corps was white. A government cabinet was formed, and all ministerial appointments went

to Americanized white Cubans. The Department of Customs was run by an American officer.[29] The economy was in ruins; 100,000 ranches and smallholdings had been destroyed. Production of sugar diminished to 70 per cent of its original capacity; that of tobacco to 80 per cent.[30] In addition, 42 per cent of the labour force was unemployed.[31]

The American government and its representatives in Havana had expected a legal annexation of Cuba. In order to achieve this, legitimatization through elections was organized. The (municipal) elections in 1900 were restricted to a selected electorate, representing 5 per cent of the population. To the surprise of the authorities, two of the three participating political movements opted for independence after elections. Then a Convention was formed to draft a new constitution, preparing Cuba to be a formally independent republic. According to President McKinley, however, it would be connected to the United States through 'ties of singular intimacy'.[32] These ties were legalized (and afterwards enforced) by the so-called Platt Amendment (Enmienda Platt).[33] The conditions of this amendment – giving the United States the right to intervene, to approve credit and loans for third-party countries, and to provide four harbour enclaves *inter alia* – created a de facto neocolonial status for the new republic, aggravated by the territorial secession of Guantánamo as a US naval base. Eventually, the Convention approved an amendment that allowed only for a choice of either 'mortgaged independence' or no independence at all.[34] Like the exclusion of the Cuban rebel leadership at the peace negotiations in Paris, the imposition of the Platt Amendment created bitter resentment that transmitted from generation to generation and eventually exploded in 1933 and again in 1959.

After 1898, Puerto Rico and the Philippines were governed directly by American administrators and English replaced Spanish as the official language. The Philippines acquired semi-independence as a Commonwealth (associate state) in 1934, to be declared an independent republic in 1946. In the case of Puerto Rico, also a Commonwealth, the United States granted US citizenship to Puerto Rican island residents. Cuba and Puerto Rico were not the only territories in the western hemisphere to become American protectorates. US diplomacy and military also intervened in Panama, which was created as an independent state when it conceded the Canal Zone

in 1904. The US military intervened in 1904, 1912, from 1918 to 1920, and again in 1925. During World War II the Canal Zone was occupied; the most recent military invasion was in 1989. The United States also occupied Nicaragua from 1912 to 1925, and intervened again in the 1930s. Haiti was occupied between 1915 and 1934, and the Dominican Republic from 1916 to 1930.

Against this background, one cannot be surprised that the United States also intervened frequently in Cuba: between 1906 and 1909, in 1912, and again between 1917 and 1923. The Platt Amendment was formally revoked in 1934, but Cuba's position as a US protectorate lasted until 1959. Cuban presidents asked for military assistance when confronted with opposition by political movements, trade unions or peasants' associations. US envoys and ambassadors advised on internal affairs and mediated in conflicts. Dictators and civilian presidents became acquaintances to maintain respectful relations with the American proconsul on the island. They asked for recommendations and assistance, and most importantly they complied with his suggestions. Cuba's economy adjusted even more to US interests. In December 1898, President McKinley decreed the use of the dollar as legal currency in Cuba. In 1914 Cuban president García Menocal introduced the Cuban peso at a parity of 1:1.[35] By 1920 American products represented 72 per cent of all Cuban imports and 79 per cent of the island's exports were destined for the United States.[36]

US investment in the Cuban sugar sector (representing 80 per cent of Cuba's export volume) rose from 23 per cent in 1903 to 53 per cent in 1928.[37] As Gott[38] commented: 'Bankers and traders, mill and plantation owners, railroad operators and simple investors, all looked to the [United] States to protect their interests. Cuba had become a colony in all but name.' In 1927 the ten most extensive and prosperous sugar estates in Cuba, totalling 670,000 hectares, were the private property of American businessmen.[39] Between 1898 and 1930, several thousand US citizens immigrated to Cuba, accompanied by 200,000 Spanish and 150,000 Antillean labour migrants.[40]

US influence had a more positive consequence as well. During the 1920s a modernization process took place in the form of cars, electric light, urban railways, a national railway system, a national telephone system, a national broadcasting system, baseball stadiums and movie

theatres.[41] Semi-urban and rural poverty was widespread, but in comparison with other Latin American countries Cuba could at least boast a middle-class ambience for the well-to-do.

Important popular and student organizations emerged in the 1920s. In 1921 the Federación Obrera de La Habana (Havana Workers' Federation) was established. In 1925, the Confederación Nacional Obrera de Cuba (CNOC, National Workers' Confederation of Cuba) was formed under the leadership of anarchists. Several municipal and provincial committees founded the Partido Comunista de Cuba (PCC, Communist Party of Cuba) in 1925. One of its founding members was the student leader Julio Antonio Mella, who was also the founder of the Federación de Estudiantes Universitarios (FEU, Federation of University Students), created in 1922.[42] In 1923 the Confederación de Estudiantes de Cuba (CEC, the Confederation of Cuban Students) organized the secondary school students. Both student organizations, inspired by Martí's writings, closely cooperated in the decades that followed. The old veterans of the liberation wars joined together to form the Association of Veterans and Patriots (Asociación de Veteranos y Patriotas, AVP), also in 1923. Originally an organization to further the steady payment of military pensions, the association was generally critical of the successive governments. Prior to the creation of these organizations, the Movimiento de Independientes de Color – a social movement of blacks and mulatos – tried to improve the marginalized situation of these population segments. The government of the day prohibited the creation of political parties based on 'race and colour'. When the movement rebelled in 1912, it was cruelly crushed as US marines arrived to protect American properties.[43]

Between 1925 and 1933 Cuba was governed, at least formally, by President Machado, a general turned businessman and a protégé of the American ambassador. Establishing a de facto civilian–military dictatorship, he created a formidable opposition: the army (some officers started an armed revolt that was crushed), the veterans, the students, the labour unions and the political left. In 1927 a Directorio Estudiantil Universitario (DEU, University Students' Directorate), a radical protest organization against Machado, was created. Machado's second term coincided with the Great Depression. Economic conditions in Cuba deteriorated when the United States was also affected by the crisis.

In a couple of months, 25 per cent of the entire Cuban labour force was unemployed. A national strike paralysed the country in 1930. Several clandestine organizations emerged; the Directorio Estudiantil Universitario went underground. A more socialist-oriented wing split off into the Ala Izquierda Estudiantil (Students' Left Wing, AIE), preparing for urban guerrilla activities. One of its leaders was Raúl Roa, Cuba's minister of foreign relations after 1959. Another member of the Directorio Estudiantil was the revolutionary Antonio Guiteras; he headed a guerrilla group in the Sierra Maestra and overtook the army barracks of San Luis.[44]

The strike of 1930 was fiercely repressed, but the clandestine resistance movements remained unbroken. Despite the presence of military governors and an active political police, unions continued to organize strikes. In July 1933, bus drivers organized a transportation strike that spread rapidly to other sectors. In August 1933, the army opted for Machado's resignation while the American ambassador procured a transition government. Over the course of four months, a revolutionary fervour flooded the island. Protesters occupied sugar factories and sometimes established local soviets. In September 1933, sergeants, corporals and rank-and-file soldiers staged a coup, supported by the DEU and some university professors. A key figure was sergeant-major Fulgencio Batista. In 1933/34, a revolutionary wind swept across Cuba.[45]

A revolutionary presidency was formed by five members, the so-called Pentarquía (Pentarchy), which only managed to govern for less than a week.[46] Thereafter, at the request of the DEU, Grau San Martín was appointed president while Antonio Guiteras integrated the cabinet as minister of government, war and navy. In fact, the army was the stronghold for Batista, who forced most of the commissioned officers to retire and replaced them with his allies – the sergeants and corporals. As chief commander of the armed forces, he controlled the Grau government. The government implemented a series of reforms: the creation of the Ministry of Labour, a minimum wage, free unionization of the labour force, collective labour negotiations, a social security system, several nationalizations, and the de facto abolishment of the Platt Amendment.[47]

The American ambassador refused to recognize the Grau government. Batista had already clashed with Guiteras and saw a successor

for Grau in Colonel Mendieta, leader of the shrunken Liberal Party. Grau went into exile in Mexico. In 1934, a new Reciprocity Treaty was signed between Cuba and the United States; the US military base at Guantánamo was maintained. In opposition, Guiteras founded a clandestine movement, Jóven Cuba, and prepared for a national strike in 1935. The new government – and Batista – imposed martial law and crushed the strike. When Guiteras prepared for exile by initiating a guerrilla movement and returning to the island, he was murdered. Consequently, Cuba came under military control. This time, from 1934 to 1944, Batista – a sergeant-major turned general – governed the country from the military Camp Columbia (in Spanish the Ciudad Militar Columbia), the army's headquarters in Havana. Between 1934 and 1940, he first acted as military strongman and delegated government to seven puppet presidents of his choice. In 1940 he was finally elected president.

By fusing populism with authoritarian governance, Batista acquired certain popularity, skilfully manoeuvring between reforms and concessions to the right and left. He convened a Constituent Assembly and produced the constitution of 1940. The new constitution was progressive – at least for its time – with an eight-hour workday, a forty-four-hour work week, a pension system, a progressive social security system, freedom of association and universal suffrage. Public education was free and mandatory, racial and sexual discrimination were outlawed, and the death penalty was abolished. Grau's political followers opted for electoral opposition and Batista sought and found political support from the Communist Party, legalized in 1939.[48] The party was permitted to create a new union structure, the Confederación de Trabajadores de Cuba (CTC, Confederation of Cuban Workers), a supporter and beneficiary of the Ministry of Labour.

Cuba, a staunch ally of the United States, had a flourishing economy during World War II. In 1944, Batista lost the presidential elections to Grau, who assumed Cuba's presidency from 1944 to 1948. During that period Cuba's economy was in even better shape. The war period benefited the island with favourable sugar export terms. Between 1940 and 1947, sugar export value jumped from 2.7 million to 54.2 million per ton; its overall export value ascended from 110 million to 746 million dollars (pesos).[49] Hence, the new government had spending

power for public works and employment policies. The Cuban pub-
lic sector expanded enormously: from 60,000 positions in 1943 to
131,000 in 1949.[50] Along with prosperity, corruption also peaked.
Personal enrichment of the president (and his successors) and cabinet
members (and their successors) became notorious.[51] Corruption, mis-
management, 'gangsterism' (*gansterismo*, a Cuban slang term), and
even control of student movements and trade unions, became ingre-
dients of everyday politics. To quote Henken:[52] 'Sadly, over the next
eight years Grau, his party, and his successor, Carlos Prío Socarrás,
went on to violate nearly every principle of good government in a
fashion that would bring shame perhaps even to the utterly venal and
corrupt politicians of Cuba's first republic.' While Grau shifted to the
right during his presidency, Prío Socarrás – who, prior to his presi-
dency, was the minister of labour – was a right-wing hard-liner from
the outset. His fierce anti-communism was equally reflected in his
persecution of the labour movement and the CTC in particular.

The 1940s and 1950s were also decades that saw the penetration
of American organized crime in Cuba's economy, society and political
structures. Smuggling and trafficking to the United States had also
been an important clandestine economic activity during the 1930s, the
World War II years and the early post-war years. Yet especially dur-
ing the government of Prío Socarrás, the gambling and prostitution
rackets – and the casinos associated with American mafia bosses –
flourished as never before.[53] Meyer Lansky was the unofficial mafia
representative during the 1940s and early 1950s. He founded the
company Cuba Nacional in Havana (which later merged with the
National Cuba Hotel Corporation). The company had partial ownership
of Hotel Nacional and the Hilton Hotel chain.[54]

By 1947 a former student leader, Eduardo Chibás – a talented radio
speaker and debater – broke with the ruling political party alli-
ances and organized a new party, the Partido del Pueblo (Ortodoxo)
(PCC–O, the (Orthodox) People's Party). The new party adhered to
the ideals of the revolutionary 1930s – freedom, social justice and
labour reforms, property and agrarian reforms, educational reforms,
and honesty in public affairs.[55] He rapidly achieved enormous pop-
ularity, especially by means of his campaign against corruption. His
well-known statement (*'verguënza contra dinero'*, or shame against

money) remained in the collective memory of his and the subsequent generation. All revolutionary veterans I interviewed remembered Chibás for his honesty in public affairs and his anti-corruption campaign. He would have been a serious presidential candidate in 1952.[56] But in 1951 he shot himself during his weekly radio transmission, unable to present definitive proof against a minister he had accused of misappropriation. His funeral caused a great popular demonstration, attended by hundreds of thousands of mourners. After his death, Chibás became a man venerated with popular mystique.[57]

Dictatorship and rebellion

The 1952 elections were organized in an atmosphere of disillusion caused by Chibás' death, and by a discredited government. It was assumed that the opposition would gain control; Batista had acquired a meagre 14 per cent in the polls. He then staged a coup – early in the morning of 10 March 1952, he and his followers arrived at Camp Columbia and arrested all senior officers. President Prío sought refuge in the Mexican embassy. It was a textbook coup; the plotters seized all army posts and strategic positions. Communications and transport were immediately controlled. The university was closed, union offices occupied, the Communist Party banned. Constitutional guarantees were suspended. The right to strike in labour disputes was revoked. Batista promised new elections in 1954 and decreed a salary increase for all military and police officers.[58] He also dissolved the existing political parties and disbanded the Senate and the Chamber of Representatives.

The United States was quick to recognize the new government; Batista acted with energy and was, after all, an ally in the Cold War. The number of American corporations proliferated and Cuba became a major tourist destination. In adherence with the wishes of Meyer Lansky, who had privately furnished huge cash provisions, Batista opened Havana to large-scale gambling, hotel and casino investments, and prostitution.[59] He became very rich as a result.[60] Initially, Batista at least received the half-hearted support of important population segments and institutions: the bankers, the sugar elite, rural landowners and even some labour leaders like that of the CTC, Eusebio

Mujal.[61] The two significant political parties, the Partido Auténtico (the Authentic Party of Grau and Prío Socarrás) and the Partido Ortodoxo (Chibás' Orthodox Party), split up into factions. A small minority joined the ranks of the Batista sympathizers and the majority opted for a 'non-insurrectional opposition'.[62] The Communist Party, the Partido Socialista Popular (PSP, Popular Socialist Party), took an ambiguous position until 1958. Their leadership had never been in tune with Guiteras' resistance movement in the 1930s. Moreover, they had – with instances of hiatus – collaborated with Batista for two decades.[63] Denouncing the coup as 'pro-imperialist', they abstained from insurrectional activities, sailing their private course without much affinity for other movements that opted for insurgency against Batista.

Resistance against the Batista regime grew rapidly, but the reasons were political rather than economic. Cuba in the mid-1950s, though affected by poverty and racism, was not a poor or underdeveloped country by Latin American and Caribbean standards. As Pérez[64] remarked, the frame of reference for Cuba's middle classes was the standard of living of the United States, not that of other countries in Latin America and the Caribbean. In 1957, Cuba ranked second in terms of per capita income after Venezuela; first in terms of telephones, newspapers and motor vehicles per thousand inhabitants; third – after Brazil and Mexico – in terms of radios and TVs; and third – after Argentina and Uruguay – in terms of daily food consumption. In 1958 Cuba had between thirty and forty radio stations and five TV channels, one of which was in colour. Literacy was relatively high: only 30 per cent of the national population was illiterate.[65]

Moreover, in accordance with Cuba's tradition of armed rebellion and armed liberation movements, secret organizations with clear insurrectional aims also emerged: the Asociación de Amigos de Aureliano, the Movimiento Nacional Revolucionario (MNR, National Revolutionary Movement) and Acción Libertadora (AL, Action for Liberation).[66] Their leadership had participated in the rebellions against Machado in the 1930s. The Triple A, created by Prío Socarrás' minister of education, Aureliano Sánchez Arango, and financed by Cuban emigrants in the United States, conducted sabotage using explosives and prepared plans for assaults on Batista. They were allied with retired and active-duty military. The MNR, headed by university

professor (and former member of the DEU in the early 1930s) Rafael García-Bárcena, organized a clandestine movement of students and intellectuals. Their most militant members tried to overwhelm the military Camp Columbia in April 1953; their insurrection failed.[67] Acción Libertadora – headed by Justo Carrillo Hernández and consisting of students, journalists, labour union leaders and organized workers – launched an underground journal, prepared an attack against Batista, and conducted actions of sabotage in Havana and Santiago de Cuba.

A new clandestine movement then changed the situation, putting a definitive stamp on Cuba's development. It was founded by Fidel Castro, a young lawyer who as a student leader had been affiliated with the left wing of Chibás' Partido Ortodoxo. Castro proved to be the charismatic leader of the revolutionary insurgency movement that quickly triumphed over Batista's dictatorship and acquired a mass following. Between the second half of 1952 and the beginning of 1953, the movement (initially called El Movimiento) began in Havana and the surrounding provinces. It was a conglomerate of secret, selective and compartmentalized cells of carefully selected members. It was organized around a national directorate composed of two committees, one military and another civilian. It included 1,500 members – students, workers and former disenchanted affiliates of the youth organizations of the traditional parties, along with their trusted friends and family members. Castro was preparing for an armed insurrection in the eastern region, based on its tradition of armed rebellion and strong support for the liberation armies of the nineteenth century. Of the 1,500 members, 165 were selected for an assault (on 26 July 1953, subsequently to become, as 26-7, the designation of the revolutionary movement) on the military barracks of Moncada in Santiago de Cuba (the second-most important in the country) and of Carlos Manuel de Céspedes in Bayamo.[68] Once the barracks were overpowered, the large stock of weapons would be distributed to the people.

The assault failed, however. The army captured and massacred fifty attackers. Fidel and his brother Raúl escaped with a smaller group of twenty-five to the Sierra Maestra, where they were subsequently captured.[69] At his trial in September 1953, Castro defended himself by invoking José Martí. The written version of his defence, *La Historia*

Me Absolvará (History Will Absolve Me), in fact a political programme of nationalizations and land reform, circulated clandestinely afterwards and impacted the radicalizing Cuban youth. All contemporaries I interviewed in Cuba (see Chapter 1) said that they felt at the time that the (then relatively unknown) Fidel expressed the wishes of an entire generation. Fidel and the other attackers were incarcerated. When Batista tried to legitimize his regime with fraudulent elections in 1954 – he ran unopposed and acquired 40 per cent of the electorate – he proclaimed an amnesty policy that, after a public campaign, also incorporated the Moncada assailants.

Probably by coincidence, on exactly the same day the Cuban Buró para la Represión de las Actividades Comunistas (Bureau of Repression of Communist Activities, BRAC) – designed by CIA officers – was created. In addition, a structure of somewhat rival repressive institutions – the Servicio de Inteligencia Militar (SIM, Military Intelligence Service) and the Servicio de Inteligencia Naval (SIN, Naval Intelligence Service) in the cities; and the Servicio de Inteligencia Regimental (SIR, Regimental Intelligence Service) and the Guardia Rural (Rural Guard) in the rural areas – was set up, each operating with a network of snitches (*chivatos*).[70] The climate of increasing repression resulted in Fidel and his closest comrades seeking refuge in Mexico to prepare an armed insurrection, sensing that 'all doors of the civic struggle [had] closed'. Before departing for Mexico he appointed Frank País, another charismatic leader of the first hour, as national chief of action in Cuba.[71] They would launch the guerrilla movement in the Oriente province, the most important region during the three wars of independence. País organized the first urban and regional networks of 'action and sabotage' of the public sector, along with the execution of snitches throughout the country. He also set up committees of funding, armament provision, medicine, transport and logistics.[72]

The student movement fostered a second current of insurgency. The Federación Estudiantil Universitaria (FEU) had periodically demonstrated against Batista since March 1952. Most of the protest marches were spontaneously organized; the police would intervene harshly, using brutal violence against the demonstrating students.[73] In early 1955 the president of the FEU at the time, José Antonio Echevarría, launched a campaign of organized marches and publicity for

wounded students. Moreover, realizing that the FEU itself did not have a structure of insurgency, he founded a Célula Central (central cell) as the nucleus of the subsequent Directorio Revolucionario (DR):

> Echeverria knew that the structure of the FEU was not suitable for the armed struggle [...] the *Directorio* would be the organisation of the revolutionary students [...] In early 1955 he convened a meeting in a residence in Calle Lesquina a Calle 27 No. 460 [...] There we decided to change the name to Directorio Revolucionario [instead of Estudiantil Universitario. Present were José Antonio Echeverría, Faure Chomón, Fructuoso Rodríguez, Jorge Ibarra, José Luis Varona and René Anill.] Thereafter we organized nuclei throughout the country and organised the clandestine structures. In September 1955 we were invited, as the central cell, to another meeting with newly recruited compañeros, and it was then that we established an Ejecutivo Nacional [...] In another meeting we chose 24 February 1956 as the official announcement [...] That day José Echeverría, the organisation's Secretary General, publicly presented the DR as founded in the Magna Aula of the University of Havana, and announced that it would be the armed branch of the FEU.[74]

By 30/31 August 1956 Echeverría and Fidel Castro had signed a formal insurrectional alliance, the so-called 'Carta de Mexico, signed with the decision to die or to triumph'.[75] During these years of insurgence (1956–58) they would support each other's actions, and after the triumph in 1959 the two organizations would merge. In fact, part of their recruitment base overlapped and the members of the two insurgent movements were like-minded. Their approach, however, was different: the DR opted for spectacular urban guerrilla activities while the M 26-7 favoured a combination of rural guerrilla and urban insurgency. Student units of the DR organized protest marches, working from the idea of 'armed manifestations' in which armed commandos 'incentivised the masses'. Their actions, aiming to hit Batista's top leadership, sometimes triggered escalating violence. In 1956 they executed Colonel Blanco Rico, chief of the

SIM, while he attended a nightclub performance. In retaliation, hit men of the intelligence community assaulted the Haitian embassy, where nine student members had sought refuge. They were murdered but during the fight the students killed Colonel Piedra, chief of the feared Buró de Investigaciones de la Policía (Bureau of Police Investigation).[76]

The Mujeres Martianas (short for the Frente Cívico de Mujeres Martianas, or Civic Front of Martí Women) was created at the University of Havana in 1953 on the occasion of Martí's hundredth birthday. It was a non-armed but influential national organization, which was also a significant support for the armed insurgents. It would quickly function as a civilian sustenance organization for both the M 26-7 and the DR. When the first board members of the Mujeres Martianas were arrested in January 1953, Fidel Castro was their lawyer. In September 1955 Fidel invited them to affiliate with the M 26-7; several of their national and provincial members joined the guerrilla and the urban armed resistance groups as well.

Meanwhile, Fidel had assembled and trained an expeditionary group of members in Mexico.[77] There he and his brother had befriended Che Guevara, who would join the overcrowded *Granma* yacht as the medical officer of the expedition. Once in Cuba Fidel appointed him as first *comandante* of a guerrilla force, above even Raúl.[78] According to plan, the expedition to the Oriente province would set sail on 30 November 1956. Frank País, already waiting with a support group of locally trained volunteers, started a rebellion in Santiago de Cuba. Young rebels, who were wearing the olive-green uniform and red-black bracelets of the M 26-7 for the first time, occupied the city for several hours.[79] But the expedition did not go ashore (*Granma* was two days late). When the insurgents' ammunition was exhausted and they had to look for safe houses in Santiago, the city's population spontaneously hid them – a standard practice during the insurgency years of 1957 and 1958 (see Chapter 3). The alarmed Batista immediately sent military enforcements to the eastern region. The DR had organized a protest march on 27 November 1956. It was the last one; the march was bloody and repressed, and the government closed the university shortly thereafter.

Castro's campaign

Owing to poor weather conditions, the disembarkation of the *Granma* expedition was a failure. It was 'more of a shipwreck than a landing', according to Che Guevara's sardonic comment.[80] Of the eighty-two members of the crew, many were massacred by the army in the first two weeks of December 1956. Some were imprisoned;[81] others managed to flee and later participated in activities in other provinces or outside of Cuba. In any case, Fidel lost the better part of his General Staff. Of the survivors, only twenty or so (initially twelve) reached the Sierra Maestra, among them Fidel Castro, Raúl Castro, Che Guevara, Camilo Cienfuegos, Faustino Pérez, Efigenio Amejeiras, Juan Almeida, Ciro Redondo and others.[82] The tiny guerrilla force turned to a Plan B and recruited their first guerrilla pelotons from the poor rural population. For most of the first year of operation, the force in the sierra depended on the llano 'for everything from medicine, weapons, ammunition, food, equipment, clothes and money to domestic and international publicity'.[83] In February and March 1957, Frank País sent reinforcements of about fifty young *guerrilleros* from Santiago de Cuba with arms and equipment.

Fidel then established the first formal guerrilla Column 1. País' organizational brilliance also provided M 26-7 with the elementary structure of an urban guerrilla: action and sabotage, civilian support, propaganda, finances and liaisons with labour unions and students.[84] Frank País was assassinated on 30 July 1957 and buried as a guerrilla *comandante* in the M 26-7 uniform after a spontaneous general strike of five days, the largest popular demonstration in the history of Santiago de Cuba. The leadership of M 26-7 was encouraged by the enormous popularity of the rebels' case. He was succeeded by René Ramos Latour (*nom de guerre* Daniel), who consolidated the organization of the movement's cell structure.[85]

The assassination of many of the *Granma* expeditionists, the ruthless persecution of the small guerrilla column in the Sierra Maestra – and of the urban and provincial insurgents by the army, police and intelligence institutions – generated a general climate of repression.[86] Paramilitary forces like the Tigres de Masferrer, a death squad of several hundred members that operated in the Oriente province, further

reinforced tensions.[87] Initially only in the province of Oriente – and then across the entire country from the second half of 1957 – civil disobedience and support committees sprouted up under the supervision of the M 26-7. The founding members of these committees were professionals: medical doctors, dentists, head teachers, businessmen, and leaders of Baptist and Roman Catholic organizations.[88] The Communist Party still joined the protests, but expressed an adverse position vis-à-vis the M 26-7 and the guerrilla in the Sierra Maestra. In a statement published on 26 February 1957, the party leadership wrote:

> In reality, there are only two oppositional factors that act with intensity. One [is] the '26 July' who does it in its own way, with its anti-governmental *foco* [guerrilla centre] of the 'Sierra Maestra' and its erroneous ideas about political action. The other one [is ours], our Partido Socialista Popular, labouring to move the workers and the people based on the correct tactics of union and mass struggle [...].[89]

Based on the ideas of Frank País, Armando Hart formally organized the committees into the Movimiento de Resistencia Cívica (MRC, Civic Resistance Movement) as a non-partisan, non-violent movement of clandestine cells.[90] The middle classes provided adequate support for the movement. Their members published national protest announcements (the editor of the journal *Bohemia* was one of its leaders), organized periodic 'days of civic resistance', requested intervention by the Red Cross and the United Nations, urged the re-establishment of constitutional rights, and advocated for political amnesty. Eventually, the National Confederation of University Alumni, the National Medical College, the National Lawyers' College, the Engineers' College, the national professional organizations of university professors, secondary teachers, public and private elementary school teachers, the Gran Loge of Free Masons, the Catholic (male and female) organizations of Acción Católica, the Council of Evangelical Churches, and even the Rotary and the Lions Clubs were represented.[91] Oltuski was the M 26-7 liaison with this movement, representing 300,000 Cuban professionals.[92] Sometimes the personal relations among the various organizations of protest and insurgency converged:

After entering the civic resistance movement I received [the instruction] [...] to guarantee the largest possible numerical strength of the demonstrators in the streets of the city [Havana] on any given day. We were authorized to mobilize not only the women in the Resistance and other front organizations of the M-26-7, but also the members of other organizations. These included the Frente Cívico de Mujeres Martianas, the Federación Democrática de Mujeres Cubanas, the women of the Directorio Revolucionario, etcetera. As a parallel activity, the members of the Movimiento de Resistencia Cívica who were in possession of a car would block the streets to impede or postpone political repression, giving time for the women to retreat and disappear.[93]

Political hegemony within the opposition movements' support was contested. In November 1957, several political forces signed the so-called Pact of Miami to establish a Junta de Liberación Cubana (Cuban Liberation Junta). Co-signers were the Partido Ortodoxo, the Partido Auténtico, the FEU, the DR and some union movements. Some lower ranking M 26-7 members signed the declaration without having consulted the movements' leadership. Fidel publicly dissociated himself from the declaration. After all, his movement took on most of the fighting and the pact could potentially enable a post-Batista military junta, with the silent agreement of the United States. To clarify his position, he announced in December 1957 that the president of the post-insurgency civilian government would be Judge Urrutia, who had declared that the defendants of the imprisoned *Granma* survivors had acted legally.

Networks of exile organizations arose in the United States, Mexico, Venezuela and other countries. Exiled Cubans formed 'patriotic clubs' and contributed with financial support. A vital exile and foreign financial Comité del Exilio (Exile Committee) was headed by Mario Llenera and afterwards by Luis Buch.[94] Internal financial support was also obtained by selling '*sellos*' (sympathy vouchers) in denominations of 1 to 20 pesos. In early 1958 the monthly total in Havana was between 15,000 and 20,000 pesos (dollars).[95] In February 1958 Radio Rebelde, a rebel radio station, started to transmit from the Sierra Maestra under Che Guevara's supervision. Although the

Batista government captured several clandestine radio transmitters, Radio Rebelde continued to broadcast throughout the year of 1958. After 1959, it became Cuba's most important broadcasting station. The rebel journal *Aldabonazo* also circulated secretly. Clandestine operations of the urban action and sabotage groups acquired national fame: on 8 November 1957, one hundred bombs exploded simultaneously across the city of Havana. There were no victims, no wounded, no deaths. From that point on it was impossible to deny the presence and power of the M 26-7 in the national capital.[96]

In March 1957, a commando of the Directorio Revolucionario attacked the Presidential Palace and the radio station Radio Reloj. Both actions, which were nearly suicidal, failed. One of the many student victims was José Antonio Echeverría. The weapons used in this dramatic attack were, afterwards, transported to Frank País and then to the Sierra Maestra by Manuel Piñeiro.[97] A month later four other DR leaders, one of them being Echeverrría's successor Frutuoso Rodriguez, were assassinated by secret agents. The universities of Havana and Oriente (Santiago de Cuba) were closed. Many students joined the clandestine local insurgent organizations. Faure Chomón became the new leader of the urban guerrilla of the DR and its incipient rural guerrilla column in Escambray. In February 1958, the relatively small DR guerrilla in Escambray, just north of the city of Trinidad, organized three landings of combatants and equipment. Some of the arms were used to reinforce their insurgents in Havana. The guerrilla expanded slowly but it did fight. In August 1958, DR combatants attacked the barracks of Güinía de Miranda. Two months later, they occupied several villages in Las Villas and blockaded the Carretera Central, Cuba's national highway that stretches between Havana and the central and eastern provinces. In October 1958, Faure Chomón joined the guerrilla columns of Che Guevara and Camilo Cienfuegos.[98] After the triumph in January 1959, he was appointed Comandante de la Revolución.[99]

In fact, with all these competitive revolutionary forces debilitated, the M 26-7 remained the only strong armed resistance force campaigning against Batista. Slowly but steadily their numbers increased. On several occasions they attacked or counter-attacked Batista's troops. Although a numerically small force, they had survived all

attacks to their columns. Sometimes they even put Batista's troops on the defensive. The propaganda value of their fierce resistance was enormous. Within the organizational structure of the entire M 26-7 movement, the Sierra became a kind of safe haven for those urban militants who were '*quemados*' (identified as rebel) and persecuted. On the other hand, the guerrilla forces in the Sierra constituted 300 combatants (until March/April 1958). The number of urban and rural militia units in the llano was much larger: an estimated 300 in the Pinar del Rio province, 3,000 in Havana, 150 each in Las Villas and Camagüey, and 200 in Santiago de Cuba.[100]

Batista's armed forces became demoralized; factions within the army and navy even rebelled. There were precedents – as early as 1956, Colonel Ramón Barquín had tried to overthrow Batista with the most prominent members of the army, a group of 200 officers. All conspirators were released from duty, while the principal leaders ended up incarcerated. In September 1957, navy officers organized another conspiracy across the island. When the marine base in Cienfuegos rebelled, the local population quickly sided with the mutiny. Batista ordered an air attack and sent in the army's special forces. The invading soldiers wounded many of the conspirators and their supporters, killing several and executing others. The members of the Resistencia Cívica attended to the wounded and hid those who were persecuted. Later that year conspiracies were discovered in the air force, the medical corps and the police.[101] The captured military rebels and the clandestine members of the M 26-7, who were lucky enough to be brought to court, were incarcerated in the Presidio Modelo at Isla de Pinos (present-day Isla de la Juventud). There, Hart and other arrested M 26-7 leaders organized a kind of revolutionary academy.[102]

Meanwhile, the urban militia movements of M 26-7 achieved spectacular success. In February 1958, the Grand Prix for Formula 1 was organized in Havana. An urban commando accomplished the kidnapping of world champion Juan Manuel Fangio, who (after he was released) expressed sympathy for the cause of the rebels.[103] The kidnapping of Fangio was world news and the propaganda boost for M 26-7 was enormous.[104] M 26-7 had already launched the daily news programme of Radio Rebelde; at least seven clandestine journals circulated regularly. Even Batista's press chief Suárez Nuñez recognized

the superiority of M 26-7's propaganda.[105] The M 26-7 also advanced in a more military sense. By March 1958, Fidel had split up his forces to gain the initiative in the entire eastern region of Cuba. Raúl Castro's second Frente 'Frank País', consisting of sixty-seven combatants (although only fifty-three of them were equipped with rifles), established a territorial base in the Sierra Cristal. With his third Frente, Juan Almeida opened another base north of Santiago de Cuba; meanwhile, Fidel still commanded his remaining first Frente. The entire rebel force then consisted of several hundred regular soldiers.[106]

In the 'Liberated Territory' of Raul Castro's second Frente (an area of 15,000 km²), the rebels established an administrative apparatus. They introduced a series of local reforms that afterwards, between 1959 and 1961, were implemented on a national scale: a land reform, a literacy campaign, construction of schools and hospitals, and a public health system. In addition, a structure of policing and justice was established. Micro-ministries of transport, logistics, education and health managed twenty hospitals and fifty schools. In the Sierra Maestra a similar reform system was established. It had its own legislation and police force. Formal governance in the regions that were controlled by the rebels illustrates that the insurgency was successful. In the summer of 1958, this process would gain even more momentum. After the failure of Batista's offensive (see below), Cuba's larger sugar enterprises and industrial and commercial companies began to pay 'war taxes' to the M 26-7. The amount of incoming revenue surpassed the money collected little by little through *bonos* (sympathy vouchers), which were sold to the civilian sympathizers. It also trumped the contributions collected under the Cuban diaspora abroad.[107]

March and April 1958 were the turning point for the revolution. First, the United States decided in March to withhold military support for Batista. That same month, Faustino Pérez – the leader of the national urban resistance movement in Havana – came to Fidel's camp in the Sierra Maestra to discuss a national strike planned for April, which would bring down Batista's regime. Organizing a successful general strike would, the Havana leadership thought, recalibrate the balance between M 26-7's urban resistance and rural guerrilla forces – those of the llano and the sierra. Pérez insisted on a strike and was

convinced that Havana would be the key to Batista's demise. Fidel had misgivings. Weapons, mostly light arms, were scarce. Maybe the militias in the llano were not prepared to resist the regime's armed forces. Maybe the coordination with other organizations that opposed Batista, and especially the labour unions, was not completely adequate. Maybe the strength of the forces of the llano had been over-estimated in comparison with smaller, but better disciplined, guerrilla forces in the sierra. In other words, would M 26-7 risk the fate of all his forces in vain?[108]

The outcome of the strike (9 April 1958) was indeed failure. Militia members of the M 26-7 were quick to occupy radio stations in Havana and Santiago shortly thereafter. Other commandos attacked an armoury and police stations, but most industrial and transport workers in the capital managed to complete their work shifts. Also, there were few worker strikes and the public transport system kept running. In the following days, many militia members were arrested, militia captains disappeared, and nearly all safe houses were exposed.[109] In Santiago and the eastern region, workers did strike and both militia and guerrilla units attacked specific targets. Yet on 10 April, it was clear that the failure was definite. The urban underground had received a fatal setback.

In May 1958 the national M 26-7 leadership convened in the Sierra Maestra (in a place called Alto de Monpié), where the internal balance of the movement had significantly shifted in favour of the sierra.[110] As a result, Fidel Castro was appointed secretary general and Comandante en Jefe (Chief Commander) of all M 26-7 forces. The General Secretariat was transferred to the sierra. The guerrilla forces in the sierra were renamed Ejército Rebelde (Rebel Army) and the urban and rural militias were renamed 'columns'. Membership of all armed M 26-7 organizations was open to all who wanted to join, regardless of their political origins. Radio Rebelde would be the major propaganda tool and was transferred to the sierra. Judge Urrutia was officially ratified as president of the Provisional Revolutionary Government. M 26-7 would be the vanguard party in future coordination with other opposition movements. Haydée Santamaría, also the movement's financial manager, was sent to Miami as fundraiser and representative of the Florida diaspora. Luis Busch went to

Caracas on a similar mission.[111] Fidel had turned an external defeat into an internal political victory. As Sweig rightly remarks: 'Once the vanguard, the urban underground had finally relegated to the revolution's rearguard.'[112]

After the failure of the April strike, Batista thought the time was ripe to launch an overall offensive to dislodge and destroy the guerrilla forces. In his war memoirs,[113] Fidel mentions having been astonished about the careless preparation of Batista's military campaign. General Batista codenamed the military offensive 'Plan FF' (Fin de Fidel, End of Fidel). He first deployed 7,000 and then 10,000 combat soldiers along with air force squadrons and offshore naval units, all of whom fought against an estimated total of three hundred-plus armed rebels. The majority of the armed forces were assembled against the first Frente of Fidel Castro: fourteen infantry battalions and seven independent companies, mobilized against 220 guerrilla combatants with rifles.[114] The rebels had anticipated the offensive and were prepared for a bitter defence, assembling an arsenal of shells, mines and makeshift weapons along with stockpiles of food, water and medicine. Radio Rebelde was transferred, intelligence networks were reinforced, and hospitals and schools were camouflaged and prepared for wounded combatants and prisoners. The rebels knew the terrain inside out.[115]

The campaign went on for seventy-four days of uninterrupted combat and ended on 6 August 1958 with the retreat of Batista's army. It resulted in the loss of 1,000 combatants, 300 of which were fatalities. Several military units were completely destroyed or disintegrated. The Rebel Army took 443 prisoners (and sent them back home through the Red Cross). The captured army officers were permitted to keep their pistols; the wounded soldiers were attended to first.[116] The Rebel Army obtained 507 pieces of equipment, including two tanks, ten mortars, several bazookas and twelve machine guns.[117] In some cases, captured officers and soldiers asked to be incorporated into the guerrilla columns.[118] The demoralized armed forces licked their wounds, suffered desertions and began to disintegrate. Fidel's star rose as his military and political leadership were widely acknowledged. It had immediate effects on all segments of the broad, and growing, opposition groups across the country and in exile. Now Castro could negotiate and make agreements on his own terms

After the fall of Venezuelan dictator Pérez Jimenez in January 1958, Caracas had become the focus for all Cuban opposition forces. During the first weeks of Batista's military failure, in June 1958, Castro's new standing was confirmed by the assisting leaders of all opposition groups, who recognized him as their senior (the so-called Pact of Caracas). The Communist PSP did not sign the pact. However, in the summer of 1958 the PSP established a formal alliance with the M 26-7 and sent a prominent leader, Carlos Rafael Rodriguez, to the Sierra Maestra. A few months before the final triumph on 1 January 1959, it granted them a comfortable position within the ranks of the post-1959 revolutionaries.[119]

The failure of Batista's counter-insurgency campaign brought about a change in the hitherto warm relations between the State Department and the Batista regime. Now the idea of regime change and a transition to a civilian or civil-military government was openly discussed. The American ambassador tried – in vain – to establish negotiations between Batista and representatives of civil society and former politicians.[120] Castro's forces had taken up the initiative immediately after Batista's military misfortune. His own forces grew. In August, 1958 he added a fourth Frente to the three Frentes operating in the eastern region. In September 1958, he created five more Frentes to storm the llanos, although the operations did not start until October.

Then, thirty-two columns and detachments (two from the DR and one from the PSP) covered Camagüey, the northern zone of Las Villas (Camilo Cienfuegos), the southern zone of Las Villas (Che Guevara), or were on their way to Havana, Matanzas and Pinar del Río.[121] This time the rebels were better equipped, although the only ones with arms were the veterans who served as the nucleus of the llano Frentes (eighty men under the command of Cienfuegos and 140 combatants under the command of Che Guevara). During their campaigns the combatants swelled with new recruits, militia members of the urban underground, and peasants and civilians who had secretly formed their local resistance groups. Meanwhile, armed urban militia combatants also carried out local attacks on Batista's forces.[122]

In autumn, the fighting continued against new detachments of the dispirited army of Batista. During their final campaigns, Che Guevara

and Cienfuegos distinguished themselves heroically and acquired national fame. In November 1958 Fidel, Raúl and Almeida descended from the mountains and advanced to Santiago de Cuba with their veterans and new recruits. In early December 1958, Judge Urrutia and Luis Busch flew from Caracas to the Liberated Territory with 7 tons of weapons, a donation from Venezuela's interim president, Admiral Larrazábal.[123] The rebel commanders had around three thousand combatants at that moment. Meanwhile, disillusioned army soldiers laid down their arms or joined the rebel forces. Entire army units had melted away. On 23 December 1958 the *coup de grâce* was provided by Che Guevara, who derailed an armoured train with 400 soldiers and an enormous amount of armament and equipment.

By December 1958, Batista's army commander in Santiago de Cuba was reporting that 90 per cent of the population supported the Rebel Army. On 28 December, General Eulogio Cantillo (army Chief of Operations) agreed with Fidel that the army would overthrow Batista on 30 December and then surrender; Fidel postponed the takeover of the garrison of Santiago de Cuba.[124] But General Cantillo, appointed by Batista as army General Commander a few hours before, allowed the dictator to flee the country on New Year's Eve. He flew to the Dominican Republic, which was ruled by his friend, the dictator Trujillo.[125] Cantillo then tried to form a civil-military junta with help from the American embassy.[126] Via radio, Fidel ordered a general national strike, which was a resounding success this time around. He also sent an ultimatum to Colonel Rego Rubido, commander of Santiago's garrison. The officer accepted and joined the Rebel Army with 5,000 soldiers. The peaceful transfer impeded a bloody battle and completely frustrated the planned coup.

That day the revolutionary government under President Urrutia was constituted in the provisional capital of Santiago, while Fidel Castro was appointed General Commander of the Cuban Armed Forces. In Havana, a euphoric popular mass swarmed the streets. The M 26-7 militia and mixed DR and M 26-7 action groups took over government buildings and police stations. Fidel had ordered Camilo Cienfuegos and Che Guevara, the most charismatic *comandantes* of the Rebel Army, to swiftly move to Havana and take over command of the military Columbia barracks and the fort, La Cabaña.

Fidel himself and the core of the Rebel Army embarked on a long victory march, from Santiago to Havana. Their following expanded by the day. The march was halted by speeches, salutations, meetings with M 26-7 veterans and sympathizers, and other ceremonies.[127] By the time Fidel arrived in Havana, on 8 January 1959, the Rebel Army had come to power across all of Cuba. The national hero was welcomed by a jubilant crowd, while the new Revolutionary Government – comprised of respected, pro-revolutionary citizens and some M 26-7 members – took office. He spoke to an overjoyed audience of sympathizers, emphasizing the need for revolutionary unity. As he was finishing his speech, a white dove settled on his shoulder.[128]

CHAPTER 3

· · · · · · · · · · · · · · · · · · ·

From insurgents to socialists

The insurgents

Revolutions are achieved by generations engaged in collective action, subject to collective suffering and motivated by collective sentiment. Their views and thoughts are the legacy of the past and the dreams of the future: shared frustration, mutual moral commitment and ideological conviction.[1] Revolutionary generations also share an ethos of sacrifice and willpower. They will remember their collective history as a 'calling'. There is a spirit of belonging, being chosen for the membership of a special community with new and superior morality and new codes of conduct. They, and the selected members of their age cohort, are destined to perform great things: rebellions and revolts; profound transformations of the economy and of economic rationality; transformations of society and the rebuilding of a new and more decent class structure; transformations with deep political reforms, creating new and more noble power elites, and new and more dignified rules of control. As a new ideology dominates, new cultural expressions and lifestyles emerge. Cultural role models will be different. It will generate new family and gender relations. Sometimes even different moral and religious concerns and expressions will surface.

A revolution also implies destruction: the radical restructuring of the old economic, social and political order; resistance and migration of the old elite and adherents to the former regime; and reorganization of the key institutions of justice, order, security and defence. The old leadership disappears in favour of new governance. Economic leaders with new urgencies replace the old guard. Representatives of the new classes and new social strata establish the boundaries of equality, inequality and opportunity in society. Maybe a dream of a

classless society will become reality. New political parties and social movements replace the movements and institutions that support the old regime. Career paths will be completely different.

The leaders and adherents of the Cuban Revolution had a common mind-set: a fervent patriotism, strong anti-imperialist and anti-American feelings, pro-poor sympathies, and a conviction of urgency for social justice and social reform. They all venerated the revolutionary heroes of the nineteenth century. Roots and triggers of the rebellions included the following: being confronted with a coup by a detested dictator supported by the United States; situations of direct persecution of family members or fellow students; the visible presence of poverty and social injustice; the shared disdain for a negligent economic elite; national political and economic dependence on the United States; and the sycophant behaviour of the ruling class with respect to representatives from the 'Colossus of the North'.

As already indicated in the previous chapter, the rebellion against Batista was not a homogeneous movement. Fidel's Movimiento 26 de Julio (M 26-7) was not the only oppositional force, and even within this movement there were dissenting opinions – at least until April 1958 – about the importance of urban insurrections vis-à-vis the rural guerrilla, and in the llano (the flat regions of the island) versus the sierra (the mountains in the Oriente, the Eastern Region). There were other competing rebel groups that fought clandestinely in Havana and other cities, or participated as urban and rural militias against the despised dictator Batista. Leaders of the traditional political parties that were in place prior to Batista's coup in 1952, now in exile, supported the insurgents with money and arms and made formal pacts and agreements.

As early as 1955 an important resistance group headed by Frank País – Acción Revolucionaria Oriental (afterwards renamed Acción Revolucionaria Nacional) – merged with Fidel's rebel movement.[2] In August 1956, during his exile in Mexico, Fidel signed a pact of coordination and support with José Antonio Echeverría, the leader of the Directorio Revolucionario Estudiantil (DRE or DR, basically a national students' resistance movement). In practice there has always been a considerable overlap of the student participants in both groups.[3]

While interviewing the revolutionary combatants in 2011 and afterwards, I asked them about their social, religious and educational backgrounds. I also asked about their intellectual mentors and role models, and about the experiences that helped shape their moral and ideological convictions. We talked about their ideological roots, the influence of their teachers and icons, the evolution of their own vision of society, and the path that had led each of them to embrace a life of armed revolutionary struggle. Almost all interviewees were very young – sometimes even teenagers – when they opted for a clandestine existence. Nearly all veterans reckoned that their patriotic ideals were transmitted by their parents, grandparents and great-grandparents, and that their patriotism had been fostered by nationalistic teachers during their primary or secondary education. Without exception, the interviewed veterans explained that their radicalization in the period of armed insurrection was also due to their confrontation with social injustice in Cuban society.

Most combatants were influenced by the heroes of the nine-teenth-century wars of independence: Martí, of course (Cuba's *pater patriae*), and the revolutionary generals and the rebellious soldiers, many of whom were former slaves (*mambis*). Other heroes were the patriotic leaders of the 1930s (Guiteras) and the 1950s (Chibás). Nearly all insurgents had a religious upbringing: Roman Catholic, Presbyterian, Episcopalian or Baptist. The Cuban Revolution was not widely supported by the Roman Catholic hierarchy. There were some revolutionary priests, but the majority of the bishops did not sympathize with the revolutionaries or were explicitly opposed to 'communism'. The more socially progressive Catholic priests remained silent during the 1960s.[4] In the 1950s, most of the bishops were Span-ish-born; as a result many of them had sympathies for the Spanish Falange.[5] The majority of the Cuban revolutionaries had a religious upbringing. Both Fidel and Raúl had attended a Jesuit college prior to their university studies. Frank País, the important leader of the urban underground, was the son of a Baptist pastor; he had provided Catho-lic and Baptist chaplains to the guerrilla forces in the Sierra Madre. One of them, Father Sardiñas, had been appointed *comandante*; he baptised and performed marriage ceremonies. In January 1959, many of the *barbudos* – the bearded *guerrilleros* – descended from the

mountains adorned with the rosary of the Virgen del Cobre, St Mary and Cuba's patroness.[6] Contrary to the subsequent official atheist preferences within the Cuban Communist Party, many Cubans – also party members – believe in 'God and the Virgin', while simultaneously distancing themselves from the official church hierarchy.[7]

The members of the insurgent generation that made up the Cuban Revolution were largely engaged in the urban underground until 1958. Students – from the university and from the institutes of secondary education and of arts and crafts – constituted the majority. More men than women were incorporated.[8] Most members were young, aged fifteen to eighteen, when they decided to participate in the resistance movements. The oldest combatants, and leaders, were around thirty years old in the mid-1950s when they began to prepare for the underground insurgency and guerrilla campaign.

The initial leadership of the urban resistance movement and the guerrilla had a middle-class background. Fidel and Raúl Castro were sons of an immigrant father from Spanish Galicia, who had become a prosperous landowner. Che Guevara's mother was a descendant of the last Spanish viceroy of Peru, De La Serna. Manuel Piñeiro's parents were provincial upper middle class, sufficiently well-off to send their radical son – identified as a rebel by local police – to Columbia University in New York.

A smaller percentage of the urban insurgents joined the guerrilla columns in the Sierra Maestra, where a larger number of the local *guerrillero* recruits were peasants. Several of them acquired top positions after the revolution.[9] Many ordinary members of the underground were also the sons and daughters of labour-class upbringing or poor, though not destitute, families. They grew up in popular neighbourhoods, both urban and rural. Here is the summary of the infant and adolescent years of Ramiro Abreu, who later became Cuba's liaison with the Central American revolutionaries and remained so for more than thirty years:[10]

I was born in a distant peasant hamlet, very humble. Our house was made of mud. My dad was a muleteer. He died after my first school year, which was a disaster for a poor peasant family. We had to move periodically, first to the village of Caibarién

and then to Havana. We were always on the move. Once we moved six times in a year. My primary and secondary education was completely irregular. The result was that I was a functional illiterate. Thanks to the revolution I could study.

After 1959 he studied sociology and diplomacy; he now holds a doctorate in history. A similar case is that of Jorge Risquet, who was president of the Committee of International Relations of the Comité Central del Partido Comunista de Cuba (the Central Committee of the Communist Party of Cuba) until his retirement. Previously, he led a guerrilla support detachment in Congo-Brazzaville, played a crucial role in Cuba's intervention in Angola, and participated – as Cuba's ambassador – in the peace negotiations with South Africa. He remembers his infancy, living with his parents in a '*solar*' – a one-room family unit with a multi-family bathroom, the habitual home of the urban poor in Central Havana at that time. This is his description of his mother:[11]

Flora, my mom, was white, a granddaughter of Spaniards migrants. That is why I have 5/8 Spanish, 2/8 Chinese and 1/8 African blood. Her parents were workers. She believed in God and in spiritism. She hated the priests and had experienced what extreme poverty and discrimination were like. She started working at 10–11 years of age, along with my grandmother, who was also a tobacco worker in a workshop. She was so tiny, that when the labour inspectors arrived, they put her in a barrel where the tobacco leaves were stored and closed the lid. Mom couldn't write, but she could read. She learned to write during the literacy campaign, in 1961, and sent a letter [of gratitude] to Fidel.

Luis Morejón, for many years the vice-director-general of the Instituto Cubano de Amistad con los Pueblos (ICAP, Cuban Institute for Friendship with the Peoples), was a shoeshine boy who was also working in a clandestine cell of the M 26-7. He even continued polishing shoes during the first months of the revolution:[12]

I was born in a remote rural smallholding. My mother was of peasant origin. My father sold furniture and household items.

When I was nine years old I started working as a shoeshine boy in Villuendas Square. My mother worked as a maid for a wealthy, devout Catholic; they got me a scholarship with the Jesuits. There I studied until I was twelve years. I continued cleaning shoes on Saturday and Sunday. In June 1956, I came to Havana to clean shoes in the Venus Bar in El Vedado. [A doctor helped me to get into the Instituto del Vedado.] The Institute was rebellious. I was a classroom delegate. [I established ties with] a cell of the 26 July Movement. I was a shoeshine boy, cleaning cars, selling newspapers, selling tickets [...]. Obviously, the cell members knew me and they assigned me to the task of watchman while they were meeting. And when someone succeeded in escaping police detention, my job was to watch them, go out with them at night. At the time of the triumph of the revolution I was thirteen years old. I was still cleaning shoes. But when the first milicias were created, I joined them, following Fidel's call for artillery people. In 1960 I joined the first course for anti-aircraft artillery.

During the insurgency against Batista, many urban rebels were persecuted by the police and the security apparatus – arrested, tortured or condemned to long prison terms. Some of them even disappeared after torture. In order to understand this generation, I present below the exemplary careers of some members of the urban underground, of the *guerrilleros*, and of the captured prisoners.

Insurgent women

The first rebel history is that of María Antonia Figueroa Araujo. She is one of the oldest insurgent members of the movement whom I interviewed, aged ninety-two at the time. She represents the numerous female militants who joined the clandestine movement in the Eastern Region. In her case she volunteered to support the attackers of the Moncada, hiding the wounded and survivors in Santiago de Cuba.[13]

I was born in 1918. I became a member of the female section of the Orthodox Party. When the Moncada was attacked, I rescued six *compañeros*. The attack was at 04.00. And at noon I get

a call from a colleague. He says to me: 'María Antonia, there are six combatants in a friend's house and we have to allocate them.' And they were rescued. All the families wanted a boy: 'No, there are only six of them.' We were very helpful, everyone in Santiago de Cuba. It moved us, the carnage of that day. We saw the trucks pass with corpses.

Fidel [was] imprisoned. I remember when his trial started, at the hospital. We knew where he was going to be judged: in the nurses' room. And indeed, at exactly eight o'clock they arrived: run, run, a military march! And when they brought him in, handcuffed, I paced among the guards. I grabbed his hands and said: 'Everyone is with you.' And he made [a gesture of] gratitude [...]. When he was released from jail [two years later], he sent someone to look for me: 'the *compañera* from Santiago who rescued six lives'.

At that point, Fidel Castro and Melba Hernández had already recruited the first members of the local cell structure in Santiago. Most participants were friends or friends of friends. The leader – Lester Rodríguez, a Moncada assaulter – was a pupil of María Antonia's mother, a well-known activist and schoolteacher. Her maternal uncle had been the godson of General Maceo, hero of the liberation wars. More than thirty members of the Araujo family had been killed during the rebellions of the nineteenth century. Fidel invited María Antonia to join the M 26-7:[14]

And when I am talking to him he says: 'I want you to be the treasurer of the Movement in the east. Lester Rodríguez is a friend of yours. He will be the coordinator. You have to form a full committee, one for action and sabotage, another one for financial matters, for propaganda, for coordination, for law-yers' assistance.' And thus I was appointed treasurer. It was 1955 [...]. I started with my family and my mom helped me a lot. She wrote it all in a book as I told her: 'X donated 20 pesos, Y 30 pesos.' In 1957 and 1958 we mostly collected money from the poor. But at the end of the war, Fidel appointed Pastorita Núñez [as treasurer]. So she went to collect at the sugar estates,

at the big companies, with a letter signed by Fidel. At that time they already had territorial control. So I left the treasury because, at the very moment that millions of pesos entered, I could no longer manage these amounts.

Although she had a full-time job as head of a prestigious educational institute, she went up to the sierra on the weekends:[15]

I went to the mountains, to fight in the third Frente with Almeida. First I had to talk to each one of the peasants about the reasons for our guerrilla. I assisted in that task. Then I mended the wounded returning from battle, along with the doctors. But mostly I talked a lot with the *guajiros* [the local peasantry], so that they joined the Rebel Army.

On 1 January 1959 she returned home as a captain of the Rebel Army, a high-ranking officer of the third Frente headed by Juan Almeida Bosque. In 1959 she became the Superintendent of Education in Havana, until she retired.

Another female guerrilla member is Consuelo Elba Álvarez (Elba), daughter of a maid, who was a young adolescent living in one of Havana's slums. She is one of the many young female adolescents with vague sympathies for the left, who joined the urban underground and afterwards 'went to the mountains'. She compares daily life in the urban underground to that of the guerrilla in the liberated territories:[16]

I was born in 1942. I lived with my mother in a marginal neighbourhood of Havana, in a *'solar'* – a one-room dwelling with collective facilities. My mother was black and poor and we frequently moved just because she was a maid. There was a black, squint, ugly, old man: Roberto Azcuy. I'm beginning to call him Dad, because it was him who reviewed my school books when I went home ... because my mother was never home during the day. [Roberto] practically became my family. And he and his friends were communists, members of the Partido Socialista Popular. Of course, I didn't know that. I believed

in God, attended catechism meetings. For me, communists ate children; that was what they told us. When I perceived that they were communists, it was shocking news. But after a week I went back, with a logical conclusion. They are practically my family; if they are communists, they cannot be bad people.

In 1955, when I was thirteen years old, I joined the Socialist Youth. I began to participate in everything, all tasks I was given. In 1956, they arrested me for the first time [at a demonstration]. When the police arrived, everyone screamed: 'Down with Batista!' It was enormous and tremendous turmoil and confusion. Three of us were arrested. They carried us to the First Police Office. From there they moved us to the Buró de Investigaciones, and afterwards to the VIVAC [detention centre] for women. At the end of 1957 I was detained again. They took me to the Buró Represivo de Actividades Comunistas [BRAC, the Repression Bureau for Communist Activities]. That was definitely worse. I was discharged because one of Batista's spokesmen intervened. I was fifteen years old. I was released, but I was super '*quemada*' [identified as a rebel]. It was then that I went to the guerrillas, to the sierra.

After a period of clandestine work as a teenager, Elba was incorporated into the guerrilla, working in several areas of the sierra. She remembers that the total number of (female) *guerrilleras* was around three hundred. There was even an all-female guerrilla peloton of twelve combatants, Las Marianas, founded in September 1958 and headed by Tita Guevara:[17]

In the sierra I was a member of Columna 1 'José Martí' [Guerrilla Column 1], headed by Fidel. I was a courier and also a teacher; the Rebel Army had a general policy about the literacy of their members. Really, there were people who didn't know what Cuba was. Cuba was the small place where they lived and nothing more. I was with the first Frente until the triumph of the revolution.

Daily life in the sierra was complicated, especially for us, the women. From the perspective of the [urban] underground, it

was glorious. But when I got there, the reality was different. To take a bath, I had to go to a river where I could do laundry, leave my clothes there, wait until they were dry and then put them back on. Moreover, the troops are men. You are the one with problems, like menstruation. Everyone noticed it, there was no way around it.

Another terrible thing were the planes that bombed us. They threw bombs at whatever movement they observed. I had a little school; the children could have been injured or killed. The daily meal was the worst. You had to eat anything you could find.

Several former guerrilla members emphasize the strict codes with respect to the local population. Llibre, aide-de camp to Fidel in the Sierra Maestra, vividly remembers that Fidel, Che, Camilo and other *comandantes* always insisted on reverence towards local peasantry:[18] 'Take care. Always pay the price a peasant askes you, without discussion.' Fidel followed the rules set out by Céspedes and Martí during the wars of liberation. The guerrilla was a people's war that required sensitive and tactful relations with the population that supported the *guerrilleros*, especially in matters concerning women and girls, and land and animals. This was essential for maintaining the sympathy of the local peasant population:[19]

The rules in the sierra were very strict; you couldn't take anything from the peasants. And that explains why the peasants supported the Rebel Army so strongly. They won their sympathy with their exemplary standing, with everything they were doing. Far from violating a woman! On the contrary, the rules were very clear. Not that there weren't relations in the Cuban guerrilla, but only if they were mutually consensual. And they could marry. There was a priest, Sardiñas, who married a lot of people in the guerrilla movement. I don't remember any pregnant woman within the guerrilla. Among the couriers, yes. There were never relations of disrespect, because people were severely punished if something like that happened. Many [local] people joined or supported the Rebel Army.

Asked about the similarities and differences between life in the underground and that in the guerrilla, Elba considered the daily life in the cities – especially Havana – more dangerous and difficult:[20]

> In my opinion, the urban underground was more difficult than the Rebel Army. The money, the resources, the support came from the [local] base. I lived in both places. This [urban ambience] was more difficult, because in the city, including Havana, there were many repressive organizations operating: SIM, the BRAC, the people of the Buró de Investigaciones. They were targeting the clandestine, the young guys. Being within the guerrilla felt as if it were paradise. You had the enemy in front of you. But acting there [in the city] was like staying in a mousetrap. In Cuba [at that time], the mere fact of being young was enough to be convicted. I think that being young was a sin at that time. The repression was very harsh, very strong.

After 1959 she studied journalism and became one of Cuba's eminent radio and TV documentarists. She is still engaged in TV productions and several of her documentaries, about female guerrilla combatants in Cuba and elsewhere, have received honours and awards.

In one of the action and sabotage groups within the urban resistance, a woman was part of the leadership. It was a group of five: three young male and two young female students. They formed a collective leadership and called themselves the Pentarquía, in reference to the civilian junta of 1933. Three members were killed; two survived and became important figures in the government and public sector – Gladys (*nom de guerre* Marel) García-Pérez and Amador del Valle.[21] During the last months of 1958, Marel headed action and sabotage groups in Havana and Matanzas. Eventually she had a diplomatic career; she became a historian and a member of the Cuban Academy of History. She wrote a seminal work (2005) about the urban underground in Havana and Matanzas. One of her dearest memories is her first meeting with Che Guevara and Fidel in early January 1959:[22]

> Che and Fidel wanted to know me in person. Che was laughing like crazy. He asked me what I wanted to do: 'Do you know

what you want to do?' I said: 'Not exactly, I can only make and detonate bombs.' He laughed, because everyone he met asked him for favours. 'I don't know anything like that.' Then Che says to me: 'Look, now we want to organize the women, some brigades of women in the Capitolio.'[23] I said, 'Ah, that's perfect, organize the Brigadas Femininas Revolucionarias [Women's Revolutionary Brigades, BFR].' And I organized them, with more than three thousand members.

Insurgent men

I selected the experiences of two militants. The first one (Carlos Amat Forés) was a young adult at the time of Batista's coup in 1952. The second one (José Antonio [Tony] López) was twelve years old when Batista carried out his coup. Amat, eighty years old at the time of the interview, was a university student who earned his family's income as an employee of the telephone company in Santiago de Cuba, a subsidiary of the International Telephone and Telegraph Company (ITT):[24]

> I was born in a small town in the north-eastern Oriente province. We were the poor part of my family. When I was thirteen years old, my family moved to Santiago de Cuba. I stayed there until the triumph of the revolution, when I went to Havana. My father had embarked on a life in other places; he got lost and we never heard anything else about him. That obliged me to find a job to help my mother. I was seventeen years old. The ITT in Santiago were accepting applications for a vacancy; I ranked first and was admitted. Meanwhile, I continued studying and graduated from high school.

Until 1947, the University of Havana was the only university in Cuba. In that year, a second university – modelled after those in the United States – was founded in Santiago de Cuba. Yet its faculty was recruited from nationalist, progressive intellectuals and scientists. Some new professors were refugees of the Spanish Civil War. The professor of criminal law, for instance, was José Luis Gálvez – former

Attorney General of the Spanish Republican government. Amat could arrange a convenient timetable with his employer and his colleagues: attend classes and seminars in the afternoon, and work during the morning and night shifts and weekends:[25]

> I'm talking about the year 1951. I worked at the department of transmission, the long-distance radio communication with Havana plants. And I enrolled in the Faculty of Law. I was involved in the entire university life. Then Batista carried out a coup in 1952; there was an enormous student protest. The Batista government embarked on a policy of repression. In Santiago you could see murdered labour leaders, from the left, supposed communists. They started to persecute them. They began to torture people. Because of my employment at the telephone company, I was able to eavesdrop on the long-distance calls; no one could perceive that I was listening in. On the day of the Moncada assault I overheard terrible things, like the order to massacre all captured combatants.

That strongly influenced Amat's political radicalization. When the news of the killing orders leaked out, the population of Santiago de Cuba – outraged – hid as many of the assaulters as they could. The wounded were brought to trusted doctors. It was the beginning of the clandestine circles of family members and friends, support groups for the underground resistance in Santiago. Most rebels were young and studied at the university or at the secondary educational institutes. They were unified by Frank País, then a student leader. They printed and distributed the clandestine copies of Fidel's defence pamphlet, *La Historia Me Absolverá* (History Will Absolve Me). When the first student members were captured, tortured and killed, spontaneous strikes erupted. After Fidel's release and the fusion of Frank's and Fidel's rebel forces, cell structures emerged within the student and labour movement.[26]

> [...] people didn't ask if you were a cell member. If they saw a boy, because he had put a bomb in a street corner or when a policeman was going to seize him, they opened the door and

hid him. And when the police came to look after him they said: 'No, I saw him running away.' And they hid him in a back room. No one asked if you were a member of their cell, or if you were distributing one of the illegal pamphlets that he then passed from hand to hand. Because in each cell they gave it to their neighbours, to friends whom they knew. The clandestine cell movement really became very strong.

Amat's job at the telephone company made him very valuable to the resistance movement. Vilma Espín became a trusted contact, then a friend. When the *Granma* expedition was organized, he also sent messages to Frank País, Armando Hart and Haydée Santamaría. Eavesdropping became dangerous. The army and the police posted guards to supervise the incoming and outgoing communications with other cities, and with Mexico:[27]

The operators had their 'argot' signs: 'Take number one,' they said, and I knew what to do. The National Directorate [of the M 26-7], already founded in Santiago, got to know it. We detected all [military] communication and notified them about it, notwithstanding the presence of the guards. Nearly all ITT operators in Santiago worked for the 26 July Movement. I worked directly with Vilma. She was my immediate contact. And later with Haydée, already clandestine – I also contacted her. Frank was my chief. We worked out a code language. Like it is at present, all telephone employees are long-distance friends, with mutual trust.

That network was maintained during the insurgency years. It was an enormous help because, for instance, you heard all about military movements. They sent in I don't know how many thousands of soldiers from Havana for the [counter-insurgency] campaign in the Sierra Maestra. We all noticed it, and we even sent messengers to Fidel. At a certain moment my job became indispensable. And that was one of the reasons that I didn't go to the sierra. [Meanwhile I had graduated as a lawyer.] I defended the detained guys in the courtroom. I tried to conceal

it, so that they didn't discover that I worked at the telephone company. But I also worked as a defence lawyer.

In January 1959, Carlos Amat was appointed vice-minister of justice in Havana. But almost immediately afterwards, the magistrates of the Supreme Court collectively resigned. They were replaced by the 'revolutionary lawyers', former law students within the underground movement or the Rebel Army. Amat's minister appointed him Deputy Attorney General at the Supreme Court. When the Attorney General was relieved because of health problems, he became his successor. Several career changes followed. When the dean of the Faculty of the Humanities of the University of Havana died, he was asked to reorganize the faculty. Three years later Fidel appointed him rector of the Universidad del Oriente, in Santiago. He was then relocated to the Ministerio de Relaciones Exteriores (MINREX, Ministry of Foreign Affairs). He served as ambassador to Canada. Upon returning to Cuba, he was appointed minister of justice for seven years. Again he was asked to represent Cuba, this time in Geneva. Subsequently he was in charge of the General Directorate of Latin America of MINREX. After his retirement he was appointed director of the Cuban Institute of the United Nations, a position he still held when I interviewed him.

Tony López was born in an extended family with communist sympathies: his grandfather, his father and his uncle had been Party members from the 1930s onwards. His father was a tile maker, the provincial leader of the tile workers' union in Camagüey. He remembers him travelling across the Sierra de Cubita, where the Party had a strong peasant following. There he attended the secret meetings where Soviet movies circulated. He remembers his father's admiration for Stalin, and Stalin's bust at home, in a prominent place: 'Stalin: military uniform! Proletarian face! Iron fist!', according to his father. After 1956, when Khrushchev denounced Stalin's Terror, his father's appreciation of the Soviet ruler diminished. Tony's younger uncles, leftists, became members of the Orthodox Party in the early 1950s. After Batista's coup, soldiers and police officers routinely, and unannounced, checked his home for illegal activities and visitors. Of

course, many visitors went and came secretly. No wonder that young Tony, like many of his family members and friends, joined the local insurgents. He became a member of M 26-7:[28]

In 1957 I became a member of the 26 July Movement, in their action brigades. I was fifteen years old. My uncle was the chief of the area where we lived. They were very active there. Later I formed and even headed a small cell. I was appointed to do so by my uncle, after his detention. My three uncles were arrested. We did well, burned buses and threw Molotov cocktails. We burned a police assault van. We disarmed an army corporal, recovering weapons. We attacked a '*chivato*' [snitch]. We didn't kill him, but we threw a Molotov cocktail at his house, which was made of wood. But we always avoided hurting civilians. It was a code we respected. It was rather like armed propaganda. And besides, Fidel was against kidnapping. Fidel always forbade kidnapping someone.

In September 1958 I was warned that I was very '*quemado*' [identified as a rebel] and I asked to be transferred to the sierra. I no longer lived at home; I had been brought to my aunt's house, then to another place. In November 1958 it was decided that I could go to the mountains, to join the Rebel Army. I came to the encampment of Comandante Víctor Mora, head of Column 13. There were a few veterans, but also a group of young people, untested recruits [...]. There we experienced the revolutionary triumph. Later we were sent to the city of Camagüey. And on 12 January [1959] Fidel sent Column 13 of Víctor Mora to Havana. It was the first time in my life that I boarded a plane; I was sixteen years old. I turned seventeen here in Havana.

Tony tried, to no avail, to be incorporated into the early expeditions to Nicaragua, to fight against dictator Somoza, or to join the guerrilla columns against dictator Trujillo in the Dominican Republic. He found employment as aide-de-camp at the Ministry of Public Works. In 1960, he was admitted to the first crash course on socialism and revolution at the Primera Escuela de Instrucción Revolucionaria (First

Revolutionary Instruction Course). After graduating, he entered the Cuban security and intelligence system, organized a short time before by Manuel Piñeiro. He served in the Departamento America (and the earlier institutional structures) for the rest of his career: in East Berlin, Prague, Paris, Argentina and Central America. But his most memorable appointment was his liaison function with Colombia, generally as an envoy or a diplomat, for eighteen years. His last posting was in El Salvador and Nicaragua. He retired in 2010.[29]

Imprisoned insurgents

Between 1952 and 1959, a substantial number of the rebels and militants were persecuted, interrogated, arrested, tortured and sent to prison. I chose a woman and a man to illustrate the plight of those in captivity. Ángela Elvira Díaz Vallina (Elvira), aged seventy-seven at the time of the interview, was elected president of the Federación de Estudiantes Universitarias (FEU) in 1957. She was arrested seven times:[30]

I was the president of the FEU and they assigned me the task of organizing the National Student Front [Frente Estudiantil Nacional]. Ricardo Alarcón, who is now president of the National Assembly, was my co-responsible. [I was arrested] first when I was caught in a demonstration, which I myself had organized, to support the landing of the *Granma*. [The last time was when] the SIM captured me on Mother's Day in 1958. They arrested me, searched the house, picked up every paper item they could find – even the bus and tram fare tickets. It was the seventh time that they picked me up. And this time it was worse, yes, really worse.

Finally, they took off my clothes, they were abusive [...] [The rector of the university intervened.] Then there arrived an invitation for a student conference in Chile and the rector sent it to me. He procured me a safe home at the residence of the Colombian ambassador. The ambassador arranged the departure formalities. He said to me: 'This is the largest file I have seen, it is yours. You will stay not a minute more; I am putting you on the first plane to Miami.' Off I went to Miami.

The case of Manuel Graña Eiriz is representative of all underground members captured by Batista's political police and anti-communist paramilitary bands (the Servicio de Inteligencia Militar in the cities and the Servicio de Inteligencia Regimental in rural areas). His parents had been members of the resistance movement against Machado in the 1930s. He quickly joined the protesting student movement and had already been detained twice by 1952. Both times, he was released after one night in a police station. He then became a member and successively the leader of a clandestine student network that eventually comprised seventy-four participants. When the M 26-7 was founded, the entire network adhered to Fidel's movement. Graña and other *compañeros* participated in armed actions and even made contact with some young, insurgent members of Batista's armed forces. In 1957, during one of the largest student demonstrations in Havana, he was captured again. This time he was tortured:[31]

They hit me all the time, did me the 'submarine'[submerged my head under water] and broke my eardrums. Before that they wielded a canvas bag full of sand, in the form of a sausage, and began to beat me with it. That was the standard package for all guys arrested: hit after hit, blow after blow, by six, seven people. I guess that I spent months in pain, all over my body, my muscles painfully contracted.

And I was scared. I was scared and the fear increased. To be very clear: fear. It is like when someone corners a peaceful animal somewhere. What I say is that there's no such thing as bravery or cowardice. From my point of view there is only fear. Because [once in prison] I had the opportunity to talk with people of the Moncada assault and the *Granma* expedition who were imprisoned there. And they told me: 'I was afraid at the Moncada and I was afraid at the *Granma*.' I talked to every one because I remained traumatized by the fear that I had at the time. Well, there is fear. And a medical *compañero* who was in prison told me, if you have no fear then you had no value. Because only the fools, who cannot realize what could happen to them, have no fear.

He was brought to court; the public prosecutor demanded six months and the judges gave him two years, under pressure from the police during the deliberations. Like many other members of the urban underground, he was imprisoned in the Presidio Modelo at the Isla de Pinos (present-day Isla de Juventud, or Youth Isle) where he was welcomed by previously arrested political prisoners: 426 members of the M 26-7, 106 former officers of the rebellious armed forces, 14 former police officers, and 32 members of other rebel organizations.[32] There he was in charge of the prison library, where the books and other publications were stored. They were used at the two 'prison academies': one was the 'department' with courses in Spanish, French and English, and the other one for 'ideology and revolutionary textbooks'. In January 1959, Graña was appointed Capitán de Milicias (Militia Captain) of the M 26-7, given his past performance during the insurgency period. At the time of the interview he held a chair endowed by the Asociación de Combatientes de la Revolución Cubana in Havana. When the first revolutionary government was installed, several of the hurriedly released prisoners acquired cabinet functions.

Socialists

The first revolutionary government was a 'Government of Lawyers'.[33] Three key positions had been reserved for respected but relatively conservative individuals: Urrutia (judge, the president), Miró Cardona (dean of the Havana Bar Association, the prime minister) and Agramonte (ambassador and university rector, minister of foreign affairs). When in late December 1958 the *comandantes* of the Rebel Army organized a meeting about the future of the government, Raúl Castro did not speak. Finally, sitting on a stone with an M-2 rifle between his legs, he commented: 'Fidel, I won't drop this iron; I am staying in the second Frente, because with people like Urrutia and Agramonte, I guess that we cannot advance along the lines that we should.'[34] It was a small incident at the time, but in 1959 and 1960 it would be followed by several others in which Raúl Castro and Che Guevara would express, in Buch's presence, their distrust of the government. It is also certain that Che Guevara wasn't very impressed by the efforts

and activities of the urban clandestine and resistance movements in the llano region.[35]

On 3 January 1959, the new government was constituted at the library of the University of Santiago de Cuba. Judge Urrutia commemorated José Martí and appointed Fidel Castro as Commander-in-Chief of the Armed Forces, Comandante Gaspar Brooks as Navy Chief, and Comandante Efijenio Ameijeiras as Chief of the Revolutionary Police. The two security institutions, the armed forces and the police were all controlled by the guerrilla *comandantes*. Faustino Pérez was appointed minister of a new special trust fund and Luis Buch minister of the presidency (a kind of chief of staff) and cabinet secretary.[36] The crucial cabinet positions of Government and Agriculture were reserved for the M 26-7. At Fidel's request, Armando Hart was appointed minister of education during the second session in Havana, on 5 January 1959. Two other cabinet members with the rank of minister were the M 26-7 members Enrique Oltuski and Julio Camacho; they were the 'civilian' members of M 26-7. All other ministers and cabinet members were political adversaries of Batista, but were not directly associated with M 26-7 or with the DR.

When Fidel arrived in Havana he first acted like a people's tribune, giving speeches in Havana's squares, in public buildings and at the university. He had a room at the Hilton Hotel (currently the Havana Libre Hotel). Very quickly, conflicts arose among the president, the minister-president and the cabinet members. The four M 26-7 ministers consulted Castro; Fidel remarked that the solution had to be structural.

On 13 February, the prime minister resigned. Fidel was appointed after a change of the constitutional article 146, which assigned the task of 'leading the government' to the prime minister. He inaugurated his political position, remarking that this task was not his choice but it had been committed to him and that it meant 'a profound concept of the necessity to sacrifice yourself for your country'.[37] Raúl Castro was Fidel's successor as Chief of the Armed Forces. Later in 1959 he would be appointed minister of defence, a post he held until 2006, when he succeeded his brother as president.

This was the beginning of a double process of political power transition.[38] Gradually, between 1959 and 1961, more M 26-7 members became ministers or cabinet members. And within the M 26-7

ministerial elite, the most prominent positions were delegated to the guerrilla leadership: Fidel (minister president), Raúl (minister of defence) and Che (minister of industry and president of the Central Bank). On 17 July 1959, President Urrutia resigned. Osvaldo Dorticós – a highly respected lawyer and dean of the national Bar Association before being exiled by Batista, who was also a leading member of the civil resistance movement – had supported the guerrilla with arms and supplies. A cabinet member without portfolio, in charge of the revolutionary reforms laws, was his successor. After a constitutional reform in 1976, which also made the president head of government, Fidel Castro became president and Dorticós became the president of the Central Bank. In fact, after February 1959, Fidel was Cuba's head of government. The perceived urgency of the quick implementation of reforms, which in prototype form had already been experimented with in the liberated zones in 1957 and 1958 – during the final months they had administered to thousands of poor people – was one of the reasons to get a firm grip on the government or, better yet, to be the executing government.

Immediately after January 1959, a kind of 'moral revolutionary aristocracy' emerged among the combatants of the Rebel Army (and the incorporated DR detachments). Many officers of the Rebel Army (the *comandantes*, captains, first lieutenants and second lieutenants) would rise to positions of great responsibility, both in the armed forces and in the central and regional government and the public sector. But their new responsibilities urgently required training and cadre formation, and that rendered the PSP, the old Communist Party, an effective monopolist of knowledge and training. As Ángela Elvira Díaz Vallina commented: 'I became a revolutionary doing it, without being communist, without being socialist, without such ideas, [only by] doing so, making a revolution, to transform our society to make it better, more just, more humane, more equal.'[39] Many, if not the majority, of those who were interviewed for this book made similar statements.

The necessity of incorporating the cadres – and the leadership – of the PSP became even more pressing when Cuba's relations with the United States quickly cooled off, then frosted, then became openly adverse. At that point the Soviet Union became Cuba's supporter and supplier.[40] The PSP 'never broke its allegiance to Moscow, and Moscow never backed Cuba's support for revolutionary movements

abroad, regarding such efforts as adventurism'.[41] And that gave rise to a third process: the rivalry between the new revolutionary cadres and the old communist guard, with its own ties with Moscow. It eventually became a power struggle between *'fidelistas'* (M 26-7) and *'comunistas'* (PSP), finally resolved during the fusion process between the revolutionary parties and the PSP. It was officially ended by Fidel's campaign 'against sectarianism'. Cuba's relationship with the Latin American revolutions is the backbone of the remaining chapters of this book. The rivalry between Cuba and the Soviet Union, specifically regarding the support to other revolutionary movements, will become an issue in the next two chapters.

In high tempo, revolutionary laws and reforms were announced and implemented: expropriations of foreign enterprises, an urban rent reform and a pharmaceutical price reform. Then a far-reaching Land Reform was promulgated. A proto-Ministry of Industry (still a department) was formed. In fact, the newly created Instituto Nacional de Reforma Agraria (INRA, National Institute of Agrarian Reform) became the office of Fidel and Che Guevara, where a small team prepared the design for further revolutionary reforms. A social security system for all citizens was established, and a general educational reform started. And all of that was in 1959. In 1960 an urban housing reform, salary reforms, a reform of the banking system and many other smaller transformations were implemented. In 1961, the government launched a national literacy campaign, with a mass participation of around 100,000 students.[42] Discrimination based on race and gender became liable to punishment. All these reforms and new social welfare policies contributed to a kind of collective euphoria. Birth rates increased as a result.[43]

These were the years of the revolutionary honeymoon. Hundreds of thousands, sometimes more than a million, people attended the speeches of Fidel. Often these discourses galvanized the audience and minutes-long applause extended over the duration – sometimes six or seven hours – of these mass meetings.[44] Pérez Jr comments:

> Fidel became the object of popular importuning, both cause and effect of a style of personalismo that fostered direct dialogue between the leader and his followers. He listened to grievances,

received petitions, considered complains. Fidel's effectiveness increased in direct proportion to rising confidence in it. As the belief took hold that Fidel could provide redress, immediately and easily, so too did his ability to do so [...] Fidel was becoming the government. More and more he responded directly to popular calls for action. Fidel propounded the goals of the revolution; the people demanded deeds of the revolution. This interplay gathered and soon assumed a logic of its own.[45]

In one of these plebiscitary speeches, before an audience of a million – exactly one day before the Bay of Pigs invasion in April 1961 – Fidel asked whether the public agreed with the reforms. Of course there was agreement. 'And that is socialism,' the prime minister declared; thunderous applause followed.

In February 1961, Fidel invited the Spanish-Soviet professor Anastasio Mansillo to lecture about Marx's *Capital* at the Council of Ministers. According to Mansillo, Fidel and Che Guevara had been his 'most difficult students'.[46] Soon thereafter, Che Guevara invited Mansillo to organize a more advanced seminar about *Capital* at the Ministry of Industry, to be attended by his vice-ministers and other functionaries. They also studied econometry and mathematics. In this same year (1961), the government structure was completely reformed: new ministries were established and the public sector expanded. A new National Planning Board (Junta Central de Planificación, JUCEPLAN) was set up to catalyse and to control an economy based on directive planning and state (or collective) property.[47] In the years following, reforms of the property system transformed Cuba into a country of collective or state-owned property, where even the smallest micro-enterprises were collectivized: 'bars, groceries, garages, small stores, the shops of self-employed artisans and other independent workers, from carpenters to masons to plumbers'.[48]

Already in early 1959, and in 1960 and 1961, Cuban adversaries of the revolution had left the country, generally departing for Greater Miami.[49] The adversaries were the former supporters of Batista and their families, and the wealthy (upper-) middle-class segment of society that felt threatened by the nationalizations of American- and Cuban-owned property. The Peter Pan operation (already mentioned

in note 5 of this chapter) contributed to another exodus of 14,000 children to 'host families' in the United States. By 1962, around 200,000 Cubans had left the country. After the Cuban Missile Crisis in 1962 (see below) another wave of outmigrants departed on twice daily 'Freedom Flights' between Havana and Miami. The programme lasted until 1973 and peaked in 1968, when the last remaining small businesses were nationalized. By then another 260,500 Cubans had arrived in Florida.[50]

The United States and the Soviet Union

Here there needs to be a short reference to the interplay between internal political processes in Cuba and the role of the two world powers at the time. Although the Eisenhower administration had recognized the new government, the United States reacted to the Cuban reform and radicalization process with growing unease, distress and alarm. As early as February 1959, the US–Cuban relationship was affected by the refusal of the American government to return US$424 million in bank reserves to Cuba.[51] The revolutionary war criminal tribunals during the insurgency period had caused indignation, which was nurtured by the claims of thousands of victims in the Cuban anti-Castro community in Miami.[52] The early support for rebellious movements against dictatorships in the Dominican Republic (the Trujillo regime), Haiti (the Duvalier regime), Nicaragua (the Somoza regime) and Guatemala (the Ydígoras Fuentes regime) was also upsetting Washington. In December 1959 the Eisenhower administration approved an action plan to overthrow Castro.

The overtures towards the Soviet Union were considered by the US State Department to be a direct advance towards communism. In February 1960 Soviet vice-premier Mikoyan visited Cuba and negotiated a trade agreement on Cuban sugar, crude oil and commercial loans. In May 1960 diplomatic relations with Moscow were re-established. The Soviet Union also provided support to the Cuban armed forces in the form of equipment – the higher military echelons received advanced military training in Moscow and Leningrad.[53] Che Guevara visited China and secured another sugar trade and loan agreement. In July 1960 the United States cut, then suspended, sugar imports from Cuba; afterwards they were barred. The final nation-

alizations of all US property (oil refineries, sugar estates, electric and telephone companies) resulted in a trade embargo in October 1960. Prior to this, US agencies had embarked upon covert support to counter-revolutionary movements in Cuba and even upon efforts to assassinate Fidel Castro and his inner circle of revolutionary companions. In 1960 and 1961 several serious assaults on Cuban civilian targets took place: economic sabotage, bombings, assassination attempts and even killings. In the course of this action, some covert operators and CIA agents were arrested.[54]

The change in Cuba's relations with the United States and with the Soviet Union can perhaps be illustrated with an event that occurred after Fidel's trip to the United Nations in September 1960. He delivered the longest speech ever made by a head of government (four and a half hours), but shortly after his arrival in New York his plane was seized by local authorities in compensation for the expropriation of American property. Then Khrushchev lent him an Ilyushin to return to Havana with the Cuban delegation.[55] The already strained diplomatic relations of the United States with Cuba were suspended, and then ruptured in early January 1961. At the insistence of Washington, Cuba was expelled from the Organization of American States (OAS). With the exception of two, all member states broke off diplomatic relations with Cuba; only Canada and Mexico chose to maintain their embassies in the country.

Of course, it had a lasting influence on assistance and support from and, consequently, growing economic dependence on the Soviet Union. It also implied the necessity of coming to terms with the PSP and its seasoned leadership, who knew better than the Cuban revolutionaries how to behave in Moscow and how to deal with the Soviet inner circle. Former Soviet ambassador Pavlov, head of the Latin American Directorate of the USSR Foreign Ministry from 1987 to 1990, remarks:

> The Soviet leadership was also getting information and advice [...] by Blas Roca, Aníbal Escalante, and other leaders of the PSP, who were regular visitors to Moscow. Having committed a gross error in denigrating Castro's armed struggle, Cuban communists now faced the prospect of being left on the sidelines of his

revolution. They made themselves useful to Castro and gained influence with the revolutionary regime by offering their services to help obtain the Soviet Union's economic support, which appeared to be the most effective, simple solution to Cuba's problem of finding alternative markets and sources of supply.[56]

When Che Guevara headed the first significant Cuban mission to the Soviet government and Communist Party, Aníbal Escalante (secretary general of the PSP) briefed old Russian party comrades at the same time that Che Guevara toasted with Khrushchev.[57]

The Eisenhower administration had prepared an invasion plan to topple the Cuban government. The CIA already boasted a similar experience in 1954, when it successfully removed the elected government of Colonel Arbenz in Guatemala, who had announced a Land Reform and had recognized the small Partido Guatemalteco de Trabajadores (PGT) – the local Communist Party. At that time they had relied on a counter-revolutionary force of mercenaries headed by a right-wing Guatemalan colonel, Castillo Armas.[58] The incoming Kennedy administration approved the plan but restricted the involvement of any US military and (especially) air force support. The plan entailed the landing of paramilitary forces, recruited from anti-Castro refugees in Florida and trained by the CIA in two encampments in Guatemala and Nicaragua. Security measures were poor, and Cuban intelligence already had a good idea of the number of mercenaries involved as well as their leadership, equipment and fighting capacity (see Chapter 4).

Washington had expected that the landing of the invasion force would trigger a widespread revolt against the regime. The battle group of 1,400 mercenaries, however, was met with fierce resistance when it set foot on Cuban soil. Fidel had mobilized the army and the newly created militias. He participated as a front-line commander at the Bay of Pigs (Playa Girón), the theatre of the invasion.[59] After two days of severe fighting the invaders suffered the loss of 114 dead and 1,200 captured. National pride was immense – the crowds cheered, the nation was unified. The revolution was declared victorious – the 'Colossus of the North' had failed to oust their leaders. In May 1962 Khrushchev became Cuba's self-appointed military protector by

soliciting Fidel Castro's permission to deploy nuclear missiles on the island. He intended to kill two birds with one stone:[60]

> [...] positioning nuclear weapons on the doorstep of the United States with the noble justification of the 'defence of Cuba against possible American aggression'. An agreement was reached about the deployment of intermediate and tactical nuclear missiles and specialized Soviet forces, a total of 45,000 enlisted men and officers with munitions and other supplies for thirty days of combat, while 'authorizing Field Commander Pliyev in Cuba to exercise his own flexible response [...] without asking for Moscow's permission'.

When the Kennedy administration was informed about the presence of the Soviet missiles and their launching capacity, the president ordered a naval blockade. With the world at the brink of a nuclear war, the Soviets and the Americans cut a secret deal – without consulting the Cubans. Khrushchev agreed to remove the missiles under the condition that the United States would not attack Cuba. Simultaneously, as part of the agreement, the Americans withdrew their missiles positioned in Turkey. The Cuban leadership got wind of the deal through the radio. They were furious, realizing that they were too dependent on the continuance of direct economic and military support from the Soviet Union while feeling treated like a Soviet satellite of secondary importance. In retrospect, Fidel Castro reflects:[61]

> We learned of the Soviet proposal to withdraw the missiles from public sources. And this wasn't discussed with us at all! [...] Khrushchev should have told the Americans: 'The Cubans should take part in this discussion.' At that moment, he failed to show equanimity and determination. As a matter of principles, they should have consulted us. If that had been the case, the terms of the agreement would have surely been better. The Guantánamo Naval Base wouldn't have remained in Cuba and the high altitude surveillance flights would have been discontinued. We were deeply offended; we protested.

Khrushchev tried to soften the Cuban embitterment with multibillion-dollar grants and abundant military assistance, and the continued presence of Soviet military on the island (a combat brigade of 2,800 men).[62] The relationship with the Soviet Union was maintained. In 1972 Cuba became a full member of COMECON, hitherto limited to the Soviet Union, Warsaw Pact members and Mongolia. The Missile Crisis became a turning point in Soviet–Cuban relations: 'Numerous mutual proclamations of everlasting friendship and loyalty notwithstanding, that mental block remained forever in Cuban leaders' minds.'[63] The relations improved only during the Brezhnev years, during the 1970s and most of the 1980s.[64]

Becoming socialists

After January 1959, a significant number of combatants thought that they had fulfilled their patriotic duty and went back home to resume their daily lives. The sisters Laura and Carmen Fernández Rueda, ninety-three and eighty-eight years old at the time of the interview, had been couriers and had hidden leaders of the M 26-7 in their home on several occasions. They also returned to their jobs after January 1959.[65] Carmen, a schoolteacher, became a provincial inspector of education in Pinar del Río. She became a member of the Party in 1971. Laura, who had been a United Nations functionary, turned down specific employment in the public sector, and even refused Party membership:

> In January 1971, they provided my sister Carmen with the Party membership. But I never wanted to be a member of the Party. For the revolution I would do anything, but I don't like those offices. I was, with all that I had, against Batista. The revolution was nice and worked well and there were many boys who fought for it. But all that is over; now there are only memories.

Most insurgents were reunited with their families. Héctor Carmona Heredia, a prisoner of Batista, was liberated and put on a plane to Havana, where he met Camilo Cienfuegos.[66] Camilo asked what his former rank had been within the M 26-7: 'Captain of the militias,', he replied. 'From now on you are Captain of the Rebel Army.' Off

he went to his family in Camagüey, where he was welcomed as a war hero. He became Fidel's helicopter pilot during the Bay of Pigs crisis, flying the helicopter that Mikoyan had brought as a gift to Fidel.

Many of the interviewees mention the euphoric meetings and local celebrations that characterized the first weeks of the revolution. After the festivities in the first months, nearly all student participants of the insurgency returned to the university and finished their studies in special crash courses. In general, they combined study with postings of responsibility within the public sector, army, police and militias. When Cuba became a socialist country in 1961, there was an urgent need for schooling. Then the Cuban leadership initiated a massive training programme for the young revolutionary adherents and militia members.[67] Most of the textbooks were of Soviet origin. Karol[68] sketches the difficulties with which the Cuban leaders were confronted, resuming a description of a discussion he had had with Che Guevara:

> So far so good. But then I asked whether, given this rather elementary plane of political education, it might not be dangerous to throw into what C. Wright Mills had called this 'ideological vacuum' a whole lot of Soviet literature of questionable value. At this question, he became furious [...]. I contented myself with giving him my own views on the works of academicians Konstantinov, Mitin, and Lysenko, who had adorned the shelves of the library [...]. Che raised his arms up to heaven: 'We want to turn our young people into socialists as quickly as we possibly can, and that means consulting textbooks from the Eastern Bloc. Have you got others you can recommend?' [...]. While he spoke, his look seemed to say: 'Please, try to forget all your preconceptions and put yourself in our shoes.' He did not attempt to defend the Marxism of Konstantinov and Mitin any more than he approved of my opinion of them. He let it be understood that he had never read these works and that the political education of Cuba did not depend on the sort of marginal aberration they might represent.

One of the students who followed the obligatory training in Marxism-Leninism was young Fernando Martínez Heredia, who afterwards

became one of Cuba's most influential philosophers (albeit not always an orthodox one). He somewhat ruefully remarks on his first training in dialectical materialism:

> In the summer of 1962 I received military training in the Unidad Militar 2254. [Suddenly I discovered that I was selected] for the School of Marxist-Leninist Philosophy [...]. I literally left my FAL rifle to board at school with 104 students. My first session there left me horrified, because the lecture was about dialectic materialism. They spent the whole afternoon discussing whether or not a shadow is an object, an absolutely sterile debate. I wondered: 'This has to be a punishment. It cannot be that they sent me to this crap.' But I joined the school with the same extreme dedication with which everybody then did everything. I spent five months in that school. In the philosophy classes we studied *Materialism and Empirico-Criticism* of Lenin, and the *Anti-Dühring* of Engels as well as his *Ludwig Feuerbach and the End of Classical German Philosophy*, and several monographs. But our basic text was the Soviet manual, the *Foundations of Marxist-Leninist Philosophy* of Konstantinov and others, published by the Academy of Sciences of the USSR. It was an unbearable book. I threw it away while reading Chapter 7 [...]. At school I had a row in public [...]. Everyone had to present a topic from the manual in front of the entire school. I had to lecture about the dictatorship of the proletariat. I presented a résumé of what the book said, but then I concluded with the comment that Stalin had ordered the murder of his *compañeros* in the USSR.[69]

Socialism required a unification process and the fusion between the two revolutionary movements (M 26-7 and the DR) – the combatants with a revolutionary ethos, and the PSP with their good standing in the Soviet-oriented party and their experienced cadres. On 26 July 1961, the three movements merged into one single unified structure, the Organizaciones Revolucionarias Integradas (ORI, Integrated Revolutionary Organizations), under the leadership of Aníbal Escalante. In 1962 the ORI was restructured into the Partido Unido de la Revolución Socialista de Cuba (PURSC, Unified Party of the Socialist

Revolution of Cuba), with Fidel and Raúl as its First and Second Secretaries. Here, the influence of the PSP was very strong: of the twenty-five members in leadership positions, fourteen were M 26-7 members, one a member of the DR and ten of the PSP.[70] In addition to the party membership, the younger militants were admitted into the Association of Young Rebels (Asociación de Jóvenes Rebeldes, AJR), a creation of Che Guevara that merged in 1960 with the Juventud Socialista of the PSP. In accordance with the unification of the PURSC, the name was modified to the Unión de Jóvenes Comunistas (UJC, Union of Young Communists).

The fusion process also brought misgivings. Enrique Oltuski, once a former employee of Shell with an engineering degree from the University of Miami, was an acclaimed leader of the resistance movement in the llano. Appointed minister of communications in January 1959, he was asked to leave the cabinet in June 1960. He remembers:[71]

> In my opinion, there were three main lines, with theirs nuances and complexities, within the revolution. They were the Communists [the PSP members] plus the compañeros of the 26 July Movement who had positions and strategic purposes that coincided with them, mainly Raúl and Che; other revolutionary combatants with anti-communist ideology, who quickly moved to openly counterrevolutionary positions [...]; and we, the combatants of the 26 July Movements, with leftist ideas that were not anti-communist but highly critical of the PSP, due to some historical errors that weighted too heavily, especially their persistent adverse attitude towards the armed struggle [...]. When I took charge of the Ministry of Communications, I brought in some of my compañeros to occupy the highest positions [...]. I knew them and I had confidence in them; they had fought with me. That was completely normal in those early months. On the other hand, the Communists began to establish themselves at the Ministry of Communications. I knew them; some of them occupied key positions [...]. A fight quickly ensued, like in almost all other Ministries, between the Communists and their following, and some members of the 26 July Movement and others who were not counterrevolutionary and also wanted to be part of

the process. The Communists embarked upon accusing several compañeros of being negative elements, even of being counter-revolutionaries, and forced them out of the key positions that they occupied.

President Dorticós and Prime Minister Fidel Castro discussed the issue of the growing internal division within his ministry. Oltuski continues:[72]

Dorticós asked me to come over [to his office]. After explaining some things, he said to me: 'It has been decided to discharge you because of the divisions in your Ministry. The situation is so problematic that you're not able to resolve it. We have to bring a compañero who has no commitment to the parties involved. That is the reason why you are to be replaced, and that is it.' While President Dorticós was telling me that, I got angry. And when he says to me: 'Do you have any ideas where you want to work? Do you need some support?' I thought: 'I'll work with the most radical guy there is, to make clear who I am.' And I said: 'I'd like to work with Che.' 'Who?' 'Yes, with Che.' The President was pretty surprised. He only managed to tell me: 'Okay, we'll try doing that.' Immediately afterwards Che called me: 'Damned, I'm really glad. Come over.'

And it worked well. Eventually Oltuski became Che's very esteemed vice-minister of technical development, then his vice-minister of planning and finally, until his death in 2012, vice-minister of fishing industries.[73] Oltuski's case was fought out at the highest levels. Also notable was the case of one of Cuba's leading historians, Ibarra Cuesta, a former combatant as well:[74]

I have a dispute here with someone from the PSP, of Escalante. Raúl [Castro] went to Santiago to see what a mess it was. There was a discussion with him, and he asked me what I was doing. And he said: 'Come with me to the army, to the Political Directorate, so that you can work with a few Spanish Republicans who are writing the military history.' Well, these Republican Spaniards did not have a clue about Cuba's history.

Thus the chief of the Political Directorate said to me: 'Hey, look, why don't you stay with the project and write the history of Cuba?' And I wrote the *Historia de Cuba*, a book for the members of the Revolutionary Armed Forces that was later adopted for university courses. And after the 1970s, our pro-Soviet friends withdrew it.

The memories about the (uneasy) process of amalgamating the former insurgents and the old communists at all levels of government – in the public sector, at the university, and in training centres – are still traceable more than fifty years later. In various interviews with diplomats, liaison officers with other Latin American guerrilla movements and retired public officers, I could perceive the continuing irritation and indignation. Several former insurgents mentioned having been a victim of the Escalante period. In many of the interviews one could feel the lingering grudge.

In Cuba, this episode is known as the period of 'sectarianism'. In fact, it was a power struggle between the old Moscow guard and the *fidelistas* in the Party. Many of the *fidelista* victims, dismissed from office or sent away to stay at home, were reinstated in their old or equivalent functions. Roberto Márquez, afterwards a diplomat, finished his career as Chief of the Special Forces at the Ministry of the Interior (Ministerio del Interior, MININT). He was explicit about the damage and the upset within the ranks of the revolutionary insurgents:

[In the public sector] there was an urgent need to fill up the positions of trust, of importance, [with] people of absolute loyalty. And one began to place people of the PSP in those sorts of functions. But that generated damages, due to the attitudes of the Secretary of Organization of the ORI, which was Aníbal Escalante, a leader of the PSP [...]. That permitted him to become a very powerful man, and he began to place his confidants – people who responded to his [personal] interests – in every state agency, wherever. And that happened in all structures of the ORI, without participation of the masses. Therefore it was called the period of 'sectarianism'. And it caused the most blatant stupidities. There were revolutionary *compañeros* who

were detained. Others went abroad, as a consequence of the pressure of the sectarian period.[75]

Eventually, Fidel Castro intervened. Escalante was forced to step down and accepted minor postings.[76] In theory, after Escalante's fall, unity was restored. 'Escalante' stood for many former PSP party bureaucrats whose qualifications were indispensable for the national, regional and local administrations. And Escalante's demise did not prevent the thousand and one small purges and insults of the 'new revolutionaries'. For a long period, bad feelings about the actions of PSP members lingered just beneath the surface.

The formation of the unitary party was accompanied by a simultaneous process: the creation of the revolutionary mass movements. It was a process organized and implemented from above. As in the case of the economy, which was gradually brought under state control, civil society was reorganized in broad, sectoral organizations that 'represented the masses'. In the context of the growing threat from the United States and the emerging counter-revolutionary movements ('bandits'), aside from the armed forces, numerous militia members were trained as a kind of auxiliary troops. They served as vigilance for public buildings and as assistance to the regular armed forces in case of necessity. Sometimes very young adolescents were incorporated. On the eve of the Bay of Pigs invasion, the government created a nationwide system of locally based Comités de Defensa de la Revolución (CDR, Committees for the Defence of the Revolution). They were considered to be 'the eyes and ears of the Revolution', on the lookout for danger and counter-revolutionary activities related to the state security services. The CDR also organized neighbourhood vigilance and festivities.[77]

Other mass organizations, unions and associations were also created between 1960 and 1963.[78] Probably the most encompassing of all was the Federación de Mujeres Cubanas (FMC, Federation of Cuban Women) with more than four million members in 2015.[79] It was created in 1960; all other existing women's organizations were incorporated during the merging process. Until her death in 2007, Vilma Espín (Raúl Castro's wife) was its president. Equally important was the Central de Trabajadores de Cuba (CTC, the Unitary Organization of Cuban Workers), formerly created as the

Confederación de Trabajadores (Workers' Confederation) in 1939 when the Communist Party was legalized. The CTC became a unitary labour movement, in which all existing and competing labour organizations were merged. In 2015 the CTC had around three million members.[80] A new unitary movement for the agricultural smallholders' association (ANAP, Asociación Nacional de Agricultores Pequeños) – in fact a federation of cooperatives – was formed in 1961.[81] The student federation FEU was resurrected.[82] A unitary writers' and artists' association (UNEAC, Unión de Escritores y Artistas de Cuba, 1961) and a similar organization for journalists (UPEC, Unión de Periodistas de Cuba, 1963) complemented the restructuring process of mass organizations.[83]

Much later, in 1993, the combatants' association (Asociación de Combatientes de la Revolución Cubana, ACRC) was founded by Raúl Castro 'to unconditionally support the defense of the Revolution and the conquests of socialism'. In 2015 it had 330,000 members: former combatants of the Rebel Army, members of the insurgent underground, members of the Bay of Pigs defence forces, members of the campaigns against counter-revolutionaries, combatants in international missions, and members and retired officers of the Fuerzas Armadas Revolucionarias (FAR, Revolutionary Armed Forces) and the MININT with a minimum of ten years of service.[84]

With the exception of one, the previously mentioned interviewees in this chapter were members of the Party, the CDR and the ACRC. Even in the case of one former member of the urban insurgency, Ricardo Gómez Rodríguez – a member of the Havana insurgency who had spent eight months in one of Batista's prisons and went home after 1959 – the Party discovered him after years. 'I went to work in Matanzas because I didn't have any aspiration for anything else,' he remembers.[85] But afterwards he studied civil engineering. In 1968 he was invited by a friend to talk about his work in a youth encampment. He decided to speak about his time as an insurgent in Havana. When it was discovered that he had been a revolutionary combatant, two young female Party members advocated his Party membership. But the municipal administration refused him as an aspirant member because he had not been a member of the CDR. Furious, he told the committee members:

When I was fifteen years old, I risked my life [for the revolution]. I sacrificed the life of my mother and father, the stability of my family. I risked my life many times, spent eight months in jail, and took part in a nine-day hunger strike when I was fighting in Havana [...] If that means less than paying 25 cents a month and keeping guard on a street block with a wooden stick, then I agree.[86]

After an extraordinary meeting, the Party granted him his membership under the condition of his incorporation into the CDR.

CHAPTER 4

· · · · · · · · · · · · · · · · · · · ·

Revolutionary fervour (the 1960s)

Cuba's impact in Latin America

The impact of the Cuban Revolution on the Latin American armed left was immense. In nearly all Latin American countries guerrilla movements emerged. With the sole exception of the Peruvian (officially Maoist) guerrilla of Shining Path in the 1980s and 1990s, all existing politico-military movements drew inspiration from the Cuban insurgency against dictator Batista; they found hope in the creation and consolidation of a stable socialist economy and society. In most cases that influence was indirect. But Cuba also attempted to encourage and disseminate similar revolutions abroad, in Latin America and the Caribbean as well as in Africa. And that meant direct efforts, sometimes intromissions, by sending Cuban military advisers and guerrilla detachments abroad. In Africa (Angola, Ethiopia and several other countries) Cuba deployed regular military units and participated directly in war theatres. In Latin America, however, guerrilla support was nearly always given under cover, and the number of Cuban combatants who were directly involved never exceeded twenty per country. The cases of direct involvement in Latin American and Caribbean revolutions, and revolutionary movements by Cuban combatants, occurred in the 1960s.

It was one of the most vehement periods in the Cold War, when anti-communism dominated the discussions among members of the Organization of American States (OAS). In many countries in the region, military dictatorships had taken over civilian governments. Counter-insurgency campaigns against communists, and supposed communists, were accompanied by 'civil action'.[1] Every rebellion, every armed struggle, every resistance movement, every large strike,

every protest march and every mass demonstration was interpreted as the result of a sinister plot masterminded by Cuban agents. In that sense, the influence of the revolutionary island was overestimated. Nevertheless, Cuba supported most opposition movements, moderate and insurrectional, against dictatorships and military juntas in the region.

The 1960s were also a decade of revolutionary fervour in Cuba. This period of Cuban 'revolutionary internationalism' started a couple of months after January 1959. Cuba became a leading country within the Movement of Non-Aligned Countries (NO-AL, Movimiento de los Países No Aliados) and generously received persecuted intellectuals and politicians, especially those from the Latin American region. Many of the persecuted leaders became personal friends of Fidel Castro and Che Guevara (until his departure to the Congo). The influence of Cuba in the foundational period of almost all guerrilla movements is demonstrable. Che Guevara acquired world fame as a revolutionary theorist and for his ideas about rural guerrilla focal points (*focos*, or *foquismo* in Spanish). In fact it was his personal interpretation of the Cuban rebellion in the Sierra Maestra, putting major emphasis on the guerrilla (and less on the enormous support of the urban underground and the early sympathy of a significant part of the population). His ideas were discussed and applied by almost all rebellious Latin American movements. Fidel Castro's war memoirs[2] were recently published at the end of the first decade of the twenty-first century: they are the history of his campaigns in a strictly military sense. Raúl Castro never published his extended war records; he remained the brilliant organizer of Cuba's regular armed forces (the FAR, Fuerzas Armadas Revolucionarias).[3] In this book I barely mention the role of the Cuban FAR, originally a strong defensive apparatus that was also capable of launching effective offensive expeditionary forces to Africa in the 1970s.[4] I mention the FAR only when officers of the regular army were participating – as instructors or combatants – in the Latin American guerrilla movements of the 1960s. However, in most of these kinds of activities it was not the FAR members who participated but rather special envoys or instructors of the special forces within the Ministerio del Interior (MININT, Ministry of the Interior), under the leadership of Manuel Piñeiro.

During the 1960s, the *foco* approach, and in particular Che Guevara's ideas about revolutionary combat, were part of the support package to rural guerrilla warfare in the region, sometimes but not always accompanied by Cuban mentors, instructors or participants. Cuba was diplomatically isolated by exclusion from the OAS in January 1962, under pressure from the United States. All Latin American countries ruptured their diplomatic relations with Cuba, with the exception of Mexico.[5] In the following pages I will typify the kind of Cuban involvement, maintaining a rough chronology. I reserve for the last part of this chapter, however, Che Guevara's plans for a continental revolution that ended in 1967 with his death in Bolivia.

Proliferation of the revolution

In discourse and action, Fidel Castro and Che Guevara were the most outspoken Cuban leaders in favour of the proliferation of the (ideas of the) Cuban Revolution. Castro and especially Guevara were convinced of the fact that the triumph in Havana could not be limited to the continental borders of Latin America. While Latin America was the *Patria Grande* (Greater Fatherland), Cuba focused on the entire Third World. Che Guevara translated these feelings and his own experiences as guerrilla leader into monographic publications.[6] In short, a miniature version of Guevara's *foco* thesis is that revolutions can successfully start with a rural guerrilla force that will unite peasants against suppressive governments, military dictatorships and imperialism. At that time, the initial guerrilla *foco* was a kind of starter motor that would ignite the real engine of the 'popular masses'. In turn, many Latin American guerrilla leaders, leaders of the armed left and leaders of dissident factions of the hesitant communist parties found their inspiration in the Cuban example and in the iconic figures of Fidel Castro and Che Guevara. They were seduced by their revolutionary mystique, read their books, became true believers of the *foco* ideas, and went to Cuba for advice and training.[7]

Fidel and Che waxed lyrical about the revolutionary consequences for the independent and other Antillean island-states of American, British, Dutch and French statehood; for the 'semi-independent' Latin American countries; and for the entire 'colonized and underdeveloped'

Third World. In reference to Latin America, the Cuban government announced in the First Declaration of Havana (August 1960) that it 'energetically condemn[ed] the overt and criminal intervention exerted by American imperialism for more than a century over all the nations of Latin America, which have seen their lands invaded more than once – Mexico, Nicaragua, Haiti, Santo Domingo and Cuba'. The Second Declaration of Havana (February 1962) has a text with the intonation of the Communist Manifesto. But it is a new manifest for a sort of Fifth International with Cuba as the vanguard nation of the Latin American Revolution:[8]

> To the accusations that Cuba wants to export its revolution, we reply: Revolutions are not exported, they are made by the people ... What Cuba can give to the people, and has already given, is its example. And what does the Cuban Revolution teach? That revolution is possible, that the people can make it, that in the contemporary world there are no forces halting the liberation movements of the people [...]. There is a place for all progressives, from the old militant Marxist to the sincere Catholic who has nothing to do with the Yankee monopolists and the feudal lords of the land [...]. Anxious hands are stretched forth, ready to die for what is theirs, to win those rights that were laughed at by one and all for 500 years. Yes, now history will have to take the poor of America into account, the exploited and spurned of Latin America, who have decided to begin writing history for themselves for all time.[9]

In January 1966, Cuba was the organizer of the First Tricontinental Conference, an international solidarity meeting of Asians, Africans and Latin Americans, where delegates from eighty-two countries (of which twenty-seven were Latin American) discussed the strategies to combat 'imperialism, colonialism, and neo-colonialism'. The conference established the 'inalienable right of the people [of Asia, Africa and Latin America] to complete political independence and to resort to all forms of struggle that may be necessary, including armed struggle, to conquer this right'.[10] At that conference, the Third World Organization of Solidarity of the Peoples of Africa, Asia and Latin

America (Organización de Solidaridad de los Pueblos de Asia, África y América Latina, OSPAAAL) was created. Here the famous message of Che Guevara about the creation of '[...] two, three ... many Vietnams [...]' was read to the delegates. At the same conference, the founding of another organization, the Organización Latinoamericana de Solidaridad (OLAS, Latin American Solidarity Organization) was announced.

In late 1964, all Latin American leaders of the (pro-Soviet) communist parties met in Havana, officially to prepare for the OLAS conference. The meeting was prepared by Piñeiro at the VMT and presided over by Carlos Rafael Rodriguez, veteran old PSP leader who had joined the M 26-7 in 1958 and was also held in high esteem by the parties of the Moscow line.[11] Some delegates openly complained about Cuba's preferences for radical splinters from the good old Party.[12] Fidel addressed the delegations, analysing the 'pre-revolutionary conditions' and the need for 'anti-imperialist and anti-oligarchic struggle'. He also maintained that the Soviet–China split was an 'artificial division'. The meeting ended in a firm promise to not openly discuss the China–Soviet contradictions, to maintain a low profile and to concentrate on the Latin American problems and the national realities. At the first OLAS conference in Havana, in July/August 1967, the already existing divergence between the communist parties (with strong loyalty to the Soviet Union) and the presence of the armed left in Latin America (supported by Cuba) became concrete. The delegates sent a message to Che Guevara: 'The path of Viet Nam is our path, the continental confrontation our task: the creation of the Second and the Third Viet Nam in the world.' Cuban–Soviet relations were cooling off and it took several years for a new rapprochement to come about.

Algeria and Mexico were of crucial importance to Cuba. Algeria was the pre-eminent country for diplomatic and other contacts with liberation movements in Africa and Asia. In 1962, Piñeiro formed a 'working group' for strategic cooperation. Cuba assisted with a mission during the Algerian–Moroccan conflict in 1963. In 1965, an agreement on intelligence cooperation was established between the two countries. In 1965 a special unit was created within the Dirección General de Inteligencia (DGI, Directorate General of Intelligence), to accommodate relations with other African liberation movements.

Che Guevara travelled to Africa for three months in 1964/65, establishing more direct contacts. Algeria was instrumental in establishing these relations.[13] Cárdenas became the acting section head at the VMT; he had to attend to the exfiltrated Cuban combatants from the Congo (see below). Ulises Estrada, Piñeiro's experienced assistant, was appointed unit head after his return from Prague, where he had attended to Che Guevara. Estrada was made the director of the new Africa and the Middle East directorate, with sections for East and Southern Africa, West Africa and North Africa.[14]

Mexico was the only Latin American country that had not ruptured its diplomatic contacts with Cuba.[15] This country (and by the late 1960s Panama under General Torrijos as well) was the bridgehead for travel and contact with the clandestine movements in the region. In Mexico City and Panama City, many revolutionary refugees found a home, and institutional contacts had been established during the decades of military dictatorship. From the Cuban embassy in Mexico to the legation in Panama, intensive contacts with the Central American guerrilla were maintained.[16]

The Departamento América and its predecessor organizations

The most publicly acknowledged Cuban organization for relations with other Latin American rebel movements was the Departamento América. The Departamento América was formally created in 1975 but had operated under other names since early 1959. Its chief was the charismatic Manuel Piñeiro Losada, a close personal friend and confidant of Fidel and Che Guevara. Prior to 1959, he was the head of the action group of M 26-7 in the city of Matanzas. Persecuted by the local police, he went to the Sierra Maestra, where he finally became a *comandante* in the second Frente of Raúl Castro. There he was in charge of intelligence, security and policing. In January 1959, Piñeiro was assigned as Jefe de Plaza de Santiago de Cuba (Chief of the First Military District, in the old Oriente Province) but he was quickly transferred to national intelligence tasks.[17]

Even during the insurgency period, the Ejército Rebelde had its Departamento de Investigaciones (DIER, Department of Investigation

of the Rebel Army), the embryonic institution for all Cuba's intelligence services. In January 1959, DIER was incorporated into general military intelligence. The transition was supervised by Ramiro Valdés Menendez, one of the famous *comandantes* in the Sierra Maestra. The international branch of the DIER, called 'M', was headed by Piñeiro. 'M' had several sections, such as 'M-A', 'M-B'. M-OE was reserved for 'Special Operations' (M – Operaciones Especiales in Spanish), the paramilitary unit that trained many future guerrilla members at Punto Cero.

Section M always operated completely autonomously because it was created with the consent of Fidel Castro and Che Guevara, who wanted a swift and agile organization without bureaucracy.[18] When in 1961 the MININT was created, Valdés became minister. Piñeiro, as first vice-minister and head of the Vice-Ministerio Técnico (VMT, Technical Vice-Ministry), built up the Cuban intelligence and security apparatus. When the internal and external security functions were separated, the VMT was split into the Departamento de Seguridad del Estado (DSE, Department of State Security) and the DGI, again headed by Piñeiro. Its function was to coordinate external intelligence and counter-intelligence, and to support foreign revolutionary movements.[19] In 1971 DGI was divided into new directorates: DGI (intelligence and counter-intelligence) and Dirección General de Liberación Nacional (DGLN, Directorate General of National Liberation), the last of which was controlled by Piñeiro.

All these organisms and consecutive directorate generals operated within the jurisdiction of the MININT.[20] The functionaries of the DGI and the DGLN used pseudonyms and were engaged in covert operations or were working in Havana as analysts, country and region overseers and section heads. They held military ranks. When the Departamento América was officially created in 1975 under the umbrella of the Central Committee of the Communist Party, the officials used their real surnames, abandoned their pseudonyms and operated as party representatives with diplomatic ranks and careers. They even lost their military ranks; the institutional realignment also implied losing their (better) salary as functionaries of the MININT while becoming staff members of the Central Committee.[21] At that moment the department had around one hundred officers.[22] Many of

the higher-ranking officials eventually became formal diplomats. It was no secret that the staff members of the Departamento América, officially under the authority of the Central Committee, were 'the eyes and ears' of Fidel Castro.

Here I present some representative career paths of the members of the Departamento América: Giraldo Mazola, Fabio Escalante Font, Alberto Cabrera and Ulises Estrada.[23]

Mazola was a member of a Havana action and sabotage group in the M 26-7. In 1959 he was appointed as Secretary of International Relations of the movement, and Fidel requested that he design the ICAP in 1960. He was appointed president of that institution with a ministerial rank. Afterwards he was designated vice-minister of MINREX and then ambassador to Algeria, Nigeria and Chile.

Escalante Font, a member of an urban clandestine section of the Socialist (Communist) Youth in Havana, became a member of the advisory staff of Valdés in 1959. He was transferred to the DSE. Afterwards he headed the section that monitored the CIA. He also worked for Piñeiro to confirm the rumours about the secret CIA training camps for the Bay of Pigs invasion. He moved through the ranks and, during the Contras war in the 1980s in Nicaragua, he was chief of counter-intelligence in Cuba at the same time that he was chief adviser on counter-intelligence to Nicaragua's Ministry of the Interior (MINTER).

Alberto Cabrera, inducted at the age of twelve into a militia battalion during the Bay of Pigs invasion, was selected for the first course at the Intelligence School of the MININT. He entered the DGLN to look after Colombia, and moved to the Departamento América in 1975. He served as a diplomat at Cuba's embassy in Colombia, and later as minister councillor at the embassy in Panama. Arrested by the US army during the US invasion, he was released by the local CIA chief. With his ambassador, Lázaro Mora, he organized the defence of the embassy and the repatriation of Cuban and Panamanian refugees (also General Noriega's family members) to Havana (see Chapter 6).[24] A diplomat in Ecuador, Venezuela and Uruguay, he ended his career as a functionary of the ICAP, again looking after Venezuela.

Ulises Estrada, a distant relative of Antonio Maceo and member of an M 26-7 action and sabotage group in Havana and Santiago de Cuba, was appointed as a military intelligence officer in 1959.[25] In the early 1960s he participated as a combatant and intelligence officer in the counter-insurgency operations in Escambray.[26] He joined Piñeiro's Vice-Ministry in 1961, as vice-chief of the section of Special Operations (M-OE). Stationed in Bolivia, he was involved in the preparations of Che Guevara's plans for a guerrilla in Argentina, Peru and Bolivia. After participating as adviser to the Palestine National Liberation Movement and in Amilcar Cabral's guerrilla in Guinea-Bissau, he was selected by Piñeiro to be on a special task force with Che Guevara. He travelled to Africa for six months and accompanied Che Guevara in his exfiltration from the Congo to Tanzania and from Dar es Salaam to Prague. Upon his return to Havana he assisted Piñeiro, as his number two, in the design of the DGLN and the Departamento América. During the Allende government in Chile he was in charge of the special forces within the Cuban embassy, and served as the security liaison with the Chilean government.[27] He defended the embassy against the Chilean army during Pinochet's coup.[28] He also assisted Amilcar Cabral's Partido da Independência da Guiné y Cabo Verde (PAIGCV). Upon his next return to Havana he was appointed vice-chief of the Departamento América. Fidel Castro appointed him ambassador to Jamaica during the government of Manley. His next postings were those as ambassador to Yemen, Algeria and Mauritania. At the MINREX, he was the chief of the Directorate of Africa and the Middle East and the Directorate of the NO-AL Movement, retiring as vice-minister. After his retirement he became the director of the Cuban journal *Tricontinental*.

Manuel Piñeiro headed the Departmento América (and the preceding institutions) from 1959 to 1992.[29] He was succeeded by one of his vice-chiefs, José Antonio Arbesú Frage, who in turn retired in 2013. Piñeiro was the brilliant Cuban intelligence chief.[30] Audacious, sharp, courteous, modest, soft-spoken and a great listener, he lived largely in the shadows of power. As a member of the Central Committee, his real influence in state affairs was based on his relationship of absolute confidence with Fidel; he was his fiercely loyal political operator.

According to several of his vice-chiefs at the department, he was one of the very few who could say 'no' to the Commander-in-Chief.[31] Deeply respected by his officers, he was venerated by most department members; for many he was a father figure:

> All our missions were risky; we were always observed by the American Special Services in the countries where we operated. Piñeiro took care of our families, called [our wives at] home, was interested in our problems and family affairs [...] One of his many virtues was that he was the only one who could reprove or criticize his subordinates. He [always] defended his subordinates and afterwards he checked the evidence. If necessary, he and only he sanctioned [...] Piñeiro taught us to detest dogmatism. He was anti-dogmatic, he wasn't a sectarian. [He said:] 'If we always and only talk to the left, we are wrong. We have to talk with everyone. And remember that between black and white, there are many nuances and many shades of grey.' He permitted us unlimited freedom on the job. But we all knew where the limits were and what we could do or not do. Any one of my colleagues could phone a minister or a leader and request a meeting to address a specific topic. And we were attended to immediately. They knew that the demand was on behalf of Piñeiro. And that our missions were approved or even required by the chief of the Cuban Revolution. And that our missions could not be delegated [to others] [...] As far as I know, we never did anything that was not ordered, authorized and known by Fidel Castro.[32]

Code of conduct

Those who were recruited by Piñeiro read a book by former American intelligence operator General Washington Platt (1957), who considered intelligence-gathering to be a social science and insisted on the fact that 90-plus per cent of the information would be told voluntarily to a trained field officer.[33] The style of operation at the department was 'convince, not command'. Another code of conduct was strict neutrality in ideological disputes. In Argentina, Central

America, Colombia, Peru and Venezuela – where several larger guerrilla organizations operated at the same time and sometimes in the same regions – the Cuban representatives were forbidden to use terminology that could be explained as judgemental.[34] Time and again, Fidel's instructions were consistently repeated: 'Programmatic and operational unity of the revolutionary forces, whatever ideological differences would arise between conflicting politico-military organizations.' Nearly all interviewed members of the Departamento América reflected Fidel's (and Piñeiro's) instructions. The prescribed ideological neutrality, however, did not mean that Cuba refrained from influencing the Latin American guerrilla movements. Cuba's leadership had its own preferences and its own dislikes and it operated as an influential actor in the political left of the Third World. It could also privilege some movements or be restrictive with respect to others. In general, Cuba did not actively support the Trotskyist or Maoist armed left in Latin America, but definitely wanted to be informed about their intentions and activities.

There were many ideological disparities within every unified movement of the armed left in Latin America. Splits, divergences and breaches were the order of the day, as Gillespie and Sprenkels[35] make clear with respect to the Argentinian and Salvadorean guerrilla movements. Eduardo Sancho, one of the five members of the Salvadoran *comandancia general* of the Salvadorean Frente Farabundo Martí para la Liberación Nacional (FMLN, the Farabundo Martí Front for National Liberation), characterized the five guerrilla movements under the umbrella of the FMLN as the 'diaspora of the left [...]. We were transformed into sects, political sects. And it was worse, because we were Marxists. So we were even more sectarian [...]'.[36]

Also in the Colombian panorama of guerrilla movements, ideological discussions about orthodoxy caused a rift among many *compañeros*. Darío Villamizar, the historian of the Movimiento 19 de Abril (M-19, Movement of 19 April), the most effervescent urban guerrilla movement in the country in the 1970s and 1980s, sketches the context in which the M-19 unexpectedly appeared: 'At that time [...] I was very close to the communist Marxist-Leninist party, to the EPL. And we were not only Marxist-Leninists, but Marxist-Leninist-Maoists. We were quite sectarian. We were very young lads.'[37]

Fidel Castro remarks in retrospect:

> I must say that we contributed a lot to the unity of those people in Nicaragua, in El Salvador and in Guatemala. The Sandinistas were divided; the Salvadorans were split up into no less than five organisations; the Guatemalans were similarly divided. Our mission was to unite them, and truly, we succeeded in unifying them.[38]

'Working together with Piñeiro' did not always mean working within the VMT, the DGI, the DGLN or the Departamento América. Piñeiro, his vice-chiefs and section chiefs had their feelers in other Cuban organizations and institutions: of course with the Ministerio de las Fuerzas Armadas Revolucionarios (MINFAR, Ministry of the Revolutionary Armed Forces), with the other institutions coordinated by the MININT, with the MINREX, and with the ICAP. Piñeiro always had direct access to Fidel and that meant that he could make use of any department and institution of the Party and the state. But the network around the Piñeiro's people was much larger: academic and research institutions; the (international divisions) of Cuba's youth organizations; the federation of labour unions; the women's federation; the journalists' union; the writers' union; Radio Habana Cuba; Prensa Latina; the singer-songwriters of Cuba's Nova Trova; individual TV documentary directors; the film institute (Instituto Cubano del Arte e la Industria Cinematográficos, ICAIC); the medical missions, and the disaster and reconstruction missions; the literacy missions; and other missions that went abroad and returned to Cuba.

By 1968, small 'offices' had been established in Havana by the Brazilian Ação Popular (Action of the People, José Jarbas Cerqueira) and the Movimento Nacionalista Revolucionario (MNR, Nationalist Revolutionary Movement, Aloisio Palhano), the Guatemalan Fuerzas Armadas Rebeldes (FAR, Rebel Armed Forces, Francisco Marroquín), the Peruvian Movimiento de Izquierda Revolucionaria (MIR, Revolutionary Movement of the Left, Tania Álvarez) and the Ejército de Liberación Nacional (ELN, National Liberation Army, Jesús Maza), the Uruguayan Movimiento Revolucionario Oriental

(MRO, Revolutionary Movement of the East, Eduardo Díaz), and the Venezuelan Movimiento de Izquierda Revolucionaria (MIR, Revolutionary Movement of the Left, Carlos Palacios).[39] In the 1970s, they were followed by offices of the Argentinian Montoneros and the Colombian ELN. In fact, the offices were typically one or two rooms in the accommodation allotted by the Cuban leadership. In the 1970s and 1980s, Cuban representatives of the VMT, the DGLN and the Departamento América also extended contact to the 'periphery' (diaspora) of Latin American refugees and politicians in exile who were established in Chile, Mexico, Peru, Panama and Venezuela.[40]

Investment in respectful long-term and friendly relations and a deep knowledge of the local political situation were the ground rules of the Departamento América. To give some examples: Cervantes, who also had experience in Portuguese-speaking Guinea-Bissau and Angola, was the in-house expert for Brazil for more than thirty years. After the re-establishment of diplomatic relations, he became the political councillor at the Cuban embassy in Brasilia. Over decades he developed a personal friendship with labour leader, and later president, Luiz Ignácio Lula da Silva (Lula).[41] Abreu, also a member of the Central Committee, was in charge of the relations with Central America and the armed left in El Salvador, Guatemala and Nicaragua for more than thirty years.[42] In 2012, after nearly forty years, Otto Marrero Núñez retired as chief of the Caribbean Section of the Department of International Relations (the successor institution of the Departamento América) of the Central Committee. He had an encyclopedic knowledge of the who's-who in the Caribbean political landscape.

Then there were the numerous '*amigos de Cuba*' (friends of Cuba): visitors, journalists, politicians and researchers interested in the Cuban Revolution. Piñeiro, a workaholic with a ravenous appetite for facts and details, always found time for an interview, a good conversation or a dialogue among friends. Latell,[43] CIA officer at the Cuba desk in 1964 and the National Intelligence Officer for Latin America in the 1990s, considered Cuban intelligence to be 'one of the five or six best such organisations in the world, and has been for decades'.

Early expeditions

In January 1959, on a visit to Venezuela, Castro called for rebellions against the 'old dictatorships' of the Somoza dynasty in Nicaragua, the Trujillo dictatorship in the Dominican Republic, and the apparently eternal Stroessner dictatorship in Paraguay.[44] Exiled revolutionaries, their family members or their sympathizers – even informal delegations of exile and rebel movements in countries administered by military dictatorships – were welcomed in Cuba. Former Guatemalan president Arbenz, ousted by a CIA coup in 1954, stayed on the island. He was received by Fidel and was interviewed by the young Guatemalan lieutenants who had initiated their small guerrilla movements. Other political refugees of that country would follow. A small Nicaraguan colony of exiles was established in Havana as well. The founders of the Nicaraguan Sandinista guerrillas – named after the rebellious General Sandino who, in the 1930s, had resisted an American marine invasion and had been murdered on the orders of Somoza – came to Cuba and met Che Guevara.

Spain

A rather odd plan for an invasion surfaced in January or February 1959, set off by Alberto Bayo – the venerated old lieutenant colonel of the Spanish Republican Army, who had trained Fidel's *Granma* expedition force in Mexico – and Eloy Gutiérrez Menudo, a Cuban *comandante* who afterwards changed sides. They prepared for an expedition against the dictatorship of Franco in Spain. The plan was quickly shelved.[45]

Dominican Republic

On 14 June 1959, Dominican and Cubans volunteers, combatants of the Sierra Maestra and militants of the Movimiento de Liberación Dominicana (MLD, Liberation Movement of the Dominican Republic) headed by (Dominican) Comandante Enrique Gutiérrez Moya, sailed from Cuba's Oriente province in an attempt to start an armed rebellion against Trujillo; they were massacred. In Cuba, the expedition force was trained by Comandante Delio Gómez Ochoa, but the general supervision was in the hands of Camilo Cienfuegos.[46] I continue here with the Dominican case because it reveals a tragedy,

comparable with Guevara's campaigns in the Congo and in Bolivia. The Dominican reverse in 1959 brought about another rebellious movement, the Movimiento Revolucionario 14 de Junio (1J4, Revolutionary Movement 14 June), which launched a guerrilla campaign in November 1963. In less than a month, the *guerrilleros* were decimated. In 1965, after the US intervention in the Dominican Republic,[47] Colonel Francisco Caamaño – ex-member of the presidential triumvirate – was sent as a military attaché to London. But he went in self-exile to Cuba. Now, a refugee living as 'Comandante Ramón' and getting older, he slowly but surely lost contact with his sympathizers at home and with the senior Cuban leadership as well. He and his group were relegated to Osvaldo Cárdenas, head of the Caribbean section at the time:

When I take care of Caamaño and his group, there are problems, complaints, contradictions, misunderstandings. There are also problems with the Dominican Republic because we have secret connections with Caamaño [...]. I got to know Caamaño at Punto Cero, because there we had trained his people [...].The presence of Caamaño had lost interest for those at Liberación Nacional. Caamaño had not seen Fidel for a long time. [But he] was well aware that he was ageing. I think that the urgency to do something in the short period of our lives has been a concern for not only a few revolutionaries. This problem with age, I guess, is what also happened with Che. You can't wait to be sixty years old to go to a guerrilla. We are talking about men who aspire to transform the world, to have impact during their lifetimes. I don't think that any of them expected to have a long life. Maybe if Che had more time after the Congo, things would have been better organized. But he was pressed by the short time of his life. And he had also left a letter of farewell that had already been read to the Cuban people. He didn't have much time.[48]

Caamaño had a hard-headed discussion with Piñeiro.[49] Fidel called in Abrantes, his chief of personal security and the commander of the special forces, as an intermediary. They tried to persuade him to think it over. The conditions for a guerrilla campaign were not good, they said. He could always stay in Cuba. But Caamaño had decided,

he wanted to go now. And then, in February 1973, Caamaño and nine *guerrilleros* departed for the Caracoles Beach in the Dominican Republic to be captured alive, and then murdered the day after.

Panama and Haiti

Other small-scale operations by guerrilla units of exiled volunteers – and sometimes a couple of Cuban participants – were organized against Panama and Haiti.[50] In April 1959 a Cuban-Panamanian crew disembarked in Panama to support an armed uprising. Very probably it was a private initiative by former M 26-7 combatants. Their ship came aground in the marshes and the crew surrendered after rescue. In August 1959, a small group of Haitian exiles and some Cuban volunteers came ashore in southern Haiti in an effort to overthrow dictator Duvalier. They were captured or killed in action.

Paraguay

In December 1959, a heroic but nearly suicidal adventure started in Paraguay. A group of exiles tried to overthrow dictator Stroessner. They were inspired by the Cuban example but there is no evidence of direct Cuban support. Two small guerrilla bands, the Movimiento 14 de Mayo (M-14, Movement of 14 May) and the Frente Unido de Liberación Nacional (FULNA, United National Liberation Front, associated with the Paraguayan Communist Party), crossed the Argentine–Paraguayan frontier. The two movements operated separately. The FULNA was a movement of national liberation (modelled after the Cuban example) and the M-14 tried to provoke a spontaneous mass insurgency. Both movements were easily overwhelmed by infantry battalions with assistance provided by the United States. Recently, in 2004, some of the few survivors felt safe enough to testify.[51]

Intelligence and counter-intelligence: the Soviet Union and the United States

In the 1960s, Piñeiro was also in charge of Cuba's external intelligence. In that capacity, he and his colleagues were engaged in the infiltration of the anti-Castro movements of the Cuban migration colonies, concentrated in Florida and especially Miami. The first

recruits were asked whether they were willing to infiltrate the Miami communities of counter-revolutionaries. Tony López, for instance, then a young guerrilla veteran eighteen years old, remembers:

> In October 1961, I was summoned to an interview with Piñeiro, at 23.30 hours. Piñeiro invited me to be part of an undercover team working in the United States, to discover activities against Cuba. Recently, the CIA had established an office in Miami to recruit counter-revolutionaries. Piñeiro began asking me if I was ready to perform whatever mission to the benefit of the revolution and to comply with whatever task the revolution would request of me. He explained the what-to-do. I should go to the United States, pretending to be a dissident, and ask for asylum in an embassy. I asked him how I could travel and what were the [financial] resources to go to the United States. He says: 'What? Aren't you a revolutionary?' I said: 'Yes, Comandante, I'll ask asylum in an embassy. But, how am I going?' And he replied: 'After your request they have the responsibility to get you out of the country. Go to the country that lets you stay there and then to the United States.' 'We don't have structure yet,' he said to me. 'We still have to create it. You are [one of the] the pioneers. Look, you joined the revolution, as young as you were. You became a revolutionary and nobody paid you a cent for that. You went on your own terms to the guerrilla. This is more or less the same; you have to start from scratch.'[52]

That was the very beginning. Piñeiro and his companions learned quickly to overcome their logistical and financial difficulties. The Soviets and the Germans of the German Democratic Republic (GDR) offered a helping hand. In the early 1960s, a Cuban mission was established in Moscow. It served as a liaison between the KGB and the VMT and to recruit young Latin American students to Patrick Lumumba University.[53] In 1961, nineteen members of the nascent Cuban intelligence community were sent to Moscow for training at the Soviet Intelligence School. Escalante Font, then a rising star in the Cuban intelligence organization, was one of them.[54] Previously, in September 1968, Piñeiro had requested that he go to Costa Rica.

A local police officer there had information about American base camps in Central America, which were apparently preparing for assaults in Cuba. The trip brought about essential and vital intelligence about the invasion of the Bay of Pigs:

> Manuel Mora [secretary general of the Communist Party in Costa Rica] introduced me to a police officer. He revealed the information about the encampments of the counter-revolutionaries in Retalhuleu, Guatemala. And how they prepared the airport of Puerto Cabeza, Nicaragua, for the air transport at the start of the expedition against Cuba. He had several written reports, with rather detailed information within them. I read them; I see the convergence between what he told me and the text of the reports. The camp in Retalhuleu was accessible to the public; many things were known. What happened is that the report mentioned 6,000 to 10,000 persons, instead of the 1,500 that they were in reality. All numbers were exaggerated. The report even mentioned the date and points of departure, but not the real ones.[55]

The relations with the equivalent services of the countries of the Warsaw Pact, especially the KGB and the Stasi, were collegial but uneasy. The years 1966–70 constituted a period of relative frost. Several of Piñeiro's closest associates participated in missions to eastern Europe. Morejón, who in 1967 was a cultural attaché at the Cuban embassy in Moscow, remembers:

> The ideological dispute was gigantic. The contradictions of our line and that of the Soviets with respect to Latin America became utterly clear [...] the difference was about the guerrilla warfare in Latin America. When the news came out that Che was [fighting] in Bolivia, we organized a meeting in front of the embassy. KGB officers blatantly transmitted in front of everyone, so that everyone could see them. Olivares, the Cuban ambassador, said: 'Well, I realize that representatives of the KGB are also here in solidarity with us Cubans. I have not the slightest doubt that they came here to show their solidarity with the struggle of Che Guevara in Bolivia.'[56]

In 1970, Piñeiro headed a ten-person delegation to the Soviet Union and the COMECON countries. Antelo, one of the mission members, can still remember the atmosphere of tension.[57] Ulises Estrada was the deputy delegation leader. The trip took three months; the mission visited the entire socialist bloc with the exception of the GDR. Piñeiro went to Berlin alone, and upon his return to Moscow he never briefed his colleagues about what he had done or discussed. Here are Estrada's reminiscences:

> It was the 'delegation of the padlock of the chastity belt'. Sexual relations were prohibited. We had to be careful with drinks. The core of the trip was about political intelligence. In every country they spoke about their structures and objectives. But there was no mutual understanding because there was no coincidence in positions. For example, with respect to the United States, they had their appreciation and we had our opinion. When we were talking about the fight against imperialism, they had one vision and we had another one. In all countries there was some anti-Soviet touch [...]. In Hungary they took us to where the Soviet tanks had killed I don't know how many people, in 1956. However, the social treatment was very good: great attention and lots of food. Now, the political discussions were really bad. My relations with the Soviets were always bad. When I went to the Soviet Union, I always had disputes with my counterparts. Because, firstly, I could not tell them what we were doing. They knew something but we compartmentalized or misinformed them. Che was more radical. Half in jest and half seriously, he said that they all were penetrated by the CIA.[58]

The GDR was an enigma. Apparently, the relations between Manuel Piñeiro and Markus Wolf, head of the Stasi, were pleasant enough at a professional level.[59] But Walter Ulbricht, the leader of the Communist Party, had convictions about the etiquette and behaviour of the petit bourgeois. He was not fond of the hugs and the loud voices of his Latin American visitors, and was especially wary of *barbudos*. For him, Che Guevara was a messily dressed radical and an iconoclast.

Under his successor, Erich Honecker whose daughter was married to a Chilean, political relations with Cuba improved.[60]

With respect to the United States, however, Cuban intelligence swiftly created a network of infiltrators in the Miami community, even in the FBI and the CIA.[61] An example is the career of a double agent of Guatemalan descent, who retired as a colonel of the security forces: Percy Alvarado (agent Fraile). Percy's father and mother were also Cuban spies. In 1956, his father had befriended Che Guevara during his stay at the Argentinian embassy in Guatemala, playing cards with his Argentine friend. All his brothers and his sister were Cuban army officers; some of them joined the Guatemalan Ejército Guerrillero de los Pobres (EGP, Guerrilla Army of the Poor). He was recruited by Cuban State Security as a double agent:

> In a small apartment on Avenida Salvador Allende, two *compañeros* of the State Security swore me in, on the Cuban flag, as a Cuban security agent. So I swore to serve Cuba unconditionally. I guessed that I was also serving Latin America and my own Fatherland. Back on the street I felt euphoric.[62]

Percy Alvarado sought contact with the United States Interests Section in Havana. The CIA sent him abroad. He was employed by the CIA and he suggests that he also worked for the Israeli Mossad: 'I was helpful for my Palestinian friends. I worked for four enemy services and they never knew of my ties with the Cuban service.'[63] The KGB offered him a position as a Soviet agent, and the Cubans told him to feel free to do accept. But he refused the offer and decided to stay with his Cuban companions:

> I was never trained by the Cubans. I mastered the spy techniques in the service of the enemy. They helped me to develop a range of professional skills that were very useful later on. Espionage techniques are universal. Counter-intelligence techniques are universal. The techniques of communication using mailboxes are universal. All intelligence services use [the same] skills.[64]

Alvarado was asked to infiltrate the Cuban Miami community.[65] Apparently, he was very successful; the anti-Castro Cubans paid him

huge cash amounts and he got a multiple entry visa for ten years. He infiltrated the Cuban American National Foundation and was asked to prepare assaults: to leave bombs in cinemas, assassinate employees, release counterfeit money. All these plans failed but he worked undetected for years. When, in 1998, it appeared to be convenient for the Cuban authorities to reveal the infiltration of the Foundation, Cuba's State Security blew his cover.[66] Alvarado is not the only one who published information about the covert actions against Cuba. Escalante Font, in charge of the DSE from 1976 onwards, mentions the fact that Fidel Castro survived more than six hundred assassination attempts between 1959 and 2006.[67]

The guerrilla in Guatemala

Che Guevara had friends within the emerging Guatemalan guerrilla movements. In 1954, while staying in Guatemala City, he had been witness to the CIA coup against the elected president, Colonel Arbenz. He then spent months at the Argentinian embassy, where the most important Arbenzistas and the leaders of the left had been offered exile.[68] The first leaders of the Guatemalan guerrilla movement were disillusioned young officers who had participated in a military coup against the dictatorship established after the demise of Arbenz. Two of them, Lieutenants Yon Sosa and Turcios Lima – along with a third one, César Montes – initiated guerrilla movements in the eastern (Ladino, mestizo) region of Guatemala. Along with Colonel Paz Tejada (a former minister of Arbenz), they led groups of former soldiers, students and peasants.[69]

Cuba's attention was immediately alerted and the VMT sought contact with the Movimiento 13 de Noviembre (MR-13, Movement of 13 November), comprised of young guerrilla *comandantes*. In due time, radical members of the communist Partido Guatemalteco de Trabajadores (PGT, the Guatemalan Workers' Party) also merged with this movement and formed the Fuerzas Armadas Rebeldes (FAR, Rebel Armed Forces). The VMT offered and provided support: clandestine transition routes for arms, even connected with 'that vast arms market in the United States'. In 1965 the VMT arranged for the presence of Turcios Lima in Havana, to assist the First Tricontinental

Conference in January 1966. He was praised as a hero and Norberto Hernández, then the Cuban overseer of Central America, spent many hours in discussions with him.[70]

Nevertheless, the Guatemalan guerrilla of the 1960s was modest in terms of military significance and results. The several small columns did not coordinate and operated in Guatemala City (as urban *guerrilleros*) and in a relatively restricted region: the south-eastern departments of Zacapa, Izabal and the Sierra de las Minas. The guerrilla attacks were mostly of local impact. The leaders were ex-military, and their cadres were ex-students or even current students of the San Carlos University. The *comandantes* could still be interviewed by the national press, sometimes in a local bar or restaurant. Yon Sosa and Turcios Lima maintained contact with their former brothers-in-arms; they met in movie theatres or drive-in restaurants in the capital. In October 1966, when Turcios Lima died in a car accident, his coffin was carried through Guatemala City; it was halted before the cadet school, the Politécnica, to receive the last salutation from his fellow officers. Yon Sosa was ambushed by the Mexican police while crossing the Mexican–Guatemalan frontier, in 1970. Cesar Montes (*nom de guerre* of Julio Cesar Macías) was his successor.

In 1966 the Guatemalan army started a counter-insurgency offensive with the support of American military advisers and paramilitary militias recruited from the local population. General Balconi, then a lieutenant but in 1996 the minister of national defence who negotiated with the guerrilla leadership in secret – and whose memoirs I co-authored[71] – remembers how the paramilitary forces were formed:

In 1966, there were about fifty full-time *guerrilleros* in the Zacapa area [...]. They had the support of the population: for information, food and protection. [But] there were about two hundred civilian patrol members. Their efforts were voluntary. During the day they worked, but at 6 p.m. they came together and went on patrol. They spent the night in shifts, until 5 a.m. Local community leaders were at ease with the army officers in the region. They came frequently to receive suggestions, to comment on what they did and how they did it [...]. They also collaborated with the army, providing information

or acting as guides for areas where it was suspected that there were guerrilla groups.[72]

With the participation of those patrols, the army acquired superiority. The guerrilla was crushed in two years; the leadership was either killed or managed to escape to Mexico or other countries. Younger cadres went to Cuba for training, but the guerrilla forces as such disintegrated. In the 1970s, however, a second generation of insurgent movements appeared in the indigenous territories of western Guatemala, recruiting primarily from the Mayan population. The insurgency and counter-insurgency operations continued into the mid-1990s. The Cuban involvement will be discussed in the next chapter.

The guerrilla in Venezuela

Fidel Castro and Che Guevara had evident interest in the Venezuelan guerrilla. As in the case of Guatemala, the first guerrilla leaders became officers after a revolt.[73] In January 1958, after days of street fighting in Caracas, dictator Pérez Jiménez left the country on a flight to the Dominican Republic. A five-person civil-military junta, headed by Rear Admiral Larrázabal, took over. Larrázabal resigned in order to participate in presidential elections. President Betancourt, an anti-communist, won the elections despite the fact that Larrázabal had acquired a large majority in Caracas. Demonstrations in the capital were forbidden; peasants who occupied land were harassed by the police. Betancourt 'cleansed' the armed forces but only just fulfilled his presidential term without a coup or a revolt.

In 1960, the youth wing of his party, Acción Democrática, split off to form the Movimiento de Izquierda Revolucionaria (MIR, Revolutionary Movement of the Left), a guerrilla movement inspired by the Cuban example. The president announced the persecution of 'servile followers of Moscow and Havana' and disbanded the Communist Party. In 1962, other small guerrilla movements were created, one headed by former Communist Youth member Douglas Bravo and others by ex-military officers and by Fabricio Ojeda, a key player in the revolt against Pérez Jiménez. Luben Petkoff was another insurgent leader. At a certain moment, there were around twenty Frentes

operating in many Venezuelan departments, without an umbrella organization or a unifying strategy. Most guerrilla units were over-powered by the army. But in May 1962, a marine detachment rebelled; in June, another naval base revolted. Young naval and army officers joined the existing and newly formed clandestine movements. The hitherto reluctant Communist Party formed guerrilla units as well.

In the early 1960s, Che Guevara suggested that Germán Lairet, representative of the Partido Comunista de Venezuela (PCV, Commu-nist Party of Venezuela), could unify a guerrilla group. Lairet 'had to consult the Politburo' and the answer was negative.[74] Then these het-erogeneous groups of military officers, communist cadres and radical youth leaders formed an umbrella organization in Caracas in February 1963, the Fuerzas Armadas de Liberación Nacional (FALN, the Armed Forces of National Liberation). But then divergences and break-ups followed.[75] In 1964, after presidential elections, the former MIR opted for a 'peaceful struggle', arguing that Venezuela was not ripe for guerrilla warfare. The Communist Party followed suit. In April 1965 the Party officially opted for 'legal opposition'. The government launched a series of successful counter-offensives. Ojeda was killed in action; by the end of 1966, the only real guerrilla force left was that of Bravo and Petkoff.

There had been a long-term relationship between the Venezuelan guerrilla movements and the VMT. In fact, Cuba had silently pro-vided support with training and access to the island's medical and journalistic services. Now the guerrilla leaders asked for training and military assistance on Venezuelan soil. By 1966 a small contingent of the Cuban Fuerzas Armadas Revolucionarias (FAR), headed by Arnoldo Ochoa, joined a guerrilla unit of the FALN under the com-mand of Luben Petkoff.[76] Its other leader, Douglas Vega, was killed in action. In May 1967, another Cuban-Venezuelan team disem-barked at Machurucuto beach. The Cuban participants were officers of the FAR.[77] Three MIR leaders, Moisés Moleiro (*nom de guerre* El Ronco), Héctor Pérez Marcano, Eduardo Ortiz Bucaram, and a peasant called Américo Silva, accompanied them. Immediately after landing they found themselves confronted by units of the army and the National Guard. After three months the group reached their guer-rilla Frente, after zigzagging through difficult terrain, persecuted by military units, and suffering from hunger and diseases. A couple of

days afterwards they were assaulted by the army's special forces. Several combatants were killed; Tomassevich, wounded, escaped and was transferred to Cuba via Caracas, Rio and Paris.[78] In his memoirs, President Carlos Andrés Pérez mentions that consecutive presidents had also created (and subsidized via the Ministry of the Interior) large networks of snitches and police and army informants in peasant grocery shops in the rural villages.[79]

In Cuba, a survivor reconstructed what happened. Military intelligence discovered that the head of the Institute of Geodesy and Cartography, who had provided maps of the area, had sold them out to the CIA. 'Of course, the captain was arrested, tried and shot.'[80] In 1989, when Cuban–Venezuelan diplomatic relations were re-established, Cuban and Venezuelan forensic anthropologists exhumed several of the skeletons. There are indications that some of them were tortured. The remains of Vega could never be identified. A special unit of the FAR succeeded in exfiltrating fifteen Cuban combatants; Arnoldo Ochoa was one of them.[81] They returned to Cuba via Moscow.[82]

The guerrilla in Brazil

The military coup of March 1964, although prepared and negotiated with the national entrepreneurial elite, surprised much of the left.[83] The Partido Comunista Brasileiro (PCB, the Communist Party of Brazil) still defended the thesis of peaceful coexistence.[84] Just as in Guatemala and Venezuela before, the first Brazilian guerrilla leaders were disillusioned army officers. In September 1963, even before the coup, non-commissioned officers – sergeants of the navy in Rio de Janeiro – had revolted. They had already sought refuge in Cuba, but the Cuban leadership denied them guerrilla training because of extant diplomatic relations.[85] There is, however, information about the guerrilla training that Clodomir Morais, other members of the Ligas Camponesas (Peasant Unions) and some members of the Partido Comunista Brasileiro had received in Cuba, in July and August 1961.[86]

In 1964, after the coup, relations were ruptured. Leonel Brizola, brother-in-law of the disposed president Goulart and himself a leader of the Partido Trabalhista Brasileiro (PTB, the Brazilian Labour Party), founded a resistance movement, Movimento Nacionalista

Revolucionário (MNR, Nationalist Revolutionary Movement). He sent some of his associates to Cuba and asked for them to be trained, together with the Brazilian sergeants.[87] He planned three parallel guerrilla *focos*: in the Serra de Caparaó of Minas Gerais, in Mato Grosso on the border with Bolivia, and in Goiás. The guerrilla movements were headed by the rebellious sergeants.[88] Capitani, one of the leaders, remembers the strict separation of technical issues from political aspects in the training that they received in Cuba:

> There is no training that makes you a [good] guerrilla soldier. That depends on the political aspects. The local political conditions have to be appropriate. That was one of the problems of the *foco*. It provided you with technical knowledge, but it neglected the fundamental, essential political options. Without the political issue we turned into para-troopers. I felt like a para-trooper dropped in the Serra de Caparaó. A strange element [...]. We couldn't recruit anyone in that region.[89]

In October 1966, eleven *guerrilleros* settled in the hills of Caparaó. They spent five months there; isolated and without interference from enemy forces, they were hungry and depressed. The army mobilized a force of 10,000 soldiers. Eventually, the *guerrilleros* were arrested by the military police of Minas Gerais.

After the First Conference of the Organización Latinoamericana de Solidaridad (OLAS, Latin American Solidarity Organization) in Havana (1967), new Brazilian politico-military movements emerged.[90] Carlos Marighella, already a veteran member of the Partido Comunista Brasileiro, was visibly present at this meeting, pitted against the orientations of the party leadership. He broke with his old comrades and founded Ação Libertadora Nacional (ALN, Action for National Liberation), a resistance movement against dictatorship. Praised by Fidel as a great revolutionary, Marighella modified Guevara's *foco* thesis in the sense that he explicitly preferred urban *focos* in countries like Brazil.[91] The movement, with young students and other young militants as combatants, was reinforced by the incorporation of ex-army captain Carlos Lamarca and his resistance movement Vanguarda Armada Revolucionária (VAR, Armed Revolutionary Vanguard), in

1969.[92] Between 1968 and 1971 four' '*exércitos*' ('armies', in fact small units of twenty to twenty-five persons) were trained in Cuba.[93] One of the guerrilla novices remembers the pride they felt to be in the vanguard of their generation:

> He who went to Cuba thought he'd be back as guerrilla coman-
> dante [...]. There was an intense mythology about it, because
> the Cubans encouraged the idea to the organisations of Latin
> America that, when you went there, spent there a period, and
> endured training, you would return half Che Guevara, half
> comandante [...].[94]

The majority of the combatants were members of the ALN and the VAR, but other small movements sent their recruits to Cuba for training as well. Marighella was killed in action in 1969; Lamarca in September 1971. The high number of captured, tortured and killed members of all revolutionary movements trained in Cuba not long after their return to Brazil is the reason that historians (and the Cuban liaison officers as well) are of the opinion that these movements were infiltrated by the Brazilian Serviço Nacional de Informações (SNI, National Information Service).[95]

One of the consequences of the change in guerrilla tactics was the creation of the Cuban Escuela de Lucha Urbana (the Cuban School of Urban Warfare). After the formation of the DGLN in 1971, Piñeiro appointed Cárdenas to 'reorganize and modernize' the school. The Brazilian, Uruguayan and other Latin American experiences were incorporated into the courses on intelligence, counter-intelligence, urban warfare, communications, propaganda and counter-propaganda, interrogation, camouflage, and infiltration. Until mid-1975, many new recruits of the Uruguayan and Chilean clandestine movements were trained at the centre. In 1975, however, the school was closed after pressure from the Soviet Union.[96]

The guerrilla in Uruguay

Uruguay, country of European immigrants, had a tradition of democratic, bipartisan and welfare governance, where the parties of

the left represented 10 per cent of the electorate. It was a configuration of anarchist, socialist and communist backgrounds. In the 1960s, an economic crisis profoundly affected the national economy and society. Between 1962 and 1967, the annual inflation rate was 60 per cent.[97] The government gradually became more authoritarian. Labour and other social conflicts erupted along with increasing repression, as legalized by emergency decrees. In the context of a generally decreasing standard of living, increasing labour conflicts and emerging new social movements, a radicalization process affected the traditional parties of the left.

As in other countries, the Uruguayan political left saw the Cuban revolution as a watershed. The impact of Fidel, Che and the other young Cuban revolutionary heroes resulted in splits within the communist, socialist, anarchist and Catholic youth movements. It explains the divergence among loyalties to reformist programmes and revolutionary action. It also explains the divide between the security of the Soviet ideology and that of the Second International on one hand, and the galvanizing revolutionary ethos of the Cuban *guerrilleros* which implied secessions, factions and preferences for new and more militant movements on the other hand.[98] Ariel Collazo, who later became one of the leaders of the Movimiento Revolucionario Oriental (MRO, Revolutionary Movement of the East), remembers:

> The Cuban revolution meant a shock in the consciousness of Latin Americans, above all for the university students. I was elected Member of Parliament of the Lista 51 in 1959. At the end of the year 1960 we – a group of MPs, union leaders and journalists [...] – were invited to travel to Cuba. In April 1961, the Movimiento Revolucionario Oriental (MRO) [...] is formed. [With fractions that departed from the] Partido Colorado we decided to create the Frente Izquierda de Liberación (FIDEL, Leftist Liberation Front). In the election of November 1962, FIDEL obtained 41,000 votes, the Communist Party 27,000 and the Socialist Party [another] 27,000 [...]. Then, after the election, I had the idea of starting to explore the subject of urban insurgency. And, in December 1962, I let it be known at the Embassy of Cuba: 'I am interested in learning a little bit more

about how to handle weapons and all that' [...]. They managed to bring in a group of Uruguayans [...]. The most important for us were the modules on safety measures. Much more than armaments training, this was something to learn starting from scratch.[99]

At the OLAS conference in Havana in 1967, the tensions between the reformist left and the revolutionary left were probably most evident within the Uruguayan delegation. Arismendi – the leader of the Partido Comunista Uruguayo (PCU, Uruguayan Communist Party), a personal friend of Fidel Castro and one of the most loyal partners of the Communist Party of the Soviet Union – was one of the vice-presidents and co-author of the final declaration. It was obvious that he had to meander during the debates and the write-up of the final text. Ravelo had perceived his dilemma. Arismendi had a lot to lose; he could not alienate the militants of the Communist Youth, nor could he turn his back on his old comrades in Uruguay and the Soviet Union. He opted for an 'export move':

> The objective [of the OLAS] was to create the conditions to support the international endeavour led by Che in Bolivia [...] Arismendi was never informed of the whereabouts of Che. But when he learned from his own sources that he was in Bolivia, he sent twenty-five militants of the PCU to Cuba for military training to let them fight in that country.[100]

But that could not impede the emergence of movements of the armed left in Uruguay. In 1962, several nascent politico-military groupings established a kind of managing structure: the Coordinador. It was the direct predecessor of Uruguay's most prominent guerrilla movement, the Movimiento de Liberación Nacional–Tupamaros (MLN–T, National Liberation Movement–Tupamaros), which evolved in 1966.[101] The name reflects the Cuban influence (Liberación Nacional) but also refers to Tupac Amaru II, the great Peruvian Quechua rebel who fought against colonial rule and was a precursor to Latin America's independence movements. The MLN–T developed a clandestine cell structure in Montevideo and in other parts of the country, and formed

an executive committee (whose members were Raúl Sendic, Tabaré Rivero and Euleterio Fernández). Sendic went to Cuba for military training; other MLN–T militants prepared for armed operations on the island. The Cubans welcomed the principal leaders of the (competing) Uruguayan MRO as well.[102] In 1967, the MRO prepared a small detachment to assist Che's guerrilla movement in Bolivia; but before they departed, Che Guevara was captured and killed.

The militants of the MLN–T were young: workers, but mostly students, coming from labour unions, the Communist and Socialist Youth, and some smaller leftist parties.[103] They operated mainly, but not exclusively, in the urban sphere. In their ideological expressions and revolutionary activities ('armed propaganda'), one can discern the legacy of anarchism and socialism and a nostalgic evocation of Che Guevara.

Eventually, the Tupamaros (MLN–T), the Federación Anarquista Uruguayana (FAU), the Movimiento Revolucionario Oriental (MRO), the smaller Organización Popular Revolucionaria 33 Orientales (OPR-33), the Fuerzas Armadas Revolucionarias Orientales (FARO), and the Frente Revolucionario de los Trabajadores (FRT) were unsuccessful. Military intelligence captured or killed most combatants. Anti-communist death squads executed other militants. In fact, before the coup in 1973, the guerrilla in Uruguay was already largely eliminated. Those who survived were incarcerated in one of the huge military prison camps.

The guerrilla in Colombia

Colombia was also a country with strong bipartisan tradition. Rural violence erupted in 1946, after the forced presidential change of the Conservative Party.[104] Guerrilla bands and paramilitary units of the Conservative and Liberal Parties waged local wars. In 1948, after the assassination of the Liberal presidential candidate Jorge Eliecer Gaitán in Bogotá, rural and urban civil strife amalgamated in a brutal confrontation that caused an estimated death toll of 100,000 or even 200,000 in the period from 1946 to 1962.[105] The most gruesome period of mass murder (1948–53) was ended by a de facto government under General Rosas Pinilla, who decreed an amnesty.

But the Communist Party (Partido Comunista Colombiano, PCC), which had formed armed '*autodefensas de masas*' (mass self-defence organizations), refused to disarm their peasant movements. They had already formed 'independent peasant republics' in various regions, of which the republic of Marquetalia was to become the most well known. The Colombian army, assisted by American support, started a successful counter-insurgency campaign. In 1957, the Conservative and the Liberal Parties reached an agreement to alternate the presidency and to divide the official positions equally; but the peasant guerrilla bands continued fighting. In 1959 the struggle was ended with a 'pacification campaign' launched by the army.

As in the other countries I have analysed in this chapter, the Cuban Revolution had an electrifying effect on political groupings of students and intellectuals of the left. Small revolutionary movements, like the Movimiento de Obreros, Estudiantes y Campesinos (MOEC, Workers', Students' and Peasants' Movement), the Frente Unido de Acción Revolucionaria (FUAR, United Front of Revolutionary Action), the left wing of the Liberal Party, and the Movimiento Revolucionario Liberal (MRL, Revolutionary Liberal Movement) went to the countryside and started independent guerrilla operations, attacking remote army posts. In 1960 a CIA mission visited Colombia and recommended counter-insurgency operations against threats of communism. The following years saw the appearance of three guerrilla movements, the '*guevarista*' Ejército de Liberación Nacional (ELN, National Liberation Army, 1962), the Fuerzas Armadas Revolucionarias de Colombia – Ejército Popular (FARC-EP or FARC, Rebel Armed Forces of Colombia – People's Army, 1964) and the Ejército Popular de Liberación (EPL, Popular Liberation Army, 1967).

Meanwhile, in 1961, the outlawed PCC organized a clandestine congress that recommended 'a combination of all forms of struggle' and sent high-level cadres to the region: Luis Morantes, a member of the Central Committee of the PCC (*nom de guerre* Jacobo Arenas, a reference to the ousted Guatemalan president Jacobo Arbenz) and representatives of the Juventud Comunista (Communist Youth). Also as a result of pressure from the United States, the army reinitiated their 'pacification campaigns' in 1962 and 1963. In 1964 it initiated 'Operation Marquetalia' with a force of 16,000 soldiers, which

constituted a third of the Colombian army at the time. But the peasant guerrilla, headed by Pedro Antonio Marín (*nom de guerre* Manuel Marulanda Vélez or Tirofijo) broke the encirclement and officially founded a political party with a military arm, the FARC-EP, in the same year. Two years later it already had 300 combatants distributed over six Frentes.[106] It also created distance from the PCC.

The ELN was inspired by the Cuban Revolution; its first members were directly related to Cuba.[107] A group of fourteen or fifteen persons received military training. One of them was Fabio Vásquez Castaño, a lawyer and professor at the Universidad Nacional, who was leader of the ELN until 1974.[108] They made a plan to start a guerrilla *foco*. Back in Colombia they initiated a *foco* near Barranca-bermeja. Their political ideas were not strongly Marxist; they came from the student movements, the labour unions and the peasant movements. Several ELN members were priests, nuns, former seminarists or radicalized Catholics. One of them was Father Camilo Torres Restrepo, a radical theologian and sociologist and one of the first Liberation Theologists. He broke with the Catholic Church and joined the ELN as a guerrilla recruit, after a public message in December 1965, only to die in combat. His death was lamented. Like Che Guevara, through his death Camilo Torres became a symbol of revolutionary martyrdom. In Bogotá, at the main plaza of the Universidad Nacional, two large murals of Camilo Torres and Che Guevara dominate the landscape.

In the early 1970s, Fabio Vásquez would instigate a reign of terror within the ELN, with extreme violence, purges, torture and executions of 'dissenters' and 'enemies'. The ELN entered into a state of crisis. Military offensives gravely harmed the fighting capacity of the then 200 combatants. Vásquez, seriously disturbed, went to Cuba to be treated, decided to stay there, and directed the ELN by radio-telephone. The crisis within the guerrilla movement deepened; the active membership was reduced to thirty to forty persons.[109] Only when a Spanish-Colombian priest, Manuel Pérez, and the very young Nicolás Rodríguez Bautista (*nom de guerre* Gabino), assumed the combined leadership of the guerrilla movement in the second half of the 1970s did they succeed in salvaging and reviving the ELN.

Guevara's continental projects: Africa, Argentina, Peru, Bolivia

Until his departure to the Congo, Che Guevara, even more than Fidel Castro, had supervised the activities of the VMT of Manuel Piñeiro. In many cases, he had even discussed details with Latin American politicians and guerrilla leaders visiting or being trained in Cuba. From the beginning of Che's revolutionary career he had had dreams of a Latin American revolution. When in power, these ideas were gradually incorporated into plans to launch a more coherent wave of revolution on a continental scale. 'Argentina, Peru, Bolivia ... was part of his encompassing project to bring forward his strategy of revolutionising the continent,' says Manuel Piñeiro, who prepared all Che's guerrilla missions.[110]

The African campaign

But Guevara's first operation was in in the heart of Africa, the Congo. In the first months of 1964 Che had tested the waters, discussing his participation in the Congolese struggle with Nyerere (Tanzania), Ben Bella (Algeria) and Nasser (Egypt). Apparently, Nasser had told him that Che's personal involvement leading a Cuban expedition force would be a mistake. To go in like 'Tarzan, a white man among blacks, leading and protecting them' could only end in disaster.[111] When he took the decision to leave for the Congo, he probably did it after an arduous debate with Fidel and Raúl Castro about the merits of 'Real Socialism' in the Soviet Union and the European socialist countries.[112] He had gradually expressed his critique about the authoritarianism and dogmatism of the Soviet Union. He ultimately did so in public, in Algiers, while Fidel and Raúl were negotiating with the Russians about economic and military support and training programmes.[113] But Che Guevara was also their dear friend and one of Cuba's iconic *comandantes*. The Cuban leadership had sent 140 veteran combatants with him to Africa, a much larger contingent than any other sent to Latin America.[114] But eventually, his dream of a continental revolution against colonialism and imperialism ended in a misadventure and the Cuban guerrilla force had to be exfiltrated.[115]

Afterwards, in his safe house in Prague, where he was accompanied by his most trusted companions (Ulises Estrada and Juan Carretero of

the VMT), he had prepared and reviewed his seven-volume collected works on economy and society.[116] But ultimately, he was a fighter rather than a writer. After the failed Congo campaign, he conceived schemes for an even more grandiose Liberation Project, this time not in the centre of Africa but in the heart of Latin America. According to Piñeiro, he preferred to launch a

> Revolutionary Struggle in another country of Latin America, preferably Argentina. He was always on the alert about any alternative that would represent a prospect for developing revolutionary armed combat, be it in Nicaragua, Venezuela or Colombia [...]. His concept, rooted in the Cuban Liberation War, was to found a mother column integrated by revolutionaries of several Latin American countries. Once having passed the first phase of survival, with experienced combatants and proven cadres, in its [subsequent] phase of development and growth, the conditions would be created to form other columns and thus expand the fighting to other countries of the continent.[117]

When still in power, he had overseen several interconnected expeditions: one to Argentina (Operation Sombra) and several to Peru (Operation Matraca). Operation Sombra was the priority. They were launched from Bolivia, the most central and landlocked country of Latin America with many indigenous ethnicities (Aymara, Quechua and Guaraní being the most spoken languages). After independence, Bolivia's territory reduced to 50 per cent of its original surface area as a result of frontier conflicts with all of its neighbours: Argentina, Brazil, Chile, Paraguay and Peru.

Operation Sombra[118]

Che Guevara and the Argentinian journalist Jorge Masetti had been friends since Masetti's trip to the Sierra Maestra in 1958. In March 1959 Che had asked him to found and manage Cuba's official press agency, Prensa Latina. He had also travelled, as Che's emissary, to Algeria. There he acquired 'some kind of combat experience, and he had also received military training in our country [Cuba]'.[119] In 1962, Guevara and Masetti initiated a plan to launch a guerrilla movement

in northern Argentina – Salta, the border region with Bolivia. Masetti would be the *comandante segundo* (second-in-command) of the Ejército Guerrillero del Pueblo (Guerrilla Army of the People). Guevara would be in charge of the guerrilla movement after the initial phase. Manuel Piñeiro remembers:

> [The initial phase is] the most risky one, of survival, when the guerrilla basically depends on their own strength. Guevara had wanted to lead the first column himself, but was persuaded by Fidel to wait 'until the advance party had created [more adequate] conditions'. It is a principle that Fidel developed in the Sierra Maestra [...]. Fidel didn't want someone of continental prominence like Che to be at risk during the first phase of the guerrilla struggle.[120]

Years later, Fidel Castro also commented in the same way:

> When Che, in his impatience, wanted to go on his mission, I told him: 'Conditions aren't ready yet.' I didn't want him to go to Bolivia to organise a small group. I would have rather he waited until the forces were well organised [...]. I said: 'Che is a strategic leader, and he shouldn't go to Bolivia until a sufficiently sound and solid force is in place.' He was impatient; but the minimum necessary conditions weren't ready yet. I had to convince him [...]. He should not be exposed to risk at such an early stage.[121]

Ulises Estrada, José Maria (Papi) Martínez Tamayo and Abelardo (Furry) Colomé Ibarra (until 2015 the minister of MININT) were sent to Bolivia and northern Argentina to prepare the logistics;[122] the three had also worked with Che Guevara in the Congo.[123] In Argentina, Isabel Larguía and John Cooke – both members of the revolutionary Peronism (see Chapter 5) – were the liaisons.[124] In Cuba, Alberto Castellanos – Che's former bodyguard and loyal companion (he had been a member of Che's 'Suicide Peloton') – was asked by Guevara to lead the expedition:

> You will be in charge until I come over [...]. I had been a first lieutenant [in the Rebel Army]. And [Che] would also incorporate

captains and *comandantes*. I had never left Cuba. Ulises Estrada prepared me for a week. I invented a legend for my family – secret military training in the USSR – and told them that they couldn't write to me. I travelled to Prague and got another passport there as Raúl Moises Dávila Sueyro, a student. From Prague to Rome, then to Lisbon, Dakar, Rio de Janeiro, São Paolo. Overland to Curumbá, at the Paraguayan frontier, then to Santa Cruz de la Sierra, Cochabamba and La Paz. There I met Furry [Abelardo Colomé] and Papi [José María Martínez Tamayo] [...]. With Furry and Papi we travelled to Cochabamba, then by jeep to Tarija, at the Emborosú encampment [...]. There I hugged Masetti and Hermes [Peña, Castellanos' friend and 'colleague bodyguard' of Guevara].[125]

From September to December the group of nearly twenty-five *guerrilleros* – Argentinians and a few Cubans – plodded through the jungle, set up camp and undertook reconnaissance missions.[126] Sometimes they suffered from hunger; it could happen that they were without water for twenty-four hours. The region was thinly populated, the inhabitants dirt poor. Armed propaganda did not attract followers. Most of the Argentinian combatants were university students.

Masetti sent a public 'Letter from the Rebels' to the Argentinian president-elect, announcing the liberation war. Although the immediate impact was not very strong, it alerted the Gendarmerie Nacional. They moved troops into the region. The Gendarmerie assaulted their camp at La Toma, arresting five combatants and seizing all weapons and supplies. It turned out that some of the arrested were turncoats and that police informers were among the newcomers. Masetti split up the group: Castellanos had to train new volunteer *guerrilleros* and Masetti advanced. Castellanos was wounded and captured in a police ambush. Masetti's group was trapped as well. Some men died in combat (Hermes Peña, for instance); some were wounded and died afterwards. The group split up again. Most of the combatants were captured. Some died of hunger and were found later on. Masetti and one of his men disappeared and were never seen again; the Gendarmerie searched the entire region but returned empty handed. Eighteen combatants were imprisoned; Castellanos was one of them.[127] Che

Guevara, travelling in Europe when he heard of the debacle, was deeply depressed.

The guerrilla was crushed. Castellanos remained silent in prison, pretending he was a Peruvian, and endured three and a half years in captivity.[128] Amnestied, he returned to Havana in 1968 and was received by Raúl Castro. He was reincorporated into the army, fought in Angola in the 1970s and was a military adviser in Nicaragua in the 1980s. Recently, in the interview that Piñeiro granted to Luis Suárez, his activities were declassified.[129]

Masetti's campaign was not the first one in Argentina and definitely not the last of the guerrilla movements. There were several previous rebellions and small armed clandestine groups: the early Peronist resistance group of John Cooke in the 1950s, the Uturuncos movements in 1959/60, and the Trotskyist Bengochea group of the early 1960s. After Che Guevara's death in Bolivia, the (former communist) Fuerzas Armadas Revolucionarias (Revolutionary Armed Forces), the (former socialist) Frente Argentino de Liberación (Argentinian Liberation Front), the Fuerzas Armadas Peronistas (Peronist Armed Forces) and the Trotskyist PRT-ERP (Partido Revolucionario de los Trabajadores – Ejército Revolucionario del Pueblo, Revolutionary Party of the Workers – Revolutionary People's Army) made their first moves.[130] However, in the decade of the 1960s their significance was rather local and the guerrilla efforts did not 'really [get] off the ground, none of them attracting popular assistance even in the provinces [...] where they attempted to operate'.[131] But in the 1970s, Argentina was the theatre of much more significant guerrilla movements, both of Peronist and Trotskyist origin.

Operation Matraca

In 1962 Che Guevara was overseeing the VMT training for several guerrilla campaigns in Peru; Ulises Estrada was directly in charge. One of the guerrilla recruits was Che's brother-in-law, Ricardo Gadea, the brother of his Peruvian ex-wife Hilda. Fidel Castro visited the encampment, but Che Guevara 'was their undisputed revolutionary mentor', as he would be for entire generations of Latin American *guerrilleros* in the 1970s and 1980s, long after his death.[132] The most important guerrilla movements that received training were the Movimiento

de Izquierda Revolucionaria (MIR, of Luis de la Puente Uceda and Guillermo Lobatón) and the Ejército de Liberación Nacional (ELN, of Héctor Béjar and Javier Heraud). The armed peasant movement in La Convención (the Cuzco department), headed by Hugo Blanco, of the Trotskyist Frente de Izquierda Revolucionaria (FIR, Revolutionary Front of the Left), was not considered a priority in Cuba. It is, however, interesting to consider that the Peruvian military intelligence officers and those in charge of the counter-insurgency operations (the future team members of the Velasco 'Revolutionary Government of the Armed Forces', 1968–75) considered Blanco's rebel movement to be the most important one. In 1961, a first group of nine ELN members had travelled to Cuba; more arrived afterwards. In 1962, seventy-two MIR members travelled to Cuba to receive training.[133]

Although the leadership of the MIR and the ELN had several meetings in Cuba, ideological divergence and lack of personal trust prevented coordination, notwithstanding all Cuban efforts.[134] Also evident is the lukewarm support from, and even distrust of, the leaders of the Partido Comunista Boliviano (Bolivian Communist Party) and the Partido Comunista del Perú (Communist Party of Peru). Initially the MIR, especially De la Puente, had opted for an urban guerrilla, which was more appropriate for the country according to the Peruvians themselves. However, the Cubans convinced them of the convenience of rural guerrilla warfare.[135]

> [De la Puente] was an expert on agrarian and peasant problems. He knew the situation very well and put Che Guevara on the defensive when he explained the organic composition of rural Perú to him. He told him that the peasants were organised in unions. [That] there was thousands of peasant communities with a tradition of internal discipline and struggle. He doubted Che's 'pure *foco*' because De la Puente told him: 'There are concrete peasant organisations, and when we call for insurgency, we have to work with what the peasants have built. Moreover, the peasants will not leave their organisations because I am starting a guerrilla. We have to work with these organisations.'[136]

The Cubans were very convincing, and the Peruvian guerrilla fighters decided to follow their recommendations. When they crossed

the Bolivian–Peruvian border, the revolutionary poet and *guerrillero* Javier Heraud was killed. De la Puente was killed; Béjar was captured.[137] For many of the initial combatants, it was an expedition destined for failure and death.[138] Even more tragic: the military in charge of the counter-insurgency operations was notified by the indigenous population and by infiltrated informants:

> The guerrilla was short-lived; we had infiltrated them thoroughly. Also, the three fronts operated without any coordination. One of Hugo Blanco's lieutenants worked for [Military] Intelligence. We had people in De la Puente's camp as well. Technically it was not difficult to wipe out the guerrilla. They were idealists to the point that they practically committed suicide. It was a bunch of idealists who took to the Andes without knowing what the place was like, without having worked there, remaining alien. They came from Lima and wanted to be brethren to the peasants without really knowing them. The guerrilla didn't get results.[139]

Che Guevara's Bolivian campaign

Asked how Che Guevara reacted when confronted with all these setbacks, Piñeiro talked about Che's growing impatience. Patience and tact were not the most striking virtues that Che Guevara possessed; he was uncompromising. His previous African mission had become a failure. Meanwhile, in October 1965, when the Central Committee of the Communist Party was created, Fidel Castro had to explain why Che Guevara was not incorporated as a member. Rumours were circulating that Che had been purged. It was the reason that his farewell letter was read in public. Recovering in Dar es Salaam and in Prague, Che Guevara maintained a correspondence with Fidel. Now he had set his mind on Bolivia, in theory a promising theatre for a guerrilla war given that the country had a long history of revolution and revolt.[140] Piñeiro's team had initiated the logistics for his new mission:

> [In Prague,] in March 1966, it was a complicated situation [for Che] for he was there undercover. Since he had already written his farewell letter and he had a great sense of honour, it never occurred to him to return to Cuba after having bid everyone farewell. Meanwhile, the cadres for the Bolivian mission had

already been selected and were undergoing training. It is then that I wrote him a letter, reasoning with him, appealing to his sense of duty and his rationality [...]. I persuaded him to return, I told him that it was more convenient for what he wanted to do [...]. I told him that it was his duty to return, to rise above any other consideration, and to complete the preparations for the Bolivian plan.[141]

He returned to Cuba in July 1966, preparing for his Bolivian trip. He was anxious to depart. He was already thirty-nine years old, and he felt 'much urged by his increasing age. He knew better than anyone how essential good physical conditions were for a comandante of a guerrilla movement.'[142] The fifteen members of his column were experienced veteran combatants, selected by Che and discussed with Fidel. Some had fought in the Sierra Maestra; others had been with Che in the Congo.[143] Physically, militarily and psychologically, they were fit.[144] The team had already begun to learn Quechua. It was the first Cuban operation in Latin America where the majority of the guerrilla column was Cuban, not national. The movement was called the Ejército de Liberación Nacional (ELN).

During unenthusiastic negotiations between Fidel Castro and Mario Monje, secretary general of the Partido Comunista Boliviano, the latter had promised his support to the guerrilla expedition. In Cuba, Monje had requested to be in charge of the expedition and Che had refused; it resulted in a bitter dispute with Monje.[145] Che, who had said goodbye to his family in disguise, was excited, even euphoric, at the hour of his departure.[146] They travelled by convoluted routes, via Prague and Montevideo. Strangely enough, the Cuban advance party had selected a base encampment in Ñancahuazú, in a Guaraní- and not a Quechua-speaking environment.

This expedition was another ill-fated foray. Once started, Che and his Cuban group, reinforced with Bolivian and Peruvian cadres – and at one point French philosopher Regis Debray and the German-Argentinian Tania, and even prisoners – were operating alone. The backing of the Partido Comunista Boliviano was half-hearted; support from the local population was meagre at best. Quechua-speaking Bolivian dictator Barrientos had made a pact with the indigenous

leadership.[147] Communications with Cuba were disrupted, and those with La Paz disturbed. After some successful initial skirmishes, the incipient guerrilla force was quickly spotted and substantial counter-insurgency operations started, with American logistical support. The CIA was monitoring Che's movements. The military acquired detailed knowledge from a captured liaison officer, and later from deserters. The guerrilla group was split in two parts that tried to find one another. Sometimes the two guerrilla groups moved in circles. Bolivian army units encircled the largest remaining guerrilla column. Che was captured, then killed in La Higuera on 9 October 1967. His hands were cut off for identification; the corpse was buried in a secret location.[148]

Some Cubans were able to escape and found refuge in Chile, where by intervention of Senator (later President) Salvador Allende they were able to return to Cuba. In an effort to revive the obliterated Ejército de Liberación Nacional (ELN), some of the (Cuban) refugees trained a new contingent of Bolivians and Chileans; of the Bolivians, many were members of the Partido Comunista Boliviano. It is also remarkable that of the sixty-seven combatants, thirteen had a leftist Christian background.[149] The operations were ended in 1971.[150]

The Cuban leadership was shocked by Che Guevara's death, as was an entire generation of revolutionaries. A million Cubans went to the Plaza de la Revolución. An army battery fired twenty-one cannon shots in honour of Che. The Mexican diplomat Iruegas remembers the thunderous silence of the mourning Cubans, the farewell of a solitary trumpet and the sad address by Fidel.[151] Che's Bolivian diary was published in 1968 in Cuba with a first edition of 250,000 copies.[152]

In retrospect, Che Guevara's campaign and death in Bolivia had an enormous impact. In a strictly military sense, the guerrilla operation was relatively insignificant. Richard Gott was absolutely right when he concluded that '[...] had it not been for the presence of Che Guevara and Regis Debray, the disastrous Bolivian *foco* of 1967, which lasted less than a year, would have been ignored by the world's press in the same way that comparable abortive uprisings [...] were neglected'.[153]

The political significance, however, was enormous. Instantly, Che Guevara was transformed from a guerrilla hero into a revolutionary

martyr, and to a greater extent a kind of civil saint. Castañeda[154] had already pointed out the explosion in Che's post-mortem popularity during the European students' revolts in 1968, and in the protest movements against the Vietnam War in the United States at the same time. His German biographer Lahrem explains the lasting fascination and the persisting allegory of Guevara as a secular saint through the coincidence of several circumstances: the beautiful and romantic Korda photo, printed on innumerable posters and T-shirts (and Cuban souvenirs) over several decades, the analogy of the image of the crucified Christ and Che on his deathbed, his ascetic radicalism and the 'purity of revolutionary violence'.[155] I cannot recall a Latin American guerrilla movement (with the exception of the Maoist Shining Path movement in Peru) for which Guevara's life and death were not a source of inspiration.

Reflection

But his theory about guerrilla warfare, and especially in terms of the revolutionary rural *foco*, did not withstand the proof of practice.[156] In all Latin American guerrilla wars between the 1960s and 1990s, it is clear that *guerrilleros* did not achieve victory in rural environments; they could only hide and become 'invisible'. But time and again, regular armies have defeated rural guerrilla movements, generally after barbaric counter-insurgency campaigns.

With the wisdom of hindsight, it is easy to pinpoint the tepid support of the (Soviet-oriented) communist parties in Latin America. In most Latin American countries where guerrilla movements erupted, the communist parties preferred a sort of political abstinence: in Bolivia, in Brazil, in Colombia, in Guatemala, in Peru, in Uruguay and in Venezuela. Maybe there was an occasional early commitment but eventually the communist parties remained on the margins. The Soviet Union, the country of their old and trusted comrades, was never a fervent devotee of guerrilla movements in Latin America. The western hemisphere was the home continent of the United States, the country with which the Soviet leadership sought stability and a peaceful coexistence.

But there is more: Cuba did not have a significant indigenous population. Even the poor peasants in Oriente spoke and understood

Spanish, at least in dialect. The guerrilla was not alien to the peasants and the peasants were not alien to the combatants. But in the 1960s, the reality in other Latin American countries was different. In Central America and in the Andean countries, huge contingents of indigenous peoples, sometimes more than 50 per cent of the total population, were monolingual in non-Spanish languages: they spoke a Mayan language or Quechua dialects, Aymara or Guaraní, to list only the dominant indigenous tongues. Their centuries-old segregation, communal land tenure, '*usos y costumbres*' (traditions and conventions), poverty and backwardness all made it difficult to facilitate contact with strangers who suddenly appeared, without deep knowledge of the indigenous societies, aspirations and culture. And if there was one institution whose members were more or less familiar with the indigenous masses (from which they recruited their soldiers), it is the army. In Latin America at that time, the army was probably the only representative of the state with which indigenous peoples were familiar. They knew the army officers, but also the army doctors and nurses who cured the wounded and the sick, the army engineers who traced and built the small roads, and the army lawyers who explained and enforced the law. It was not uncommon for former enlisted men, trained and literate after military service, to become community leaders. The highly committed *guerrilleros* of that period, coming from the outside, were strangers operating in an unknown environment.

In the early 1970s, another change took place in Latin America: the rise of progressive military governments with nationalist-leftists programmes in Peru and Panama, and afterwards in Bolivia and Ecuador. Allende's 'civilian transition to socialism' appeared to become reality. In the Caribbean, progressive governments emerged as well – in Jamaica, Grenada and Guyana. The Cuban institutions of national liberation and intelligence perceived a change in the political panorama: progressive generals, progressive social movements, progressive student movements and progressive religious movements. It was the time of the proliferation of Liberation Theology in the churches and of Dependency Theory at the universities. This is the context of the next chapter, when Cuba's leadership, sadder and wiser, reoriented their support for the Latin American left.

CHAPTER 5

. .

The mature years (early 1970s–late 1980s)

Realignment with the Soviet Union

The death of Che Guevara in Bolivia sent a traumatizing shock wave through Cuba. It generated an internal discussion and a reassessment of Cuba's revolutionary politics. In the western hemisphere, Cuba was politically isolated after its expulsion from the Organization of American States (OAS). Only Canada and Mexico maintained diplomatic relations. While Guevara had promoted 'one, two, three Vietnams', the United States had succeeded in preventing two or three other Cubas. The meagre support of the Bolivian Communist Party for Che's campaign was evidence of the divided loyalties of many Latin American communists: between the good old (and generous) Soviet Party and the radical revolutionaries in Havana. Cuba's new approach was one of flexibility and pragmatism with respect to the Latin American revolutions and the Soviet Union. The forging of revolutions abroad required more than just 'revolutionary fervour'.

There was also a more domestic reason for a political recalibration. By the late 1960s it had become clear that Cuba's economy could not be built on revolutionary spontaneity alone. Cuba's economic development stagnated and its growth depended more and more on external supplies and subsidies, basically those delivered by the Soviet Union and other member countries of the COMECON. Warmer relations and realignment with Moscow, accompanied by ideological moderation, were thus unavoidable.

Two events, in 1968 and 1970, clearly illustrate this new realism. In Europe, 1968 was a revolutionary year. Students in France and Germany demonstrated under the Korda portrait of Che Guevara.

In Czechoslovakia, the Communist Party chose the path to reform. But a Soviet army – reinforced by military detachments from Poland, the GDR and Bulgaria – invaded the Czech lands and Slovakia. After a brief period of silence, Fidel Castro appeared on national TV to support the Soviet invasion and denounce the Czechoslovakian leaders as counter-revolutionaries. This was not the man who was considered to be the Third World spokesman struggling against injustice and dictatorship. It came as a shock to his sympathizers in western Europe and Latin America and, very probably, also in Cuba. Castro justified the invasion, referring to the Warsaw Pact as a last resort of defence for the island in the event of an American invasion.

The second moment was in 1970, when the Cuban leadership publicly admitted the failure of overestimating the expected sugar harvest of 10 million tons. Sugar was Cuba's only real export commodity at the time. At that moment, capitalist and Soviet economists were unanimous about the wisdom of continuing this mono-product culture, despite all previous efforts of industrial diversification and import substitution. The existing processing facilities were relatively outdated and transport and harbour facilities were deficient in guaranteeing a regular supply of Cuban sugar to the Russian markets. A national campaign on the 'battle for sugar' was announced and virtually everyone within the Party, the public sector, the trade unions and mass organizations – even schoolchildren and students – were mobilized to reach the target. Experts who suggested that the plan was overambitious were dismissed. The harvest of that year was the best yet achieved: more than eight million tons. But the target was not reached. Fidel took responsibility, acknowledging that building socialism was difficult. The only remedy that the Cuban leadership saw was to invite, on a massive scale, Soviet experts:[1] for economic planning, business management, engineering projects, infrastructural design, military and technological advancement, and even higher education.[2] In 1972 Cuba became a full member of the COMECON, an association for economic integration but not a military defence alliance like the Warsaw Pact, of which Cuba never became a member.

Soviet investments and development assistance contributed to a remarkable growth of new industrial plants and the reconstruction

of antiquated enterprises (including 156 sugar plants).[3] The Soviet Union had practically become Cuba's mono-supplier of oil, coal, pig iron, cotton, timber, grain and flour (90–100 per cent) and its principal provider of fertilizers, trucks, cars, and road-construction equipment (70–90 per cent). Initially Cuba could cover these imports by exporting sugar and nickel to the USSR at highly subsidized rates. But it soon had to ask for more credits. The Soviet Union also paid the running costs of transportation in both directions, dispatching about three hundred cargo vessels on a permanent basis. On average, 100 ships were docked in Cuban ports.[4] In 1990 the deficit reached an estimated 24.6 billion dollars. Repayment was constantly postponed and Cuba did not service the debt:

> The vicious circle of increased Soviet aid only escalated Cuba's 'needs' and became a permanent headache for the officials of the Soviet State Planning Commission (GOSPLAN). Each year, Soviet planners had to stretch their imaginations to find ways and means of allocating additional funds and material resources to Cuba [...]. The standard formulation of the [Politburo] was to 'Find the possibility to satisfy the request of the Cuban leadership'.[5]

Cuba became a mono-product agricultural exporter.[6] Under the first Agrarian Reform Law of 1959, all rural large and medium-sized estates had been expropriated and brought under state control. In 1963, while the counter-revolutionary 'bandits' waged war in regions with many smallholdings, the second and more radical Agrarian Reform Law expropriated all rural private property. Cuba's leadership launched a policy of 'urbanization of the countryside', creating rural communities with an 'urban infrastructure' of medical services, schools, electricity and apartments. 'Voluntary rural communities' prepared for huge sugar harvests. After the failure of the projected 10 million ton harvest in 1970, the government created, alongside the large state sector, a sector of agricultural production cooperatives in around 10 per cent of the rural land in production. After an assessment of the eastern European agricultural system, Cuba opted for the model of the German Democratic Republic (GDR). After it became a member of the COMECON, over-specialization in sugar affected its

overall agricultural structure. Most fruits, including malanga roots (Cuban children's basic food), disappeared; even cucumbers and pickles were imported from Bulgaria.

By and large, the 1970s and the 1980s were years of relative prosperity. Housing, medical provision, schools and universities, electricity, domestic telephone provision, sports and cultural facilities, radio, TV and even clothing were provided by the state. A professional could earn 500 pesos per month; a secretary went home with 150 pesos. Prices were controlled. Transport was becoming a problem, but one could win a Lada car by merit.[7] Unemployment was below 4 per cent. Cuba's annual growth between 1975 and 1985 was more than 4 per cent, more favourable than that of the economies of the rest of Latin America and the Caribbean, with average growth rates around 1 per cent.[8]

One of the institutions that strongly benefited from the Soviet support was the Fuerzas Armadas Revolucionarias (FAR).[9] The Cuban military maintained warm relations with their Soviet counterparts; commanding officers received training in Moscow or Leningrad.[10] The FAR were modernized along Soviet lines. In the early 1970s a programme of re-equipment was launched with the most sophisticated weaponry (MiG fighter-bombers, T-62 tanks and BM-21 missile launchers) and military technology of the time.[11] During the three decades of 'fraternal cooperation' between the Soviet Union and Cuba, on an annual basis the FAR was provided with supplies, training and equipment worth about one billion dollars.[12] By the late 1970s, the armed forces had expanded hugely. The Youth Labour Army, a labour force under army command that was created in 1973, was provisioning the entire FAR.[13] At the peak of expansion, by the end of the 1970s and during its Africa campaigns, the FAR had between 470,000 and 510,000 members: 'It was the largest military force in Latin America and vastly bigger than those of countries Cuba's size anywhere in the world. Furthermore, man for man during the 1970s and 1980s, it may have been the best and most experienced fighting force of any small nation, with the single exception of Israel.'[14]

In the early 1970s, military officers also started to perform managerial functions beyond the soldierly realm. There had always been cabinet ministers with a military rank; from that point on, a process

started in which eight to ten senior members of the FAR were in charge of strategic ministerial portfolios.[15]

The influence of Soviet ideas on domestic ideology and culture and even the Party structure was huge as well. While the Cuban economy was reorganized and its military power was modernized and strengthened, another transformation took place behind the scenes. Soviet economists restructured the JUCEPLAN. Soviet experts and old PSP leaders advised on a new organizational structure: a three-layer system of municipal, provincial and national Asambleas de Poder Popular (Popular Power Assemblies). The government was reconstituted into a Council of Ministers and a State Council, and the Communist Party was moulded after the Soviet model. Cultural expressions in the broadest sense were more controlled. The first half-decade of the 1970s was the period of the '*quinquenio gris*' (the grey five years) of strict monitoring of political correctness and orthodoxy.[16]

Cuba's management of foreign relations

But whatever had been the Soviet influences and pressures on matters of foreign politics in Latin America, especially with respect to the political actors of the left, Fidel Castro was never a dogmatic subscriber to Soviet politics.[17] The Soviets assisted with credits lines, commercial activities, technical and military assistance and arms delivery. The Cubans acted as political advisers, and provided military training to national liberation movements in the region and in Africa. In fact, over several decades Cuba was the 'general hospital' for many wounded or crippled revolutionaries and welcomed insurgents and political exiles to the island. The Soviet Union also greatly benefited from Cuba's reputation as a non-imperialist military and medical service provider. Cuba – and not the Soviets – took the initiative in intervening with their regular military forces in Angola. This earned Cuba its immense reputation in the Third World and the NO-AL movement. As Mesa-Lago rightly remarks:

> [...] few would deny that [its foreign policy] has brought Cuba from a small country with a virtually nonexistent role in international affairs prior to the revolution to one which is a significant

actor in the world area today [...] Cuba has become a model for, or has significantly influenced, socialist revolutions or radical social movements throughout Latin America and the Caribbean; and it had won two important wars in Africa defeating movements/nations supported by the United States, the People's Republic of China, and South Africa.[18]

Militarily, Cuba became engaged in the African wars. Politically, it continued to support new politicians and actors of the left in Latin America and the Caribbean; Fidel Castro personally monitored Cuba's foreign policy in detail. This perhaps illustrated an observation by the minister of MINREX at the time, Carlos Rafael Rodríguez. In 1972, Arbesú – vice-chief of the Departamento América and Piñeiro's eventual successor – and section heads Ulises Estrada and Osvaldo Cárdenas requested an interview about the Central Committee's policy with respect to the United States. Rodríguez told them bluntly:

Look, Arbesú. If Fidel instructs me that I explain to you Cuba's policy with respect to the United States, I think that I'm able to do it. But don't worry too much. Here, [even] the members of the Politburo do not know what our policy is about. We're going to give you instructions and you follow what Fidel and I tell you to do. Because here, [the two] who handle it, are Fidel and me.[19]

But it was clear that Fidel provided the instructions and Piñeiro had day-to-day access to Fidel. Instructions were given to specific persons and sections on a need-to-know basis. As one of the vice-chiefs of the Departamento, Norberto Hernández, remarks: '[...] I can't speak about all that because our highest chiefs, Fidel and Piñeiro, never told one hand what they did with the other.'[20]

After 1975, when the Departamento América had been transferred from the Ministerio del Interior (MININT, Ministry of the Interior) to the Central Committee's offices, and the department's members were formally incorporated into Cuba's diplomatic apparatus in the region, they still maintained direct communication with Piñeiro's office in Havana.

In the 1970s, many of Cuba's political alliances with leftist movements and its leaders were based on personal friendships with Fidel.

As we will discover in this chapter, Fidel Castro developed a strong affinity for Caribbean leaders Manley (Jamaica) and Bishop (Grenada). He also became close with Chile's president Allende, Panama's leader General Torrijos, the political team of Peruvian president General Velasco, and explicitly with Venezuelan president and former lieutenant-colonel Hugo Chávez after 1994. Several times, he also hand-picked Cuban diplomats who were likely to be appreciated by these leaders and would become 'friends of the president', even before the establishment of formal bilateral relations.

The 1970s and 1980s were the period of Dependency Theory in universities and Liberation Theology in churches. The student generations and the faithful Catholics were not terribly interested in membership of the communist parties. But they were influenced by the anti-imperialist arguments of the dependency theorists and felt a moral imperative to eradicate the structures of poverty and injustice. Dependency Theory had already been developed in the 1950s and 1960s in Santiago de Chile. At the regional UN office for social and economic development in Latin America and the Caribbean (ECLAC), economists like Raúl Prebisch had elaborated the thesis of economic growth in centres and the periphery, whereby the periphery (Latin America and the Caribbean) was seen as dependent on the dynamics of the capitalist centres.[21] In the late 1960s, they trained a new generation of economists and sociologists at the Escola Latina, also established in Santiago. Poverty, exclusion, social conflict and political violence were seen as the consequences of Latin America's dependent integration into the capitalist world system. Social and economic scientists began to publish material about the roots of Latin America's underdevelopment, imperialism, the role of unsuccessful national bourgeoisies, and the inevitability of reforms and even revolutions.

Liberation Theology was probably even more influential in the hearts and minds of considerable segments of the Latin American population. In countries like Argentina, Brazil, Peru and Mexico – and especially in Central America – theologians and priests emphasized a new interpretation of the Bible. They established a moral relationship between religious ethics and political activism for the benefit of the poor, the exploited and the victims of persecution and injustice. In

many countries, Base Communities – small groups of twenty to thirty persons who met regularly for Bible study and its relevance for the solution of social and political problems – were formed. Priests and laymen were engaged in organizing workers and peasants into unions and associations that were forbidden or controlled by officials of the military dictatorships. The influence of Liberation Theology on the many emerging radicalizing groups of the Argentinian and Uruguayan armed left (who published the journal *Cristianismo y Revolución*) and on the Colombian and Central American revolutionary movements is undeniable. Also certain is its influence on the general public, community members and the student generations of the 1970s and 1980s. Che Guevara and Camilo Torres were both revolutionary and moral icons. Archbishop Romero was murdered in 1980 while celebrating mass; he and the rector and priests of the Jesuit University who were murdered afterwards in San Salvador were also incorporated into the annals of revolutionary heroes and martyrs.

One can trace Camilo Torres' influence in Cuba as well, not in the Catholic hierarchy, which kept its distance from Liberation Theology, but rather within the evangelical left on the island. Pastor Carlos Piedra, for instance, founded the evangelical Movimiento Estudiantil Cristiano (MEC) in Cuba:

> In 1966, Camilo Torres, the priest, falls mortally wounded in combat [...]. [We] inaugurated the Camilo Torres Seminars [Jornadas Camilo Torres] [...]. We met and read the texts of the Liberation Theologists in other parts of Latin America [...]. We distributed them among the fourteen groups of the MEC as discussion topics throughout the year [...]. Since 2002, I have been a member of the Communist Party of Cuba. I am the only Protestant pastor in Cuba who is a member of the Communist Party.[22]

In this context of Dependency Theory and Liberation Theology, with its empathy for Marxian sociology and philosophy, Cuba reoriented its appreciation of new actors and organizations in Latin America. The Instituto Cubano de Amistad con los Pueblos (Cuban Institute for Friendship with the Peoples, ICAP) identified other actors and

movements beyond the traditional 'revolutionaries'. It was time to pay attention to the nationalist-leftists regimes and movements. René Rodriguez, the ICAP director at that time, was explicit in his pragmatism:

> [René] opened our eyes. He told us not to neglect the nationalist sectors in every country. They had to become allies of Cuba, with greater or lesser affinity. And that caused contradictions with the revolutionary movements in Latin America. I had to tell them: 'They are friends of Cuba, just like you' [...]. There were friendship associations in Mexico, Uruguay. They flourished in almost all countries of Latin America. And we discovered that, like in Colombia, Mexico and Venezuela, there were leaders of well-known parties that were more leftist than some leaders of the communist parties. René insisted that we worked with them: 'Don't try to put in much ideology. Talk about Cuba's necessities and Cuba's courage. Tone down your discourse' [...]. We realized that by being more open-minded and using a more delicate tone, we penetrated sectors to which we otherwise would never have got access. That is what we called 'popular diplomacy', going beyond the sectors we traditionally reached, the so-called revolutionary sectors. Because many friends of the Cuban Revolution are of middle-class background, are members of the traditional political parties, or sometimes don't have a political affiliation.[23]

The ICAP also created 'visiting brigades': American visitors and students came to the island with the Brigada Venceremos, and Europeans with the Brigada Europa. Later, the Brigada Latinoamericana was founded. After the '*quinquenio gris*' (the grey five years) in the 1970s, Cuba lost the interest of many influential intellectuals. The ICAP considered its mission to be the recovery of solidarity among Latin American and European intelligentsia. Philosopher Martínez Heredia remembers the invitations that were issued to influential religious leaders and intellectuals:

> I always [worked] in complete coordination with the Departmento América [...]. One of Piñeiro's men at the United States

section sent me three books by a professor at Stanford, called Herbert Marcuse. That was shortly before Marcuse became famous. The books were *The One-Dimensional Man*, *Soviet Marxism*, and *Eros and Civilization*. I notified Fidel, who immediately required that [Marcuse] be invited to Cuba. [But] it seemed impossible to make such a sensitive trip at that time [...]. For a long period we maintained good relations with many of the progressive religious believers of the continent. A large number came to Cuba and it facilitated the ideological and political insight of Cubans into that ever so important issue. On matters of religion many Latin Americans and some Europeans, like François Houtart, assisted us. I conversed and dined twice with Gustavo Gutiérrez, the founder of Liberation Theology, and transmitted to him Fidel's invitation to come to Cuba. But he didn't dare make that trip.[24]

But with other influential intellectuals and theologists, Cuba was more fortunate. Famous Dominican Frei Betto (1985) came to Havana and interviewed Fidel Castro about religion and revolution.[25] In the early 1990s, the ICAP co-organized solidarity flights coming from Brazil, with theologists Frei Betto and Leonardo Boff. They were accompanied by entrepreneurs, politicians, students and movie and TV artists. They celebrated mass where everyone collectively made a confession. ICAP also assisted in masses celebrated by progressive priests with solidarity groups from Argentina and Colombia.[26]

At least three national labour union leaders were regular guests and attended training courses and seminars in Cuba. Afterwards these same leaders became presidents of their countries: Lula (Brazil), Morales (Bolivia) and Maduro (Venezuela). In 2011, 2012 and 2013, staying in Bolivia and interviewing Bolivian cabinet members, I became aware of the fact that several vice-ministers periodically visited Havana for their MA or PhD studies.

New revolutionary friends

During the 1960s, the United States had intended to force Cuba into diplomatic quarantine in the region. But in the early 1970s these

efforts began to dwindle. In some countries more progressive governments took office. It coincided with Cuba's turn towards a more pragmatic diplomacy, creating alliances not only with the revolutionary armed left but also with other nationalist-reformist forces. Cuba's representatives abroad described themselves in the early 1970s no longer as 'revolutionaries of impulse' but rather 'revolutionaries of the heart and thought'.[27] It served them well in a situation with hitherto unexpected allies.

Peru

In October 1968 a military government, headed by the commander of the armed forces, General Juan Velasco Alvarado, assumed political power in Peru. The military nationalized the holdings of the International Petroleum Company (IPC), a subsidiary of the Standard Oil Company involved in a fraudulent contract, and announced a radical agrarian reform and other progressive economic and social reforms. Peru's foreign policy also changed very quickly. The United States reacted by threatening a boycott and the restriction of credit and other assistance programmes.[28] But the Peruvian military did not alter their nationalistic programme. The leading generals and colonels had a vivid memory of what had happened to another leftist-reformist army officer, Colonel Arbenz of Guatemala, who had given in and was ousted by a CIA coup.

They became enthusiastic members of the NO-AL movement. Diplomatic relations were also broadened to include the eastern European countries, the Soviet Union and the People's Republic of China. Peru was extremely dependent on American armament and spare parts; in the 1950s and 1960s it had been one of the Latin American countries most favoured by US military assistance. From 1968 on, Peru diversified its arms procurements, buying western European equipment. When the Washington administration ceased delivery of weaponry, Peru turned to the Soviet Union. Ambassador Pérez de Cuellar, Peru's brilliant diplomat and future secretary general of the United Nations, negotiated the delivery of state-of-the-art tanks, armoured vehicles and fighter-bombers with the Soviet Union and the other Warsaw Pact members.[29]

A month after the Velasco coup and the nationalization of the IPC holdings, the editor of the official Cuban newspaper *Granma* asked

Joa – then Piñeiro's section chief for Bolivia and Peru – to write a commentary on the Peruvian military. *Granma* published an article depicting the new government as a 'group of gorillas, trained by the Yankees'. But the next day the paper perceived a call from Fidel with the comment that Yankee puppets are not inclined to nationalize strategic American assets. Piñeiro instructed his team to attentively monitor the next steps of this *sui generis* government and to look for an opportunity to approach the generals.[30] The Departamento América rapidly identified Colonels Fernandez Maldonado, Enrique Gallegos and Leonidas Rodríguez as core members of the revolutionary conspirators; eventually they became influential cabinet members.

In 1970 a severe earthquake affected the north-eastern indigenous region, resulting in 70,000 victims. In Cuba 100,000 people (including Fidel Castro) donated blood. Fidel immediately offered a medical brigade and a reconstruction team. The Soviet Union sent their gigantic rescue helicopters. Piñeiro created a logistical support team on the second floor of the Hotel Nacional in Havana for Operación Ayacucho.[31] The team was headed by Fernando Ravelo and functioned for more than a year. During the months of intense collaboration, the relations between Cuba and the radical colonels – some of them recently promoted to brigadiers – became warm and confidential:

The political leadership of the Cuban Revolution had become aware of the fact that new actors were joining the revolutionary struggle in Latin America. That [they] were not guerrilla movements but nationalist soldiers who already ruled in Peru, Panama and later in Ecuador. That meant a change in the concept of solidarity of the Cuban Revolution with Latin America. In the case of Peru we launched an operation of solidarity with a progressive sector of the armed forces that didn't have to do with the existing revolutionary organizations.[32]

Piñeiro sent Angel Guerra, a trusted journalist and former chief of the editorial team of *Juventud Rebelde* (Rebellious Youth, Cuba's second-largest newspaper) as a correspondent to Peru to become familiar with the most radical generals, especially Fernandez Maldonado,

and the people around them – Marxists and Christians, adherents of
Liberation Theology:

> We should also meet with progressive journalists and [leaders
> of] social organizations, trade unions, students and grassroots
> organizations. And [also] to debate with sectors of the left
> that disapproved of the Peruvian process only because of the
> fact that it was headed by the military. We should also explain
> how counterproductive it would be for the left not to give active
> support to the government of General Velasco Alvarado.[33]

The collaboration would go even further; Cuba supported, at the
request of the Peruvian army, intelligence operations against the
CIA and the Peruvian Marine Intelligence. It was a public secret that
the navy strongly opposed the more radical generals of the army. In
1974, General Morales Bermúdez – then prime minister and minister
of the army – went to Cuba to assist in military manoeuvres. Piñeiro
connected the Peruvian army leader with Escalante Font, a senior
member of the Cuban Department of State Security (DSE, Departa-
mento de Seguridad del Estado), who was in charge of the section
that monitored the CIA. Cuba already monitored CIA agents who
tried to infiltrate the Cuban embassy in Lima, via pillow talk from a
female CIA official who was in love with a Cuban undercover agent.
Escalante Font accompanied the Peruvian prime minister to Lima and
stayed there from November 1974 through February 1975. A network
of sixteen officials operated within and around the Cuban embassy.
They discovered eight or ten safe houses and the whereabouts of
many CIA agents in Peru. Cuban and Peruvian (Army) Intelligence
exchanged relevant information and the operation continued until
Peruvian Naval Intelligence discovered the presence of the Cubans.[34]

Panama

Also in October 1968, a crucial regime change took place in Panama.
Colonel (later General) Omar Torrijos Herrera, commander of the
National Guard, staged a coup with the support of the majority of
army officers. Like the Velasco government in Peru, the new Panamanian
leader announced a social reform programme for the benefit of the

poor. Unlike Velasco, Torrijos did not assume the title of president. But until his death in 1981, his position as head of the Guard made him the de facto chief of government, formalized in the new constitution of 1972.[35] Velasco and Torrijos appreciated one another. Both were reformists without being Marxists, passionate nationalists with sympathy for the underprivileged. Velasco never wanted to create a political party and instead incorporated the slum dwellers, peasants and members of the indigenous communities into a presidential ministry called SINAMOS (Sistema Nacional de Movilización Social, National System of Social Mobilization). Torrijos founded a political party, the Partido Revolucionario Democratico (PRD, Revolutionary Democratic Party), that attracted the support of the urban poor, the rural peasantry and the students' movement. Both defined themselves as military reformers with special missions to break the power of the economic and political oligarchy, to restore national control over the economy and to carry out social reforms, implemented by the armed forces:

I am a soldier of Latin America who lives his daily life in the barracks since I was seventeen years old. That gives me the right, and knowledge, to treat a delicate, complex and sensitive subject [...]. Since 1959, the year in which, utterly remarkably in our century, a guerrilla triumphs over a regular army in Cuba, at the peak of the period of McCarthyism, military schools began to analyse a problem that had not been recognised previously. What had happened in Cuba? And why? [...]: social terror, terrorism, 'exotic theories'. No, no, the real breeding ground for these so-called exotic theories is [poverty and] misery. The real cause is the lack of schools, the lack of provision of potable water, the lack of a national development programme [...]. Many common soldiers, sergeants and lieutenants, men who live in the same [circumstances of] misery in which ordinary people live, realise quickly that their rifles should be targeted at those who enslave [...].[36]

Between 1968 and 1989, the year of the American invasion in Panama, Cuba and the Panamanian generals Torrijos and Noriega (Torrijos'

Chief of Intelligence and his successor as army leader) 'provided invaluable services to the Cuban Revolution'.[37] Again, Fidel Castro personally intervened. He appointed Norberto Hernández, the VMT section chief in charge of Central America at the time, as 'friend of the president', a kind of unofficial ambassador:

> [Fidel] decided in 1969 that we should establish direct contacts with General Omar Torrijos. I came to the country to live there with my family. The position Omar Torrijos offered me was to be 'his friend', as there were no diplomatic relations, embassies or anything like that. In that condition I stayed in Panama until the year 1974, when diplomatic relations between the two countries were renewed [...]. The main objective for which I was sent to Panama was not the re-establishment of diplomatic relations. I went to Panama to support the Latin American revolutionary movements. During my stay in Panama I firstly secured direct contact with the Colombians. Thereafter, with all [movements] that passed through there, be it Central Americans or South Americans [...] through Omar Torrijos and from Panama, I established connections with representatives of the political forces in Colombia, Costa Rica, Ecuador, and Venezuela. I'm not speaking about relations with the revolutionary movements – we were already connected – but with the formal government structures and key persons of the traditional parties in each of those countries.[38]

Other progressive military

Military reformism was not restricted to Panama and Peru. Other army chiefs followed suit and adopted similar, albeit more modest, programmes: in 1971 in Bolivia (Generals Alfredo Obando in 1969/70 and Juan José Torres in 1970/71) and in Ecuador (General Guillermo Rodríguez Lara in 1972). Rodríguez Lara announced an agrarian reform; it was only partially implemented. But he also procured the construction of highways, roads and electrification networks, and created state enterprises in the petroleum and petrochemical sector. Ecuador became a member of the Organization of the Petroleum Exporting Countries (OPEC). Bolivian president Torres was less lucky;

he was quickly removed from power. Exiled in Argentina, he was murdered in 1976. Peruvian president Velasco was ousted by a coup in 1975 and was succeeded by a more conservative military team. Rodríguez Lara shared the same fate and held power until 1976, when conservative officers ended this reform period. In retirement, several of the reformist military founded an NGO for progressive officers in retirement, the Organización de Militares para la Democracia, la Integración de América Latina y el Caribe (ORMIDELAC, Organization of Military Officers in favour of Democracy and Integration of Latin America and the Caribbean). In the mid-1990s its president was the Venezuelan Comandante (Lieutenant Colonel) Hugo Chávez.[39]

Chile[40]

The most important political change in Latin America took place in Chile. In September 1970 a candidate of the leftist coalition Unidad Popular (UP, Popular Unity), Salvador Allende, won the presidential elections. He re-established diplomatic relations with Cuba, severing the political OAS cordon sanitaire. His electoral triumph also signified the potential for a peaceful and democratic transition to socialism, an astonishing event in the region. During many trips to the island, Allende had cemented an enduring personal friendship with Fidel Castro. On one of these trips Allende's daughter Beatriz had fallen in love with Luis Fernandez Oña, one of Piñeiro's officials at the Chile desk.[41] Beatriz was a member of the Chilean branch of Guevara's Ejército de Liberación Nacional (ELN, National Liberation Army) and Allende had personally accompanied the three Cuban ELN survivors on their way home. Immediately after Allende's victory, Beatriz (now married to Fernandez Oña) and Allende's secretary and lover Miria Contreras visited Havana; the two were Allende's closest confidants. Suspicious about the domestic capacity to guarantee Allende's personal safety, they asked for Cuban assistance to bolster the president's security detail. Fidel and Piñeiro sent three Cuban specialists, one of them being Beatriz's husband.[42] In Cuba, Piñeiro created a special task force of twenty-one persons, headed by Ulises Estrada, to report to Fidel on a daily basis.[43]

In 1971, Fidel Castro made a long trip to Chile, Peru and Ecuador. During his 'technical stopover' in Peru he was welcomed at the airport by all Velasco's army generals. The military were clearly impressed

and the members of Velasco's inner circle began to visit Cuba.[44] After Chile and Peru, Fidel made another stop in Ecuador, where he also had dinner with the president and the military general staff.[45]

But his principal objective had been Chile. He visibly supported Allende's position within the political alliance of the Unidad Popular, made speeches across the country and explained that he had come to 'learn about the Chilean process'. But in private he also expressed his worries about the strength of the 'counter-revolutionary forces' and had told Piñeiro to prepare for the worst. He also inspected the Cuban embassy and was impressed by its defence infrastructure. He remained afraid of a military coup against Allende, by the domestic right or orchestrated by the CIA. By 1972 the situation had gradually worsened and in 1973 rumours about a possible coup by the armed forces circulated in Chile and abroad.[46] In August 1973, Ulises Estrada was sent to Santiago as second-in-command within the Cuban embassy, in charge of security and contingency plans for the defence of Allende:

Everything that we did in Chile happened with the agreement of Allende. We were instructed by the Commander-in-Chief to be of help in whatever way he would like or agree. You could not do anything in Chile unbeknownst to Allende. We trained the socialists and the communists and we provided arms to both parties. In Chile, Luis Corbalán and Carlos Altamirano, the senior leaders of the PCCh and PSCh, respectively, didn't believe in a *coup d'état*. [But Allende did.] We prepared a plan for the defence of the residence of Allende in Tomás Moro and in La Moneda [the presidential palace]: shooting positions, weapons, et cetera.

On 11 September at ten o'clock in the morning [Beatriz] Allende called. She told Luis Fernández Oña: her dad said that we not could move out of the embassy [...]. I called Samuel Riquelme [PCCh]: a coup was ongoing. He said that it was impossible. I also called Carlos Altamirano and told him the same thing. He replied: 'Ulysses, please, I am told that you are sick. Take rest. In Chile there cannot be a coup.' On the afternoon of 11 September, the military called the embassy to tell us that Allende was dead, that he had committed suicide. At that time we had already informed Fidel [on a trip in Vietnam]

about the situation. His response was: 'If they try to storm the embassy, then shout "Fatherland or Death [*Patria o Muerte*] and fight to the death." [The Chilean soldiers attacked us several times. The second time] we received a hail of bullets from the house across the street from the embassy. But immediately, from the four walls of the embassy, we answered them in bursts with tracer bullets. And the Chilean soldiers went running [...].[47]

That same day, 11 September 1973, Pinochet's government broke off diplomatic relations with Cuba. Eventually, with the assistance of the Swedish ambassador, Harald Edelstam (who also took charge of safeguarding the stock of Cuban arms at the embassy), the Cubans succeeded in evacuating the embassy personnel and the refugees. Between 1973 and 1975, Estrada remained in charge of a task force to support the Chilean resistance movement. In the 1980s, Cuba tried to generate a united guerrilla movement, an umbrella organization of the MIR and the Frente Patriótico (Patriotic Front) Manuel Rodríguez (FPMR), then the armed branch of the Partido Comunista de Chile (PCCh, Chilean Communist Party).[48] The effort failed and many *guerrilleros* died. The Departamento América put considerable effort into trying to forge a unitary political front against the government of Pinochet. In 1986, the Christian Democrats, the Socialist Party and the Communist Party formed an alliance, after discussions in Cuba. The following year the FPMR and the PCCh ruptured. Cuba made a judgement of Solomon: to deal with both the PC and the FPMR. But the Departamento América told the *guerrilleros* of the FPMR about Fidel Castro's promise to the Christian Democrats that, after Pinochet's eventual demise, Cuba's relationship with the Chilean left would only be 'humanitarian'. Indeed, the Departamento América maintained good relations with the FPMR and the PC, but in 1990 it broke off all relations with the FPMR.[49]

Diplomatic relations and the left in Brazil, Argentina and Venezuela

During the 1970s, Cuba managed to resume diplomatic relations with various Latin American countries:[50] Chile (November 1970),

Peru (July 1972), Ecuador (August 1972), Panama (August 1974) and Argentina (May 1973) after the return of Perón. Venezuela reinstated its embassy in Havana in December 1974 and Colombia in March 1975. In 1977, Costa Rica resumed bilateral consular relations. Some countries suspended their bilateral relations temporarily: Colombia (1981) and Costa Rica (1981). In the 1990s and 2000s, all Latin American countries had established or renewed their diplomatic relations.

Brazil

The formal relationship with Brazil remained suspended until June 1986, after the redemocratization of the country. But even in the period of dictatorship, when General Geisel assumed the presidency of Brazil (1974–79), relations improved. Cuba's intervention in Angola and southern Africa coincided with Brazil's oil interests in that region.[51] A silent rapprochement between the countries was the result. Sergio Cervantes, already operating under the wings of Piñeiro in 1964 and as an artillery officer assisting the guerrilla in Guinea-Bissau in 1973/74, was the liaison officer for Brazil at the Departamento América from 1974 until his retirement in 2010.[52] In 1976 he made his first trip to Brazil as a member of the International Atomic Energy Agency. The Brazilian authorities knew about his status as a functionary of the Departamento América; his permission to stay in Brazil was perceived as a signal that the Brazilian government was interested in an unofficial liaison with Cuba. Between 1976 and 1985 he made eight such trips. In 1985 he went to live there with his family; in June 1986 diplomatic relations were restored.

He lived in São Paulo, warmly received by the Brazilian Jewish community. From São Paulo he travelled across Brazil. He developed a personal friendship with Lula, the labour leader at the time and later president of the country; he even stayed at his home on a regular basis. The initial contact was made by another personal friend, Dirceo, then a political exile in Cuba and later a key cabinet member during Lula's first presidential period. He also cemented relations with the Partido dos Trabalhadores (PT, Workers' Party) and all of its leaders. Cervantes remained posted in Brazil for thirteen years and was twice appointed Minister Councillor at the embassy. During the

first democratic government of President Sarney he befriended Marco Maciel, minister of education and politician of the right. When Maciel was appointed Ministro-Chefe do Gabinete Civil (prime minister), he instigated the normalization of diplomatic relations. When Maciel became the vice-president, as running mate of Fernando Henrique Cardoso (1995–2002), Cervantes' position was even more strategic. When Lula was elected president in 2003, he was invited to the presidential palace as a close friend. His ambassador, uncomfortable with a deputy with easy access to Brazil's top politicians, asked Havana to have him retire. He returned, despite Lula's efforts to convince Fidel to let him stay.

Argentina[53]

With the emergence of Peronism as a political movement and party – the Partido Justicialista – social reformism was an important ingredient; it attracted both the labour unions and reform-minded youth movements, the so-called Peronist left. During the two decades of Perón's exile after a military overthrow (1955–73), two segments of what later became the Argentinian armed left arose.[54] The first, the Montoneros, was the heir of the Peronist left. Leading members of the Montoneros were influenced by Liberation Theology and the *Cristianismo y Revolución* journal.[55] In 1970 the Montoneros launched themselves into the public eye with the execution of General Pedro Eugenio Aramburú, the leader of the coup that had deposed Peróon in 1955.[56] In 1973 they merged with another small insurgent group, the FAR (Fuerzas Armadas Revolucionarias, Revolutionary Armed Forces), former members of the Communist Youth who had received military training in Cuba.[57] The Montoneros had a knack for public relations. They organized rallies for the return of Perón; the participants jumped from 5,000 to 100,000 in the early 1970s.[58] The second armed insurgency was the Ejército Revolucionario del Pueblo (Revolutionary People's Army, ERP), with many members of Trotskyist background and some others inspired by Che Guevara.[59] From the outset the ERP launched actions that were targeted against foreign company managers and government officials, especially military officers.

In 1973 Perón's deputy, Héctor Cámpora, was elected president. Soon thereafter he abdicated in favour of Perón; his (third) wife Isabel became vice-president. The same day Argentina and Cuba resumed

diplomatic relations. Ravelo, representative of the Departamento América, was the liaison with the ERP, the Partido Comunista de Argentina (Argentinian Communist Party, PCA) and the Montoneros.[60] Perón's government was informed. The Montoneros reduced their attacks against the military; the ERP continued kidnapping 'class enemies' and assaulting military officers. Repeatedly, the Cuban embassy members tried to convince the ERP leaders to cease or at least reduce the number of assassinations of (former) military officers, expressing their fear of a military takeover. They also tried – in vain – to contribute to mutual cooperation between the two guerrilla movements. But they were walking a tightrope: 'Despite the efforts we made, a dialogue and a unity among the PRT-ERP and the Montoneros was impossible. Most of the cadres of the ERP had a Trotskyist background. They were irascibly anti-Peronists. The Montoneros ranged from those who blindly believed in Perón to others who, despite being critical, were supporters of Perón.'[61]

After Perón's death, Isabel Perón assumed the presidency from July 1974 to 24 March 1976; she was ousted by a military coup. But the Peronist left (and the ERP) was also persecuted from within the presidential palace. Isabel's trusted friend and secretary José López Rega, who managed the cabinet, was also in charge of the feared death squad Alianza Argentina Anti-Comunista (AAA, Argentinian Anti-Communist Alliance). During Isabel's government, Argentina was the theatre of an 'intra-Peronist civil war'.[62] The ERP and the Montoneros resumed their armed operation on a much larger scale. Their support increased; by the end of 1974 the Montoneros had 10,000 sympathizers and had created 'military networks' across the country.[63] A year later the ERP admitted to being 5,400 members strong.[64] Both organizations could spend money. The ERP kidnapped selectively and once it requested (and got) a ransom of 12 million dollars. The Montoneros once received a ransom of 60 million dollars after kidnapping two entrepreneurs, the Bunge brothers. At least once, at the request of the Montoneros, Cuban agents transported a coffin with a million dollars in it to Paris. It is probable that they deposited part of their revenues on the island. The Montoneros launched three 'tactical military offensives' between

1974 and 1976. In one of these campaigns they occupied – momentarily – Córdoba, Argentina's second-largest city.[65]

Then the military staged a coup in 1976; they intensified the counter-insurgency campaign by means of a dirty war directed against the armed left and all suspected sympathizers, using disappearances and large-scale torture. In a series of brutal counter-insurgency operations they downsized the guerrilla considerably: not in open armed confrontations, but by using torture centres, concentration camps, abductions and murder.[66] In armed engagements, the military proved capable of disposing of better-prepared special forces, even fighting against the heroically opposing guerrilla units. But the indiscriminate kidnapping and the eventual 'confessions' and information gained under torture stripped the Montoneros of their infrastructure, their safe houses and their support bases. The ERP also lost many victims during direct engagements. Amazingly, the military did not break off its relations with Cuba.[67]

The two guerrillas slowly entered into decline. They relocated part of their funds and weaponry to Havana. They appeared, sometimes in uniform, in third-party countries and at international conferences. In 1979, a Montonero paraded in battle dress alongside the victorious Sandinista guerrilla in Managua. In 1980, a larger detachment undertook a risky return to Argentina. Military intelligence had already collected information about weapon depots and their locations.[68] They lay in wait for the incoming *guerrilleros*; it ended in disaster as the movement slowly faded away, as did the ERP. It did not disappear completely; a veteran ERP commando killed Nicaragua's dictator in 1980, then an exile in Stroessner's Paraguay. Montoneros chief leader Firmenich kept a low profile in Havana.[69] The Cuban embassy in Buenos Aires provided discreet assistance with his correspondence in Argentina. In December 1983, the dictatorship ended and elected president Alfonsín took office. Trying to return, Firmenich was arrested in Brazil, extradited and sentenced to thirty years in prison. But under President Menem he received an amnesty in 1996.[70]

Tony López, representative of the Departamento América in Argentina from 1987 to 1995, continued to liaise with the Communist Party, the Montoneros, the ERP and the new movements of the left. From Buenos Aires he monitored oppositional organizations and political

parties working against Chile's President Pinochet and Paraguay's President Stroessner.[71] He also maintained a good relationship with the chief of the Argentinian Servicio de Inteligencia del Estado (SIDE, National Intelligence Service). The SIDE chief asked him once for Cuba's assistance: the Gendarmerie had arrested a Chilean MIR leader while he was crossing the Chilean–Argentinian border. President Alfonsín did not want to extradite the captured guerrilla leader to Pinochet's Chile. Would Cuba receive the prisoner? Havana said yes, saved a guerrilla leader and improved its relationship with the Argentinian president.

Colombia

Diplomatic relations with Colombia had been resumed in March 1975 but were suspended in March 1981. This period coincided with the last half of the presidency of López Michelsen and the first half of that of Turbay. The improved relationship with López Michelsen had been initiated by Norberto Hernández, stationed in Panama and supported by General Torrijos.[72] Ravelo, stationed in Buenos Aires, was appointed ambassador in Bogotá. One of his first delicate tasks was to inform the Columbian president that Pablo Vásquez, leader of the ELN, was living in Havana and was receiving medical treatment there. Then he had to explain to the new Colombian ELN leadership, which was slowly rebuilding the organization, that 'Cuba, given the new circumstances, could not continue supporting [them] like in the previous years'.[73] The Movimiento 19 de Abril (M-19, Movement of 19 April), a new guerrilla movement conducting spectacular urban activities, had already been created but there were 'neither contacts nor arrangements' with Cuba.[74]

Of all guerrilla movements, M-19 attracted most of the public's sympathy. They were known for spectacular Robin Hood-like activities – assistance to the population of poor urban neighbourhoods – and for raids on supermarkets and distributing food among the poor.[75] In February 1980, M-19 stormed the embassy of the Dominican Republic during a reception, taking many diplomats – among them the ambassador of the United States and other ambassadors – as hostages. Cuban ambassador Ravelo negotiated among the Colombian government, the guerrillas and the Latin American missions to reach

an agreement without further victims. Eventually, in April 1980, the Colombian authorities granted permission to a Cuban plane that transported the M-19 assault team, the Latin American diplomats and the representatives of the guaranteeing third parties to Havana.[76] In Cuba, the M-19 team was free to move. They were joined by new recruits, and forty to fifty M-19 members received military training in Cuba.[77] But when a group of 150 M-19 *guerrilleros* disembarked in southern Colombia in early 1981, President Turbay suspended Colombia's relations with Cuba.

The suspension of formal relations facilitated more clandestine Cuban contact with the Colombian guerrilla movements, and the M-19 in particular.[78] Other Colombian guerrilla movements, such as the Ejército de Liberación Nacional (ELN, National Liberation Army), the Ejército Popular de Liberación (EPL, Popular Liberation Army) and the Partido Revolucionario de los Trabajadores (PRT, Revolutionary Workers' Party), also visited Cuba.[79] Contacts with the Fuerzas Armadas Revolucionarias de Colombia (FARC) were initiated as well. Hernández, appointed vice-chief of the Departamento América in 1980, and overseeing relations with Ecuador, Colombia and Venezuela, points out:

In Colombia, we had plentiful relations with the M-19 [...]. We initiated direct contact with the FARC [Fuerzas Armadas Revolucionarias de Colombia]. We also had relations with the Colombian Communist Party. Its general secretary, Gilberto Viera, visited Cuba several times. But we also maintained very good relations with López Michelsen [...]. Despite the fact that both belonged to the Liberal Party, López told us that it was a great mistake to have [suspended relations] with Cuba.[80]

In 1982, M-19 kidnapped family members of the leaders of emerging drug cartels. That instigated cartel leaders, rich landowners and entrepreneurs to form the Muerte a Secuestradores (MAS, Death to Kidnappers), paramilitary units to attack the guerrillas. It was the forerunner to many regional counter-guerrilla forces of the right that were unified into the Autodefensas Unidas de Colombia (AUC, United Self-Defence Forces of Colombia) in 1997.[81]

During the consecutive governments of Presidents Belisario Betancourt (1982–86) and Virgilio Barco (1986–90), several efforts at peace agreements with the guerrilla movements were conducted. In 1985, as a consequence of the negotiations with the FARC, a political movement – the Unión Patriótica (UP, Patriotic Union) – was created to facilitate the peaceful participation of the armed left in the national political arena. The UP participated in elections and gained national members of parliament. But the systematic assassination of UP members by paramilitary forces was so immense that the CNMH report (2013: 28) labelled it the 'genocide of the Unión Patriótica'.[82] The possibilities for peace were complicated even further by the M-19's siege of the Palace of Justice in November 1985. Army troops stormed the building and more than one hundred people were killed, including twelve of the twenty-five Supreme Court justices.

Still, the government and the various guerrilla movements resumed peace dialogues. In May 1985, all movements – with the exception of the FARC – had formed the Coordinadora Nacional Guerrillera (CNG, National Guerrilla Coordination); in May 1987 the FARC joined. In September 1987 a unifying Coordinadora Guerrillera Simón Bolívar (CGSB) was created; it lasted for three years. Enrique Flores, one of the delegates of the participating Partido Revolucionario de los Trabajadores (PRT), remembers:

After the failure of the peace process [in 1985] a new reunification follows. And this time, the M-19, FARC, [the ELN], the EPL, the PRT and the Quintín Lame [an indigenous movement] participated in the CGSB. The *Comandancias* [commanding officers of each organization] discussed a unified strategy and a unitary strategic plan. Then [we] went on an international tour and the Coordinating Committee met in Cuba, supported by the Departamento América; they had always encouraged us to create the Coordinadora. We all went to Cuba where Barbarroja [Piñeiro] assisted in unifying forces. They presented us with the Salvadorean example. We came together to discuss the unification with the Salvadoreans, with the FMLN.[83]

Of all guerrilla forces, M-19 was most inclined to pursue the peace negotiations. According to their Cuban liaison at the Departamento América, another reason for the political solution to the armed conflict was M-19's deteriorating economic situation:

> The M-19 never succeeded in self-financing. During those years, the sources of foreign aid dried up and the acquisition of new weapons and equipment was complicated for them. At that moment, Comandante Carlos Pizarro came to Cuba to ask for help. [But by the end of the 1980s,] Cuba's austerity period, the 'Período Especial', had begun. Fidel told him that he should pursue a negotiated political solution. In his view, at that moment there were very few possibilities for a politico-military organization to come to power by means of weapons, as had [once] happened in Cuba and Nicaragua.[84]

When the other guerrilla movements still doubted the wisdom of formal peace agreements, the M-19 unilaterally announced that they would sign the covenant; the smaller movements joined. In November 1989 they signed the *Pacto Político por la Paz y la Democracia* (Political Pact for Peace and Democracy). A direct consequence of the peace agreement was the convocation of a Constituent Assembly in 1991, which drafted a new, progressive constitution. In 1991, during the presidency of César Gaviria, diplomatic relations with Cuba were normalized.

Many of the demobilized guerrilla members were murdered; one of them was Carlos Pizarro – the last M-19 *comandante*, presidential candidate of the Alianza Democrática, and forerunner to the Colombian parliamentary left of the present. In that same year, 1990, two other presidential candidates were murdered. During the final negotiations, the ELN and the FARC had left the Coordinadora and decided to continue fighting. The two oldest guerrilla movements, one 'guevarist' and the other communist, participated in peace negotiations several times throughout the 1990s and 2000s. Not one of the various and sometimes protracted efforts ended in a political solution. In the mid-2000s, the ELN was engaged in peace negotiations with Colombian government representatives in Havana and in 2012

the FARC started an uninterrupted series of negotiations with the Colombian government. I will return to these negotiations in Chapter 6.

Venezuela

Diplomatic relations had been broken off in 1961 but had been resumed in December 1974, during the first presidential period of Carlos Andrés Pérez (1974–79). While visiting the Soviet Union, he negotiated a covenant on the triangulation of oil delivery to Cuba with Brezhnev ('firm, solid, clear') and Kosygin ('brilliant, intelligent'):

> The Soviets were grateful for my renewed diplomatic relations with Cuba. They assured me that they wanted Cuba incorporated into the Latin American world. Alexei Kosygin told me that Cuba cost them dearly. They didn't have any interest in deepening the gap between Cuba, the United States and Latin America [...]. They assured me that they wouldn't allow the expansion of Fidel Castro. They had settlements impeding Castro from using Soviet weaponry without permission from Moscow. I bluntly replied that Cubans didn't sell them, but used them in other countries.[85]

Fidel appointed a veteran of the Departamento América, Norberto Hernández, as ambassador. When he was instructed at MINREX, they told him:

> 'You are no longer a member of the Departamento América, nor of the MININT. You are now an official of the MINREX.' Therefore, I positioned at the embassy in Venezuela the colleagues who completely enjoyed my personal confidence. Some of them came from the Dirección General de Liberación Nacional or the Departamento América. Because in my heart I felt the need to support the revolutionary movements, including those in Venezuela, although at that moment they were passing through a profound crisis.[86]

In fact, his core embassy team came from the MININT and the Departamento América. Relations with the Venezuelan guerrilla

were virtually non-existent. After the disaster of Machurucuto and the expedition and rescue of the Ochoa team (see Chapter 4), the armed left was in disarray. There were some smaller clandestine organizations operating and the Cuban embassy maintained discreet contact with them. Relations with the Communist Party were icy. When embassy functionaries visited its secretary general, Jesus Farias, he told them: 'Unfortunately, I cannot do anything for you.' Later, relations improved. The Party was seriously debilitated: a new organization, Movimiento al Socialismo (MAS, Movement for Socialism), had left the Party and 'nearly all the revolutionary intelligentsia had gone with them'. A second split produced Vanguardia Revolucionaria (Revolutionary Vanguard), headed by Guillermo García, the former military chief of the Communist Party. The embassy maintained fluid relationships with both the MAS and Vanguardia, as well as with the Movimiento de Izquierda Revolucionaria (MIR) and the Movimiento Electoral del Pueblo (MEP, Electoral Movement of the People), two leftist movements that had left the youth wing of the social democratic government party Acción Democrática (Democratic Action). The embassy also actively dealt with the Latin America evacuee diaspora in Venezuela: refugees from Chile, Uruguay, Argentina and Paraguay.[87]

In general, Venezuelan relations with Cuba were decent, also with respect to the war in Nicaragua. In the late 1970s, President Carlos Andrés Pérez supported the Sandinista rebels with funds, albeit basically via the individual Eden Pastora, considered to be a social democrat. He also offered air support to the Costa Rican president Carazo when Nicaragua's dictator Somoza threatened to attack his neighbour country. Venezuela also transported arms via Panama.[88]

In 1979, when Luis Herrera Campins became president, relations with Cuba cooled off and the new government preferred friendly relations with the United States. Ambassador Hernández received instructions from Havana to 'return for consultation' and the diplomatic relations between the two countries were lowered to the level of chargés d'affaires. In February 1989, at the very beginning of the second presidential term of Carlos Andrés Pérez, the Venezuelan president asked Fidel for Hernández's return as ambassador.[89] The Cuban embassy had developed cautious contacts with new emerging

leftist groups and they had perceived a growing discontent within the military. In 1992 Lieutenant Colonel Hugo Chávez, leader of a group of rebellious officers, staged a coup. But loyal army officers in Caracas put the president in the boot of a car and brought him to a TV station. From there he ordered a nationwide transmission by TV, won over the military in Caracas and prevented other military units from joining the rebels. Chávez was condemned to prison but was granted amnesty in 1994. Cuban ambassador Hernández spoke with him for only a few minutes during a farewell lunch a couple of days after Chávez's release. But other members of the Departamento América developed a more confidential relationship with Chávez in the years thereafter. The growing friendship between Hugo Chávez and Fidel Castro is a theme in the next chapter (Chapter 6).

Revolutionary friends in the Caribbean

The ethnic and thus political configuration of many Caribbean states is a legacy of slavery, its long period of abolition, and the immigration of contract labourers at the end of the nineteenth century. In 1804 the former French colony Saint-Dominique declared itself the independent Republic of Haiti after defeating a French invasion army. The British abolished slavery in 1833 in their colonies and the French in 1848.[90] The Dutch abolished slavery in their East (Indonesia) and West Indies (Surinam, the Dutch Antilles) colonies in 1863, the same year that Abraham Lincoln declared all American slaves free. Colonial Cuba (1886) and independent Brazil (1888) were the last two territories in the western hemisphere where slavery was banned. The abolition of slavery in the Greater Caribbean saw the arrival of indentured labour from the British and Dutch East Indies. It created a significant Indo-Caribbean labour force, especially in Guyana and Trinidad and Tobago, and a Javanese- and Indo-Caribbean labour force in Surinam that became numerically larger than the Afro-Caribbean population segment.

In the second half of the twentieth century, Cuba's foreign policy in Latin America was based on its perceived revolutionary mission. But it has a special affinity with the Caribbean island states.[91] There is certainly a kind of 'Caribbeanism' that makes personal relations easy,

despite linguistic differences.[92] The English-speaking independent or recently independent states were sympathetic to Cuba: Barbados, Guyana, Jamaica and Trinidad and Tobago took the collective decision to inaugurate diplomatic relations with the country in December 1972. The Bahamas followed in 1974, Grenada in April 1979, (Dutch-speaking) Surinam in May 1979, and Santa Lucia in August 1979. In the 1990s, San Vicente and Nevis, Antigua and Barbuda, San Cristobal and Nevis, and Dominica did the same. Relations with the Association of Caribbean States (ACS), in which islands and territories with American, English, French and Dutch statehood also participate, were fluid. The two republics of the former Hispaniola, both governed by dictators who had suspended (Haiti) or ruptured (Dominican Republic) their diplomatic relations, normalized their relations in 1966 (Haiti) and 1998 (Dominican Republic).[93]

In the 1970s and 1980s, Cuba had a special relationship with Guyana (Cheddi Jagan), Jamaica (Michael Manley),[94] Barbados (Maurice Bishop) and Surinam (Desi Bouterse). Three of these recently independent states were former British colonies. The Dutch colonies were granted autonomy and in 1954 Surinam and the six islands of the Netherlands Antilles became 'countries' within the Kingdom of the Netherlands. Surinam opted for independence in 1975 and the Netherlands Antilles chose to preserve formal ties with the Dutch.[95]

Guyana

Cuban relations with Guayana go back as early as the 1960s, when the country was still a British colony. As was the case with its neighbour, Surinam, ethnicity more than ideology played a dominant role in colonial and post-colonial politics. The two main ethnic population segments are the descendants of former Indo- (East Indian) Guyanese labour migrants and former Afro-Guyanese black slaves. In 1950 the British granted self-rule to the colony. In 1953, the multi-ethnic People's Progressive Party (PPP) – founded by Cheddi and Janet Jagan and Forbes Burnham – formed the first self-rule government with a radical reform plan. The British sent troops 'to prevent a Marxist revolution'.[96] The PPP was removed from office and a conservative 'interim government' of businessmen took over. The PPP split in 1955: Cheddi and Janet Jagan, husband and wife, remained the

leaders of the (rural Indo-Guyanese) PPP and Burnham founded the (urban Afro-Guyanese) People's National Congress (PNC). A third, middle-class-oriented party, United Forces (UF), regularly made a coalition with the PNC. The PPP took a course to the political far left; the PNC professed itself 'moderate socialist'. In 1966 the country was granted independence.

The Jagans never hid their sympathies for Cuba. In 1961 the PPP won the elections; Cheddi Jagan became prime minister. He asked the Cuban government to open a liaison office; Osvaldo Cárdenas was appointed office chief. When Cárdenas departed, Che Guevara told him that Cuba owed a debt to Guyana and especially to Cheddi Jagan. He had been the only head of government in Latin America to offer assistance during the Bay of Pigs crisis, even while Guyana was still a colony with self-rule. But quickly Jagan was confronted by a destabilization campaign conducted by the PNC and UF, probably with American support. Riots, demonstrations and disturbances were the order of the day in 1962 and 1963; organized strikes threatened to paralyse the country by cutting electricity provision and impeding food deliveries. Now, in despair, Jagan asked his friend Fidel Castro for a helping hand. Castro sent two ships, one of them with fuel and the only tanker that Cuba had at the time. The situation calmed down. After the elections of 1964 the PNC and UF formed a majority coalition and Forbes Burnham became PM; Cuba decided to close the office.[97]

In 1972, Cárdenas, then chief of the Caribbean Section of the Departamento América, visited Guyana again for a preparatory conference for an NO-AL summit. Burnham received him as a good friend. Cárdenas was instructed to make a démarche regarding the possibility of formal relations. Burnham told him that, yes, that was a good idea but that it would be more convenient to do it as a collective, as the Community of the Caribbean (Barbados, Guyana, Jamaica and Trinidad and Tobago). He was as good as his word and the four countries established relations with Cuba together.

In September 1973, Castro had a meeting with the four Caribbean heads of government: Errol Barrow of Barbados, Forbes Burnham of Guyana, Michael Manley of Jamaica and Eric Williams of Trinidad and Tobago, in Port-of-Spain. In addition, he travelled together with Burnham and Manley to the NO-AL summit in Algiers. When Burnham

returned to Guyana, Cuba sent an ambassador who became friends with Burnham. Ulises Estrada, Piñeiro's deputy at the Departamento América, visited the country every two or three weeks, also in order to facilitate relations between the Jagans and Burnham.[98]

Jamaica[99]

Norman Manley, founder of the social democratic People's National Party (PNP) and prime minister, guided his country towards independence, but lost the elections just before Independence Day. In 1969, his son Michael Manley succeeded his father as leader of the PNP and won the elections in 1972. He initiated a social reform programme of minimum wages, union rights, literacy programmes and an agrarian reform. Cuba cautiously sent emissaries.[100] He met Fidel Castro in 1973 in Port-of-Spain. In September 1974 he made an unofficial trip to Cuba; the year after he officially visited the island. Fidel made the official return trip in 1977, where he was received by a multitude of 100,000.[101] Cuba sent school construction and medical brigades as well as fish and aviculture experts to Jamaica. With 900 Cuban civilians present, the country was the second-most privileged country in terms of civilian *internacionalistas* after Angola at that moment.[102] Both the personal friendship between Castro and Manley and the Cuban–Jamaican collaboration intensified.

But an oppositional movement (headed by Edward Seaga) won ground. In 1979, Castro sent trusted Ulises Estrada as ambassador to Jamaica. When he arrived, the political opposition, assisted by the CIA, started a smear campaign against him, the beginning of an extremely violent crusade against Manley and his Cuban friends.[103] In 1980, when 800 Jamaicans were killed in acts of political violence, Seaga won the national elections; immediately afterwards Estrada was declared *persona non grata*.[104] After a period of resolved opposition, Manley became prime minister again in 1989. His second term was relatively smooth and without armed opposition. He left office owing to his fragile health and died in 1997.

Grenada

In the 1970s, Grenada was heavy-handedly governed by Sir Eric Gairy, an authoritarian politician with a labour union background

who also employed paramilitary forces. His political opponent was young lawyer Maurice Bishop, born to a migrant family in Aruba (Netherlands Antilles). After studying in London where he was radicalized, he returned to Grenada to become the co-founder of an opposition movement, the New Jewel Movement (NJM).[105] In 1974, Grenada became independent. Via members of the Afro-Caribbean Liberation Movement of Saint Vincent, Dominica and Antigua, Cuban emissaries made contact. He asked Piñeiro for military training and weapons for his supporters, but was told that 'after Angola and Ethiopia, Cuba had to be cautious'. Piñeiro put him in contact with Burnham, then president of Guyana, who provided his followers with equipment and training.[106] In March 1979, Bishop and his followers seized control of the island and proclaimed a revolutionary government that initiated Cuban-like reforms, founded mass organizations and established popular militias. His Cuban friends tried to convince him to tone down his rhetoric and present his movement as a social democratic instead of a Marxist-Leninist one. But Bishop insisted and again asked Piñeiro for support. This time Cuba sent him a ship with military equipment.[107] Ulises Estrada remembers:

[...] at Punto Cero the special forces of the MININT began to train twenty men. Given the delicacy of this mission, Comandante Abelardo Colomé 'Furry' Ibarra [a four-star general and minister of the interior from 1989 to 2015] trained them personally. The night before their departure we organized a farewell meeting. We waited for Fidel and Piñeiro; only Fidel arrived. Fidel told me that he wanted to talk in private. Bishop had sent him a [confidential] message: don't send [Ulises] or Osvaldo Cárdenas. When they had searched the archives of the Security Police, they had found a lot of information about us. 'Now Piñeiro is looking for a *compañero* that fulfils the necessary conditions, including his colour, to send him to Grenada [as ambassador].' Fidel began to talk to [the members of the special forces] and I remember that he said: 'There will be an American invasion in Grenada. I don't know if it is now, next year or later, but there will be an invasion by the marines. Grenada has a terrain that is not very favourable for guerrilla fighting. [Your] mission number

one is to explore Grenada and seek a high enough elevation
to hold out there for ten days, to get time to mobilize interna-
tional agencies and public opinion. And then we bring in our
troops. There we will toy with the Americans if they get in.' Soon
thereafter came Piñeiro with Julián Torres Rizo and Osvaldo
Cárdenas. Fidel knew him personally; he was mulatto and could
speak English very well.[108]

The American ambassador strongly advised Bishop against Cuba's
assistance but he answered that 'We are not anybody's backyard and
we are definitely not for sale'.[109] Bishop established diplomatic rela-
tions with Cuba and the Soviet Union. The first Cuban diplomats and
advisers were followed by doctors, teachers, nurses, engineers and
construction workers. With Cuban assistance a large international
airport was built. Bishop visited Cuba several times and developed
a warm friendship with Fidel. He even considered a summit of rev-
olutionary Caribbean leaders.[110] However, within the revolutionary
government a more pro-Cuba (Bishop) and a more pro-Soviet line (led
by Bernard Coard, his second-in-command) emerged, accompanied
by a bitter rivalry between the two leaders over power and pres-
tige. In October 1983, Bishop was arrested; his supporters released
him and marched to the military headquarters, where the politi-
cal hardliners were housed. The military killed Bishop and several
other leaders; it culminated in severe riots. An American detach-
ment invaded Grenada 'to restore order and democracy'.[111] Of the
Cuban soldiers ('armed construction workers'), twenty-five were
killed and more than six hundred captured. Colonel Torteló, the
highest-ranking Cuban officer, sought refuge in the Soviet embassy.
The captured officers were demoted. Torteló was degraded and he
and the other 'officers who had behaved cowardly' were sent to
Angola as common soldiers.

Surinam[112]

Neither the Dutch nor the Creole (black and mulatto) population
segment of Surinam was pleased with the colonial status of the coun-
try. The Creole political parties opted for independence. The Dutch,
concerned about the West Indian migrants and the heavy subsidies

to 'the West', wished to decolonize as rapidly as possible. In 1972, a Dutch Social Democratic member of parliament publicly declared that '[...] if they don't declare themselves independent, we send them their Act of Independence by certified mail'. In 1973, a Creole minority government took office in Surinam and they and the Dutch hastily began to negotiate.[113] The independence was sweetened by a generous development programme of 1.6 billion euros. After independence, the Surinamese minority government was no longer popular.

In the Dutch army, officers and NCOs are unionized. When the (returned) Surinamese NCOs – some of them leftists and the majority nationalists – negotiated with the government about labour conditions, the union leadership was arrested. Then their comrades, headed by Sergeant Major Desi Bouterse, staged a coup. They formed successive civil governments while Bouterse, now colonel and army commander, controlled both the army and the government. Osvaldo Cárdenas had contacted them two weeks after the coup via Guyana; he was surprised at the high standard of living at the time of independence: '[...] the secondary schools look like five-star hotels in Cuba'.[114] The Surinamese army leaders were inclined towards the left, proclaimed a revolution and sought ties with Cuba and the Sandinista government of Nicaragua. Bouterse quickly befriended Maurice Bishop and secretly visited Cuba. There he asked for support, especially on security matters. The head of his security detail and some others were trained in Cuba.[115]

The turn to the left and the preference for Caribbean revolutionaries alienated him from important population segments. In 1982, when Bishop visited Surinam, the labour unions announced a general strike and organized a massive counter-demonstration. Meanwhile, after a new visit to Cuba by Bouterse, Castro appointed Osvaldo Cárdenas as ambassador at his request. In spite of the language barrier, Cárdenas was rapidly at home with the several political splinter parties on the political left (there was even a small Albania-oriented one).[116] In December of that year, on a night of booze and drugs, the military set oppositional radio stations and editorial buildings on fire and arrested fifteen leaders of the oppositional Association for Democracy. They were summarily executed after torture. It was a social and political watershed. The traditional parties were now operating

underground and refused to negotiate with Bouterse. The Dutch suspended financial development while at the same time the global price of bauxite, Surinam's most important export product, plummeted. It is even possible that the Dutch, urged by the United States, prepared for a military intervention.

That was also the perception of the Brazilian military government. In 1983, Brazilian security chief General Venturini landed after an unannounced flight.[117] After a veiled warning about the possibility of 'unpleasant steps' on the part of the Brazilian military, Venturini offered a military and financial alliance with Brazil – instant credits to alleviate Surinam's economic crisis.[118] Bouterse agreed, a decision he justified by remarking that 'We military march left, right, left, right.' The Brazilians came in and Cárdenas was declared *persona non grata*; the embassy was closed.[119]

In 1992, when Bouterse had lost his military command and thus his political influence, Cuba and Surinam renewed their diplomatic relations.[120] But Bouterse returned to the political arena in the mid-1990s. He founded a political party with an explicitly multi-ethnic character. Skilfully reconciled with former adversaries, his party became the largest in 2010. He was elected president, and in 2015 he was re-elected. Present-day Surinam (2016) is an observer at the sessions of the group of ALBA countries, headed by Cuba and Venezuela.[121]

The Central American revolutions

In the 1970s and 1980s, Central America was the theatre of complicated civil wars; the involvement of the United States, the Soviet Union and Cuba made them sometimes appear as proxy wars.[122] Cuba was intensely committed to the wars and the peace process. Between the early 1960s and the mid-1990s, nearly all Central American guerrilla leaders visited Cuba: as exiles and for military training, for political consultations, for medical treatment, and for relaxation. Young guerrilla leaders and recruits were trained in Cuba. The Departamento América had a prominent role.[123] In the case of Nicaragua, El Salvador and Guatemala it decisively contributed to the unification of the national umbrella organizations of the various politico-military organizations.[124]

In Central America, Liberation Theology was of enormous influence. Half of the circa forty Nicaraguan *comandantes* were recruited by radicalized priests. Thousands of Comunidades Eclesiales de Base (Church Base Communities) supported the guerrilla organizations. In Guatemala the direct influence of Liberation Theology was maybe less predominant, although Jesuit and Maryknoll priests were organizing Mayan communities.[125] Several Guatemalan *guerrilleros* of the 1970s and 1980s also had religious backgrounds, especially the young intellectuals of the Maryknoll discussion groups.[126] Radical priests participated in the small guerrilla movements in Honduras as well.[127] Many young military and civilian leaders were previously engaged in the Central American student movement.[128]

Nicaragua

Three young leftist insurgents founded a rebel movement in 1961; it was named after General Sandino, who had waged a guerrilla war against invading American marines and the Somoza dictatorship in the 1930s. Its first members were mostly young Catholic students. Many Sandinistas were trained in Cuba or found a safe haven there in exile. Until the mid-1970s the Sandinistas sustained a Che Guevara-style rural *foquismo* strategy. Then the movement – Frente Sandinista de Liberación Nacional (FSLN, National Sandinista Liberation Front) – began to split into three branches; the fragmentation had both personal and ideological roots.

Fidel and Piñeiro, worried about the fragmentation, were essential to the unification of the three branches.[129] Ulises Estrada was sent to Panama and Costa Rica to convince the Central American communist parties to assist the Sandinistas in their countries.[130] A team from the Departamento América travelled on and off for six months. Joa, at the Mexican embassy, was sent to Costa Rica for an operation to clandestinely bring Humberto Ortega (Daniel's brother) to Panama, and to assist in the negotiations between the three Sandinista factions:

> It was hard to manage the existing sensitivities between the leaders of [the three branches]. It created difficulties for our country to deliver the aid that the Venezuelans sent through our channels. Piñeiro instructed me to travel to Panama, to assist

Ulises Estrada in an effort to unify the FSLN: one [group] led by Tomas Borge, the one headed by the brothers Daniel and Humberto Ortega and that of Jaime Wheelock [...] On the other hand, Cuba's coordination with the Central American revolutionary organizations and the Mexican political authorities was such that President José López Portillo was willing to provide an operational base on Mexico's territory [...] they had an airport in Chiapas that they did not use. It could be leased to the FSLN. With the exception of weapons and explosives, supplies, backpacks and food could be handed over to the Sandinistas.[131]

In February 1979, the formal unification was celebrated in Havana in a meeting between Fidel and Piñeiro, and the Sandinista leadership:

Between 1976 and 1979 the Departamento América was very important for the Sandinista movement. Fidel had a keen eye for the possibilities of a victory. [He] was enormously important. Without a doubt, he brought order in the final phase. He knew everything. He was involved in all things that mattered [...]. He spoke and we asked for his advice. We stayed at his office for hours, many hours and days after the triumph. He was decisive in the unification of the FSLN, 'he, Piñeiro and Abreu'.[132]

One of the most successful political initiatives was organizing the active support of civilian sympathizers in exile: the so-called Group of Twelve, a kind of cabinet-in-waiting. Castro had built a coalition of Costa Rican, Cuban, Panamanian and Venezuelan heads of government, providing arms to the Southern Front in Nicaragua with roughly one thousand Sandinista *guerrilleros*, headed by Humberto Ortega.[133] It was reinforced by Argentinian, Cuban-Chilean, Salvadorean, Guatemalan, Uruguayan and other Latin American insurgents: the 'International Brigade', headed by a Cuban whose *nom de guerre* was Alejandro.[134] At the same time, urban insurgency groups launched attacks against the National Guard in Managua and other cities.[135] Two female *comandantes*, Dora María Telles and Mónica Baltodano, liberated the former capital cities of León and Granada. On 19 July 1979 Somoza gave up. The Sandinista

guerrilla columns, accompanied by the Group of Twelve, entered the jubilant capital city of Managua.

Cuba immediately sent a prominent medical brigade by plane: surgery professors, hospital directors, anaesthetists, gynaecologists, neonatologists, nurses, technicians and paramedical personnel.[136] Many Nicaraguan doctors had disappeared and Managua, bombarded by Somoza's air force, was a city in ruins. The arriving Cuban staff had to clean abandoned hospitals and attended to injured *guerrilleros* and even wounded members of the National Guard who were left to their own devices. When the Sandinista government launched a literacy campaign, 2,000 Cuban teachers arrived to join the tens of thousands of Nicaraguan urban youth volunteers. In the first months, Cuban airplanes maintained a kind of airlift. During the Contra war (1983–89) Cuba sent six flights per day with equipment and arms.[137] Even up to the end of the 1980s, Cuban pilots flew the military and civilian airplanes to distant regional centres. Army matters were negotiated with Humberto Ortega (minister of defence) and police, intelligence and security affairs with Tomás Borge (minister of the interior).[138] While Cuba supported many essential government institutions, Castro had explicitly forbidden involvement in Sandinista party affairs.[139]

High-ranking Cuban generals were sent in to transform the *comandantes* and other officers of the guerrilla columns into military commanders and strategists. Cubans trained the General Staff and regional commanders, acted as advisers at the military schools, and accompanied the Nicaraguan brigades.[140] Officers were also trained in Cuba by the hundreds when the Contra war began and the counter-revolutionary fighters, trained and equipped in Honduras – first by the Argentinians and then by the CIA – acquired superiority.[141] The Sandinista People's Army (Ejército Popular Sandinista, EPS) eventually won the war, but at the cost of economic and military attrition and electoral defeat in 1990.

The Nicaraguan Ministry of the Interior (MINTER) was, in a certain sense, 'adopted' by the Cuban MININT. At MINTER, Cuba's Director General of State Security, Fabian Escalante Font, became Borge's general adviser. Intelligence and counter-intelligence were to a certain degree handled by the Cubans. Nicaraguan *comandante* Lenin

Cerna, Daniel Ortega's cellmate during his prison years under the Somoza regime, was Borge's vice-minister in charge of security.[142] But Escalante was a recognized expert, on and off in Havana and in Managua; his deputy, General Ramiro Mayans, stayed in Managua while Escalante personally advised the brigade commanders of the Sandinista Army and the Special Troops of the MINTER. Furthermore, Ramón Montero, a Cuban officer made a Nicaraguan *comandante*, headed the foreign intelligence and the counter-intelligence office in Managua, operating directly under Lenin Cerna.[143] Cuban support to MINTER was sustained during the entire period of the Sandinista government (1979–90).

El Salvador

For many decades military dictators persecuted 'communists': leaders of the trade union and peasant organizations, journalists, intellectuals and even priests. The Partido Comunista de El Salvador (PCES, Communist Party of El Salvador) was a clandestine, albeit beaten organization. In 1970, Salvador Cayetano Carpio (Comandante Marcial), secretary general of the PCES, decided to leave the party with members of the Communist Youth and young students with a Catholic upbringing.[144] His rebel movement, the Fuerzas Populares de Liberación Nacional (People's National Liberation Forces) Farabundo Martí (FPL), was named after a communist leader who had headed a peasant insurgency in the 1930s. The FPL students brought him into contact with their Liberation Theology tutors and the student organizations at the university.

The FPL was organized into a military and a civilian wing (labour unions and peasant organizations). In the years to come three other organizations with a comparable structure were formed, initially tiny politico-military organizations but with growing memberships. The FPL was largest with roughly 80 per cent of the membership of all insurgent organizations. The second one in importance and membership was the militaristic Ejército Revolucionario del Pueblo (People's Revolutionary Army) of Joaquín Villalobos. Dogmatism and personal antagonism produced a continuous atomization of the Salvadorean insurgent movements during the entire decade of the 1970s. Marcial's orthodoxy about the 'prolonged popular struggle', in discussions with

an irritated Fidel Castro, revealed the latter's view that: 'If we in the Sierra Maestra would have dedicated ten per cent of what you are discussing about, we would still be sitting high in the mountains.'[145]

His orthodoxy led him to paranoia. In 1983 his second-in-command Ana Maria (*nom de guerre* of Mélida Araya Montes) was murdered in Managua, after a dispute with Marcial about the necessity of political negotiations (an option favoured by Ana Maria). Nicaraguan intelligence arrested the attackers and they confessed to having acted at Marcial's instigation. The Nicaraguans left it to the FMLN leadership to resolve the situation. Confronted with the evidence by his comrades, Marcial committed suicide.[146] His successor was Salvador Sánchez Cerén, present-day (2016) president of El Salvador.

As in Nicaragua, Fidel and Piñeiro strongly insisted on the necessity of a Salvadorean umbrella organization. In early 1980, at the outbreak of the civil war, four politico-military organizations reached an 'epidermic unity', to use the euphemistic terminology of one of the principal Cuban negotiators.[147] The incorporation of the fifth and smallest group – the guerrilla of the Communist Party, headed by Schafik Handal – kept the Cuban negotiators busy for the rest of that year. Until the end of the war in 1992, Schafik Handal handled the day-to-day affairs at the FMLN office in Managua. Handal had many good friends in Cuba. Tomás Borge at the Nicaraguan MINTER also befriended Handal, whereas the Nicaraguan military preferred Villalobos. The Departamento América had a guiding principle to treat the five Salvadorean insurgent organizations as equals; but '[...] we took into consideration the capacity of every one [...]. We had magnificent relations with Schafik Handal, but we always comprehended that the FPL had a stronger military strength, so they received more assistance. It also helped that they operated in zones closer to Nicaragua.'[148]

During the war years, the FMLN and Cuba maintained warm relations. The FMLN did not depend only on Cuba's assistance. It raised war taxes and it could rely on gifts from the western European, Canadian, American and Mexican solidarity committees, and of course on the sustained support of the Sandinista government during the entire decade of the 1980s. From Managua, the Cuban-Nicaraguan *comandante* Ramón Montero arranged the logistics of transport and weapon delivery. But the relationship with Cuba was special owing

to its unrestricted medical support for the wounded and crippled. Cuba trained new recruits and provided military training to guerrilla officers (especially in the field of artillery) when the guerrilla units in the mid-1980s reached the strength of military battalions. The Salvadorean leadership had a kind of father–son relationship with Fidel Castro, whose advice was sought on decisive matters. The respect for Fidel was such that in 1988 and 1989, during the preparations for the final offensive on San Salvador, the five members of the FMLN leadership presented their war plans to Castro and discussed them.[149]

Cuba's involvement in the war can be illustrated by the experiences of two guerrilla officers, one a (female) Cuban-Chilean army lieutenant and the other a (male) Salvadorean artillery officer, afterwards the FPL representative on the island. Fedora Lagos, a member of the Chilean Communist Youth, was exiled with her parents and brother after Pinochet's coup in 1973 – first to Romania and later to Cuba. Her brother died while participating in the Nicaraguan guerrilla. She also opted for a military career and graduated as an army lieutenant and radio-communications engineer. In 1986, she taught communications to the Sandinista officers in Nicaragua. But at the request of Schafik Handal she was transferred to El Salvador, where the FMLN urgently needed a communications specialist at Radio Farabundo Martí. There she was known as the 'Cuban lieutenant'. At the same time, she attended a guerrilla school for children and orphans – future guerrilla members. Her most dramatic memory of the war was the death of some of these children:

> The Salvadorean army had offered sweets and coffee to children who visited relatives in neighbouring villages in exchange for information about the guerrilla encampment. [The army at the time had assaulted and killed many *guerrilleros*.] There were children who had to be interrogated and sanctioned. That means killing a child of twelve, thirteen years. It was an absolute disaster. Some of them were children of my school. I had to speak with them. I said that they were children but they told me: 'No, they aren't children any more, they are combatants.' With a lump in my throat I couldn't speak, [the children] spoke to me. They said to me: 'We know that they are going to kill

us, but please tell them that we will never do it again. We don't want to die.' Then my favourite girl, fourteen years old, gave me a kiss on my forehead and said: 'The only thing they gave us was a sugar bag and three coffee packages. And therefore I have to die.' How can you kill children of eleven, twelve, thirteen and fourteen years who sold themselves for coffee and sugar because they were hungry? There were months that we didn't have anything to eat; we ate roots, lizards, snakes, iguanas [...]. 'I am not bad,' she told me. For sure, they weren't bad, but through their fault an entire squad was killed. That is the war. [Question:] 'Were they shot?' [Answer, in tears:] No, they couldn't waste bullets.[150]

In 1979, Jorge Juárez joined the FPL at the age of seventeen. He participated in the first offensive in 1981 in Santa Ana. In 1984, he was sent to Cuba for artillery training with the special forces of the MININT. Upon his return he joined a mortar and machine-gun unit of a FPL battalion, as military instructor. As with all other FMLN trainees, his life history and motivation were recorded on video by the Cubans: 'In Cuba all things are registered and guarded.' After the restructuring within the FPL, from large battalion-size units to smaller units, he became chief of a peloton. Wounded in a mine-field, he was sent to Cuba for convalescence. There he was appointed co-administrator of an encampment of wounded FMLN members:

It is surprising, but nobody wrote a study about the enormous efforts of the Cubans to attend to the many injured of the wars in Central America. Nearly all patients received literacy courses, primary or secondary education as well; the blind were trained in Braille. It was probably the most important contribution of Cuba to the combatants of Central America.[151]

He returned to El Salvador to participate in the second offensive, in 1989. As chief of a peloton of young, inexperienced recruits (fourteen, fifteen to twenty years old), he was severely wounded, and was left for dead. He was saved by a retreating unit commanded by a friend. Sent to Cuba, to the same encampment that he had recently left, it

took him three years to convalesce. He attended university courses and graduated in history in Cuba, serving as the FPL representative in Havana. After the peace agreements in 1992, the FMLN reduced its infrastructure in Cuba. He maintained contact with the Departamento América. But after the war, they seemed somewhat uncomfortable with his presence; his former counterparts always pretended to have another appointment. When Sánchez Cerén visited Cuba, he also became aware that within the FMLN things had changed, that there was an ongoing power struggle. He gradually began to maintain some distance and upon his return to El Salvador he decided to move into academia instead of being immersed in politics.[152]

Three of the five 'historical leaders' silently left the FMLN when it was reorganized as a political party. Eventually, the cadres of the Communist Party acquired the upper hand within the new party structures. The party lost three successive presidential elections, but its electoral attraction gradually increased. Schafik Handal became the undisputed party leader and, with him, orthodoxy became the dominant ideological line. After his death in 2006, a museum and a memorial monument were built.[153] The memorial is a pantheon to three revolutionary heroes: Handal (above), Farabundo Martí and Archbishop Romero (below). His successor, Sánchez Cerén, served as vice-president in 2009 and won the presidential elections in 2014.[154]

Guatemala

After the fiasco of the guerrilla in the 1960s, the Guatemalan army had discovered reports of the guerrilla leaders that admitted their failure. Guatemala was declared insurgency-free. Colonel Arana, chief of the counter-insurgency operations, was promoted to general and sent as ambassador to the Somoza dictatorship in Nicaragua. With his support he participated in the elections of 1970 and became president. With only one exception, from 1954 to 1985, all presidents, elected or fraudulent were generals, and all political parties sought a general as their presidential candidate.

The guerrilla had disappeared but had not disbanded. In exile in Mexico and Cuba, the Fuerzas Armadas Rebeldes (FAR, Rebel Armed Forces) split into three movements: the EGP (Ejército Guerrillero de los Pobres, Guerrilla Army of the Poor), headed by Che Guevara's old

friend Ricardo Ramírez de León (*nom de guerre* Rolando Morán); the ORPA (Organización del Pueblo en Armas, People's Armed Organization) under the command of Rodrigo Asturias (*nom de guerre* Gaspar Ilóm); and the remaining FAR, directed by Pablo Monsanto (*nom de guerre* of Jorge Soto). They were joined by a small detachment of the PGT (Partido Guatemalteco de Trabajadores, Guatemalan Workers' Party, the Communist Party) under Ricardo Rosales (*nom de guerre* Carlos González). In the 1970s, these four organizations operated independently. The leaders of the EGP, the FAR and the ORPA had an antagonistic relationship; Rolando Morán was in a certain sense the accepted *primus inter pares*. Rosales was in fact the odd man out, commanding an insignificant number of combatants.

It was perceived that the Cuban leadership had a preference for the EGP. The first sixteen combatants were trained in Cuba and many recruits also received their military instruction there. The EGP was the largest insurgent movement; it had firm roots in the indigenous region, western Guatemala. They were supported by the Comité de Unidad Campesina (Peasants' Unity Committee), a mass organization of rural workers and landless indigenous peasants that was capable of organizing tens of thousands in protest marches. The EGP created a system of Fuerzas Irregulares Locales (FIL, Local Irregular Forces) to support the guerrilla. But it had no means to equip and train the supporting Maya population in the FIL. In the late 1970s and early 1980s, when the army command organized brutal counter-insurgency campaigns, the guerrilla left the peasants defenceless. Furthermore, the army established a system of 'self-defence patrols' (Patrullas de Autodefensa Civil, PACs) wherein 1.2 million indigenous men were incorporated, of an estimated national population of 9 million persons:

> The military, often by assault during holidays, forced young indigenous men into compulsory military service, only Mayas [...]. Second, there was the system of Patrullas de Autodefensa Civil, created as a strategic response to counter the guerrilla's civilian patrols [the FIL]. The army was fighting an unconventional war but with a training in conventional warfare. And they began to mirror what they were doing [...]. Giving them arms was

the idea of General Benedicto Lucas García [brother of the general-president, Romeo Lucas García], who had been in France and had absorbed the design of how to gain the sympathy of the indigenous population. And the first patrol commanders were the *comisionados militares*, the ex-conscripts, former petty officers and sergeants [...] That is how they acted under [successive general-presidents until 1985].[155]

From the early 1980s onwards, the guerrilla retired to remote rural zones. In 1982, advised by the Cubans, the four organizations finally agreed to form an umbrella structure – the Unidad Revolucionaria Nacional Guatemalteca (URNG, Guatemalan Revolutionary National Unity). Ironically, the leadership had moved to faraway Mexico City, directing a guerrilla war at a distance of 660 miles. Recently, in 1986, priority issues like logistics were unified. In retrospect, the Cubans are critical with respect to the Guatemalan guerrilla. Always respectful, they were sometimes in despair about the internal antagonisms, the ideological splits (in fact disguised personal feuds), the lack of coordination and the loss of popular support. Joa, situated in Mexico City, remembers that:

The EGP had many contradictions with the people of ORPA. We told the leaders of both organizations that we could help them establish contacts with the Mexican government, provided that they gave the impression that they were coordinating and organizing a unitary revolutionary front. I made a similar comment to the secretary general of the PGT when he came to Mexico. They were the last to join the URNG.[156]

Ravelo, vice-chief of the Departamento América at the time and in charge of Mexico and Central America, is even more outspoken:

Although we never said it directly, our criterion was that the URNG should have created strong guerrilla columns, capable of protecting a territory and its citizens. But they chose to create small guerrilla groups all over the country, to give the impression that they controlled the country. But that wasn't the

case. And when the army advanced, it bulldozed all opponents and killed all peasants. In my opinion, the URNG leadership [...] had very narrow criteria and applied the wrong tactics. That is the reason that the enemy killed so many indigenous people. The guerrilla forces didn't know how to defend them.[157]

The peace negotiations lasted nearly ten years. After the counter-insurgency campaigns, the guerrilla was in fact defeated. In 1982 Rios Montt offered peace negotiations and amnesty through intermediaries.[158] But the URNG never reacted. Later, after the inauguration of the first civilian government of President Cerezo in 1986, the guerrilla decided to test the waters. Official negotiations started in 1991 and lasted until December 1996. During the negotiation process, the United Nations established a Human Rights Commission that contributed through its good offices.[159] Cuba had a crucial role in the peace and reconciliation process. That will be examined in the next chapter.

Honduras[160]

The guerrilla in Honduras was smaller and of lesser significance. In the mid-1960s, members of the Partido Comunista de Honduras (PCH, Communist Party of Honduras) formed a local guerrilla movement, but they were easy prey for the army. During the 1970s, consecutive military governments were more reformist; during López Arellano's second government term (1972–75), even a prudent land reform was initiated.

In the 1970s, Honduras bought Cuban sugar and the Departamento América maintained relations with the Honduran government and the PCH. In the early 1980s, another army commander and provisional head of state, Policarpio Paz García (1980–82), had intensified relations with Cuba, was treated in a Cuban hospital and was awarded a golden medal by FidelCastro.[161]

Meanwhile, the nascent Salvadorean guerrilla movement Partido Revolucionario de los Trabajadores Centroamericanos (PRTC, Revolutionary Party of the Central American Workers) had already formed a Honduran wing of circa ninety insurgents. From excisions of the PCH, new insurgent movements had emerged: the Fuerzas Populares de Liberación (People's Revolutionary Forces) Lorenzo Zelaya and

the Movimiento Popular de Liberación (People's Liberation Movement) Cinchoneros. There was a lukewarm effort to unify all armed movements in a Directorio Nacional Unificado (Unified National Directorate), but the army crushed most of the combatants in 1983 and 1984. Some of the survivors succeeded in assaulting and killing former army chief Gustavo Álvarez Martinez.[162] Castañeda, Cuba's liaison from 1982 through 1990, does not 'remember that we worked [actively] here on a unifying process [...] The Directorate wasn't strong. And all [movements] were somewhat sectarian.'[163]

After the wars

The insurgency in Nicaragua ended in the victory of the first Sandinista government (1979–90). It was confronted with a second civil war (the Contra war) that ended in a pyrrhic victory and produced an electoral defeat in 1990. The new government of Violeta de Chamorro ruptured diplomatic relations with Cuba. The Cubans maintained relations with Daniel Ortega, notwithstanding all rifts and schisms within the party. Formal relations were re-established when Ortega initiated his second presidential period (2007–present). Nicaragua immediately joined the group of ALBA countries, originally a Cuban–Venezuelan alliance. The war in El Salvador ended in a military stalemate. After the peace in 1992, the FMLN was transformed into a political party that won the presidential elections twice after 2009. The Guatemalan war of thirty-six years ended in de facto defeat of the URNG. After the peace in 1996 the URNG, converted into a political party, gradually lost significance and voters. The political situation in Honduras remained unaltered, until the late 2000s. Then a progressive president – Manuel Zelaya, radicalized – announced social reforms and prepared to join the ALBA countries group; he was ousted by a military coup in 2009. That was probably the reason why the Salvadorean FMLN, electorally victorious in the same year, did not opt for ALBA membership. Its relations with Cuba continue to be warm (2016).

Reflection

When assessing the entire period of the early 1970s to the late 1980s, one has to take into consideration that Cuba's military role was

mainly focused on Africa. In fact, most FAR officers were involved in the wars in southern Africa and operated also in the Horn of Africa. In Latin America, Cuba continued to play a role in revolutionary politics – less assertive perhaps, but always significant. Economically, the country was sustained by generous support from the Soviet Union and the other COMECON countries. Cuba significantly depended on subsidies and credits and on substantial military equipment provided by the socialist bloc. But Cuba preserved its relative independence with respect to its standing and acting in Latin America and the Caribbean: by training, advising, facilitating and using the island's infrastructure and resources for anti-dictatorship coalitions, insurgent movements and guerrilla rebels. In one case, that of Nicaragua, it led to a triumph in 1979. The Cuban leadership succeeded in overcoming the political isolation of the 1960s and rebuilt diplomatic relations with most countries in Latin America and the Caribbean. Its status as a leading Third World country was established in the 1960s and reconfirmed during the 1970s and 1980s.

Cuba continued to support guerrilla anti-dictatorial coalitions and insurgent movements when it perceived it to be convenient. There is, however, a difference from the years of revolutionary fervour in the 1960s. In the 1970s and 1980s, the Cuban leadership operated more pragmatically and explicitly emphasized the necessity of revolutionary unity. Previously, the Vice-Ministerio Técnico – the institutional predecessor of the Departamento América in the 1960s – had trained all varieties of insurgents in a country of guerrilla warfare and with a preference for rural *foquismo*. Now the impetus for political pacts within the armed left, and the achievement of national umbrella organizations within each country, predominated. One can perceive the continuous efforts to shape unitary politico-military organizations in the case of Argentina, Colombia, El Salvador, Guatemala and Nicaragua. A considerable part of the activities of the Departamento América was dedicated to this objective. All section heads and Piñeiro's vice-chiefs, who are quoted in this book, remember the incessant instructions by Piñeiro and by Castro to be respectful but not to forget to contribute to the indispensable unifications of all revolutionary actors.

A second differentiating factor from the 1960s is the extension of Cuba's medical services to all revolutionary combatants of the region

and the growing importance of the medical brigades, sent to friendly countries or to countries affected by natural disasters. It is without a doubt the most laudable, selfless and generous contribution of Cuba to all insurgent movements, highly regarded by all who received medical treatment and could convalesce on the island. It is a scarcely documented endeavour, but it has probably improved the quality of life of thousands of former combatants. In interviews, it sometimes sounded as if revolutionaries and guerrilla combatants were entitled to receive medical treatment on the island. And in reality they practically were. Furthermore, Cuba sometimes extended its medical services to its enemies. In the period immediately after the Sandinista victory in Nicaragua, in 1979, the first Cuban medical team attended to wounded Sandinista rebels and suffering members of the National Guard, left for dead by their own brothers-in-arms.[164] In 1992, when the dying ex-major D'Aubuisson – founder of the Salvadorean ARENA[165] party, leader of its death squads, and a visceral antagonist of the left and of Cuba's support for the guerrilla – was denied proper medical attention in the United States. Abreu (chief of the Central American section at the Departamento América) offered him hospitalization in Cuba.[166]

By the end of the 1980s, worldwide East–West relations were changed dramatically by the implosion of the Soviet Union and the dissolution of COMECON, Cuba's economic buttress structure. It meant dramatic alterations in terms of the national standard of living, military position, reliance on its defence capabilities and possibilities of external intervention. These changes and the effects on Cuba's relations with the Latin American and Caribbean left are the subject of the next chapter.

CHAPTER 6

The years of soft power (1990s–present)

The end of the Cold War

The year 1989 saw a cascade of political earthquakes in eastern Europe. In February 1989 the Soviet army, humiliated, retreated from Afghanistan. In March this was followed by Yeltsin's electoral victory in Moscow, the economic and political reforms in Hungary, and the victory of the Solidarity Movement in Poland in June. In August the de facto separation of the Baltic states succeeded. In September and October there was a massive exodus of East German citizens; it caused the ousting of party leader Honecker and soon afterwards the implosion of the regime. The year ended with the fall of the Bulgarian regime, the velvet revolution in Czechoslovakia, and the toppling of Ceauescu in Romania. Two years later the Soviet Union disintegrated into fifteen separate countries.[1] Comparing the events in eastern Europe and those in Cuba, one has to remember that the constitution of the European socialist bloc was the result of Soviet military power's advance to Berlin in the last years of World War II, and the presence of the Red Army and the KGB as political enforcers in the late 1940s and 1950s.[2] Cuba became a socialist country after its victorious revolution against dictator Batista.

When the Cold War came to an end and the United States remained the only military superpower, the consequences for Cuba were disastrous. Soon after the revolution in 1959, the island had become highly dependent on economic and military support from the Soviet Union and eastern Europe. Economically, Cuba had been generously supported by credits, soft loans and export subsidies. Its economic structure had been transformed, making it a mono-exporter of sugar and agricultural products to the COMECON countries. Although not a member of the Warsaw Pact, its military standing had benefited

enormously from special training and favourable delivery of equipment and spare parts, as if Cuba were a kind of overseas Warsaw Pact member.

The downfall of the socialist bloc was not the only catastrophe that struck Cuba. The United States intensified their already damaging embargo and showed their military muscle by invading Cuba's strategic partner, Panama (1989). In 1990 Cuba's ally, the Sandinista government in Nicaragua, lost the elections. This was at least partly due to the devastating Contra war initiated by contra-Sandinista forces who were equipped, trained and supported by the CIA.

Panama and Nicaragua

Panama was one of Cuba's economic and political lifelines; Nicaragua was Cuba's political hope and pride, the only country boasting a successful revolution in Latin America after Cuba. In both cases, (the threat of) military intervention played an important role. Since the first years of Torrijos' government, Panama had been a precious ally: its strategic location and its leftist-reformist government had made the country Cuba's diplomatic focal point for its relationships with Central American and southern neighbours Colombia and Venezuela. Torrijos functioned as a mediator in several cases.[3] Panama had also been a transport hub for Cuba's assistance to the left in Latin America. After Torrijos' death in 1981, his former security and intelligence chief, Noriega, succeeded him as head of government. As Torrijos' security and intelligence chief, he had maintained friendly contacts with various intelligence organizations, ranging from the CIA and the DEA to Cuba's DOE and the Departamento América, not neglecting pleasant relations with Lieutenant Colonel Oliver North (involved in the Iran-Contra scandal), ex-Major D'Aubuisson (controlling the death squads in El Salvador) and General Álvarez Martínez (Honduras' strongman who was allied with the CIA and the Argentinian junta).[4] He performed and returned favours for American and Cuban organizations. At the request of CIA chief Casey, in 1984 he asked Fidel under what conditions Cuba would take back some of the 'criminals and social misfits' among the refugees of the Mariel boatlift (see below in this chapter).[5] He also maintained relations with private and maybe

illicit organizations in Panama's neighbouring countries; according to Cuban sources he had several million dollars stashed away.[6]

I never heard exactly how exactly Cuba benefited from Noriega's contacts and the information he channelled to Cuba's intelligence officers. His accomplishments were at least such that, as in the case of Allende's Chile and later Chávez's Venezuela, Cuba provided him with strong advice on his personal security and the necessity to arm popular militias:

> Noriega told me: 'Last night I had a meeting with X or Y, tell that to Fidel.' On numerous occasions there were things like that, both in Panama and Cuba [...]. He was very loyal to the revolutionary movement [...]. Noriega offered limitless sup-port to Salvadoreans, Guatemalans, to the M-19 of Colombia, the FARC of Colombia [...]. We gave him full support. We even advised him where to store the armament, which was done in different places. We supported him because one per-ceived what was to come, just like what happened in Chile, the same thing.[7]

But in December 1989 an American invasion force of more than 27,000 soldiers landed for a 'surgical operation' against a Panamanian army of 3,500 combatants. The official death toll after the bombard-ment of the El Chorillo neighbourhood, where Panama's General Staff was established, was around five hundred; the number was probably much higher. Cuban diplomats who left the country two weeks after the invasion observed that the Americans had hastily flattened the bombed house blocks of the underprivileged neighbourhood dwellers and transformed them into an esplanade of red earth.[8]

At the Cuban embassy a defence plan had been prepared as in the case of Chile in 1973. During the night of the bombardment, embassy personnel had transported AK rifles, machine guns and ten rocket-launchers from Noriega's deserted house to the embassy. Noriega's family members as well as the families of the staff members, and Cuban and other Panamanian refugees, had sought protection in the Cuban embassy and the ambassador's residence. They were sur-rounded by American tanks and mortars. After a dialogue between

the American and the Cuban ambassador (the American ambassador had understood that the embassy was armed with rocket-launchers), the tanks were withdrawn and the Cubans were permitted to evacuate all personnel, family members and refugees.[9]

Already in the mid-1980s, the Sandinista government in Nicaragua had planned defence operations against an American invasion. Already engaged in a war against the invading Contra troops, the General Staff was split in two: one to lead the war against the Contras and the other to rebuff a US-led invasion:

> All efforts were aimed at carrying out a war of resistance. If there was going to be an invasion, all notion of borders would disappear. We also let them know this: if we go into Honduras, we will join forces with the Salvadoran guerrillas [...]. The idea was to force the gringos to enter an ant colony so that they wouldn't be able to just come in, strike a single blow, and take care of business in one week like they [later] did in Panama. The idea was that this would be a long-term situation that would go on indefinitely – a quagmire. They would not be doing battle with regular forces, which are at a huge disadvantage, where the other side would enjoy complete command of the air and seas. They would instead be forced to proceed on foot, conquering the territory one metre at a time. The price [that they would pay] would be very high.[10]

The invasion did not materialize; but the Contra war that continued slowly exhausted and eventually shattered the patience of the Nicaraguan electorate in February 1990.

Consequences of the Soviet implosion in Cuba

The collapse of European communism hit Cuba very hard, although it had not come as a total surprise. When Gorbachev initiated the perestroika policy of economic and political reforms in the Soviet Union, Fidel Castro was not a warm supporter. Sometimes *Granma* published a polite article about the new policy, but in Cuba a similar reform discussion remained absent. Castro launched a 'rectification of errors' campaign, more a programme of ideological purity and unity within

the party than one of liberalization.[11] Cuban–Soviet relations were becoming tense. Castro must have had a premonition of what was going to happen. At his 26 July Commemoration speech in Santiago de Cuba, Fidel Castro declared:

> Our revolution – nobody can deny it – has maintained its tremendous ideological strength. Why here [in Cuba]? Because here, if the imperialism attacks us, who will defend the island? There will be nobody to come defend our island. We will defend our island! [applause] It is not that there isn't anyone who wants to defend us, but there is nobody who can do it [from outside]. Because our Socialist Revolution is not a couple of kilometres away from the Soviet Union, but 10,000 kilometres.[12]

In 1988 the Soviets had suspended delivery of heavy arms to the Nicaraguan army. Without consulting Cuba, Gorbachev negotiated the end of the Soviet involvement in the Central American wars with American president Reagan. Gorbachev's visit to Cuba in 1989 was formally affable. Nevertheless, although a new friendship treaty was signed, it had become clear that the huge volumes of economic and military assistance were a thing of the past. Gorbachev had clearly given notice that the Soviet Union, owing to its huge economic problems, could no longer support its substantial 'fraternal economic and military commitment' to Cuba.[13] The COMECON was disbanded in June 1991. In September Gorbachev announced the withdrawal of all remaining troops from the island, without prior notice to his Cuban counterparts.

The changes in the Soviet Union and eastern Europe came as a shock for many Cubans. Even functionaries at the Central Committee, with access to information from outside, had only vague ideas about the dissimilarities and disparities within the socialist bloc until the very end. One of them comments:

> I've always considered myself to be an informed person. I read [Russian journals and] the international wires [...] No one here knew of the commotion of Yeltsin in Moscow, nor did they know what was going on in the urban black markets. All that surprised us. Here some informed people knew that Tito was

not well seen, that Ceausescu in Romania was quite divergent. But Honecker, Yidkov, Kadár, Andropov, Chernenko were loved and admired in Cuba. That we had learned from our press and our Party. We never knew about these internal conflicts [...]. For me, the Komsomol was perfect. When our representatives returned, they wrote only about [wonderful] interventions [...]. We never knew that they were defunct, that Brezhnev could not even manage [the situation]. That was unknown to our population.[14]

When Gorbachev's domestic power was restricted, the new Russian rulers distanced themselves even further from Cuba. Nor did it help that the members of the attempted coup against Gorbachev in 1991 had maintained strong ties with Cuba in the past.[15] It should be noted that the Russians did not abruptly halt all provisions. But between 1989 and 1991 subsidies for imported sugar were cut and the price of oil deliveriess was adjusted to current world prices. Even before the final collapse of the Soviet Union, Cuba's commercial ties with the COMECON were maintained on a cash basis. The end of the military and economic assistance had undeniably dramatic effects on Cuba. Fidel Castro mentioned it clearly in the fourth congress of the Communist Party that year. Pavlov, after living in the United States in 1991, comments:

[It] was like a funeral service for the deceased benefactor of a household, with the bereaved heir lauding the virtues of the late provider and explaining to the family members – loudly enough for the neighbors to hear – what they had lost. His eulogy stressed that now they were on their own and needed help, but charity would be accepted only on the condition that he as the heir would be allowed to practice, as before, the religion of the deceased and to run family affairs in accordance with his own interpretation of that religion.[16]

Cuba's military was also hit hard by the downfall of the socialist bloc. In December 1982, Soviet Party leader Andropov explicitly notified Raúl Castro that the Soviet Union would not defend Cuba by sending troops.[17] Subsequently, the MINFAR had created a defensive tunnel structure

and a voluminous militia system with the 'nationwide capabilities to revert to guerrilla warfare in the event of major military hostilities'.[18] Economic and military support by the Soviets continued on a diminishing scale after 1985, but fell dramatically by the end of 1991, when the Soviet Union morphed into Russia.[19] Delivery of new weapons and spare parts was very difficult, and the FAR's only way to maintain operational conditions was cannibalizing older equipment. Fuel was another crucial shortage. When a Guatemalan army delegation visited the island in 1996, during the reconciliation sessions with the guerrilla, the pilots were shown MiGs but the engines were not started; that was permitted only in emergency situations.[20] Training in Russia was cancelled; intelligence hardware was restricted. Military service was reduced from three to two years. The FAR's personnel was officially halved; the reductions probably went further, to one third or less of its previous strength, while the budget was cut in half.[21] A similar process occurred within the military structures of the Ministerio del Interior (MININT, Ministry of the Interior) and the intelligence provisions. In 1994, the special forces of the MININT, *inter alia* the training specialists of the Latin American guerrilla in former decades, were dissolved.[22]

But the fear of a possible American invasion remained; the FAR kept training their reserves and created its own elite units that were later redeployed across the island.[23] The budget cuts and the lack of new equipment, spare parts and fuel considerably diminished the fighting capacity of the FAR and the troops of the MININT. But although the offshore offensive capacity of the Cuban military had shrunk considerably, its priorities for defence and deterrence were maintained.[24] But in the mind of the senior officers, the FAR always had to be prepared to withstand a smaller or large-scale invasion. One has to bear in mind that the Cold War in Cuba did not end in 1989 but rather in December 2014, when the United States and Cuba announced the re-establishment of diplomatic relations.

The 'Special Period'

Many observers – foes like the Miami-based anti-Castro community, the American political leadership and also friends in the Latin American labour union, the women's confederations and the national

friendship associations – were surprised that Cuba survived its disastrous last decade of the twentieth century.[25] By 1992, Cuba's purchasing power abroad had dwindled and only 19 per cent of its trade was with the former COMECON countries. From 1989 to 1993, Russia's trade with Cuba dropped by 93 per cent. Even worse: the United States tightened its embargo after the Torricelli Bill of 1992.[26] Cuba was on its own again.

The Cuban government announced a 'Special Period in Peacetime', to tighten the belt, to hold out and to work towards the future while the standard of living shrank severely.[27] Cuba's economy and society were transformed into a spartan system of extreme austerity and ideological tightening. Food was incredibly scarce and produced nutritional deficiencies. The desperate shortfall of fuel nearly caused a standstill of the public transport system. In one sad sentence, Gott[28] describes the effects of the crisis between 1989 and 1993: 'Horse-drawn carts and carriages replaced cars and lorries; half a million bicycles circulated in the streets of Havana, courtesy of the Chinese; 300,000 oxen replaced 30,000 Soviet tractors.' Fuel and food provision were an absolute priority. A Programa Alimentario Nacional (National Alimentary Programme) was quickly implemented and Party cadres were asked to dedicate a substantial part of their free time to voluntary construction work of hospitals and other essential public buildings.[29]

The government prevented hunger and starvation by distributing packages of essential food and clothing. Foreign tourism and joint venture investment were promoted and a dual currency system was introduced: the dollar (and later its Cuban equivalent, the CUC) and the Cuban peso with which salaries were paid (at a rate of 1 CUC = 24 pesos). Joint ventures in the profitable emerging tourism sector attracted direct foreign investment from Canada, Spain and other Latin American countries.[30] A bank reform was implemented, a chain of exchange (CADECA, *casas de cambio*) offices was opened and foreign banks (from Spain, Canada, France and the Netherlands) were permitted to operate. Economic reforms decentralized the management in agriculture, industry and tourism.[31] In the last years of the 1990s the first timid signs of recovery were observable.[32]

A system of registered self-employment (*cuentapropismo* in Spanish) and micro-enterprises (especially in the restaurant sector) was introduced.[33] But alongside these officially tolerated non-socialist reforms an enormous informal economy erupted, via (officially forbidden) second and third self-employment jobs in the service sector: street sellers, taxi drivers and domestic personnel. Part of it extended to the illegal sector of the economy, the so-called 'parallel market' of home-made rum, stolen watches and cell phones, cloned DVDs and later also USB sticks with TV soap operas, rock and Miami-Cuban music and dance shows. A widespread black market and part-time prostitution ('*jineterismo*' in Cuban argot) flourished within the urban ambience and the growing tourist sector as well. The visiting tourists came from Canada, Germany, Spain and other western European and Latin American countries; Americans came to Cuba via the Canadian route.

The first source of foreign currency was nickel, which had replaced sugar as the principal export commodity. Another, smaller but also important, source of hard currency was the growing 'medical tourism' of members of the Latin American middle classes who opted for the services of the highly revered Cuban biomedical and pharmaceutical services sector. Tourism and the expanding diaspora to the United States, Canada, Spain and other Latin American countries – where many Cuban families had brothers, sisters, cousins, children or in-laws – produced a stream of dollar remittances; it basically benefited the urban population more than the rural one, and the white population segment more than mulato and black Cubans.[34]

More so than during the period of relative welfare throughout the Soviet decades, smaller and large-scale corruption flourished: some CUCs for immigration or police officers, a small gift before an examination, another gift for enrolment at the university, a favour for a copy of necessary documentation, et cetera.[35] The fact that a large segment of the informal economy is officially forbidden, and thus not registered, makes it difficult to make a serious estimation of the volume of and the financial streams within this sector. The twilight zones within the economy and the payment of 'incentives' in dealings with authorities and state functionaries have become standard practices in the present day.

The sudden reduction in relative welfare and alarming levels of impoverishment had another effect on post-Soviet Cuba: anguish, general misery and public disturbances in the 1990s. Cuban diplomats, returning to their families between two postings, were horrified to see their relatives and neighbours walking on the street or forming endless queues for bread or vegetables 'like living skeletons'. Some burst into tears and told their family and in-laws that they preferred to share their ordeal and starve together. 'Don't do it,' they answered, 'we only survive receiving your packages and your remittances.' A new barter economy emerged: cigarettes became a kind of currency. Jorge Juárez, representative of the Salvadorean guerrilla movement Fuerzas Populares de Liberación (FPL, People's National Liberation Forces) in the 1980s and the 1990s, clearly remembers the changes in the first years of the Special Period:

I have to admit that, as a representative of the FPL, I always had certain privileges. For example, I had a special card. You could not buy in dollar supermarkets but I had access to supermarkets with special products. But I remember how hard that was. Sometimes you couldn't even find a glass of water. However, the Cubans had a good policy: milk and yogurt were free for the children, a great measure to combat the undernutrition in that period. And there were the food packages. Cigarettes were almost hard currency. Soy meat was introduced, a thing the Cubans saw as something sci-fi. Rum was rationed. Shoes, clothes and sanitary napkins disappeared; they invented something with cotton rags. Those things don't look important, but have a tremendous impact on everyday life. In 1988, Cuba's transport system was very good, efficient; [then] the entire system collapsed.

There was a severe brain drain: teachers emigrated. It affected the entire educational system: PhDs, philosophers, scientists, they all went to Miami. But also at the level of primary schools you could see the consequences. And you could discern the differences between the children: those who have and those who don't have much. Inequality spread. Crime increased. Problems with drugs began to arise, especially among children of

the generals, the military, the sons and daughters of the better situated. The media didn't publish anything about it, but it is certain that crime and robbery increased. And another thing: suicides seriously increased. Nothing was made public but one who had contacts with people working in psychiatric hospitals knew about it. Prostitution expanded as well. Was it purely prostitution or something else or something more? With the arrival of the tourists and foreigners, *jineterismo* [part-time prostitution] increased. And at all levels: university-educated young women, for instance. In the building where I lived, several girls had fluctuating sexual relations with foreigners. And not only for getting a blouse, new pants or money. Also to be able to escape from the island. I know many cases of girls who travelled abroad [with their new fiancés].[36]

The economic problems triggered the bizarre but sad third exodus wave, after those of the elite and middle classes in the 1960s and the Mariel boatlift in the 1980s. This time, in the mid-1990s, people left the Havana seafront in home-made rafts in order to reach Florida; the rafters (*'balseros'* in Spanish) were seen off by their depressed family members. It became a daily spectacle. In August 1994 an angry crowd assembled on the front, clashed with the police and smashed the windows of nearby offices and a hotel. Fidel Castro left his office and hastened to the disturbance. He succeeded in calming the growing mob; his personal intervention saved the situation. When he left he was even cheered by the protesters. I was told about this occurrence by MININT officers in 2013; they ruefully remarked that 'now Fidel would have encountered more resistance'.[37]

It was around this time (1993) that the Asociación de Combatientes de la Revolución Cubana (Association of Combatants of the Cuban Revolution, ACRC) was established, organizing all insurgency, guerrilla and military veterans with experience in warfare and all 'civilian internationalists' like the participants in the medical and literacy brigades – the backbone of the old cadres.[38] In general, the role of the military, and especially the FAR officers, was expanded;[39] they became managers in the plentiful state enterprises in the existing sugar and mining sectors, or in the new joint ventures in the tourist

industry. In the early 1970s, the FAR had created a conscript task force to provide its own food programme.[40] Now, during the hardest years of the crisis, the FAR also deployed its regular officers to administer the National Alimentary Programme. It also provided assistance in medical campaigns and natural disasters.

New enterprises, such as Cubanacán (tourism and hotels), Habaneros (tobacco) and ETESCA (telecoms, a joint venture with the Italians) were created and staffed with general officers of the FAR. Raúl appointed his most trusted companions, such as Julio Casas Regeiro (his first vice-minister at the MINFAR), as manager of a new industrial and entrepreneurial complex, GAESA (Grupo de Administración Empresarial), and Luis Alberto Rodríguez (his brother-in-law) as manager of the already existing UIM (Unión de Industrias Militares).[41]

A silent but constant 'Raúlization' took place in the economic and political higher echelons, a process that was reinforced after 2006 when Fidel ceded the reins of government to his brother. Former Rebel Army *comandantes* and FAR generals had always been appointed to the cabinet; now their numbers extended into the Council of Ministers and the Council of State. Senior officers of the FAR were appointed at 'civilian' ministries – as ministers, vice-ministers or leading functionaries. In 1989 the so-called Ochoa case caused a radical change in the management and staffing at the MININT. General Arnoldo Ochoa (a Rebel Army veteran, adviser to and participant in several guerrilla organizations in Africa and Latin America, and a prominent military leader in the wars in Angola and Ethiopia) and twelve other high-ranking military officials at the MINFAR and the MININT – even the minister of the MININT, General José Abrantes – were found guilty of large-scale smuggling and drug trafficking; some were executed and others condemned to extensive prison terms. Fidel and Raúl cleansed and reorganized both ministries and placed the absolutely trusted four-star general Abelardo (Furry) Colomé Ibarra, an old friend and former collaborator of Che Guevara, as minister of the MININT.[42] Key functionaries at the MINFAR were transferred to the MININT and, during the years of reduction of the FAR, many officers were relocated to the MININT.[43]

The political rearrangement in the early 1990s also had consequences for the Departamento América. In 1992, Piñeiro resigned as

chief after more than thirty years of leading the department and its institutional predecessors. He retained his membership at the Central Committee of the PCC. His successor was Arbesú, his senior vice-chief. Piñeiro was widely known as Cuba's spymaster, explicitly identified with nurturing revolutions abroad. However, during the crisis years of the Special Period it was more convenient to appoint a less outspoken head of this sensitive task force. Within the Departamento América business continued as usual. Arbesú remained in charge of the department until his retirement in 2013 and the members of this elite unit continued to represent the political leadership of country and party with the same dedication. But after Piñeiro's departure the situation was not quite the same. Piñeiro was the unconditional Fidel loyalist, a personal friend whose opinions were highly respected by the Comandante-en-Jefe. Arbesú was the trusted senior party official whose well-substantiated fact-finding was appreciated by Cuba's political leadership; but he was not Fidel Castro's old friend and adviser. Piñeiro, although formally in retirement, still continued to play a role as Fidel's personal operative in sensitive cases, especially with respect to Venezuela.[44] The department remained the source of excellent political information about the left, the centre and the right in the region.[45]

The first two years of the Special Period, with its economic reforms for survival, produced a 'liberalization atmosphere' in matters of culture and new ideas. New journals appeared in Cuba; the most important journal, *Temas*, was one of the fifteen magazines that appeared or reappeared.[46] The political authorities were not completely clear about the exact course of Cuba's economy and tolerated a certain degree of non-orthodox discussion. Nevertheless, in the early 1990s the Party banned the circulation of Russian and Chinese ideological journals, preventing contagious 'misinformation' among the members of the FAR.[47] It was the beginning of a new wave of ideological purity that looked like a mild version of the *'período gris'* in the 1970s.[48]

In the mid-1990s an institution closely related to the Departamento América – the Centro de Estudios de las Américas (Centre of the Study of the Americas, CEA), an academically respected research institute in Cuba and abroad with a first-class staff and a prestigious

journal and book series – was closed after an ill-fated discussion with the Buró Político. It is not improbable that the CEA's comparative studies about reforms in the Latin American and Caribbean region (plus Cuba) were the cause of offence. The director and senior staff members were dispatched to mid-level functions in the public sector or cultural institutions; others emigrated. In the aftermath of my interviews I asked for more details and the general consensus is that Raúl Castro had slammed on the brakes.[49]

Cuba's foreign policy: soft power, peace-building and civilian missions[50]

Over the course of several decades, the American press and mass media portrayed Cuba as the archetypical warmonger, whose secret service was always on the alert to nurture subversive, terrorist and guerrilla movements worldwide, and especially in Africa and Latin America. Interestingly enough, the Departamento América began to get involved with peace negotiations in the late 1980s and thereafter. In Chapter 5 I mentioned the explicit efforts of Fidel Castro and Piñeiro to convince the leaders of the M-19 and the other members of the Colombian Coordinadora Guerrillera Simón Bolívar (CGSB) to engage in a political rather than a military solution. Piñeiro even organized meetings between the CGSB and the Salvadorean FMLN in order to facilitate the initial steps in formal and informal peace dialogues. Cuba continued to play a leading role in the peace process in Colombia and in Guatemala.[51] These two countries were the last in which guerrilla movements were still fighting in the last decade of the twentieth century.[52]

Guatemala[53]

In fact, after the brutal years of counter-insurgency (1978–83) under the military governments of the general-presidents Lucas García and Ríos Montt, the guerrilla lost the war. They had retired to the remote indigenous regions, retaining some smaller urban pockets in the western highlands and the northern jungle. The leadership of the URNG lived in exile in Mexico City, from where the chief commanders directed the war by fax and telephone. After the return to

democracy, in 1986, the guerrilla sought contact with civilian president Cereso. Informal conversations were initiated in Costa Rica and Spain. Cereso formed a National Reconciliation Commission (Comisión Nacional de Recolciliación, CNR), headed by the archbishop. The CNR organized peace talks in Oslo in 1990. In 1991, newly elected president Serrano coerced the recalcitrant old guard of the military to participate in the peace sessions. They were succeeded by more moderate colonels and generals who wanted to end the ravages of the war. From 1991 to 1996, the peace negotiations were presided over first by the archbishop and then by a special UN envoy.

But the real breakthrough came when two key negotiators, Rodrigo Asturias (Comandante-en-Jefe of the ORPA, URNG) and General Julio Balconi (appointed as minister of defence in 1996), reached an agreement about informal consultation before and after the sessions in order to avoid friction and confrontation at the peace table. During these informal conversations they developed a relationship of mutual trust and rapport. In early 1993 army delegates and the guerrilla leadership convened in extra-official sessions, with the silent approval of the civilian presidents. Norway and Cuba played favourable roles as facilitators. In March 1996, Cuba's good offices were employed to organize a three day session of reconciliation between the army and the guerrilla.[54] Both Fidel and Raúl were very accommodating and after the Havana session, the URNG announced a unilateral ceasefire while Balconi dissolved and disarmed the PACs (the paramilitary patrols). The army staff and the second-in-commands of the guerrilla worked out a timetable of disarmament. Between March and December 1996, when the final peace agreements were signed, the army ceased to attack the guerrilla encampments and disarmed the paramilitary forces. The peace negotiations were successfully ended after the Havana session and Cuba's relationship with Norway on matters of peace in Latin America would continue throughout the larger period of the Colombian peace talks in the 1990s and 2000s.

Colombia

After the peace process, which lasted from 1989 to 1991 – when M-19 and other guerrilla groups signed a peace agreement and were incorporated into Colombian society – Cuba continued to act as a

peace facilitator, at the request of both the Colombian government and the guerrilla movements FARC-EP and EI N. During the next two decades, the Departamento América and Fidel Castro dedicated much time to the efforts of consecutive Colombian presidents and the changing leadership of the FARC and the ELN to reach an agreement or to establish periods of temporary ceasefire. Castro even allowed publication of a book[55] about the repeated requests for Cuba's good offices, with excerpts from diplomatic reports, accounts by officers of the Departamento América, and taped conversations between Castro and guerrilla leaders in Havana and elsewhere.

In the early 1990s, the FARC negotiated with representatives of President César Gaviria in Venezuela and Mexico without even reaching the minimum terms for an agreement. In 1998 President Pastrana offered the FARC a demilitarized zone in El Caguán in order to initiate new peace consultations. Previously, he had requested the good offices of Fidel Castro through a representative of the Departamento América. When Marulanda (for decades the principal leader of the FARC) and Pastrana solicited Castro's intervention, he sent Arbesú and López on a fact-finding mission to Bogotá and Caguán. On their return with guerrilla leaders, they had a lengthy nocturnal conversation with Fidel:

> At the airport, Fidel's private secretary informed us that the Comandante wanted to have a discussion with us after the formal reception. From 11 p.m. until almost 6 a.m. the following morning, Arbesú, Ambassador Martinez Beaton and I spoke with the Chief of the Revolution. We were subject to a rigorous cross-examination. He emphasized the need to avoid errors. He didn't understand the situation of peace talks in a demilitarized zone while the war went on outside of this zone. He considered it a strategic mistake that would endanger the dialogues. He disagreed with the kidnapping of civilians and did not understand why war prisoners hadn't been transferred to the authorities. He thought that it was not positive to begin a dialogue and at the same time cause difficulties that would be used by the enemies of the peace. With great respect for the Colombian combatants, he explained that during his campaigns in the Sierra Maestra, the politico-military strategy of

the guerrillas was to not keep prisoners of war in their power for many days. Prisoners, he said, must be given humane and considerate treatment; the wounded must be attended well. You had to explain to your captured enemies the reasons for which you were fighting. Then you would achieve two fundamental objectives: one, to eliminate impediments of free movement for the guerrilla, conserving food and not employing fighters as prisoners' guards. And two, returning former prisoners would comment on their good treatment, and would explain the ideas of the guerrilla. That would contradict the negative campaigns of the military chiefs, provoking doubts and maybe sympathy for the cause of the guerrilla. Then he reflected on the hypothesis of a military triumph: How to consolidate power? And he asked: 'Is there nationwide support? Is there a strong political movement behind the military operations? Is there a successful alliance with other political parties and movements? Is there an ongoing dialogue with entrepreneurial sectors and the military?' And he answered his own questions: 'If you don't have broad popular support, a political alliance with other national progressive sectors and a certain international support, it will be very difficult to form a sustainable government that can maintain power.'[56]

In fact, in 2001 the FARC and the government exchanged prisoners – 359 soldiers and police officers for fourteen rebels.[57] But the peace negotiations stagnated. In 2002, President Pastrana suspended the dialogues and the war continued. When Uribe won the presidential elections that year, the war intensified and both the FARC and the ELN lost territorial control and saw their number of combatants reduced. Uribe initiated a programme of mass demobilization of the paramilitary forces and established a legal opportunity for individuals to leave the guerrilla on easy terms. In 2011, around 27,500 former combatants (of which 25 per cent were reported to be deserted *guerrilleros*) were enlisted in a programme of social reintegration.[58] When in 2010 President Santos was inaugurated, the FARC requested a new round of negotiations and the new president acceded. Through the good offices of Norway and Cuba, bilateral negotiations started

in Havana in 2012. By the end of 2015, several partial agreements had been reached. In June 2016 the FARC and the Colombian government signed the crucial agreement on ceasefire and disarmament, the last step to a final peace agreement that is expected in the second half of 2016.

The ELN had always been a smaller guerrilla force than the FARC. In the 1990s, the ELN – more so than the FARC – was also severely beaten by the counter-insurgency campaigns of the paramilitaries in their areas of operation. During the presidencies of Samper (1994–98) and Pastrana (1998–2002) the Colombian government had also initiated a series of peace dialogues. They were supported by the Catholic episcopate, a committee of facilitators from civil society, and delegates of the UN. In January 2002 delegations of the ELN, the Colombian government and the committee of facilitators convened in Havana. But in May of that year, President Pastrana unilaterally suspended the dialogue. During the term of President Uribe, the Colombian government tried to come to an agreement with the ELN in Mexico. The effort failed and the parties involved came to Havana to once again appeal to Cuba's good offices. Arbesú and López repeatedly travelled between Cuba and Colombia.[59] Between 2004 and 2006, four negotiation sessions were organized, without a clear result. In early 2007 a similar session was organized in Caracas; then the negotiators returned to Havana for a fifth round of conversations. Raúl Castro and Colombia's famous novelist Gabriel García Márquez were present to announce their support. The negotiations proceeded in 2007, 2008 and 2009.[60] The final result was again a failure. During the negotiating rounds with the FARC, between 2012 and 2016, informal ELN envoys visited Havana to put out feelers.

Cuba's civilian internationalism

Cuba's soft power diplomacy, which was evolving in the 1990s and continued into the 2000s, also implied the deployment of civilian missions. Cuba's internationalism, which in previous decades had been predominantly expressed by support for guerrilla movements in Latin America and the Caribbean and large-scale military operations in Africa, had now turned into the provision of humanitarian assistance in the form of medical and literacy teams.[61] In fact, most

military missions in Africa had always been accompanied by medical and literacy campaigns, but on a lesser scale. The most striking example was the spontaneous after-war development assistance in Angola. When the Cuban military contingents were due to return after their tour of duty in Angola, the authorities asked Raúl Castro for urgent reparation and reconstruction assistance. Many common soldiers and officers, mechanics, drivers, engineers and paramedics took off their uniforms and continued working for a couple of weeks or sometimes months as civilian volunteers, applying their own professional experience.[62]

Cuba's civilian development aid ('internationalism') is a consequent effort, over five decades, to provide poor citizens in underdeveloped or poor countries with assistance in which Cuba has leading expertise: public health provision and literacy campaigns, post-disaster reconstruction, and sport (training and facilities). According to the statistics of the MINREX, between 1959 and 2001, around 156,000 Cuban civilians worked as 'internationalists' worldwide: 81,000 in Africa, 47,000 in the Americas and 10,000 in the Middle East. In the same period around 40,000 academic professionals, of whom 30,000 came from Africa, graduated in Cuba.[63] Cuba assisted in the establishment of medical schools in Yemen (1976), Guyana (1984), Ethiopia (1984), Guinea-Bissau (1986), Uganda (1988), Ghana (1991), Luanda (1992), Gambia (2000), Equatorial Guinea (2000), Haiti (2001) and Eritrea (2003).[64] The first Cuban medical mission abroad was in Algeria (1963). Already by 1978, around 2,000 Cuban health personnel worked abroad; in 1999 there were around 3,000. That number then increased to 3,800 in 2001, 15,000 in 2003, 25,000 in 2005 and 30,000 in 2007.[65] During the administration of Raúl Castro (2006–present) this number has grown and other medical initiatives (medical schooling for foreigners, for example) has been continued or expanded. It brought and brings Cuba an enormous amount of prestige in the global South.[66]

In October 1998, Fidel Castro launched the idea of a special medical school for Latin American students, the Escuela Latinoamericana de Ciencias Médicas (ELAM); the new university opened its doors in September 1999 with students from eighteen Latin American and Caribbean countries. But in the mid-2000s it started to attract students from other continents and, between 2010 and 2012, the annual

number of ELAM graduates was around three thousand. In 2012, students from ninety-eight countries (with thirty-one mother tongues) matriculated at the ELAM. The ELAM system and the study allowances also expanded to other countries when, after the creation of the ALBA alliance between Cuba and Venezuela (see below), Hugo Chávez co-financed and co-developed the Cuban initiative. ELAM-like medical schools were established in Bolivia, Nicaragua and Venezuela and an undergraduate school was set up in Guyana and Nicaragua.[67] In addition to the medical-technical curriculum, the ELAM system emphasizes a professional medical ethos of dedication to the poor and underprivileged. In January 2010, when Haiti was hit by a severe earthquake, the ELAM staff emailed their worldwide alumni; within seventy-two hours, around a thousand professionals had agreed to join the Cuban medical brigades.[68]

Medical brigades operated or still operate in many Latin American and Caribbean countries, especially after natural disasters.[69] They continued to work even when, after a regime change, a new national government was adverse to Cuba.[70] In 2004, Cuba launched the programme Operación Milagro (Operation Miracle) to cure cataract and other eye diseases, co-financed by Venezuela. It started in that country and was extended to many other countries in Latin America and the Caribbean, and also in Africa and Asia. According to official data 2,577,000 persons benefited from this Cuban-Venezuelan initiative between 2004 and 2015.[71]

A second instrument of international assistance is that of literacy campaigns. In Cuba, a massive literacy campaign was organized in 1960; in 1961 the island had been officially declared 'free of illitaracy'. Nearly one million Cubans had learned to read and write; according to UNESCO, in 2015 Cuba was the only country in Latin America and the Caribbean that succeeded in '100% education for all'.[72] On the basis of these experiences, Cuban teachers advised on, assisted in and implemented literacy programmes in Angola and Nicaragua, and in other assistance missions in Latin America, the Caribbean and Africa. In 2000 the instrument was standardized in an audiovisual programme called '*Yo, sí puedo*' (Yes, I can).[73] In the early 2000s it was widely implemented in Venezuela on a massive scale.[74] Half a million unemployed students were incorporated into the programme as teachers

and around five hundred Cuban experts assisted in the specific design; in 2006 the country was also declared 'free of illitaracy'. In 2006, within the context of Cuban and Venezuelan support to Bolivia, when Evo Morales had initiated his first term as president, the programme was adapted in this multinational and multilingual country. Of the indigenous population, around forty thousand Quechua and Aymara monolingual Bolivians benefited from the programme. Cuban and Venezuelan teachers re-adapted the programme for a second campaign during the period of assistance to Haiti in the aftermath of the 2010 earthquake.[75] Meanwhile, Cuba had implemented adapted versions of 'Yes, I can' in thirty countries.[76]

Chávez and the ALBA

At the turn of the century, Cuba gained a formidable friend that fortified both its economy and its internationalist aspirations. Even before Hugo Chávez was elected president of Venezuela, he and Fidel Castro had developed a personal and political friendship that had matured into an enduring father–son relationship over the years. This friendship has to be contextualized. In several interviews with members of the Departamento América it was emphasized that Fidel never overestimated the lasting influence of Cuba, an island in the Caribbean with a population of ten or eleven million and a modest economy. In his opinion, it was obvious that Cuba alone did not have the clout to compete as a leading power with the larger economies in Latin America. Fidel considered Cuba to be a revolutionary vanguard nation *pro tempore*, always on the lookout for a substantially larger country that could take over the revolutionary baton. He had a certain preference for Colombia or Venezuela.

At least once, Castro embarked on a serious effort to convince a Venezuelan president to assume the leadership of the Latin American left. In August 1988, Fidel sought an opportunity to speak in private with Carlos Andrés Pérez, presidential candidate for a second term at the time. After mutual consultations, on the occasion of the inauguration of the new president of Ecuador, Rodrigo Borja, Fidel and Pérez met each other and Pérez invited Castro to his room. Present were Carlos Andrés Pérez and his trusted intelligence chief, Orlando

García. Fidel was accompanied by General José Ramón Fernández, then vice-president of the Council of State and the Council of Ministers, and Carlos Antelo, minister councillor at the Cuban embassy in Caracas. Antelo taped the session:

> In the meeting with Carlos Andrés Pérez, Fidel tells him: 'You're going to be the presidential candidate in Venezuela and you'll not only be president of Venezuela.' Carlos Andrés Pérez says: 'But can I be president of Venezuela if I don't have [the vote of] the CEN [National Executive Committee of Acción Democrática]?' Then Fidel answers him: 'You have two CEN members in favour, that's enough for you. You are going to be the candidate, you will win and you will be the president.' Even at that time, Carlos Andrés Pérez was not yet a candidate, but Fidel had all the information that we had sent to Cuba, and his chances of [electoral] victory were already perceptible.
> Fidel continued: 'You're the only one capable of leading us all, all Latin American leaders, including me. Venezuela has the morale, its historical tradition, its favourable economic situation, its enviable geographic position, to convene us. If you are willing to do this, I will renounce socialism in Cuba. Even the Miami people can return. If you will convoke the Latin American unity, I am willing to do that. It is a single objective, all of us confronting the Big One Here Above.' He never mentioned the United States, only 'the Big One Here Above'.[77]

But Carlos Andrés Pérez gave only non-binding answers. After leaving the room, Fidel was severely disappointed. He told Antelo: 'I fulfilled the historic mission.' When Antelo returned to Caracas, Piñeiro requested that he send him the tape and the complete transcription. Piñeiro brought it to Fidel, who archived it as a historical document.

The Cuban embassy staff had slowly developed a confidential relationship with the Venezuelan leftist military. The staff was aware of the fact that many Venezuelan officers come from families in poor neighbourhoods, and their nationalism is a mixture of patriotism and vague ideas about the necessity of social reforms. Some mid-career

officers, members of a group called COMACATE (Comandantes, Mayores, Capitanes y Tenientes; Lieutenant colonels, mayors, captains and lieutenants), were clearly conspiring against President Luis Herrera. The instructions from Havana were: monitor the movement without involvement. The contacts remained clandestine, but its leader – Lieutenant Colonel William Izarra – visited Cuba. The Cuban observers afterwards believed that Chávez – then a captain, son of a shoemaker – was one of the COMACATE members. But there were other, parallel military opposition groups in operation.[78]

In 1992, Lieutenant Colonel Hugo Chávez, a lifelong devotee of Simón Bolívar and an admirer of Latin America's progressive generals Velasco and Torrijos, staged a coup that failed. He and his followers took control of several large cities but failed to take Caracas. He went to prison. Until then, the functionaries of the Cuban embassy did not know him personally. But from that moment on, they were interested in him and contacted him via mutual friends. When he was released from jail, he was twice interviewed very discreetly, once by a Cuban diplomat and the second time by the Cuban ambassador. Chávez, in disguise, visited Antelo. He told his Cuban companion about a triple plan: the military conspiracy that he never abandoned;[79] a new political party; and his candidacy in the presidential elections. While monitoring Chávez's public appearances, Antelo visited a rural village called La Victoria. He stood as a bystander among the general public and was impressed by the number of participants. But when he heard the very religious Venezuelan villagers saying, 'The Messiah has come, I want to touch the Messiah,' he was finally convinced that the next Venezuelan president would be Hugo Chávez.[80]

As a prisoner, he had already made it clear that he was interested in visiting Cuba and meeting Fidel. Antelo reported that to Havana. It was 1994, the year of the worst economic situation in Cuba during the Special Period since the implosion of the Soviet Union. But the Departamento América reacted very cautiously and let Chávez know that 'he had to wait for a more favourable conjuncture'.[81] But soon thereafter, Venezuelan president Caldera formally met with the head of the Cuban American National Foundation, the most hated Cuban exile organization in Havana with a record of attacks and

assaults. In that context, Fidel decided to invite Chávez to Havana, in 1994. Antelo received a telephone call from Arbesú· 'Your friend has to come over.' 'And how do I do that?' 'Invent something.' 'And who is inviting him?' 'I don't know.' It took some time to convince Chávez to go to Cuba. Not sure of being received by Fidel, he seriously doubted the wisdom of the trip. Antelo had told Chávez that he was invited by Eusebio Leal, the Historian of Havana, to a conference about Simón Bolívar.[82] Could he send a ticket? Arbesú answered that Cuba not even could buy him a matchbox. Chávez decided to buy the ticket himself.[83]

When Chávez landed, Fidel greeted him as if he were the head of state. At that moment, Fidel changed the entire meeting agenda, let him speak in the Aula Magna at the University of Havana, received him in private and accompanied him on most of his visits in Cuba.[84] It was the beginning of a special bond: Fidel the wise old mentor, Chávez his young revolutionary successor. Chávez, a 'presidentiable' candidate, would control the oil revenues of Venezuela in the 1990s and 2000s, and had an enormous financial reservoir to spend on revolutionary projects and provisions for the poor and underprivileged. Antelo was absolutely sure of Fidel's intention and ability to present to Chávez the same project he had previously offered to Carlos Andrés Pérez.[85] And maybe Pérez was also aware of it. In his memoirs he laments 'the seduction of Chávez': 'As if by the magic of Latin American politics, he has become the one and only real disciple of Fidel Castro who sees him, thanks to the Venezuelan oil affluence, as his successor, his continuator. He is the most educated disciple of Fidel, no doubt about it.'[86]

In the 1970s Fidel had befriended progressive army leaders-turned-presidents like Velasco and his team of military ministers in Peru, and Torrijos and his trusted military advisers in Panama. It was a friendship based not only on pragmatism and political convenience, but also on shared values and interests as reform-minded soldiers. Chávez, Torrijos and Velasco were thinking – in terms of the military mystique – about the indivisible unity between people and the armed forces. This unity was based on the forming of a nation, patriotism and a 'revolutionary calling'. Chávez, as a first-time president, emphasized the role of the military as vanguard of the revolutionary process

he was about to undertake. Torrijos and Velasco had expressed themselves in nearly the same way as Chávez:

> We can say that it is like the formula of water: H_2O. If we say that the people are the oxygen, the armed forces [are] the hydrogen. Water doesn't exist without hydrogen. Let's see: the first rebellion in 1992. Who took the initiative? The army! A movement of the Bolivarian military youth. But later, the armed forces as an institution came in: if it hadn't been for the attitude of the majority of the military, the process of '98 would have failed [...]. Once the Government was installed, the army engaged in an attitude of support.[87]

Fidel and many Cuban revolutionary *compañeros* in the insurgency were also soldiers, who admired the characteristic soldiers' virtues and heroism. They had – according to various comments from functionaries within the Departamento América – sometimes found it easier to understand and engage with the progressive military than with the civilian socialists and communists who supported Allende. Raúl was the innate military organizer. There was no doubt that the military mystique of the two Castro brothers had contributed to their lifelong maxim of revolutionary unity and to the calling of the revolutionary vanguard to lead the Cuban nation to its socialist destiny.

During the fifteen years of Chávez's presidency (1999–2013), his political trajectory and his legislation demonstrated a deepening radicalism.[88] His first years were periods of moderate centre-left government, based on a coalition of centre and leftist parties and movements. At the same time, he started an extended social welfare programme and let the army build and repair roads and hospitals, and distribute food. The new president visited regions and municipalities and decided on instant solutions to the dilemmas with which he was confronted. Fidel visited him and Chávez showed him the country; the Venezuelan president was driving and the Cuban one was seated next to him. But Fidel also told him: 'Chávez, you cannot be the mayor of all of Venezuela'[89] and convinced him of the necessity for a political party and medium- and long-term social and political programmes. Chávez organized a Constituent Assembly

and the new constitution of December 1999 considerably expanded presidential prerogatives.

In 2001 he nationalized the country's natural resources and brought their exploitation under joint venture contracts with the state-owned oil company, PDVSA. He survived a (failed) counter-coup in 2002 and a (failed) general strike organized by heterogeneous alliances of opposing military and political leaders. Fidel provided him, as in the case of Allende in the early 1970s, with Cuban bodyguards. In later years the Cuban and Venezuelan security and intelligence communities would reach an agreement of mutual cooperation that *inter alia* permitted operations in one another's territory.

Already in the late 1990s, on the occasion of a disastrous flood in the coastal regions, 1,500 Cuban doctors had come to Venezuela's assistance; in 2003 there were more than 10,000 Cuban doctors and paramedics working in Venezuela.[90] In 2000, Chávez and Castro cemented their relationship with a mutually beneficial agreement: Cuban doctors, literacy trainers and educational experts went to Venezuela and Cuba received a generous quantity of oil every day. In the 2000s this would be expanded to 90,000 barrels per day at preferential rates. The Cuban–Venezuelan covenants were periodically extended. By 2005, Cuba had sent 30,000 doctors, dentists and paramedics; it promised to train 40,000 Venezuelan doctors and 5,000 medical specialists in Venezuela. In that year, by means of the Milagros mission, 100,000 Venezuelans had already been treated in Cuba.[91] By the late 2000s, around 40,000 Cuban teachers, literacy experts, university professors, doctors, dentists, paramedical personnel and other experts were employed in Venezuela. In 2013, the year of Chávez's death, that number increased to 50,000. During the Chávez administration and the first two years of that of his presidential successor, Maduro, many of Venezuela's domestic social programmes were co-designed and staffed by Cuban civilian internationalists.

In 2004, with his continuously growing electoral successes and his maturing position as Venezuela's leader, Chávez – already six years a reformist military president – began to expand his reach, emphasizing an anti-imperialist political path and launching his own brand of 'socialism of the twenty-first century'. He had become the charismatic leader of the Bolivarian Revolution of fundamental economic

and social changes. Always in close synchronization with Cuba, he launched a large series of consecutive social and economic 'missions', headed by trusted military and loyal civilians. It created a system of presidential ministers and cabinet members who depended directly on the president's orders. This was not unlike the system of presidential military ministers during the Velasco years in Peru. The missions were accompanied by workers' cooperatives, co-management initiatives, government expropriations and worker occupations, land distributions, and transfers of authority to community organizations.[92] Chávez eventually founded his own political party, the Partido Socialista Unido de Venezuela (PSUV, United Socialist Party of Venezuela).

In his early years as president, Chávez was strongly influenced by the iconic and charismatic Fidel Castro. But from alumnus he had in time graduated to partner. In 2004, Castro recognized this in his welcome speech at the signing of the Cuban–Venezuelan agreement, which would become known as the ALBA, the Alianza Bolivariana para los Pueblos de Nuestra América (Bolivarian Alliance for the People of Our America). It is a special government alliance between Cuba and Venezuela that would afterwards encompass various other like-minded socialist and social democratic governments in Latin America and the Caribbean. Castro stated:

Hugo, you said ten years ago that you didn't deserve the honours you were being given [...]. You promised to come back one day, with your hopes and dreams come true. You have returned and you have returned a giant, now not only as the leader of your people's victorious revolutionary process but also as an important international figure, loved, admired and respected by many millions of people all over the world – and especially by our people.[93]

Cuban and Venezuelan leaders even thought seriously about advancing into a kind of further political unification. Carlos Lage, secretary of the Council of Ministers and vice-president of the Council of State at the time, claimed in Venezuela in October 2005 that 'there was only one country with two presidents'.[94] In October 2007, Chávez launched the idea of a Cuban–Venez/uelan confederation: 'We should

look beyond. In the near future we, Cuba and Venezuela, could perfectly establish a confederation of republics: one confederation, two republics in one, two countries in one.'[95]

But that was a bridge to nowhere. Venezuela and Cuba had two decidedly different economies, a different political structure, and Venezuela's society – more than Cuba's – was already strongly polarized. Venezuela and Cuba opted for an extension of the ALBA structure. After the creation of the ALBA, Chávez turned out to be its financier. During the first years of its existence he received large-scale Cuban support for his social and economic missions. He also began generously co-financing Cuba's civilian internationalism abroad.

The ALBA began to incorporate other countries: Bolivia (2006), Nicaragua (2007) and Ecuador (2009).[96] Cuba provided medical and literacy assistance and Venezuela delivered oil under concessionary financial agreements for the discretionary use of the Bolivian, Nicaraguan and Caribbean presidents of the member states.[97] The politics of subsidized oil delivery to friendly governments of poor countries and cities came to be known as 'Venezuela's oil diplomacy'.[98] Fidel Castro and Hugo Chávez had like-minded political ideas about joint revolutionary projects in the region. Together they initiated and built up the new integration movement with public health and social improvement services that had a serious effect in the region.

At the end of the first decade of the twenty-first century the Cuban and Venezuelan leaderships could seriously consider socialist expansion across the Caribbean, Central America and the entire South American subcontinent.[99] With the support of friendly governments in such important countries as Argentina (under the presidency of the Kirchners, 2003–15) and Brazil (under the presidency of Lula, 2003–11) it felt as if the social democratic and socialist left could determine the future of the entire region.

CHAPTER 7

. .

The legacy

The Fidel–Raúl succession and the cautious reforms

Rumours about Fidel Castro's health problems circulated over the years. In 2004 it became public that his well-being was in decline. After giving a TV speech before a large audience in Santa Clara, he fell to the ground; he needed surgery and convalescence. On 26 July 2006 he barely escaped death from a severe intestinal haemorrhage. The first surgical treatment was unsuccessful; after several emergency operations his health was slowly restored. Meanwhile, he had temporarily conceded all of his government and party positions to his brother Raúl, who was already his deputy in most functions and was officially designated as his successor in 1997. The only post he preserved was that of First Secretary of the Party.

Cuban TV showed a bedridden Fidel, visited by his brother and his friend Hugo Chávez. Other Latin American friends paid a visit. Fidel reappeared in public, albeit in a sort of semi-retirement. He started an extensive series of 'Reflections of Compañero Fidel' in *Granma*. In February 2008 the transfer of power was made official by Raúl's election as president in parliament. In 2011, Raúl also became First Secretary and Fidel was henceforth referred to as the 'Historical Leader of the Revolution', rather than the 'Comandante-en-Jefe'. As Hoffmann justly remarked,[1] it was a change from charismatic to institutional leadership. Raúl Castro took command of the Party and the government, explicitly announcing that he was appointed 'to maintain socialism'. But he also announced the need for reforms and, referring to 'the biological factor', the need for a generational shift.

At first, Raúl's appointments seemed to indicate the contrary. He promoted or brought back several of his old military comrades in key

positions within the Party and government. But in February 2013, five years after his presidential election, he announced his future retirement in 2018. As Deng Xiaping had done in China in the 1980s, Raúl also instituted a maximum of two legislative terms of five years each for all elected representatives and office holders, thus providing for a political generation shift for the future. At the same time, he discharged – with full honours – some of his most trusted military friends and civilian cadres, assigning them as advisers of the Central Committee of the Party and other key institutions. He designated Miguel Díaz-Canel, then fifty-two years old – appointed minister of higher education in 2009 and vice-president of the Council of Ministers in 2012 – as first vice-president of the Council of State as well. Most foreign observers consider this double appointment to be a pre-selection for Raúl's succession.

Raúl's programme of 'structural and conceptual reforms' – announced as an 'updating of the model without abandoning socialism' – would be implemented 'without alacrity but also without interruption' (July 2007) and would result in 'increasing inequality but in moderate terms'.[2] Some of these reforms were modernizations, related to the following: private property titles; the possibility of selling real estate and vehicles; permission to buy or import mobile phones, smartphones, DVDs, iPods, tablets and USB sticks; a legal increase of five years in the pension age; the annulment of the prohibition on lodging in tourist hotels; permission to travel abroad for two years for all citizens; the possibility of renting rooms or apartments to foreign tourists; and the possibility of salary increases in the non-state sector. Campaigns to tackle corruption were announced but their results were not made public.

Some reforms are really structural, such as the possibility of acquiring property in the agricultural sector, the possibility of contracting salaried labour, and the possibility of creating small-scale enterprises – especially in the restaurant, service and tourist sectors. Other reforms were announced but, up to now (2016), have not yet been implemented. In 2010, for instance, the government published its decision to dismiss 1.3 million workers, around 20 per cent of the national workforce. They would be relieved of their duties in the state sector and would find self-employment 'outside the government

sector': in the informal economy. The government published a long list of professions that would now be legal; it was in fact a legalization of the existing informal economy. The shock wave this announcement produced prompted the government to postpone its implementation. Another announced reform, the abolition of the dual currency system and the possibility of a gradual devaluation of the CUC (a lifeline for all Cuban households with family members abroad), was also met with public concern; in 2016, the reform was still undergoing a feasibility study.

The freedom to travel abroad resulted in a new, albeit silent, migration wave between 2010 and 2015. Cubans who obtained a passport were caught in a kind of Catch-22 situation: they could buy an airline ticket and travel to another country, but one after another the neighbouring countries in the region refused to provide in-flight visas. The only country that accepted Cubans without a visa, Ecuador, attracted so many visitors that it withdrew the possibility of temporary residence. The outmigration during the last three years is estimated to have encompassed 30,000 to 40,000 people per year.

In the first decade of the twenty-first century, Cuba's economy depended substantially on the generous Venezuelan oil deliveries and the salary transfers of the Cuban medical and other experts resid ing in Venezuela. Most of these transfers were paid directly to the Cuban state and helped the country import essential foodstuffs, medicine and industrial inputs.[3] The economic asymmetry between Cuba and Venezuela (in 2012, the bilateral trade amounted to 21 per cent of Cuba's GDP and 4 per cent of Venezuela's GDP) is balanced by Cuba's social and political support mechanisms: the doctors, paramedics, teachers and other professionals who staff social missions – the base of the Venezuelan government's popularity. In addition, Cuba provided and still provides (2016) high-level intelligence and military advisers to the Venezuelan security services, who monitor dissidence and conspiracies. Cuban military advisers support the Presidential Guard. Intelligence and military advisers are deployed directly in military units and serve at the Ministry of the Interior and Justice, in military intelligence and for the Servicio Bolivariano de Inteligencia Nacional (SBIN, National Bolivarian Intelligence Service). In 2009 a formal Cuban military coordination group was

established. The Venezuelan armed forces altered their former US-inspired military doctrine and adapted the Cuban model of protracted warfare, which foresees the incorporation of civilian militias in the event of an (American) invasion.

The Cuban–Venezuelan partnership was initiated by and established on the basis of a strong personal friendship between Presidents Fidel Castro and Hugo Chávez. Chávez, who in October 2012 had won the election for his third six-year presidential term, underwent cancer surgery in Havana in December of that year. Maduro assumed power as interim president and Chávez returned in March 2013 to Venezuela to die in his country. The two friends, Fidel Castro and Hugo Chávez, are now succeeded by Presidents Raúl Castro and Nicolás Maduro. Initially it appeared that Raúl was holding back in fully supporting the Bolivarian Revolution, but the new presidential duo quickly regained a political and personal friendship. Already during Chávez's last years in government and even more obviously under Maduro's administration, Venezuela was a house divided. Economic malaise, galloping inflation, a sharp decrease in the world oil price and growing opposition brought the Venezuelan economy to the brink of a breakdown.

Under Raúl's presidency, serious progress was made with regard to the dialogue with the Catholic Church. A painful incident in 2010 triggered the beginning of an improving relationship between the government and the episcopate.[4] The protest group Damas en Blanco (Women in White), spouses and female relatives of prisoners, used to demonstrate every Sunday morning around the cathedral in Havana. Counter-demonstrators intimidated the women and pursued the protesters into the church. The hitherto very guarded episcopate thought that 'enough was enough' and wrote a letter to Eusebio Leal Spengler, the Historian of Havana, also in charge of the restoration of the historical centre of the capital and a close friend of Raúl, to request a high-level meeting. As a consequence, the Cuban president and Cardinal Jaime Ortega y Alamino initiated a 'dialogue on issues of mutual interest between the Cuban state and the Catholic Church in Cuba'. Afterwards, the cardinal made several trips to Washington. This budding relationship also permitted a much better understanding between Cuba and the Vatican. In 2013, when the Argentinian cardinal

Jorge Bergoglio – in whose ideas one can trace some affinity with Liberation Theology – became Pope Francis, the Vatican functioned as an intermediary between Cuba and the United States.[5] It paved the way to restoring diplomatic ties and the normalization of relations between the two countries.

Three revolutionary phases

Cuba's relations with the rest of Latin America and the Caribbean, especially with the left and the armed left, can be categorized into three distinct phases: the years of revolutionary fervour (Chapter 4), the mature years of the 1970s and 1980s (Chapter 5), and the period of soft power from the 1990s to the present (Chapter 6).[6] For the entire period, Cuba was the referential country for nearly all Latin American revolutionary and post-revolutionary movements and insurgent generations. The island provided support to the Latin American countries during the long decades of military dictatorship. It provided shelter to the many persecuted and refugee exiles. It was always the political and medical recovery house for thousands of wounded or crippled guerrilla fighters and other political 'undesirables' in their own countries. Cuba was always loyal to their political friends and to those who took up weapons to struggle against colonialism and for independence. Despite its relatively small population, Cuba's military participated in African liberation wars and its special forces trained guerrilla and resistance movements in most of the Latin American and Caribbean countries.

One special organization, the Departamento América (and its institutional predecessors), was the vital link among all Latin American and Caribbean revolutions and rebellions. For more than three decades it was directed by Manuel Piñeiro, previously a guerrilla *comandante* in Raúl Castro's second Frente during the insurgency who became a trusted friend of Fidel and Che Guevara. He turned the Departamento into an elite force, functioning as the eyes and ears of Fidel Castro, the liaison with the armed left, and the monitoring instrument for Latin American and Caribbean politics. The hand-picked members of this elite group were political operators who circulated among three key institutions: the Ministry of Foreign Affairs (Ministerio de Relaciones

Externas, MINREX), the Ministry of the Interior (Ministerio del Interior, MININT) and the Cuban Institute for Friendship with the Peoples (Instituto Cubano de Amistad con los Pueblos, ICAP), a kind of informal Ministry of Foreign Affairs.

In 1959, Che Guevara famously asserted that 'Cuba does not export revolutions, just ideas'.[7] One can, however, argue about the validity of this thesis. In the 1960s, Fidel Castro, Che Guevara and Manuel Piñeiro were convinced of the possibility of replicating revolutions by training and assisting guerrilla movements, starting from rural guerrilla focal points (*foquismo* tactics), being supported and protected by the peasant population, and creating national insurgency movements. In fact, in many cases the rebel forces emerged as splinter parties after secessions and split-offs – via schisms and ideological disputes – with the existing communist parties. Cuba actively trained, supported and sometimes even sent Cuban advisers to incipient guerrilla organizations in the region. Tragically, all these efforts failed. All guerrilla movements in the 1960s were overwhelmed by the police, the army or both security forces together. Very few movements survived. At best, as in the case of Colombia and Guatemala, they had to seek refuge in the underdeveloped rural areas, where they could hide, or they had to go into exile in Cuba or Mexico. The dominant Cuban ideas about guerrilla warfare in the 1960s did not withstand the proof of practice. This was especially the case for the emphasis on rural *focos*.[8] In the guerrilla wars of the 1960s, guerrilla movements were not victorious in rural environments; they could hide there and become 'invisible'. But time and again, regular armies defeated rural insurgency movements, usually after barbaric counter-insurgency campaigns. In their revolutionary praxis, many guerrilla leaders underestimated the immense difficulties of incipient guerrilla movements and, very probably, the supposed enthusiasm of the population that was directly involved. After the Cuban Revolution, many South American armies, such as the Bolivian, Brazilian, Colombian and Peruvian armed forces, received advanced intelligence and counter-insurgency training through US military support programmes. They were also capable of mobilizing large paramilitary auxiliary forces.

The theoretician of the *foquismo* approach, Che Guevara, was murdered after being captured by the Bolivian military. With the

wisdom of hindsight, one can seriously doubt the good sense of the 'export model' of foreign – in this case, Cuban – *guerrilleros* to the Congo and to Bolivia. But no one can question Guevara's courage and heroism. As Ramiro Alarcón, number three in Cuba's political hierarchy until 2013, rightly commented: 'I do not know how many ministers or cabinet members voluntarily left their posts to "go to the mountains", to become *guerrillero*.'[9] The Cuban OSPAAAL cultivates his political legacy.[10]

In the 1970s and 1980s, Cuba's military role was mainly focused on Africa. When Cuba sent in revolutionary assistance, it was through strong army detachments and thousands of civilian internationalists. A new kind of leftist government emerged in Latin America and the Caribbean: progressive, reform-minded military regimes and elected governments of a socialist signature. A more moderate Cuba made alliances with all new leftist authorities. In Latin America, Cuba sought and found relationships with progressive reform-minded military governments in Peru, Panama, Bolivia and Ecuador. It heavily supported the elected socialist government of President Allende in Chile. It sustained its support to rebellious movements and guerrilla movements struggling against the many military dictatorships in the region. It tried to unify the emerging rebel movements against the military regimes. In the case of Chile, it also actively supported a civilian coalition against the Pinochet regime. Cuba's support to the Central American guerrilla was long-standing and significant. Training and assistance were professionalized; the emphasis on forging organizational unity and on military operations grew. Many rebel leaders and cadres were trained on the island. They all observed and studied the course of the Cuban insurgency and the Cuban Revolution. Support from the local population and especially from the student movements, trade unions and peasant associations became a priority in discussions with the visiting guerrilla leadership.

In the 1970s and 1980s, Cuba consistently tried to unify guerrilla movements under umbrella organizations like the Coordinadora Guerrillera Simón Bolívar (CGSB) in Colombia, the Frente Sandinista de Liberación Nacional (FSLN) in Nicaragua, the Frente Farabundo Martí para la Liberación Nacional (FMLN) in El Salvador and the Unión Revolucionaria Nacional Guatemalteca (URNG) in Guatemala.

This marks a difference in comparison with the 1960s, when the Cubans trained a number of small guerrilla organizations in the same country, sometimes competing with one another. Even more than in the 1960s, Cuba functioned as a kind of general medical recovery centre for all injured *guerrilleros* or members of the Latin American and Caribbean left. In all cases, Cuba was very generous with medical assistance. It was probably the most altruistic Cuban contribution to the Latin American revolutionary generations.

After the disintegration of the Soviet Union and the dissolution of the COMECON, many of Cuba's military or related facilities that supported the existing guerrilla movements were considerably reduced. During the Special Period, Cuba survived at great social cost, but it never ceased to provide medical assistance to the poor and disadvantaged. On the contrary, in this period Cuba expanded its soft power by sending medical brigades to poor regions in Latin America, the Caribbean and Africa. It also provided emergency assistance in the case of natural disasters and its literacy experts and teaching personnel went on internationalist 'civilian missions'. Direct support to the guerrilla was replaced by networks of mutual support among friendly governments. In terms of internationalism, civilian cooperation (i.e. medical brigades, literacy teams) replaced former explicit support for revolutionary organizations. Cuba found a strong ally in Chávez's Venezuela, whose government announced a far-reaching reform and subsidy programme of 'socialism of the twenty-first century'. Cuba and Venezuela founded an international structure of friendly countries with the same ideological preferences: the ALBA group of countries. After 2000 the two leading countries cooperated in developing and financing medical and literacy campaigns in many Latin American, Caribbean and African countries.

At the turn of the century, the Departamento América was charged with deepening relations with friendly and adverse governments, maintaining contacts with social movements of all kinds, representing the Party, and assisting in peace negotiations. It was substantially involved in the peace agreements in Guatemala and Colombia. As in the previous two phases, its functionaries remained well informed about the actions of domestic political actors. It also functioned as the PCC's liaison with the ALBA countries and the leftist governments of

Argentina, Brazil, El Salvador, Paraguay and Uruguay.[11] In Ecuador it tried to convince the indigenous movements to support President Correa. It did not succeed, although Cabrera – a highly appreciated representative – was invited to be the *padrino* (most important guest and benefactor) of the yearly festivities of the Confederación Nacional de Comunidades Indígenas Ecuatorianas (CONAIE, National Confederation of the Ecuadorean Indigenous Communities), an honour envied by all national politicians.[12] It also helped that the presidents of Brazil (Lula, Dilma), Bolivia (Morales), El Salvador (Sánchez Cerén), Nicaragua (Daniel Ortega) and Venezuela (Chávez, Maduro) had all been involved in Cuban friendships over several decades.

What remains?

Comparing Cuba with countries in the region with a similar population size, one can easily detect the enormous differences in terms of political significance and status. Cuba has a population of 11 million (2016). There are demographically comparable nations in the region.[13] But Guatemala, Haiti, Honduras, El Salvador and Nicaragua were war-torn societies for most of the second half of the twentieth century and still suffer from the consequences of those wars. Regime instability was a characteristic of those countries for decades. The economy of the Dominican Republic is that of a resort island, highly dependent on American tourism and the American economy. Jamaica also is a resort country, but it is as well a state widely known for its drugs and extreme violence. Puerto Rico is an American dominion.

In comparison, Cuba is a country with high political significance and a reputable history as a revolutionary and influential power-house, and an indestructible reputation as development donor for the poor and the underprivileged. In strictly geopolitical terms, it is a crucial country in the Greater Caribbean. With its strategic position in the Gulf of Mexico, and its short distance from the United States (Florida, 90 miles), Mexico (Yucatán, 120 miles), Haiti (50 miles) and Jamaica (90 miles), it is without a doubt the most important country in the Caribbean.[14] Furthermore, since January 1959 Cuba has been a country with a stable regime for nearly sixty years. It removed a dictator whose rule was strongly supported by the United States. It opted

for its own revolutionary trajectory and it defied all American efforts to topple its government, to obliterate its economy and to invade the island by force. In spite of efforts by the hegemonic United States, Cuba encouraged and assisted emerging movements and governments of the left in the western hemisphere.

Cuba supported guerrilla movements in nearly all countries of the Latin American and Caribbean region and it assisted leftist movements and governments wherever they were to be found. Initially, the Cubans basically advised and trained small guerrilla movements, many of them headed by urban intellectuals, student leaders or ex-members of the existing communist parties, and in some countries also ex-members of the armed forces. It took them time to understand the idiosyncrasies of the indigenous population, its uses and customs, its religious codes and languages. The Cubans were not the only ones who had to learn to understand the complex social and moral fibre of the descendants of the pre-Iberian peoples. Also, the first generation of guerrilla leaders who sought to emancipate and liberate the poor and neglected had enormous difficulties in understanding and liaising as equals with the non-Spanish-speaking ethnicities. And this was one of the reasons why the military – always recruiting from the indigenous population and at least used to respecting the traditional indigenous order – relatively easily crushed the emerging guerrilla movements in the Andean countries and in Central America during the 1960s and part of the 1970s. It is also one of the reasons why the Nicaraguan Revolution met armed resistance from the 'indigenous minorities' on the Atlantic coast. In fact, in the early years of the twenty-first century, when Bolivia's president Evo Morales created constitutional space for a multi-ethnic and multinational country, the Latin American left took explicit interest in the 'indigenous question' as a national priority of the highest importance. With respect to the Cuban international cooperation, it has to be mentioned that the Cuban and afterwards Cuban-Venezuelan literacy programmes – '*Yo, sí puedo*' – are the first in the world that were developed in the native languages of Latin America (Aymara, Quechua) and of Africa.

But having learned the lessons from failures and convinced of the necessity of unity, the Departamento América explicitly and continuously tried to forge unitary guerrilla organizations in Argentina,

Colombia, El Salvador, Honduras, Guatemala and Nicaragua. Only in Mexico (where the Mexican government guaranteed unhindered diplomatic and other facilities) and after the 1960s in Peru (the Cubans detested the murderous Shining Path guerrilla that terrorized the country in the 1980s and the early 1990s) did the Cubans abstain from support for existing guerrilla movements.

Cuba acquired and maintained an enduring reputation as a revolutionary stronghold in two continents: Africa and Latin America. For decades it was one of the leading countries in the NO-AL movement, a political partner equal in importance to India, China, Indonesia and Egypt. It fought (and won) a proxy war in Angola, against armed movements that were supported by the United States and China. In Latin America and the Caribbean, no country remained unaffected by Cuba's aspirations. During the twenty-five-year period of military dictatorships in the region, the island was the safe haven and shelter for political exiles and refugees.

Economically, Cuba depended heavily on subsidies, donations and financial and technical support from the USSR for three decades. During these thirty years, Fidel Castro and his brother Raúl were depicted as lackeys of the USSR. Nevertheless, Chapters 4, 5 and 6 demonstrate that Cuba always acted according to its own vision and followed its own call of duty. And then there is the fact that the Cuban leadership maintained its socialist trajectory more than twenty-five years after the implosion of the Soviet Union. Cuba remained a socialist country with regional and international ambitions, this time not through armed force but through soft power; it sent medical brigades, paramedic personnel, teachers and literacy experts to countries in Latin America and Africa. Even in strict technical terms, Cuba's development aid is non-political, efficient, directly targeted at poor people, and based on the country's decades-long experience in organizing instant help.

Discussion

Very probably, the Cuban government is opting for a sustained model of a one-party regime, maybe comparable with those of Vietnam or China, while reforming the national economy. That means governing through the PCC as the vanguard party preserving strong ties with

the armed forces and the public sector. It also means transforming the vital and significant economic sectors in terms of infrastructure, know-how, technology and management via joint ventures with foreign (European, American, Russian, Chinese and Latin American) capital while gradually expanding micro, small and medium-sized national private enterprises. At the same time Cuba's explicit policy is to maintain the benefits of the country's socialist system: free and accessible education and public health, elementary provisions for all and public security ensuring a basically crime-free society, the four basic differences that distinguish Cuba from all other Latin American and Caribbean nations.

At the same time, at present (2016) Cuba faces a future with conflicting perspectives. First, the necessary generational shift of the Cuban leadership, due to the ageing generation of old revolutionaries. The members of this generation are reaching the last phase of their lives. Nearly all were born in the late 1920s, 1930s and 1940s. At present they are elderly or very old. Fidel Castro, born on 13 August 1926, is ninety years old; his brother and successor (Raúl was born on 3 June 1931) eighty-five. They belong to the oldest of their generation; the youngest are surpassing the ripe age of seventy. Nearly all are retired, with the exception of a few elected office holders, cabinet members, ministers and vice-ministers. Fidel was, and still is, the charismatic and legendary historical leader; most Cubans were born while he was the Comandante-en-Jefe. Raúl is less charismatic but has the same legitimate revolutionary birthright as his brother; a more pragmatic person, he was also the brilliant organizer of the Cuban armed forces. But in 2018, who will be invested with the revolutionary legacy? The younger guard of Party leaders and cabinet members, as well as the chosen representatives in Party and parliament, appear in public as capable administrators and cautious civil servants rather than popular leaders who will galvanize the nation about the state of the revolution.

Secondly, all this is happening at the time of a certain rapprochement with the United States, after decades of open confrontation. Both countries have maintained diplomatic relations since July 2015. But there are two controversial issues that stand in the way of a further entente: the revoking of the still-continuing embargo and the transfer

of Guantánamo. The situation is delicate because improved relations with its mighty northern neighbour are a necessity for Cuba's economy and trade possibilities. Its economy is in transition, its standing in terms of solvency is improving and the uninterrupted and contininuous stream of remittances from family members of the Cuban-American diaspora is an essential source of family income in urban Cuba. However, it was the United States that during the Cold War and thereafter explicitly tried to tear down reform-minded regimes. Sometimes it reached a form of peaceful coexistence, as in the case of Velasco's Peru and Torrijos' Panama in the 1960s. However, in the case of Guatemala in the 1950s, the Dominican Republic in the 1960s (twice), Chile in the 1970s, Grenada and Panama in the 1980s, it successfully assisted in coups or organized invasions. In the case of Sandinista Nicaragua in the 1980s it preferred covert operations damaging vital (harbour) infrastructure and it trained and financed counter-insurgency groups in Honduras, Costa Rica and on the Atlantic coast that resulted in a bloody civil war, the Contra war. In the case of Cuba it tried to wreck its economic development though covert actions and a trade embargo that endures to the present. In the case of Venezuela it played an ambiguous role in the coup against elected president Chávez. It also implemented a series of sanctions against the Venezuelan oil conglomerate PDVSA.[15] There is a sound reason for continuing suspicion and distrust of the most formidable military power in the world, which in the last fifty years nearly always reacted with hostility to progressive regimes in the western hemisphere.

Thirdly, the years 2015–16 did not favour Cuba and the countries that maintained close relations with the Cuban Revolution. During the last ten years, Cuba could count on the sympathy of the presidents of Argentina, Bolivia, Brazil, Ecuador, El Salvador, Nicaragua, Peru and Venezuela, and in general of heads of government and states in the Caribbean. But in 2015, after elections in Argentina, a president of the right came to power, as in Peru in July 2016. The presidents of Bolivia and Ecuador will not opt for a new presidential term. And in May 2016 Brazilian president Rousseff left the presidential palace after an impeachment procedure; the new government follows a neoliberal route. Because of the economic difficulties in Venezuela, Cuba has recently been confronted with a substantial reduction in the oil

deliveries from its most loyal partner country.[16] It means, at least in the near future, tightening the belt in many Cuban households. That is the short-time perspective.

The long-time assessment, however, is very different. But when all is said and done, Cuba's legacy to the region is extraordinary. Cuba did and does matter, in the region and in the Third World. It the twentieth century, it decisively influenced the national political arena in many African, Latin American and Caribbean countries. During the decades of the military dictatorship in the western hemishpere it was a safe haven for refugees of the left, the centre and the right. The restoration of elected governments in the entire region is, at least partially, due to Cuba's assistance and support for those who fought against tyranny and dictatorship. In the twenty-first century, Cuba, despite its economic difficulties, acted and acts as a generous international donor with medical and literacy missions, in which it has enormous experience. It notably contributed to the peace processes in Central America and Colombia, more than the United States. The very presence of democratic centre-left and leftist governments in Latin America is at least part of the heritage of the Cuban Revolution. The Cubans kept the flame of resistance burning through decades of dictatorial persecution and civil wars in the region. Most governments in Latin America and the Caribbean cannot say the same.

APPENDIX: BIOGRAPHICAL DATA OF INTERVIEWEES

· · · · · · · · · · · · · · ·

Abreu, Ramiro. Born in 1942, sociologist, PhD in History, MINREX, combatant Bay of Pigs and Angola, Departamento América (section head Central America) for 35 years, member Central Committee PCC, interviews 23 March, 19 and 25 October 2011 and 22 February 2015.

Aguilar, Graciela. Born in 1936, M 26-7, functionary MINFAR and Ministry of Labour, interview 23 March 2011.

Alvarado, Percy. Born in 1949, Guatemalan-Cuban, political scientist, double agent DSE, retired as colonel MININT, interview 7 February 2012.

Álvarez, (Consuelo)Elba. Born in 1942, Socialist Youth and 1st Frente Rebel Army, director documentaries ICRT and ICAIC, interview 30 March 2011.

Amát, Carlos. Born in 1930, † 2014, M 26-7, attorney general, rector of the Universidad del Oriente, minister of justice, ambassador to Canada and Switzerland, DG Latin America MINREX, interview 25 May 2011.

Antelo, Carlos. Born in 1943, combatant 'war against bandits', Departamento América, diplomat with postings in Colombia, the United States and Venezuela, interviews 24 and 27 October 2011.

Aranguren Echeverría, Emilio. Born in 1950, studied for priesthood in Havana, in 1991 auxiliary bishop in Santa Clara, bishop of Cienfuegos in 1995, in 2005 bishop of Holguín, also in charge of the Human Rights Commission. Between 2007 and 2011 member of the presidency of the CELAM, interview 4 August 2010.

Arce, Reinerio. Born in 1951, sociologist and psychologist, professor University of Matanzas, secretary general MEC, member executive committee FUMEC, president Consejo de Iglesias de Cuba and rector Presbyterian Seminary of Matanzas, interview 13 February 2012.

Balconi, Julio. Born in 1946, Guatemalan, general and peace negotiator (1991–96), minister of defence Guatemala (1996), interview 15 April 2010 (Guatemala City).

Bell Lara, José. Born in 1939, professor of development studies FLACSO, University of Havana, interview 23 September 2011.

Bernal, Joaquín. Born in 1940, labour union leader, Socialist Youth, leader CTC, labour movement training in Moscow, deputy member Central Com-

mittee, Secretary of International Relations CTC and coordinator CPUSTAL, interview 31 July 2012.

Buajasán, José. Born in 1937, M 26-7, DIER, DSE, retired as a colonel MININT, interview 31 March 2011.

Cabrera, Alberto. Born in 1949, militia member Bay of Pigs, DGLN, Departamento América with postings in Colombia, Ecuador, Panama, Uruguay, Venezuela and ICAP, interview 14 February 2012.

Carcaño, Dora. Born in 1935, Spanish-Cuban, Socialist Youth, women's section, secretary general of FMC, head regional office FEDIM, member Central Committee PCC, interview 6 February 2012.

Cárdenas, Osvaldo. Born in 1943, M 26-7, sociologist, DIER, VMT, DGLN, Departamento América (section head Caribbean), ambassador to Surinam, lives in Jamaica, interview 18 January 2012 (Havana).

Carmona, Héctor. Born in 1935, M 26-7, Fidel Castro's personal helicopter pilot, combatant Angola, retired as lieutenant colonel FAR, interview 6 October 2011.

Castañeda, Humberto. M 26-7, combatant 2nd Frente Rebel Army, political scientist, MINREX and posting in German Democratic Republic, VMT, DGLN, Departamento América, postings in Barbados, Guyana, Honduras and Guatemala, interview 8 November 2012.

Castellanos, Alberto. Born in 1933, M 26-7, lieutenant Rebel Army, bodyguard Che Guevara, participant of guerrilla Massetti in Bolivia and Argentina, captured and amnestied in Argentina, MINFAR, adviser in Nicaragua, retired as colonel FAR, interview 27 February 2012.

Celis, Luis Eduardo. Colombian, former member ELN Colombia, deputy director Corporación Nuevo Arco Iris Bogotá, interviews 13, 14 and 15 December 2012 (Havana), and 19 February 2013 (Bogotá).

Cervantes Padilla, Sergio. Born 1937, FAR, adviser guerrilla Guinea-Bissau, combatant Angola, Departamento América (Brazilian section) and several long postings in Brazil over 34 years, interview 10 February 2012.

Cervantes Vásquez, Lourdes. Born in 1961. Graduated at the ISRI in 1984, afterwards a functionary of the OSPAAAL, from 2012 secretary general, interview 19 November 2012.

Collazo, Ariel. Born in 1929, Uruguayan, MP, leader MRO, guerrilla training in Cuba, interview 10 November 2011 (Montevideo).

Cuza, José Luis. Born in 1940, M 26-7 and captain of the Rebel Army, FAR, retired as rear admiral, interview 11 October 2011.

Del Valle, Amador. Born in 1935, M 26-7, combatant Angola, retired as vice-minister of transport, interview 7 October 2011.

Díaz Vallina, (Ángela) Elvira. Born in 1933, M 26-7 and president of FEU, Director General Public Health MINSAP, interview 4 March 2011.

Escalante, Fabio. Born in 1940, Socialist Youth, arrested and tortured during insurgency, DIER, director DSE, chief adviser MINTER (Nicaragua), director Political Directorate MININT, interview 21 December 2011.

Estrada Lescaille, Ulises [Dámaso Lescaille]. Born in 1934, † 2014. M 26-7, combatant Rebel Army, G-2, combatant 'war against bandits', VMT, assisted Palestine Liberation Front and guerrilla Guinea-Bissau, Guinea and Cape Verde, assisted Che Guevara in Africa and Bolivia, DGI, vice-chief Departamento América,

MINREX, ambassador to Yemen, Algeria, Jamaica, Mauritania, DG Africa and Middle East and vice-minister MINREX, interviews 21 and 28 October 2011
Fernández Rueda, Carmen. Born in 1922, M 26-7, inspector education Pinar del Rio, PCC member, interview 4 April 2011 (sister of Laura Fernández Rueda).
Fernández Rueda, Laura. Born in 1918, M 26-7, UNO functionary, did not want to be a PCC member, interview 4 April 2011 (sister of Carmen Fernández Rueda).
Figueroa, Maria Antonia. Born in 1918, first treasurer M 26-7 in Oriente, superintendent educational system Havana, interview 18 March 2011.
Flores, Enrique. Colombian, *comandante* PTR and peace negotiator 1989–90, interview 20 February 2013 (Bogotá).
García, Jorge. Colombian, member urban community command M-19, community consultant Bogotá, interview 13 February 2013 (Bogotá).
García-Perez, Gladys [Marel]. Born in 1937, co-leader of sabotage cell M 26-7, organizer female militia Havana, diplomat and historian, interviews 4 and 5 October 2011.
Gómez, Ricardo. Born in 1933, M 26-7, official ministry of education, PCC member after many difficulties, interview 27 September 2011.
González, Maritza. Born in 1976, UJC, PCC, physician-histologist, professor and vice-rector ELAM, interview 9 November 2012.
Graña, Manuel. Born in 1937, DR and M 26-7, arrested and tortured during insurgency, captain of the Milicias, member of the Economic Commission of the Central Committee of the PPC, chair endowed by the Asociación de Combatientes in Havana, interviews 21 and 26 September 2011.
Guerra, Ángel. Born in 1937, M 26-7, member of the National Bureau UJC, director journal *Juventud Rebelde*, director journal *Bohemia*, interview 21 December 2011.
Hernández, Norberto. Born in 1940, M 26-7, VMT, 'friend of the president' Panama, vice-chief Departamento América, MINREX, ambassador to Nicaragua and Venezuela (twice), retired as vice-minister of culture, interviews 19 and 25 October 2011.
Ibarra, Jorge. Born in 1931, DR, FAR, distinguished professor of history University of Havana, interview 7 March 2011.
Joa, Jorge Luis. Born in 1941, M 26-7, combatant 3th Frente Rebel Army, MINREX, VMT, DGI, DGLN, Departamento América (section head) and posting in Mexico, interview 27 October 2011.
Juárez Ávila, Jorge. Salvadorean, combatant FPL, twice wounded and sent to Cuba for medical treatment and recovery, representative FLP in Cuba, professor of history at Universidad de El Salvador, interview 15 July 2015 (San Salvador).
Krämer, Raimund. Born in 1952, German, former functionary of the German Democratic Republic with postings in Nicaragua and Cuba, professor Universität Potsdam, interview 12 April 2010 (Potsdam).
Labrada Rosabal, Javier. Born in 1968, PhD in education, professor University of Physical Culture and Sport 'Manuel Fajardo', organizer literacy programmes in Bolivia, Haiti and Venezuela, interview 8 November 2012.
Lagos, Fedora. Chilean-Cuban, military engineer and communications officer FAR, with FSLN and FMLN in 1980s, former member PCCh and member PCC, manager telecom enterprises in Cuba and Venezuela, interview 7 February 2012.
Llibre, Antonio. Born in 1933, M 26-7 and captain of the Rebel Army, 1st Frente, and aide to Fidel Castro and Che Guevara, MINREX, minister councillor

Algeria, ambassador several European countries and delegation member to the COMECON, interviews 6 and 10 March 2011.

López Campos, Julio. Born in 1946, Nicaraguan, chief of the Sandinista Department of International Relations during 1980s, interview 2 June 2011 (Managua).

López Rodriguez, José Antonio. Born in 1942, M 26-7 and combatant Rebel Army, sociologist, MININT, Departamento América, diplomat with postings in Argentina, Colombia, El Salvador, German Democratic Republic and Nicaragua, interviews 8 and 10 March, 18 October 2011 and 1 December 2012.

Márquez, Roberto Rafael. Born in 1940, M 26-7, retired as colonel MININT, interview 6 July 2011.

Martínez Heredia, Fernando. Born in 1939, M 26-7, PhD philosophy, director department of philosophy University of Havana, director journal *Pensamiento Crítico*, Departamento América with posting in Nicaragua, staff member CEA, director general ICIC, interview 2 March 2012.

Mazola, Giraldo. Born in 1937, FEU and M 26-7, head department foreign relations M 26-7, founding president ICAP, vice-minister MINREX, ambassador to Algeria, Chile and Nicaragua.

Mora, Lázaro. Born in 1938, DR, vice-president FEU, MINREX (director NO-AL, director international organizations, Director General Latin America and Caribbean), ambassador to Zaire (Congo), Nigeria and Panama, interviews 8, 9 and 10 February 2012.

Morejón, Luis. Born in 1943, M 26-7, MINREX with posting in Moscow, director Latin America and afterwards vice-president ICAP, manager tourism, interview 1 March 2012.

Moreno, José Luis. Born in 1950, † 2015, physician specializing in traumatology, member of the first medical brigade in July 1979 in Managua, interview 5 December 2011.

Muro, Yolandra. Born in 1976, physician, FEU, member of parliament, chief medical mission Guatemala during Hurricane Mitch, vice-rector ELAM, Director General Primary Healthcare MINSAP, interview 9 November 2012.

Pérez, Niurka. Professor of sociology University of Havana, agricultural specialist, interview 9 October 2011.

Piedra, Carlos. Born in 1937, Presbyterian pastor, secretary general MEC, member executive committee FUMEC, member PCC, interview 21 November 2012.

Plazas, Nelson. Colombian, leader EPL, senior member NGO Fundación Cultura Democrática (FCD), interview 11 February 2013 (Bogotá).

Ravelo, Fernando. Born in 1937, M 26-7 and captain 2nd Frente Rebel Army, vice-chief AJR, VMT, DGI, DGLN, vice-chief Departamento América, ambassador Nicaragua, vice-president Biblioteca Nacional, interview 17 October 2011.

Regalado, Roberto. Studied in Moscow, DGLN, MINREX with postings in United States and Nicaragua, professor western hemispheric studies University of Havana, editor *Ocean Press*, interview 24 October 2011.

Rojas, Luis. Born in 1952, Communist Youth Chile, Chilean-Cuban artillery officer FAR, Frente Sur Nicaragua and FSLN, co-founder and representative of FPMR in Cuba, lives in Chile, interview 20 January 2012 (Havana).

Rosada-Granados, Héctor. Guatemalan, sociologist and anthropologist, peace negotiator (1993–96), interview 14 April 2010 (Guatemala City).

Terry, Héctor José. Born in 1937, FEU and DR, retired as vice-minister of public healthcare MINSAP, interview 2 September 2011.

Vargas, Alejo. Colombian, *comandante* ELN, professor of political science and vice-dean Faculty of Law and Political Science, Universidad Nacional, adviser ELN negotiations in Cuba 2006–08, interview 15 December 2011 (Bogotá).

Vázquez, Mario. Salvadorean, combatant Resistencia Nacional (National Resistance), professor of history UMAM, interview 3 September 2015 (Mexico City).

Villaraga, Álvaro. Colombian, leader EPL, senior member NGO Fundación Cultura Democrática (FCD) and director Dirección de Acuerdos de la Verdad (DAV) del Centro de Memoria Histórica, interview 11 February 2013 (Bogotá).

Villamizar, Darío. Colombian, former member EPL and M-19, functionary UNDP, historian of the M-19, interview 21 February 2013 (Bogotá).

NOTES

.

Chapter 1: Revolutionaries

1 Interview with Osvaldo Cárdenas (18 January 2012).
2 Melba Hernández and Haydée Santamaría participated in the assault on the Moncada barracks in 1953, the very beginning of the armed resistance of the M 26-7 movement. Vilma Espín and Celia Sánchez participated in the guerrilla activities in Sierra Maestra; Celia was a member of the general staff of the Ejército Rebelde (Rebel Army). Vilma Espín, once a graduate student at MIT and chief of the M 26-7 in the eastern region during the insurgency years, became president of the Federación de Mujeres Cubanas (FMC, Federation of Cuban Woman) in 1959. Celia Sánchez, the liaison between the Llano movement and the guerrilla forces in the sierra during the insurgency years, became the secretary of the Consejo de Ministros in 1961. Haydee Santamaría was the founding director of Casa de las Américas. Melba Hernández was the secretary general of OSPAAAL, the Organización de Solidaridad de los Pueblos de África, Asia y América Latina. Vilma had a close relationship with Raúl, Celia with Fidel, and Haydée with Armando Hart, Cuba's minister of education and afterwards of culture. Aleida March, Che Guevara's widow, had been a guerrilla member; she also published an autobiography (March 2011). Recent biographies of Vilma Espín and Haydée Santamaría were published in 2015 (Ferrer and Aguilar 2015 and Randall 2015).
3 Its successor organization is integrated into the International Relations Department (Departamento de Relaciones Internacionales) of the Central Committee of the PCC.
4 A shorter version of these interviews is published in Bell Lara et al. (2015).
5 A shorter version of these interviews is published in Suárez Salazar and Kruijt (2015).
6 I anonymized one interviewee as 'Diplomat A'. This taped interview was withdrawn after transcription and I can only use the information as background or as small quotes by an unrecognizable person.
7 Kruijt (2008).
8 See Hart (1997), Oltuski's (2000, 2002) memoirs and especially Sweig's (2002) brilliant analysis. These publications contribute to a reassessment of the importance of the Llano rebellion. Sweig's analysis is the most detailed

study hitherto; she analyses the insurgency period through the confidential correspondence between the key members of the political leadership of the M 26-7. Fidel Castro's military memoirs (2010a, 2010b) were published after handing over the presidency to his brother Raúl. A recent biography of Raúl Castro has been published by Klepak (2012). The four biographies about Che Guevara that I found most useful are those of Anderson (1977), Castañeda (1997), James (2001 [1969]) and Taibo II (2007). Gálvez (1979) wrote a biography of Camilo Cienfuegos; Del Valle Jiménez (2009) published his war diary on Cienfuegos's campaign, which he wrote on commission from Camilo.

Chapter 2: Historical context

1 Interview with Antonio Llibre Artigas (11 and 15 March 2011).
2 Zanetti (2013: 40).
3 Gott (2004: 44).
4 Data quoted in Gott (2004: 20) for 1544, in Ibarra Cuesta (1985 [1967]: 45) for the period from 1608 to 1700.
5 Here I follow Zanetti (2013: 54–65).
6 Louisiana was bought from France in 1803 by President Jefferson for 15 million dollars. In 1810, West Florida was declared independent from Spain by President Madison. East Florida followed in 1819, under President Monroe. In 1842, under President Tyler, the United States and Great Britain came to an agreement about the border with Canada. Under President Polk, Texas was annexed in 1845 and Oregon in 1846. After the Mexican-American War (1846–48) Mexico ceded other territories; the USA paid 15 million dollars. A new Mexican land strip, part of New Mexico and Arizona, was bought from Mexico in 1853 for 10 million dollars under President Pierce. In 1867, the United States bought Alaska from Russia for 7.2 million dollars under President Johnson.
7 See Harvey (2002) for a comparative history of the Wars of Independence.
8 Guerra Vilaboy (2010: 223–62).
9 Around 1850, for instance, the family bloc Aldama–Alfonso–Madan controlled forty sugar plantations, was owner of 15,000 slaves and – additionally – was proprietor of railways, warehouses and credit banks (Torres-Cuevas and Loyola Vega 2011: 165). This multi-family bloc was the backbone of the 'Club of Havana', which tried to push the United States to annex Cuba.
10 Henken (2008: 53).
11 Zanetti (2013: 174–5).
12 Torres-Cuevas and Loyola Vega (2011: 190–209); Zanetti (2013: 148–54).
13 Between 1850 and 1868 Spain sent several volunteer soldier battalions to Cuba in order to protect Cuba against annexation by the United States (Uralde Cancio 2009).
14 Gott (2004: 68–9).
15 Torres-Cuevas and Loyola Vega (2011: 216–20).
16 Here I follow Gott (2004), Girón Garote (2007), Thomas (1977), Torres-Cuevas and Loyola Vega (2011) and Zanetti (2012, 2013).

17 A term coined in Santo Domingo and afterwards used in Cuba to denominate the insurgents of the Liberation Army and again during Castro's insurgency in the 1950s as a revolutionary badge of honour.

18 Moro Barreñada (2007: 52–3).

19 The American administrations during the Cuban war years – Presidents Johnson, Grant and Hayes – strongly opposed the Cuban rebellion and even prevented the direct support of Cuban immigrants (Torres-Cuevas and Loyola Vega 2011: 257–9).

20 See Torres-Cuevas and Loyola Vega (2011: 324–34) for a more detailed analysis.

21 A recent short biography was published by Fernández and Fernández (2007). A more detailed one is that of López (2014). For more references see the Centro de Estudios Martianos en Havana (www.ecured.cu/index.php/Centro_de_Estudios_Martianos).

22 Juan Gualberto Gómez, the president of the Directorio Central de las Sociedades de Color – the association of mulatos and blacks (see below) – acted as his representative in Cuba (Zanetti 2013: 184).

23 Fernández Bastarreche (2007); López Díaz 2009: 120–21).

24 Cardona (2007: 66).

25 At the Museo Naval en Ferrol (Galicia, Spain), an entire room is dedicated to the battle of the Bay of Santiago de Cuba, where the Spanish fleet was destroyed.

26 The small remaining part of the Spanish overseas empire – the islands of the Marianas, the Carolinas and the Palaos – were sold to Germany at a price of 25 million pesos in June 1899 (Pérez Prendes Muños-Arraco 2007: 86; Jirón Miranda 2007: 376).

27 Gott (2004: 104).

28 In 1919, Cuba had 426 priests with Spanish nationality and 156 priests with a Cuban one (Zanetti 2013: 219). The influence of the Spanish episcopate, part of it with Falangist sympathies, remained strong until the late 1950s.

29 Gott (2004: 105–6).

30 Zanetti (2013: 195).

31 López Civeira et al. (2012: 3).

32 Zanetti (2013: 199).

33 US senator Platt was the president of the US Commission of Relations with Cuba.

34 Gott (2004: 110).

35 A dual system of pesos and dollars and the peg to the dollar was maintained until 1960, when the dollar was replaced by the Soviet rouble.

36 López Civeira et al. (2012: 44).

37 Pino Santos (1973: 31).

38 Gott (2004: 129).

39 Henken (2008: 78).

40 Venegas Delgado (2007).

41 López Civeira et al. (2012: 62ff.).

42 Mella was also the co-founder of the Universidad Popular José Martí, the Liga Antiimperialista, the Liga Anticlerical, and the Asociación de Nuevos Emigrados Revolucionarios Cubanos in 1928.

43 Castro Fernández (2008: 259ff.); Rodríguez (2010: 247ff.).

44 Bell Lara et al. (2014: 21).

45 See Briones Montoto (2008) for a detailed analysis of the period.

46 Between 5 and 10 September 1933. Its members were Ramón Grau San Martín, Guillermo Portela, José Miguel Irizarri, Sergio Carbó and Porfirio Franca. The Pentarquía appointed Batista as army chief with the rank of colonel.

47 The revolutionary fervour of 1930 had consequences for Cuba's involvement in the Spanish Civil War. While the Cuban episcopate and the *haute bourgeoisie* expressed their unquestionable sympathy for the Franco regime, Cuba's progressive forces supported the republican cause. Young Cubans volunteered for the International Brigades: Pablo de la Torriente Brau, a Cuban war journalist and lieutenant and political commissar of one of the brigades, eventually died. After Franco's victory, Cuba received many Spanish intellectuals and journalists who influenced the foundation of the Universidad del Oriente in 1947 (Fernández Muñiz 2009: 8–19). Other Spanish refugees, many of them *gallegos*, were also welcomed in Cuba (Vidal Felipe 2009). After Mexico (464 volunteers) and Venezuela (149 volunteers), it was Cuba (136 volunteers) that sent the highest number of participants in the International Brigades of all Latin American countries to Spain (Baumann 1979: 54). Cuba also benefited from the Spanish exiles. Many intellectuals and high government officials were welcomed on the island. In Cuba, several Spanish-Cuban refugee organizations were established, such as the Formación de Ex-Combatientes Antifascistas en Cuba and the Institución Hispanocubano de Cuba (Cuadriello 2009: 62, 126). See also Vidal Felipe (2009).

48 The Soviet Communist Party had tried, after Stalin's policy change at the 7th Congress of the Third International 1935, to form alliances with other progressive organizations. Grasping the possibility to be legalized in 1939, the party leadership changed its name to Partido Unión Revolucionaria Comunista (PURC, Revolutionary Communist Union Party). In 1944, the name was changed to Partido Socialista Popular (PSP, Popular Socialist Party). Blas Roca was its secretary general from 1934 to 1962, when the party merged with the two organizations that had triumphed in the Cuban Revolution, into the (PURS, United Party of the Cuban Socialist Revolution). See also Chapter 3.

49 By 1948 sugar represented 90 per cent of Cuba's total export value.

50 Pérez (1993: 80).

51 Zanetti (2013: 240–41). Grau was accused of having misappropriated 74 million dollars and his outgoing minister of education was accused of having pocketed 20 million dollars (Pérez 1993: 80).

52 Henken (2008: 91).

53 Sáenz Rovner (2008: 75ff.).

54 English (2007: 40–41).

55 See López Civeira et al. (2012: 226 ff.).

56 In 1950 the Cuban journal *Bohemia* published the results of an early survey about preferences for the presidential elections foreseen in 1952. The two most important candidates, Chibás and Batista, obtained 35 per cent (Chibás) and 15 per cent (Batista) respectively (López Civeira et al. 2012: 241).

57 An annotated selection of his essays and articles was curated by Alavez Martín (2009).

58 Batista also agreed to extensive promotions within the army's officer corps. Before the coup, the Cuban armed forces contained a total of 480 officers. A month later there were 800. Fifteen months later the number rose to 1,300 officers (López Civeira et al. 2012: 264).

59 English, who wrote a salacious story about the Mob connections in Cuba, interviewed the then 75-year-old Comandante de la Revolución and General William Gálvez Rodríguez in Havana in 2007. Gálvez, a combatant during Fidel Castro's anti-Batista insurgency in the Sierra Maestra and himself a proficient author (who also wrote about the mafia ties in Cuba, but mostly about the insurgency campaigns and the tactics of Camilo Cienfuegos and Che Guevara; see Gálvez 1979 and 1982), told him that, although the presence of the mafia was not a reason for the revolution, the casinos and the connections with the American gangsters symbolized corruption in the eyes of the rebels (English 2007: 20). Solomon (2011: 41) mentions that in the years before the Cuban Revolution, there were around two thousand brothels in Havana.

60 By 1958, Batista's personal fortune was estimated to be 300 million dollars, mostly invested in Switzerland, Mexico, Florida and New York. He also had abundant ventures in Cuba, especially in land, media outlets and tourist properties (Sáenz Rovner 2008: 114).

61 Zanetti (2013: 257–60).

62 Also an important organization of civil society, the Sociedad de Amigos de la República (SAR, the Society of Friends of the Republic), opposed the Batista dictatorship but opted for the strategy of dialogue and negotiations with the dictator. For details see Ibarra Guitart (2003).

63 Gott (2004: 158–9). Two PSP leaders, Juan Marinello and Carlos Rafael Rodríguez, had been Batista's cabinet members in the 1940s.

64 Pérez (1993: 89).

65 Data mentioned by Sergio Guerra, head of the Department of History at the University of Havana, during a seminar at the Universidade de Santiago de Compostela, 24 April 2014.

66 López Civeira et al. (2012: 267–70).

67 Cuesta Braniella (1997: 36). García-Bárcena was incarcerated, then exiled. In 1959 he was appointed Cuba's ambassador to Brazil. Other participants were Mario Llerena, Armando Hart, Faustino Pérez and Enrique Oltuski, all of whom later became prominent members of Fidel Castro's insurgency movement.

68 The formal foundation of the Movimiento Revolucionario 26 de Julio (M 26-7) was on 12 June 1955. The first national leadership comprised Fidel Castro, Antonio López, José Suárez Blanco, Pedro Miret, Armando Hart, Faustino Pérez, Haydée Santamaría, Melba Hernández, Pedro Celestino Aguilera González and Luis Bonito Milián. Frank País would later join the leadership as well (Bell Lara et al. 2015: 27).

69 Fidel and Raúl had a third brother, Ramón, who was the oldest of the three. Ramón also assumed tasks in the insurgency, but at a more modest level. There is a communiqué signed by Raúl Castro on 30 November 1958, in which he confirms that 'Compañero Ramón Castro Ruz is appointed Chief of Supply of the FAR [Fuerza Áerea Rebelde, or Rebel Air Force]' of the Second Frente (see Espín Guillois et al. 2011: 208).

70 Bell Lara (2007: 28).
71 Guerra Vilaboy and Maldonado Gallardo (2005: 53, 57).
72 Bell Lara (2007: 26).
73 A detailed study on the sympathies of the FEU members who overlapped between the M 26-7 and the DR is that of Nuiry (2002). See also Chapter 3.
74 Faure Chomón interviewed in *Granma*, 28 February 2011.
75 Cuesta Braniella (1997: 54).
76 Bell Lara (2007: 22).
77 The expeditionary forces had been trained by Alberto Bayo Giraud, a Spanish officer during the Spanish Civil War. Born in Cuba in 1892, he went to Spain at the age of six. He found exile in Mexico in 1939, and moved to Cuba in 1959. He lived and died there as a venerated general.
78 Ernesto (Che) Guevara, born in Argentina, had already travelled extensively across Latin America. During the Guatemalan Revolution of President and Colonel Arbenz (1950–54) he had been a political tourist. After the CIA coup against Arbenz in 1954, he – together with many other Guatemalan leftists – sought exile at the Argentine embassy in Guatemala City. After his release he went to Mexico, where he met Raúl Castro and other members of the proto-expedition of the *Granma*. In Mexico he was detained and shared a prison cell with Fidel. Former Mexican president Lázaro Cárdenas intervened to release the Cuban prisoners.
79 Portuondo López (1986) published a detailed testimony about the rebellion of 30 November 1956.
80 Anderson (1977: 212).
81 In 1957 the captured participants of the *Granma* expedition and the rebellion in Santiago de Cuba were brought to court. The president of the court, Judge Manuel Urrutia, however – quoting Article 40 of the constitution – ruled that the defendants had been acting within the legal context of the constitution. In 1959, Urrutia became the first president of revolutionary Cuba (López Civeira et al. 2012: 336).
82 Almeida (1987a, 1987b, 1988), after Fidel and Raúl, was the third *comandante* to lead a Frente (battle group). He published three small autobiographical notes on his experience as a prisoner, in exile in Mexico, and as a participant in the *Granma* disembarkation.
83 Sweig (2002: 14).
84 Ibid.: 43–5, 49. Bell Lara (2007: 18–19) mentions the Frente Estudiantil Nacional (FEN) and the Frente Obrero Nacional (FOB), which were extended by unifying the labour unions into a national Frente Obrero Nacional Unido (FONU) in 1958.
85 After he was incorporated as *comandante* of guerrilla Column 10 in April 1958, he died in combat during Batista's counter-insurgency offensive in July 1958 (López Civeira et al. 2012: 333).
86 On 24 May 1957 another disembarkation of twenty-seven members of a separate guerrilla expedition, headed by the British-Cuban World War II hero Juan Calixto Sánchez White, took place in the Bay of Cabonico. Fifteen of their members, including Calixto Sánchez, were killed in combat; others were imprisoned and a few managed to escape (López Civeira et al. 2012: 330).

87 Sweig (2002: 26–7). Masferrer, once a member of the International Brigades during the Spanish Civil War, initially supported the students who protested against Batista but rapidly allied with the dictator. He formed a group of anti-Castro enforcers, heavily supported by Batista. After 1959 he escaped to Florida, where he also had mafia contacts.

88 Cuesta Braniella (1997: 75ff.). Frank País had already provided Catholic and Baptist chaplains to the early guerrilla forces in the Sierra Maestra.

89 Quoted in Cuesta Braniella (1997: 85–6). Eventually, in February 1958, the PSP permitted their members to join the guerrilla. One of the first to join the guerrilla was Jorge Risquet, a sympathizer of the armed resistance against Batista who was elected as president of the Juventud Socialista in Havana in 1956. He had lived in Guatemala in 1954, where he met Che Guevara. In the Sierra Maestra he was incorporated into the Second Frente, commanded by Raúl Castro, and was appointed to organize the political education of the combatants (León Rojas 2006: 107 ff.). After 1959 he played an important role in Latin America but especially in Africa, as delegate in Congo-Brazzaville, ambassador in Angola, and later as peace negotiator on behalf of Cuba (see also Gleijeses 2002 and Risquet's introduction in Gleijeses 2007: vii–lv).

90 See Cuesta Braniella (1997, 2010).

91 Cuesta Braniella (1997: 383–6).

92 Sweig (2002: 25–6, 51–2).

93 Elvira Díaz Vallina, prominent leader of the urban resistance movement M 26-7, quoted in Cuesta Braniella (1997: 155). She also confirmed this event in her interview (interview with [Ángela] Elvira Díaz Vallina, 3 March 2011).

94 Guerra Vilaboy and Maldonado Gallardo (2005: 53, 57).

95 Cuesta Braniella (1997: 199–200).

96 The operation was organized by Sergio González (*nom de guerre* El Curita), chief of the action and sabotage team in Havana (Bell Lara et al. 2015: 33). To read more about the Havana underground movement, see Rodríguez Astiazaraín (2009). Here I also draw from an interview with Ricardo Gómez Rodríguez (21 September 2011), one of the participants in the urban underground in Havana who operated in the action and sabotage team of Sergio González. Gómez Rodríguez (2011) wrote a detailed account of this period.

97 Castro Ruz (2010a: 11).

98 See www.ecured.cu/index.php/Faure_Chom%C3%B3n_Mediavilla, accessed 9 December 2014.

99 He had commanded his Destacamento DR 13 de Marzo and joined the Frente of Che Guevara. After 1959, he was Cuba's first ambassador to the Soviet Union, a very important post but also very far away from Havana, the political centre of the revolution.

100 Sweig (2002: 114–15).

101 Pérez Jr (1993: 86–7).

102 Hart Dávalos (1997); Graña Eiriz (2008).

103 However, in February 1958 the leaders of the urban Brigadas Juveniles and the action and sabotage teams in Havana – Gerardo Abreu (*nom de guerre* Fontán), Sergio López (*nom de guerre* El Curita) and Arístides Viera (*nom de guerre* Mingolo) – were killed in action, a serious weakening of the urban

organizations (Rodríguez Astlazaraín 2009: 108–14). See also Meneses (1995) and Rodríguez Camps (2005) for more details

104 Calvo González (2014: 260–65).

105 Ibid.: 171–212, 104–6).

106 Macaulay (1978: 289).

107 Bell Lara et al. (2015: 33–4).

108 Sweig (2002: 120ff.).

109 A testimonial booklet about the strike was published by Álvarez Estévez (1999).

110 Present were Fidel Castro, Che Guevara, Faustino Pérez, René Ramos Latour, Vilma Espín, Celia Sánchez, Marcelo Fernandez, Nico Torres, Haydée Santamaría, David Salvador, Luis Buch and Enzo Infante (Sweig 2002: 150).

111 Oltuski et al. (2007: 323–40).

112 Sweig (2002: 153). A similar conclusion was reached by Macaulay (1978: 292).

113 Castro Ruz (2010a: 14–15).

114 Ibid.: 16. At the moment of the *Granma* expedition (December 1956), the Cuban army had around 27,000 personnel, the navy 6,000, and the police 7,650. The army's officers corps had 1 major general, 6 brigadiers, 17 colonels, 47 lieutenant colonels, 119 majors (*comandantes*), 258 captains, 736 first lieutenants, 736 second lieutenants, and 379 sub-lieutenants (Uralde Cancio and Rosado Ciró 2006: 183, 193).

115 Fidel Castro devotes an entire chapter to the preparations of the defence (Castro Ruz 2010a: 17–48).

116 A fact that clearly contributed to the prestige of the Rebel Army. Allowing captured officers to keep their weapons was not a habit of Fidel alone; Raúl, Che Guevara and Camilo Torres also followed this practice (interview with Antonio Llibre Artigas, 11 and 15 March 2011). See also Fulgeiras (2009: 60).

117 Castro Ruz (2010a: 704–5).

118 In the second part of his war memoirs, Fidel Castro mentions a correspondence with a soldier of the Guardia Rural, who asked for his permission to join the rebels. He was authorized by the Comandante en Jefe to 'go to the mountains' (Castro Ruz 2010b: 123–6; 'going to the mountains' was Cuban and afterwards Latin American slang for 'joining the guerrilla').

119 Notwithstanding the formal opposition of the PSP hierarchy, several young members of the Juventud Socialista, the youth branch of the PSP, joined the M 26-7 guerrillas and especially the second Frente of Raúl Castro. Among them, Jorge Risquet, Antonio Pérez Herrero and peasant leader José (Pepe) Ramírez would fulfil important functions in the post-1959 period.

120 Ibarra Guitart (2000: 259ff.).

121 Castro Ruz (2010b: 79–86).

122 A fine and comprehensive study of the urban underground in Havana and Matanzas is García-Pérez (2005).

123 The last of six air transports; for details see Buch (1995: 168–78). See also García-Pérez (2005: 107–13).

124 Macaulay (1978: 291) estimated the total strength of the Rebel Army on 20 December 1958 to be 7,250 combatants.

125 Batista, in exile, wrote several apologetic memoirs such as *Cuba Betrayed* (1962) and *The Growth and Decline of the Cuban Republic* (1964), presenting himself as an abnegated soldier fighting against Nazism and communism

and a statesmen financing production and public housing (Batista 1964: x, 144ff., 218ff.). His adherents, such as Riera Hernández (1966), wrote hagiographic biographies.

126 For a detailed day-to-day account of the situation between 25 December 1958 and 8 January 1959, see Graña Eiriz (2008: 350–452).

127 Guerra Vilaboy and Maldonado Gallardo (2005: 78–88). The jubilant triumph caravan is described in Báez and De la Hoz (2009).

128 A nice PR ploy, which successfully mesmerized the public. In 1960, another white dove perched on Fidel's shoulders when he spoke in public in Harlem.

Chapter 3: From insurgents to socialists

1 Here I rephrase ideas from Kruijt (2008, 2013).

2 Frank País had also rescued surviving members of Fidel Castro's first assault on the military barracks of Moncada in Santiago of Cuba, in 1953, and of Carlos Manuel de Céspedes in Bayamo.

3 A book with essays and documents about the student federation FEU (Federación Estudiantil Universitaria) was published by Nuiry (2002). Nuiry was the president of the FEU, a board member of the DR and the FEU's representative to the guerrilla movement M 26-7. See also Chapter 2.

4 See Trujillo Lemes (2011: 154 ff.).

5 Interview with José Buajasán Marravi (31 March 2011). Buajasán, a Lebanese-Cuban and a pious Catholic during the insurgency period, retired as Colonel of State Security after a long career in counter-espionage. After the Bay of Pigs victory he was in charge of disbanding all counter-revolutionary organizations of the Roman Catholic episcopate that had supported the invasion: 'There wasn't anyone dead, anyone wounded, nobody hit, nobody tortured, because it was an apparatus [...] formed by revolutionary people.' Buajasán also co-authored the Cuban report on Operation Peter Pan, the exodus of around 14,000 young children to the United States under the guidance of Catholic priests and church-related organizations, with the direct involvement of the CIA and the State Department (Torriera Crespo and Buajasán Marrawi (2000). See also Eckstein (2009: 12).

6 See Ortiz (2012).

7 Ramiro Abreu, a member of the Comité Central who spent more than thirty years of his professional career as the Cuban overseer of the Central American guerrilla (in El Salvador, Guatemala and Nicaragua), went to war – during the Bay of Pigs invasion – with a necklace around his neck with the medallion of the Virgen del Cobre, a gift of his mother (Abreu 2013: 91).

8 Bell Lara et al. (2012) published a series of interviews with women who participated in the first years of the urban underground.

9 The first peasant to be incorporated into the Rebel Army was Guillermo García Frías (nom de guerre Niquero). By the end of the insurgency campaign he was a comandante and deputy chief of the third Frente. He was appointed one of the twenty-eight Comandantes de la Revolución and is decorated as Hero of the Republic of Cuba. A member of the Comité Central of the Communist Party, he was also the vice-president of the Council of Ministers

and minister of transport. He published his memoirs (García Frías 2010). Another peasant, Lorenzo Castro (*nom de guerre* Pineo), joined the army as a simple soldier. By December 1958 he was a captain of the Rebel Army and retired as a brigade general at the Ministry of the Interior; he also published his memoirs (Lorenzo Castro 2007). A third example is García Peláez (2010), born a Cuban to Galician immigrants, who returned to Spain with his parents, worked in Asturias as a truck driver and then returned to Cuba. He participated in the guerrilla as a captain in the sierra in 1959, appointed chief bodyguard of Fidel, and retired as division general. He also published his memoirs. Combatants of the DR, like Ramón Espinosa Martín (2009), also ascended to the highest FAR echelons.

10 Interview with Ramiro Abreu (25 March 2011).

11 Quoted by León Rojas (2006: 25, 27–8), Risquet's biographer.

12 Interview with Luis Morejón (1 March 2012).

13 Interview with María Antonia Figueroa Araujo (18 March 2011).

14 Ibid.

15 Ibid.

16 Interview with Consuelo Elba Álvarez (30 March 2011).

17 Ibid. Marel García (see below) trained the first contingent of female militias. Pérez Caso (2011) describes the subsequent training of the militia women.

18 Interview with Antonio Llibre Artigas (11 and 15 March 2011).

19 Interview with Consuelo Elba Álvarez (30 March 2011).

20 Ibid.

21 After 1959, Amador del Valle Portilla was vice-minister of transport; he also fought in Angola (interview, 7 October 2011).

22 Interview with Gladys (Marel) García-Pérez (5 October 2011).

23 Cuba's formal government building, a copy of Washington's Capitol.

24 Interview with Carlos Amat Forés (25 May 2011).

25 Ibid.

26 Ibid.

27 Ibid.

28 Interview José Antonio (Tony) López Rodríguez (8 and 10 March 2011).

29 Interview with José Antonio (Tony) López Rodríguez (8 and 10 October 2011).

30 Interview with Ángela Elvira Díaz Vallina (30 March 2011).

31 Interview with Manuel Graña Eiriz (21 and 26 September 2011). Graña (2008) also wrote the seminal work on the combatants captured and imprisoned during the insurgency.

32 Graña (2008: 460, 471, 477).

33 Buch and Suárez (2009: 193).

34 Ibid.: 31.

35 Ibid.: 330 and Oltuski (2000: 1). See also the remarks of several leaders of the urban underground in Sweig (2002: Introduction).

36 Luis Buch, a friend of Guiteras and a respected member of the M 26-7, was the movement's representative in the United States and Venezuela before 1959. He was also cabinet secretary until 1962. Afterwards he served as a magistrate of the Supreme Court. Buch and Suárez (2009) is an annotated and edited compilation of two manuscripts that were intended to be parts of

his memoirs; Buch died in 2002. About the Cuban revolutionary evolution, see also Kapcia (2000, 2008, 2014).

37 Buch and Suárez (2009: 81).

38 There are other interpretations of this process. Martínez-Fernández (2014: 10, 56–61, 97–8, 219–20) sees this as the beginning of a master strategy of *divide et impera* (divide and conquer), as employed by Fidel throughout his entire career.

39 Interview with Ángela Elvira Díaz Vallina (30 March 2011).

40 That also resulted in changes to the cabinet composition: González Lage (2015: 40–43) analysed the changes between early 1959 and late 1960. In January 1959, of the 19 cabinet positions, only 9 were occupied by members of the two revolutionary movements. By the end of 1959, eleven of the nineteen positions were occupied by members with direct access to Fidel and four others were 'moderate' M 26-7 members. The DR had one minister (of the interior), while three people were 'civilians' (the ministers of trade, finance and economy). By the end of 1960, fourteen were '*fidelista*' members of the M 26-7 and two others were also M 26-7 members. In the meantime, the DR maintained their ministerial post and only two 'civilian' ministers remained (the ministers of trade and economy).

41 Sweig (2012: 38–9).

42 Gott (2004: 189).

43 Interview with José Bell Lara (23 September 2011).

44 Interview with Héctor Terry (23 September 2011). Terry, who retired as a vice-minister of public health, was (in his younger years) one of the transcribers of Fidel's public discourses.

45 Pérez Jr (2011: 242).

46 Borrego Díaz (2013 [1966]: 7).

47 Orlando Borrego Díaz, Che Guevara's vice-minister of industry, describes the early years under Guevara: 'The new administrators knew nothing. Once we appointed a boy from the FAR [Fuerzas Armadas Revolucionaria] who was younger than twenty years old. When we set up the Ministry of Industries, we already had hundreds of factories and things became unmanageable. We worked from nine in the morning until three or four in the morning. I finished every night with the Comandante until he told me, on one of these sleepless nights: "Hey, we're running low too often, let's make a Pact. We'll stay here until one o'clock in the morning"' (interview in *Página 12-El País* (Argentina), 15 June 2003, www.pagina12.com.ar/diario/elpais/1-21445-2003-06-15.html, accessed 10 July 2015); see also Mesa-Lago and Zephirin (1974). Many voluntary foreign experts, such as visiting ECLAC economists, were astonished by the chaotic atmosphere at JUCEPLAN. Dudley Seers, head of a visiting team of British economists, typified it as 'euphoric planning'. Even Zimbalist and Brundenius (1989), very friendly analysts, are critical about the long-term results of the Cuban planning system. In retrospect, even the Cuban economists on the planning board had their misgivings. Fabio Gobart Sunshine (son of one of the founders of the first Communist Party of Cuba in 1925) holds a PhD from Humboldt University, then in the German Democratic Republic. He commented that, during the formative years of the Cuban planning structures, when he and his team of econometrists delivered their first reports, the then minister of planning told him: 'No, no, this is not what

we want. We will do it Cuban style' (discussion with Grobart at the University of Havana, 15 February 2015).

48 Llovío-Menéndez, quoted in Gott (2004: 236).

49 In three large migration waves, in 1965, 1980 and 1994. For a more general analysis of the Cuban migration and successive Cuban generations in the United States, see Eckstein (2009). The 2000 census registered 1.24 million Cubans (853,000 Cuban-born) living in the United States. Of them, 67 per cent lived in Florida and 52 per cent in Greater Miami (Martínez-Fernández 2014: 220). Other migration streams were to Mexico, Venezuela, Canada, Ecuador, Panama, Costa Rica, the Dominican Republic and Spain.

50 Sweig (2012: 47–8).

51 Solomon (2011: 210).

52 The revolutionary tribunals had been sanctioned by President Urrutia and were witnessed by American newsmen (Solomon 2011: 83).

53 In the late 1990s, nearly all Cuban generals had been trained in the Soviet Union; see the interviews with Cuba's military in Báez (1996). By and large, they maintain good memories of their time in Leningrad or Moscow, and some of them even begin their memoirs with quotes from Lenin instead of Fidel or Raúl Castro.

54 About the escalation of violence I follow Bolender (2011), Hersch (1998: 185–221, 268–93), Livingstone (2009: 24–38), Martínez-Fernandez (2014: 53–6, 76–80), Solomon (2011) and the Cuban authors Alvarado Godoy (2003, 2007, 2011), Arboleya Cervera (2009), Báez (2005) and Escalante Font (2010). Fidel Castro's reflections on the 1960–62 period are in Ramonet (2008: 271–326). For a more detailed overview of US–Cuban relations and the consequences of the embargo, see Bernell (2011), Dávalos Fernández (2012), Nieto (2003) and Spadoni (2010). See Dominguez (1979, 1993, 2006) and Kapcia (2000, 2008, 2014) on Cuba's internal development. Very fine and detailed analyses of the intent to normalize US–Cuban relations are LeoGrande and Kornbluh (2014) and Ramírez Cañedo and Morales Domínguez (2014).

55 Reid-Henry (2009: 221).

56 Pavlov (1994: 5).

57 Reid-Henry (2009: 223).

58 For details, see Arévalo de León (2015), Gleijeses (1992), Hersch (1998), LeoGrande (1998), Sabino (2009) and Torres-Rivas (2011).

59 Officer (and later Rear Admiral) Cuza fought next to Fidel: 'I am the only officer of the entire armed forces that can say that Fidel fought at his side. At the Bay of Pigs [Playa Girón] we fought together. And when my FAL [rifle] projectiles were running out, I threw myself into the trench to recharge my weapon. And Fidel changed his position to protect me' (interview with José Luis Cuza, 11 October 2011).

60 Pavlov (1994: 40–42).

61 Ramonet (2008: 312).

62 The combat brigade remained in Cuba until September 1991, a month after the attempted coup against Gorbachev.

63 Pavlov (1994: 55).

64 Bain (2007: 27ff.). See also Bain (2012), Duncan (1985), Frankel (2004), Latrèche (2011) and Pavlov (2012).

65 Interview with Carmen and Laura Fernández Rueda (4 April 2011).
66 Interview with Héctor Carmona Heredia (6 October 2011).
67 See Rueda Jomarrón (2009) about the role of the Cuban militias.
68 Karol (1971: 46–7).
69 Interview with Fernando Martínez Heredia (2 March 2012).
70 As of July 1961; see González Lage (2015: 43).
71 Enrique Oltuski interviewed by Buch, in Buch and Suárez (2009: 354–6).
72 Ibid.
73 As vice-minister of planning he was the chief of the Junta Central de Planificación (JUCEPLAN), the National Planning Institute.
74 Interview with Jorge Ibarra Cuesta (6 October 2011). Ibarra is the author of Cuba's military history, which became the university textbook for student generations. He also wrote two influential studies about the turn of the nineteenth to the twentieth century (Ibarra Cuesta 1985 [1967], 1992, 1995, 2007).
75 Interview with Roberto Rafael Márquez Orozco (2 April 2011).
76 Years afterwards, Escalante tried again to influence Cuban–Soviet relations. This time he was condemned to prison.
77 There are 122,000 CDR (2015) in Cuba with 8 million members; www.ecured.cu/index.php/CDR, accessed 26 June 2015.
78 Bell Lara et al. (2008: 307–76).
79 www.ecured.cu/index.php/FMC, accessed 26 June 2015.
80 www.ecured.cu/index.php/CTC, accessed 26 June 2015.
81 With 330,000 members in 2015, according to www.ecured.cu/index.php/ANAP, accessed 26 June 2015.
82 With 110,000 members in 2015, according to www.ecured.cu/index.php/FEU, accessed 26 June 2015.
83 www.ecured.cu/index.php/UNEAC, and www.ecured.cu/index.php/UPEC, both accessed 26 June 2015.
84 www.ecured.cu/index.php/ACRC, accessed 26 April 2015.
85 Interview with Ricardo Gómez Rodríguez (27 September 2011).
86 Ibid.

Chapter 4: Revolutionary fervour (the 1960s)

1 See Barber and Ronning (1966) for one of the first explicit manuals for military and civilian counter-insurgency operations. For the evolution of civil-military action in the American and local counter-insurgency strategy in Latin America, see Weitz (1986).
2 Castro Ruz (2010a, 2010b).
3 For studies about the Fuerzas Armadas Revolucionarias (FAR), see Klepak (2000, 2005, 2009, 2012, 2014) and Latell (2003).
4 According to Risquet Valdés (2007: xlvii) Cuba sent 380,000 soldiers to Angola and 70,000 additional civilian technicians and volunteers. The Cuban forces possessed 1,000 tanks, 600 armoured vehicles and 1,600 pieces of artillery (Risquet Valdés 2008: 102). Based on data in Mesa-Lago and Belkin (1982), Gleijeses (2002), George (2005), LeoGrande (1980) and my own interviews, Cuba had a military presence in Algeria, Congo, Congo-Brazzaville, Ethiopia, Eritrea, Guinea-Bissau and Mozambique, and sent

civilian '*internacionalistas*' to at least ten African countries. The involvement in Angola and Eritrea was enormous At a certain moment, Cuba could have had 100,000 ingoing and outgoing military in Angola and 16,000 military in Ethiopia (George 2005: 133, 321). For another detailed study about Cuba's involvement in Angola, see Carrasco (1997).

5 Canada never interrupted its diplomatic relations with Cuba. Bolivia, Chile and Uruguay broke their diplomatic relations in 1964 after strong admonition from the United States.

6 For a serious discussion about the content and influence of Guevara's ideas in the 1960s, see Childs (1991). See Loveman and Davies (1997) for all of Guevara's military writings.

7 See Gott (1971, 2004), Lamberg (1979), Pereyra (2011 [1994]), Pozzi and Pérez (2012) and Prieto (2007).

8 The Second Declaration of Havana was read by Fidel Castro while nearly two million Cubans attended his speech at the Plaza de la Revolución. After the First International (1864–76), the Second International (1889–present) was created by the social democratic parties. In 1919 Lenin founded the Third International, the Komintern (1919–43). Trotsky founded the Fourth International (1939–54).

9 I use the translation as presented at www.walterlippmann.com/fc-02-04-1962. html (accessed 10 June 2015).

10 I use the text of the final declaration as presented at constitucionweb.blogspot. com.es/2014/06/declaracion-continental-de-la-primera.html (accessed 10 June 2015).

11 Che Guevara was travelling in Africa and the Middle East.

12 Interview with Jorge Luis Joa (27 October 2011).

13 Several Cuban representatives, also sometimes Che Guevara, travelled with Algerian passports; see De la Rosa Valdés (2011: 135–8). This is confirmed by Osvaldo Cárdenas (interview 18 January 2012).

14 Interview with Osvaldo Cárdenas (18 January 2012).

15 Many Latin American countries commissioned Mexico to represent their interests on the island (Toussaint 2013: 116).

16 Interviews with Ramiro Abreu (19 and 25 October 2011), Jorge Luis Joa (27 October 2011) and Fernando Ravelo Renedo (17 October 2011).

17 Here I use biographical data from Suárez Salazar (1997, 1999), De la Rosa Valdés (2011), Martínez Heredia (2010: 138 ff.) and Timossi (2011), and data from a lengthy interview with José Antonio López (1 December 2012), especially about the personality of Piñeiro. I also use interviews with former vice-chiefs and section heads of the department for my sketch of the evolution of the organizations within the MININT, which eventually morphed into the Departamento América: Carlos Antelo (interview 24 and 27 October 2011), Osvaldo Cárdenas (interview 18 January 2012), Norberto Hernández Curbelo (19 and 25 October 2011), Ulises Estrada Lescaille (21 and 28 October 2011) and Fernando Ravelo Renedo (interview 17 October 2011), as well as Giraldo Mazola, president of the ICAP and vice-minister of MINREX (4 February 2012), and Luis Morejón, vice-president of the ICAP (1 March 2012).

18 Interview with Osvaldo Cárdenas (18 January 2012).

19 Basically for movements in Latin America and the Caribbean. Until 1965 there was no formal office to attend to the African and Asian revolutionary

movements. Cuba supported the independence movement in Algeria. Upon independence in 1962, Piñeiro and others formed a 'working group' for strategic cooperation. Cuba also assisted with a mission during the Algerian–Moroccan conflict in 1963. In 1965, an agreement on intelligence cooperation between the two countries was established (De la Rosa Valdés 2011: 135–8).

20 Hudson (1988) published a history of the Departamento América. His data are sometimes very detailed but are basically employed to demonstrate 'Marxist-Leninist violence'.

21 Interview with Osvaldo Cárdenas (18 January 2012).

22 Interview with Ulises Estrada Lescaille (21 and 28 October 2011).

23 Interview with Giraldo Mazola (4 February 2012), Fabio Escalante Font (21 December 2011), Alberto Cabrera (14 February 2012) and Ulises Estrada Lescaille (21 and 28 October 2011).

24 Interview with Lázaro Mora (8, 9 and 10 February 2012).

25 He was born as Dámaso José Lescaille Tabares, but he adopted his pseudonym as his name and first surname. Ulises Estrada Lescaille died in 2014. Mallin, who published a book on the 'Communist Dictator' – of which a large part is dedicated to the Departamento América – incorrectly calls him Armando Ulises Estrada Fernández (1994: 128).

26 This episode is beyond the scope of this book. However, it refers to a period of counter-revolutionary rebellions, mainly but not limited to the regions of Camagüey, Escambray, Holguín, Las Villas, Oriente and Pinar del Río, between 1959 and 1965. As far as I know, the size and scope of the rebellion of the 'bandits' and the counter-insurgency operations against them were never completely documented. Euphemistically, it was the 'campaign against bandits' (Lucha Contra Bandidos, LCB); it was probably a kind of mini civil war. Several thousands of the family members of the executed or imprisoned 'bandits' were transferred to Havana and afterwards distributed among special municipalities (interview with Graciela Aguilar Cardosa, 23 March 2011): Graciela was the special assistant to Celia Sánchez and was appointed Chief of Personnel at the Ministry of Defence in January 1959. For testimonial references, see, for instance, Borges et al. (2004), Etcheverry Vázquez and Gutiérrez Oceguerra (2008), Gárciga Blanco (2010, 2011), González de Cascorro (1975) and Herrera Medina (2006).

27 See also Harmer (2011).

28 In 2003 he wrote a detailed account of Cuba's activities during the days of the Pinochet coup (Estrada Lescaille 2003); he provided me with a PDF copy. See also Suárez Salazar (2007) on Estrada's involvement in the Bolivian expedition of Che Guevara and his love affair with Haydée Tamara Bunke Bíder (Tania la Guerrillera), who joined Che Guevara's guerrilla column in Bolivia and died during his campaign.

29 This sketch of Piñeiro's career is based on an interview with José Antonio López (1 December 2012), a long-time member of the Departamento América who retired in 2010.

30 He sported a Santa Claus-like long red beard and was hence nicknamed Barbarroja (Redbeard).

31 Interview with Carlos Antelo (24 and 27 October 2011).

32 Interview with José Antonio López (1 December 2012).

33 Interview with Luis Suárez Salazar (28 February 2012).

34 The Colombian FARC (Fuerzas Armadas Revolucionarias de Colombia – Ejército Popular, or FARC-EP), for instance, was very susceptible to the neutrality of its Cuban liaisons. When they once perceived a possible preference for another guerrilla organization by one of their Cuban liaison officers, they sent a letter to the Central Committee in Havana. After the damage was done, they formally withdrew the letter a couple of days later.

35 Gillespie (1982); Sprenkels (2014).

36 Interview with Eduardo Sancho (23 August 2005), quoted in Kruijt (2008: 62).

37 Interview with Darío Villazimar (Bogotá), 21 February 2013.

38 Fidel Castro in Ramonet (2008: 332).

39 Mentioned in Lamberg (1979: 67). I corrected the name of the Peruvian ELN.

40 Joa and Diplomat A mention these tasks as part of their instructions (interview with Jorge Luis Joa, 27 October 2011, and with Diplomat A, 2011).

41 Interview with Sergio Cervantes Padilla (10 February 2012).

42 Interview with Ramiro Abreu (19 and 25 October 2011, 22 February 2015).

43 Latell (2007: 192).

44 Here I make use of the introductory texts of Gott (1971: 1–36), Lamberg (1979: 11–67), Mercier Vega (1969), Pereyra (2011 [1994]) and Cortina Orero (2014).

45 Interview with Diplomat A (2011).

46 Ibid.

47 Analysed by Gleijeses (1978) in detail.

48 Interview with Osvaldo Cárdenas (12 January 2012).

49 According to Osvaldo Cárdenas (interview, 12 January 2012), who was present during that meeting, the atmosphere was very tense; they almost used their small arms.

50 Also against Guatemala and Nicaragua, but with the participation of very few persons.

51 I used the study of Nickson (2013) for this résumé.

52 Interview with José Antonio López (1 December 2012).

53 Interview with Carlos Antelo (24 and 27 October 2011) and Luis Morejón (1 March 2012).

54 Interview with Fabian Escalante Font (21 December 2011).

55 Ibid.

56 Interview with Luis Morejón (1 March 2012).

57 Interview with Carlos Antelo (24 and 27 October 2011).

58 Interview with Ulises Estrada Lescaille (21 and 28 October 2011).

59 Wolf visited the island regularly and in his autobiography (Wolf 1997: 346) he comments that Cuban foreign intelligence quickly had become competent.

60 See Krämer (1998). I interviewed Raimund Krämer (12 April 2010, Potsdam), who had been a GDR mission member stationed in Nicaragua and Cuba until 1989.

61 Latell (2013) relates the situation from the American side.

62 Interview with Percy Alvarado Godoy (7 February 2012).

63 Ibid.

64 Ibid.

65 For a sketch of the Miami Cubans, see the contribution of Portes (2007).

66 He published several books about his intelligence career (Alvarado Godoy 2003, 2007, 2011). He also published a booklet of poetry (Alvarado Godoy 2013).

67 See Escalante Font (2010).

68 For an account of the government and the downfall of Arbenz and the transformation of the Arbenzista army into a fierce anti-communist counter-insurgency institution, see Arévalo de León (2015). The best account of the democratic interlude of the consecutive presidents Arévalo and Arbenz (1944–54) is still Gleijeses (1992). However, the recent study by Arévalo de León (2015) gives a very detailed analysis of the relations and tensions between the revolutionary actors and the army factions.

69 Here I draw on the memoirs of Macías (1997), on Balconi's memoirs (Balconi and Kruijt 2004), on Sabino (2009), on Figueroa Ibarra et al. (2013) and on Monsanto (2013). Recently, a fine memoir was published by one of the five participating women (Paíz Cárcamo and Vázquez Olivera 2015).

70 Interview with Norberto Hernández Curbelo (19 and 25 October 2011).

71 Balconi and Kruijt (2004).

72 Interview with General Julio Balconi (15 April 2010).

73 I use the detailed chronology of Gott (1971: 121–220), still one of the best accounts of the Venezuelan guerrilla, and the studies of Pereyra (2011: 110 ff.) and Pérez Marcano and Sánchez García (2007).

74 Línarez (2007: 18–19).

75 Héctor Pérez Marcano, co-founder of the Venezuelan MIR, comments about the changes in preferences. Piñeiro and his military adviser Arana initially had a strong preference for Lairet and Douglas Bravo (PCV). The MIR sent its leader, Américo Martín, to Havana and, after long discussions, Fidel reached a kind of Solomon's Judgement: 60 per cent of the financial and military assistance for the PVC and 40 per cent for the MIR. Bravo left the PVC in 1966 and continued to be supported by Piñeiro (Pérez Marcano and Sánchez García 2007: 67–70).

76 Apparently, Luben Petkoff had come to Havana and asked Piñeiro to send 1,000 men. Fidel decided that the group would be comprised of fourteen persons: 'They are the comandantes of [guerrilla] columns, of the pelotons, who will train guerrilleros whom you can command' (Línarez 2007: 11–12).

77 Raúl Menéndez Tomassevich, Ulises Rosales del Toro, Silvio García Planas and Harley Borges, the last a doctor.

78 Menéndez Tomassevich in his memoirs (Garcíga Blanco 2009: 170–73). Tomassevich, Division General, one of the chiefs of the military mission to Angola in the 1970s and 1980s, was decorated as Hero of the Republic of Cuba in 2004.

79 Hernández and Giusti (2006: 152–3).

80 Interview with Diplomat A (2011).

81 In the 1970s, Arnoldo Ochoa was the Cuban commander in Angola and Ethiopia, and the principal Cuban military adviser in Nicaragua in the 1980s. A member of the Central Committee of the Party, he was anointed a Hero of the Republic of Cuba in 1984. In 1989 he was, with other high-ranking officers of the MINFAR and the MININT, arrested, tried and shot on counts of corruption and drug trafficking. Of the transcripts from the trial, 200 pages are on behalf of the prosecution; those by the nine defence lawyers constitute only four (George 2005: 342).

82 Interview with Carlos Antelo (24 October 2011) and with Diplomat A (2011).
83 See Dreifuss (1981).
84 In Brazil, another Communist Party exists, the Partido Comunista do Brasil (PCdoB). It is a split-off from the PCB with a preference for the Chinese party line, opting in 1978 for the orthodox Albanian (Hoxhaist) ideology. The PCdoB organized the guerrilla movement in Araguaia that ended in disaster; for a detailed analysis, see Nossa (2012). The PCdoB also criticized 'Fidel Castro's revisionism' (ibid.: 127–9).
85 Interview with Fernando Ravelo Renedo (17 October 2011).
86 Clodomir Morais, quoted in Rollemberg (2001: 18–19). She had the opportunity to interview former combatants and used documents from military and political archives.
87 Interview with Fernando Ravelo Renedo (17 October 2011).
88 Rollemberg (2001: 23).
89 Avelino Capitani, quoted in Rollemberg (2001).
90 Here I follow Amorim da Angelo (2009), Gorender (1987) and Rodrigues Sales (2007).
91 A detailed biography of Marighella is Magalhães (2012).
92 Brazilian president Dilma Rousseff was a member of the VAR.
93 The total number of people trained between 1967 and 1970 was ninety-two (Rodrigues Sales 2007: 68).
94 Segundo Domingos Fernandes, a member of the ALN and a trainee of the IV Exército, quoted in Rollemberg (2001: 38).
95 Interview with Fernando Ravelo Renedo (17 October 2011).
96 Interview with Osvaldo Cárdenas (18 January 2012).
97 Aldrighi (2001: 15–18). In 1973, the year of the start of the Uruguayan dictatorship, the inflation rate was even higher, 70 per cent.
98 Here I follow Rey Tristán (2005, 2006: 63 ff.), who presents a panoramic account of the entire Uruguayan armed left. Another good source on the MLN–T is the comparative study of Torres (2012) about the Uruguayan Tupamaros and the Chilean MIR.
99 Interview with Ariel Collazo (Montevideo, 10 November 2011) by Eduardo Rey Tristán.
100 Interview with Fernando Ravelo Renedo (17 October 2011).
101 See medios.presidencia.gub.uy/jm_portal/2011/noticias/NO_B889/tomo1/1-sec1-cronologia-hechos-represivos/5_movimiento_tupamaro.pdf (accessed 11 June 2015) for a day-to-day chronology. For a detailed analysis of the evolution of the MLN–T, see Rey Tristán (2006: 96 ff.).
102 Interview with Fernando Ravelo Renedo (17 October 2011).
103 See Rey Tristán (2006: 129–30).
104 Here I follow the Final Report of the Centro Nacional de la Memoria Histórica (CNMH 2013: 110 ff.).
105 Numbers quoted in Gott (1971: 224).
106 See CNMH (2013: 123).
107 Here I follow Luis Eduardo Celis Méndez (interview, 13, 14 and 15 December 2011, Havana).
108 His second-in-command was Víctor Medina Morón, a dissident member of the Communist Party.

109 Interview with Luis Eduardo Celis Méndez (13, 14 and 15 December 2011, Havana).

110 Manuel Piñeiro in an interview with Luis Suárez Salazar (1999: 29).

111 Anderson (1977: 623).

112 There is a controversy among Che's biographers about Che's relation with Fidel and Raúl when he departed on his campaign in the Congo. Castañeda (1997) implies a rupture of their friendship and Anderson (1977) and Reid-Henry (2009) let their friendship prevail. I follow Anderson's and Reid-Henry's interpretation.

113 From Prague, he had predicted to his trusted vice-minister of industry, Orlando Borrego, the eventual implosion of the Soviet Union as an economic and political system (interview in *Página 12-El País* (Argentina), 15 June 2003, www.pagina12.com.ar/diario/elpais/1-21445-2003-06-15.html, accessed 10 July 2015).

114 Manuel Piñeiro in an interview with Luis Suárez Salazar (1999: 35).

115 After the catastrophic intervention in the Congo, Osvaldo Cárdenas was asked to keep the original version of Che's Congo diary. He still reflects on the fact that most of the Cuban combatants who accompanied Guevara, particularly *comandante* Víctor Drecke and José María (Papi) Martínez Tamayo, knew that the Congo mission would end badly and could never be successful. They had accompanied Che Guevara out of personal loyalty. But when Guevara told them that they were free to leave but that he would stay, they preferred unanimously to continue fighting: 'with the courage', says Cárdenas, 'that reminds me of the battle of Thermopylae'. Piñeiro told him to take care and safeguard the original. In September 1982, when Cárdenas was appointed ambassador to Surinam, he asked Piñeiro what to do with the diary. 'Give it to me,' he told him. Piñeiro passed the original copy to Fidel (interview with Osvaldo Cardenas, 18 January 2012).

116 Orlando Borrego, Che Guevara's vice-minister for industry, interview in *Página 12-El País* (Argentina), 15 June 2003, www.pagina12.com.ar/diario/elpais/1-21445-2003-06-15.html, accessed 10 July 2015.

117 Manuel Piñeiro in an interview with Luis Suárez Salazar (1999: 26–7). Also confirmed by Fidel Castro (Ramonet 2008: 333): 'Che [was] fully supported by us, according to promises made.'

118 In this section I make use of the works by Anderson (1977), Castañeda (1997), James (2001 [1969]) – a hostile but interesting one, because he had abundant access to relevant CIA sources at that time – Lahrem (2005, 2010) and Reid-Henry (2009). I also consulted the elaborate analysis of Rot (2010), also a biography of Masetti.

119 Manuel Piñeiro in an interview with Luis Suárez Salazar (1999: 26).

120 Ibid.: 27.

121 Fidel Castro in Ramonet (2008: 333–4).

122 The operation was so secretive that nobody at the Cuban embassy in La Paz was informed about the campaign (interview with Ulises Estrada Lescaille, 21 October 2011).

123 Ulises, a ladies' man, was declared *persona non grata* in Bolivia after a love affair with the wife of a high functionary, in February 1962. Upon his return to Cuba, Piñeiro sidelined him for a couple of months, but on his first day

in the office he told him: 'So, you bedded her. Well, that is what we Cubans do,' and put him in charge of the training of the first Peruvian combatants of Operation Matraca (interview with Ulises Estrada Lescaille, 21 October 2011).

124 In an interview with Luis Suárez Salazar (1999: 28), Manuel Piñeiro also mentions Cooke's wife Alicia Eguren, a friend of Che Guevara. In Bolivia, the brothers Peredo and Rodolfo Saldaña assisted the Cuban emissaries and the first members of Masetti's group.

125 Interview with Alberto Castellanos (27 February 2012).

126 The number is mentioned by Fidel Castro (Ramonet 2008: 333). Castellanos was instructed to wait for Che Guevara, but when one of Masetti's men was sick, he asked that he be incorporated into the expedition. He wrote a letter to Che and sent it back with Martínez Tamayo (Anderson 1977: 575).

127 Castellanos considers Masetti to have been murdered by the police; he had 30,000 dollars with him and two Rolexes (interview with Alberto Castellanos, 27 February 2012).

128 Castellanos learned about Peru from a copy of the *Reader's Digest*, given to him in jail. But his accent is clearly Cuban. I lived for a number of years in Peru; I believe I can distinguish between the Andean melody and the Cuban staccato. Apparently the Argentinian police and prison guards couldn't.

129 He told his family about his adventures in the late 1970s, when his son asked him to translate a text from Spanish into Russian and he couldn't do it (interview with Alberto Castellanos, 27 February 2012).

130 Pereyra (2011 [1994]: 110–20).

131 Gillespie (1982: 76).

132 Ricardo Gadea, quoted in Anderson (1977: 535).

133 Lust (2013: 137, 277). Lust's fine book is by far the most detailed analysis of the Peruvian guerrilla movements in the 1960s. See also his more recent article (Lust 2016) on the significance of the Peruvian guerrilla in Che Guevara's continental project. This vision is confirmed by Angel Guerra (interview, 21 December 2011), who interviewed General Enrique Gallegos – one of the authors of Velasco's government Plan INCA, and afterwards the leading manager of the land reform and minister of agriculture in Velasco's cabinet.

134 Lust (2013: 176). On the Bolivian and Peruvian communist parties, see Lust (2013: 177 ff.). See also the testimony of Ricardo Gadea in Lust (2013: 276).

135 Interview with Ulises Estrada Lescaille (21 and 28 October 2011).

136 MIR combatant Ricardo César Napurí Schapiro, quoted in Lust (2013: 246).

137 Piñeiro, the highly intelligent Cuban overseer of Latin America's armed left, may have had second thoughts about the campaigns. After being notified about De la Puente's death, he asked Martínez Heredia (2010: 139–40), the editor of *Pensamiento Crítico* at the time: 'You who are so intelligent, can you explain to me how it could happen that De la Puente, a Marxist-Leninist, went to the Sierra and was killed right away, and that prior to that Hugo Blanco, a Trotskyist, was hidden and provided for by the peasants?'

138 Ricardo Letts (pseudonym Américo Pumaruna), another leftist Peruvian who headed Vanguardia Revolucionaria (Revolutionary Vanguard), a movement whose members would create the parliamentary left in the 1980s), also stayed in Cuba. Eventually Béjar's memoirs (Béjar 1969) received the Premio de la Casa de las Américas in Cuba and Letts' harsh analysis of the situation

(Letts 1967) was published in *Pensamiento Propio*, the leading Cuban journal about movements of the left under the editorship of Martínez Heredia. It was followed by several pages of critique by the editor. Blanco (1972) also wrote his memoirs.

139 General Jorge Fernandez Maldonado, then prime minister and one of the authors of Velasco's Plan INCA and between 1968 and 1976 minister of energy and mining, quoted in Kruijt (1994: 55; I retranslated the last sentence from its original Spanish).

140 See Webber (2011) for a detailed historical account.

141 Fidel Castro quoted in Ramonet (2008: 336–7).

142 Manuel Piñeiro in an interview with Luis Suárez Salazar (1999: 32).

143 In a footnote clarifying the interviews of Fidel Castro with Ramonet (2008: 733), all fifteen men and their *noms de guerre* are mentioned; four of them were *comandantes* and three were captains of the Ejército Rebelde.

144 Manuel Piñeiro in an interview with Luis Suárez Salazar (1999: 32).

145 Fidel Castro says, in retrospect: 'I think that Che should have made a greater effort in the interest of unity; that's my opinion. His personality led him to be very frank [...]. Monje was ambitious and his aspirations were rather ridiculous; he wasn't prepared to lead a guerrilla' (Ramonet 2008: 339).

146 Manuel Piñeiro in an interview with Luis Suárez Salazar (1999: 35) and Fidel Castro, quoted in Ramonet (2008: 337–8). The two versions vary slightly in details.

147 Dunkerley explains part of Guevara's failure as the result of the support of the Bolivian indigenous peoples for the president. His Quechua adherence brought him his 'regionalist backing and something of an indigenous identity', and also his 'significant popularity' (Dunkerley 1992: 2, 4).

148 In June 1997 a Cuban forensic team, headed by Professor Jorge González and assisted by Argentinian forensic anthropologists, exhumed the remains of Che Guevara. His hands were hidden in a closet in Bolivia for years and then transported to Moscow by representatives of the Partido Comunista Boliviano. A KGB general tipped off his Cuban counterpart, Carlos Antelo, who all but assaulted the head of the Bolivian delegation, pistol in hand: 'I pushed open the door of his room, my Makarov pistol in hand, and told him: "I'm here for the hands. Give them to me or I'll give you a shot in the head right now". He told me they were in the closet. I opened the cupboard and they were actually there: Che's hands, with the death mask and a match box with two bullets, I suppose the bullets that killed him' (interview with Carlos Antelo, 24 and 27 October 2011).

149 Rodríguez Ostria (2009: 552). Rodríguez Ostria is the historian of the second Bolivian ELN.

150 In the late 1980s, a new guerrilla movement with indigenous and Marxist tendencies emerged, the Ejército Guerrillero Tupac Katari (EGTK), named after the rebellious indigenous leader of the eighteenth century. The prevalent indigenous part was headed by Felipe Quispe Huanca and the Marxist minority segment by Álvaro García Linera, who later became Bolivia's vice-president in 2006. In October 1988 they visited the Cuban embassy, offering US$30,000 to buy Cuban weapons. The political councilor, Santiago Salas, was astonished: 'Ever since the death of Che Guevara, we have

never been offered money. All Bolivian parties of the Left did ask Cuba for money to initiate an armed struggle.' He consulted Havana and the answer was negative. But he provided a contact with the Peruvian Movimiento Revolucionario Tupac Amaru (MRTA) (Quispe 2009: 39–40).

151 Ambassador Iruegas in Toussaint (2013: 128).

152 His writings on economy and society were less appreciated. In 1996, Guevara's collected works on the economy, *El Che en la Revolución Cubana*, published in seven volumes of 650 pages each and edited by his vice-minister, Orlando Borrego, were published with a limited edition of only 320 copies (interview with Fernando Martínez Heredia, 2 March 2012). Only in the mid-1980s did Carlos Tablada revive Che's writings and the volumes he then published were acclaimed and translated into many languages. Finally, the Cuban editorial house José Martí republished Borrego's original 1966 edition between 2013 and 2015. The final two volumes were launched on 9 October 2015 at the Instituto de Investigación Cultural 'Juan Marinello' (ICIC), whose director general is Martínez Heredia.

153 Gott (1971: 9). He had already written the same statement, in Spanish, in 1968 (Gott 1968: 558).

154 Castañeda (1997: 391ff.).

155 Lahrem (2005: 131–9).

156 The Latin American discussion continues to the present. For efforts at revalorization, see Lora (2011) and Vásquez Viaña (2012).

Chapter 5: The mature years (early 1970s–late 1980s)

1 Duncan (1985: 87 ff.). The contingent of Soviet specialists increased from 1,000 in the early 1960s to 6,000 by 1975; of them, 50 per cent were military specialists (ibid.: 101).

2 Until the late 1980s, every faculty of the University of Havana had a Russian adviser and the PhD candidates travelled to Moscow to write and defend their doctoral dissertations (interview with Enrique López Oliva, former professor at the University of Havana, 3 November 2013).

3 The statistics are from Pavlov (1994: 76).

4 Ibid.: 83.

5 Ibid.: 77.

6 Here I follow Pérez Rojas, one of Cuba's foremost agricultural experts (interview with Niurka Pérez Rojas, 9 October 2011). See also Deere et al. (1998) and Jiménez Güethon (2009). The Agrarian Reform process is analysed in Valdés (2003).

7 Data mentioned by Sergio Guerra Vilaboy, head of the Department of History at the University of Havana, during a seminar at the Universidad de Santiago de Compostela, 24 April 2014.

8 Data from Guerra Vilaboy and Maldonado Gallardo (2005: 129) and Domínguez Guadarrama (2013: 136–8).

9 For the first generation of FAR officers, see Vellinga (1976).

10 See, for instance, Báez (1996).

11 Duncan (1985: 101).

12 Latell (2003: 10).

13 Interview with Niurka Pérez Rojas (9 October 2011).
14 Latell (2003: 11).
15 Duncan (1985: 108–9).
16 See Fornet (2007).
17 Pavlov (1994: 97 ff.).
18 Mesa-Lago (1982: 3).
19 Interview with Osvaldo Cárdenas (18 January 2012). At that moment, Cárdenas was head of the Caribbean section.
20 Interview with Norberto Hernández (19 and 25 October 2011).
21 For the evolution of the ECLAC ideas in Dependency Theory, see Guzmán (1976).
22 Interview with Carlos Piedra (21 November 2012). His successor as secretary-general of the MEC, Reinerio Arce, was also strongly influenced by Camilo Torres and Liberation Theology (interview with Reinerio Arce, 13 February 2012).
23 Interview with Luis Morejón (1 March 2012).
24 Interview with Fernando Martínez Heredia (2 March 2012).
25 In October 2015 Frei Betto was one of the keynote speakers at the international symposium about the Cuban Revolution, organized by the Instituto de Historia de Cuba (an institute established by the Central Committee). The day before his discourse, he received a doctorate *honoris causa* from the University of Havana. His laudation was given by Fernando Martínez Heredia.
26 Interview with Luis Morejón (1 March 2012).
27 Harmer (2011: 27).
28 See Walter (2010) for a detailed analysis of the diplomatic relations between Peru and the United States.
29 Kruijt (1994: 105).
30 Interview with Jorge Luis Joa (27 October 2011).
31 Ayacucho was the city where the last battle in Latin America took place, between victorious Marshal Sucre and the last Spanish army under Viceroy De la Serna.
32 Interview with Fernando Ravelo Renedo (17 October 2011).
33 Interview with Angel Guerra (21 December 2011).
34 Interview with Fabian Escalante Font (21 December 2011).
35 Here I use the publications of Ford González (2009), Martínez (1982), Rodríguez V. (2008) and Zárate and Vargas (2011).
36 Omar Torrijos in a speech to the Chiefs of State or Government at the Sixth NO-AL Summit in Havana, September 1979 (Zárate and Vargas 2011: 255–61).
37 Interview with Diplomat A (2011).
38 Interview with Norberto Hernández Curbelo (19 and 25 October 2011).
39 'Comandante' is an army term for a major in Cuba and for a lieutenant colonel in Peru and Venezuela. In 1974 then cadet Hugo Chávez had participated in the international celebration of the 150th anniversary of the battle of Ayacucho, Peru (the last battle against the royalist Spanish troops in Latin America). He had received a small booklet containing the public speeches of General Velasco and became an admirer of the leader of the Peruvian Revolutionary Government of the Armed Forces (Gott 2005: 35–6).
40 Here I draw on Harmer's excellent analysis of the Allende government (2011).
41 Harmer (2011: 36); also Ulises Estrada Lescaille, who was his direct chief (interview, 21 and 28 October 2011).

42 Harmer (2011: 52, 54).

43 Interview with Ulises Estrada Lescaille (21 and 28 October 2011).

44 In 1985, when I interviewed General Jorge Fernandez Maldonado, he proudly showed me a Kalashnikov, a gift from Fidel; several of his colleagues had also received similar collector's items.

45 Joa, who had prepared the stopovers in Peru and Ecuador as 'Fidel's private secretary', sat next to General Guillermo Rodríguez Lara. At the time he was Chief of the General Staff and afterwards became the president of Ecuador after the coup in 1972. He was entertained by the fact that Rodriguez Lara permanently ridiculed the aged Ecuadorean civilian president (interview with Jorge Luis Joa, 27 October 2011).

46 Earlier in 1973, Zhou Enlai, China's minister of foreign relations, had asked his visiting Chilean colleague Clodomiro Almeyda whether Allende had a back-up plan in the event of a military takeover.

47 Interview with Ulises Estrada Lescaille (21 and 28 October 2011).

48 The Frente Patriótico Manuel Rodríguez (FPMR) was formed in Cuba, with the assistance of Ulises Estrada (interview with Ulises Estrada Lescaille). See Rojas Nuñez (2011). The Cuban authorities, however, initially had reserves about an early guerrilla detachment in the 1970s (Harmer 2016).

49 Interview with Luis Rojas Nuñez (20 January 2012).

50 I follow Dominguez Guadarrama (2013: 146–7, 260–62) and Suárez Salazar and García Lorenzo (2008: 116–19).

51 Marques Bezerra (2010: 106–7).

52 Interview with Sergio Cervantes Padilla (10 February 2012).

53 Here I draw on Gillespie (1982) and Torres Molina (2011) for revolutionary Argentina.

54 By the 1960s, there had already been some previous, small efforts at guerrilla warfare; Masetti's group was one of them. They all were subdued by overwhelming police forces.

55 The three founders of the Montoneros – Fernando Medina, Carlos Ramus and Mario Firmenich – were influenced by the Argentinian liberation theologist Carlos Mujica. In May 1974, Mujica (who later, as a pacifist, publicly distanced himself from the armed insurgency) was murdered, very probably by the Alianza Argentina Anti-Comunista – the anti-communist paramilitary branch of the Peronist right. For more information about the influence of *Cristianismo y Revolución*, see Celesia and Waisberg (2011: 52–68) and Morello (2007).

56 Gillespie (1982: 89 ff.).

57 Torres Molina (2011: 48 ff.).

58 Gillespie (1982: 120).

59 Guerrero (2009) analyses in detail the convergences and disputes, the secessions and efforts to reunite, and the internal sectarianism and ostracism of the Montoneros and the ERP.

60 Interview with Fernando Ravelo Renedo (17 October 2011).

61 Ibid.

62 Servetto (2010: 242 ff.).

63 See the case studies of De Lise (2007), Gordillo (2007) and Campione (2007).

64 Torres Molina (2011: 108–9).

65 Gillespie (1982: 193–5).

66 Ibid.: 244 ff., and especially Lewis (2011) and Robben (2005). A comparison between the Argentinian and the Uruguayan dictatorship and its aftermath can be found in Rey Tristán (2007).

67 Even in 1982, during the Falklands/Malvinas crisis, Cuba's relations with Argentina became very friendly.

68 Celesia and Waisberg (2011: 302).

69 Ibid.: 286–91.

70 He went to Spain to study economics and received, in 1999, a PhD at the University of Barcelona; his thesis tutor was the Nobel laureate Joseph Stiglitz.

71 Interview with José Antonio López (18 October 2011).

72 Interview with Norberto Hernández (19 and 25 October 2011).

73 Interview with Fernando Ravelo Renedo (17 October 2011).

74 Nearly all guerrilla movements that appeared in Colombia in the 1970s and 1980s, heterogeneous and fragmented as they were, had relations with the Juventud Comunista – the youth wing of the Communist Party, among them several future guerrilla leaders: Álvaro Fayad (first FARC, then M-19), Jaime Bateman (first FARC, then the founder of M-19), Iván Marino Ospina (first FARC, then M-19) and Carlos Pizarro (the last *comandante* of M-19).

75 Interview with Jorge García (13 February 2013). As an M-19 member, García served as a community worker in one of Bogotá's poorest districts.

76 Interview with Fernando Ravelo Renedo (17 October 2011).

77 Interview with Luis Eduardo Celis Méndez (13, 14 and 15 December 2011, Havana).

78 Independently from Cuba, the M-19 maintained contacts with the Peruvian MRTA and its leader, Victor Polay (2009); see also Fournier (1991).

79 Interviews with Alejo Vargas about the ELN (15 December 2011, Bogotá), with Enrique Flores (20 February 2013, Bogotá) about the PRT, and with Nelson Plazas (11 February 2013, Bogotá) and Álvaro Villaraga (13 December 2011, Bogotá) about the EPL. See also Villaraga and Plazas (1994) on the history of the EPL.

80 Interview with Norberto Hernández (19 and 25 October 2011).

81 In 1983, the office of the Colombian Attorney General published a report demonstrating that, of the 163 members of the MAS that were identified, sixty-nine of them were members of the armed forces (CNMH 2013: 137). About the AUC, see CNMH (2013: 161–162, 170 ff., 179 ff.).

82 The paramilitary forces were assisted by the army, the police, the intelligence services, 'many times in alliance with the drugs traffickers' (CNMH 2013: 142). For a detailed one-volume analysis of the violence, see Pécaut (2001).

83 Interview with Enrique Flores (20 February 2013).

84 Interview with Jorge Luis Joa (27 October 2011).

85 Hernández and Giusti (2006: 296–7).

86 Interview with Norberto Hernández (19 and 25 October 2011).

87 Ibid.

88 Interview with Diplomat A (2011).

89 In fact, Hernández was never formally discharged as ambassador to Caracas. The Venezuelan minister of foreign affairs resolved the situation by 'accepting my letter of retirement while accepting at the same time my credentials as regular ambassador'; interview with Norberto Hernández (19 and 25 October 2011).

90 In 1794 the French National Convention had abolished slavery in all colonies but Napoleon had reinstated it in 1802.

91 See Hernández (2011) and Ceceña et al. (2011).

92 Otto Marrero, former head of the Caribbean Section of the Department of International Relations of the Central Committee, comments that Jamaicans and other English-speaking Caribbean residents in Cuba generally engage in amorous relations with Cubans of the opposite sex more quickly than, for instance, Argentinians, who share the same language (conversation, 5 December 2012).

93 In 1983, Grenada and Surinam had suspended or broken off their relations with Cuba; Grenada re-established its relations in 1992 and Surinam in 1995.

94 See Kaufman (1985).

95 In 1986, Aruba was separated from the remaining five Netherlands Antilles. The Antilles were formally dissolved in 2010. Aruba, Curaçao and Saint Maarten became 'countries' and Bonaire, Saba and Saint Eustatius acquired the status of 'special municipalities' within the kingdom.

96 See Livingstone (2009: 47) on the CIA's involvement in destabilization policies against the PPP.

97 Interview with Osvaldo Cárdenas (18 October 2012).

98 Interview with Ulises Estrada Lescaille (21 and 28 October 2011).

99 I also draw on Kaufman (1985).

100 Interview with Humberto Castañeda (8 November 2012).

101 Kaufman (1985: 146).

102 Interviews with Osvaldo Cárdenas (28 January 2012) and Ulises Estrada Lescaille (18 and 21 October 2011).

103 During one of the many riots, Jamaican junior minister of security Roy McGann was fatally wounded. McGann was a personal friend of Estrada. When he was informed about the shooting, he called the Cuban chief of the medical brigade for assistance and went with a group of armed embassy functionaries to the hospital. When he arrived, McGann was deceased (interview with Ulises Estrada Lescaille, 18 and 21 October 2011).

104 Later, Estrada was appointed ambassador in Yemen; he pursued his career at MINREX.

105 After merging his own Movement for Assemblies of the People (MAP) with the already existing Joint Endeavour for Welfare, Education and Liberation (JEWEL).

106 Interview with Osvaldo Cárdenas (28 January 2012).

107 Ibid.

108 Interview with Ulises Estrada Lescaille (18 and 21 October 2011).

109 Livingstone (2009: 89).

110 Interview with Osvaldo Cárdenas (28 January 2012).

111 Livingstone (2009: 89–90) and Nieto (2003: 390–95).

112 Here I draw on Hoogbergen and Kruijt (2005) and Reeser (2015), and on the interview with Osvaldo Cárdenas (28 January 2012), Cuban ambassador to Surinam from 1982 to 1983.

113 The Netherlands Antilles government gently declined the offer of independence as 'premature'.

114 Interview with Osvaldo Cárdenas (28 January 2012).

115 Ronny Brunswijk, a Maroon who launched a guerrilla movement against Bouterse and the elected government in the late 1980s. The war had a death toll of several hundred victims and resulted in the enormous migration of tens of thousands of Maroons to neighbouring French Guyana (Hoogbergen and Kruijt 2005: 113ff.).

116 The official language is Dutch but the street language is Sranan Tongo, a language with African and English roots, which is spoken and understood only in Surinam.

117 At least, the staff of the Brazilian embassy was not informed about Venturini's mission.

118 See Bessa (2009) and Domínguez Ávila (2011).

119 Officially, because of Cárdenas' involvement with parties of the left that were not Bouterse's choice. Cárdenas had also criticized the extrajudicial killings of Bouterse's adversaries.

120 Interview with Humberto Castañeda (8 November 2012).

121 His relations with the Netherlands are icy; there he was condemned for large-scale drug trafficking. The Dutch supported – with juridical assistance and intelligence – the indictment process against the participants in the 'December murders of 1982', a judgement that was suspended at the beginning of Bouterse's presidency in 2012.

122 In this book I will limit my analysis to the role of Cuba. For the American involvement, see LeoGrande (1998); for the engagement of the Soviets, see Paszyn (2000).

123 Interviews with Ramiro Abreu (9 October 2011) and Fernando Ravelo Renedo (17 October 2011). Abreu was head of the Central American section of the Departamento América from 1975 to 2010. Fernando Ravelo was vice-chief of the Departamento América from 1981 to 1988, dealing with Mexico and Central America, and was appointed Cuba's ambassador to Nicaragua in 1989.

124 Although insistent about the necessity of unitary umbrella organizations, Cuba never threatened to withdraw its political and material support (interview with Ramiro Abreu, 9 October 2011).

125 See Bataillon (2008), Dunkerley (1988) and Torres-Rivas (2011). For the case of Nicaragua, see Alegría and Flakoll (2004) and Martí y Puig (1997). For El Salvador, see Cabarrús (1983), De Giuseppe (2006) and Ibarra Chávez (2015). For Guatemala, see Le Bot (1995, 2009).

126 See Gustavo Porras' memoirs (2009). Porras, a former member of the Ejército Guerrillero de los Pobres (EGP), was the government's peace negotiator in 1996 and one of the signatories of the peace agreements.

127 Canizales Vijil (2012).

128 Kruijt (2008: 44–7); see also Bataillon (2008, 2013).

129 Interview with Julio López Campos (2 June 2011). López was the chief of the Sandinista Department of International Relations until 1990.

130 The Nicaraguan Socialist (Communist) Party agreed but remained an ally of Somoza (interview with Ulises Estrada Lescaille, 21 and 28 October 2011).

131 Interview with Jorge Luis Joa (27 October 2011).

132 Tomás Borge in conversation with Fidel Castro (Castro Ruz 1992: 40).

133 Cuban intelligence could intercept telephone conversations among officers of the National Guard, especially Major Bravo – commander of the Guard force

that contested the Sandinista Southern Front. Bravo first called his wife and then his lover in Managua. The information was transferred to the Sandinista command (interview with Fabian Escalante Font, 21 December 2011).

134 Interview with the Chilean-Cuban artillery officer Luis Rojas Nuñez (20 January 2012). The Chilean contingent, formed by exiled former medical students of the Chilean Communist Party in Cuba, was headed by a Chilean whose *nom de guerre* was Salvador. Rojas and his co-officers later formed the Frente Patriótico Manuel Rodríguez (FPMR), which launched a guerrilla campaign in Pinochet's Chile in the 1980s. See also Rojas Nuñez (2011).

135 The urban Frente Interno (Internal Front) was headed by Joaquín Cuadra Lacayo, who was one of only two generals of the Sandinista Army after 1979; Humberto Ortega was minister of defence and Joaquín Cuadra was Chief of the General Staff.

136 Here I draw on José Luis Moreno del Toro (interview 5 December 2011), traumatologist and poet, who was a member of the first medical brigade that arrived.

137 The Soviet Union provided the heavy equipment and oil imports.

138 Interview with Fernando Ravelo Renedo (17 October 2011).

139 Interview with Julio López Campos (2 June 2011).

140 Interview with Fernando Ravelo Renedo (17 October 2011).

141 Interview with Joaquín Cuadra Lacayo, Chief of the General Staff, in Kruijt (2008: 106).

142 An interesting biography of Lenin Cerna is Manzanhão (2014).

143 Interview with Fabián Escalante Font (21 December 2011). He published his memoirs about his Nicaraguan years (Escalante Font 2006, 2009). Montero also became an adviser to Humberto Ortega.

144 See Merino (2011: 35). See also Martín Álvarez (2013 and 2016). About the radicalizing Catholic student movement, see Cáceres Prendes (2013).

145 Abreu (2013: 194).

146 Sánchez Cerén in his memoirs (2009: 199–206).

147 Interview with Rodrigo Abreu (9 October 2011).

148 Interview with Fernando Ravelo Renedo (17 October 2011).

149 Kruijt (2008: 75–6).

150 Interview with Fedora Lagos Aguirre (7 February 2012). This book is not the place for an in-depth analysis of extrajudiciary executions in El Salvador. Two eminent historians with combat experience in the FMLN made comments about the killing of captured adversaries and/or executions of 'traitors and counter-revolutionaries': Mario Vázquez (interview 3 September 2015) and Jorge García (interview 15 July 2015). Juárez Ávila mentions the possibility of several hundred victims.

151 Interview with Jorge Juárez Ávila (15 July 2015).

152 Ibid.

153 For Handal's political trajectory, see López Bernal (2015).

154 For the political evolution of the post-1992 FMLN, see Rey Tristán and Cagiao Vila (2011), Juárez Ávila (2013) and Sprenkels (2014).

155 Interview with Héctor Rosada-Granados (14 April 2010). Rosada-Granados was the government peace negotiator between 1993 and 1996.

156 Interview with Jorge Luis Joa (27 October 2011).

157 Interview with Fernando Ravelo Renedo (17 October 2011).

158 Through Edgar Ponce, the vice-president of the political committee of Rios Montt's State Council (Kruijt 1999: 49, 61).

159 See Stanley (2013) about the role of MUNIGUA (Misión de Verificación de las Naciones Unidas en Guatemala, United Nations Mission for the Verification of Human Rights).

160 Here I draw on Becerra (2009) and Canizales Vijil (2012).

161 Interview with Humberto Castañeda (8 November 2012).

162 Canizales Vijil (2012: 11).

163 Interview with Humberto Castañeda (8 November 2012).

164 Interview with José Luis Moreno del Toro (5 December 2011), a traumatologist who participated in the first medical mission to Nicaragua in 1979.

165 Alianza Republicana Nacionalista (Nationalist Republican Alliance), a right-wing party, founded in 1981.

166 Abreu (2013: 192). D'Aubuisson refused the offer but he and his family appreciated the gesture.

Chapter 6: The years of soft power (1990s–present)

1 A fine analysis of this process can be found in Judt (2006: 559ff.).

2 For a detailed analysis, see Applebaum (2013) and Gellately (2013); see also Rodríguez García (2014).

3 Diplomat A (interview, 2011).

4 According to his memoirs (Noriega and Eisner 1997: 65–81).

5 According to his memoirs (ibid.: 200–201, 217).

6 Diplomat A (interview, 2011).

7 Ibid.

8 Interview with Alberto Cabrera (14 February 2012); Cabrera was minister councillor at the Cuban embassy. On the night of the invasion he was detained by CIA officers but his ambassador, Lázaro Mora, went with him. Two hours later a military officer chauffeured them back to the embassy; officially, they were detained because they were undocumented.

9 Interviews with Alberto Cabrera (14 February 2012) and Lázaro Mora (8 and 9 February 2012).

10 Joaquín Cuadra Lacayo, chief of staff of the Sandinista army in the 1980s, quoted in Kruijt (2008: 125).

11 See Pavlov (1994: 111 ff.), Gorbachev's translator and adviser on Latin America and especially Cuba, for the conflicting ideas between the Soviet Union and Cuba about economic and political reforms. I draw here on his and Bain's (2007) comments about the Soviet policy towards Cuba and Nicaragua in the late 1980s and early 1990s.

12 Shorthand version of Fidel Castro's speech, www.cuba.cu/gobierno/discursos/1988/esp/f260788e.html, accessed 25 December 2015.

13 Here I draw on Pavlov (1994: 185 ff.).

14 On 8 October 2015 I was one of the co-organizers of a seminar in Havana, hosted by the Facultad Latinoamericana de Ciencias Sociales (FLACSO), incorporated into the University of Havana. The seminar was about the con-

sequences of the downfall of the socialist bloc in Europe. The proceedings are not yet published; I quote from the original transcription of the recordings of roughly twenty participants (page 22).

15 See Bain (2007: 63–6); Pavlov (1994: 231–9) blames Yeltsin and the new power structure that had emerged after the failed coup effort.

16 Pavlov (1994: 244).

17 Memorandum of a conversation between Raúl Castro and Yuri Andropov, 29 December 1982, digitalarchive.wilsoncenter.org/document/117966, accessed 15 December 2015.

18 Latell (2003: 11).

19 Bain (2007: 51).

20 Conversations with General Julio Balconi in Cuba, October 2003, when we wrote the final draft of Balconi and Kruijt (2004) in Havana.

21 Klepak (2000: 3ff., 2005: 47ff.)

22 Diplomat A (interview, 2011).

23 Interview with Jorge Juárez Ávila (15 July 2015).

24 Klepak (2005: 143, 254ff.).

25 Interviews with Jorge Bernal (31 July 2012) and Dora Carcaño (6 February 2012). Bernal was the Cuban CTC leader (Central de Trabajadores de Cuba) and the country's representative to the Latin American branch of the communist labour movement; Carcaño was the Cuban FMC leader of the Latin American branch of the communist women's movement.

26 Klepak (2000: 3).

27 A full account of Cuba's economy is beyond the scope of this book. For more general studies, see Pérez Villanueva (2006, 2010) and Dominguez et al. (2012).

28 28 Gott (2004: 288).

29 I quote from the original transcript of the FLACSO seminar of October 2015 referred to above (pages 30–31).

30 For Cuba's relations with the European Union, see Roy (2009).

31 For Cuba's agriculture in the post-Soviet years, see Nova González (2013).

32 See Carmona Báez (2002: 195–215).

33 See Del Castillo et al. (2005), Xalma (2007), Fuentes (2008) and Henken and Ritter (2014).

34 Zabala Argüelles (1997), Espina Prieto (2005), Togores González (2005) and Martínez-Fernández (2014: 200–203).

35 See Ritter (2015).

36 Interview with Jorge Juárez (16 July 2015).

37 For an account of this 'Habanazo', see Gott (2004: 298–9).

38 I quote from the original transcript of the FLACSO seminar of October 2015 referred to above (pages 26–7).

39 For a detailed analysis, see Carbonel (2007) and especially Klepak (2009, 2012).

40 The Ejército Juvenil de Trabajo (Youth Labour Army, EJT); interview with Niurka Pérez Rojas (9 October 2011); see also Klepak (2014: 52).

41 Klepak (2009: 120–21).

42 Colomé Ibarra resigned as minister of MININT in October 2015 for health reasons (probably Parkinson's disease); previously, in December 2013, he had ceded his functions as vice-president of the Council of State 'in favour of a new

generation'. He was succeeded at MININT by his first vice-minister, General Carlos Fernández Gondín.

43 Mora (2007) provides a fine analysis of this process.

44 Interview with Carlos Antelo (24 and 27 October 2011).

45 In 1997, Piñeiro also gave up his membership in the Central Committee and all other functions in order to write his memoirs, which he never finished. Piñeiro died in a car crash in March 1998; he was entombed with military honours after a eulogy by Fidel, which was attended by all of the senior Party and cabinet members. His death was lamented by his former colleagues.

46 Hernández (2005: 155).

47 I quote from the original transcript of the FLACSO seminar of October 2015 referred to above (pages 29–30).

48 Here I follow Dilla Alfonso (2005).

49 See Giuliano (1998), who reached the same conclusion, for a detailed and documented account.

50 For a general overview of Latin America's foreign policies, see Gardini and Lambert (2011).

51 I consulted Arnson et al. (2007) about the chronology of the peace talks in Colombia.

52 I do not mention the Zapatista guerrilla movement that started in 1994 in Chiapas, Mexico's southernmost state. The EZLN (Ejército Zapatista de Liberación Nacional, Zapatista National Liberation Army) and its leader Rafael Guillén (Subcomandante Marcos) quickly acquired national popularity. Notwithstanding their Che Guevara symbols and rhetoric, Cuba never had a relationship with the EZLN. Immediately after the outbreak of the guerrilla and the occupation of the capital of Chiapas, San Cristóbal, the Mexican government sent high-ranking delegates to negotiate. They reached an agreement on non-fighting civilian protest operations and the federal government promised pro-indigenous reforms. Additionally, Chiapas became a paramilitary base. For studies about the EZLN, see Le Bot with Najman (1997), Le Bot (2009), Arnson and Benítez Manaut (2000) and Stephen (2002). For a fine analysis of Latin America's peace agreements, see Arnson (1999).

53 Here I draw on Balconi and Kruijt (2004) and Kruijt (2008: 144–53).

54 Interview with Ramiro Abreu (25 October 2011); see also Abreu (2013).

55 Castro Ruz (2009).

56 Interview with José Antonio López (18 October 2001 and 1 December 2012).

57 In 2007 another exchange of prisoners took place under the auspices of President Hugo Chávez of Venezuela, who was asked to mediate.

58 ASR (2012: 3).

59 Interview with Carlos Antelo (24 and 27 October 2011).

60 Ibid.

61 Here I draw on Feinsilver (1989, 1993, 2010), Kirk (2012) and Kirk and Erisman (2009) with regard to Cuba's medical assistance. On Cuba's civilian assistance, see also Kumaraswamy (2012).

62 Discussion with and presentation by ambassador Pedro Ross Leal, 'La cooperación cubana con Angola en los primeros años de la independencia y en el

período 2005–2012', at the international symposium 'La Revolución Cubana. Génesis y desarrollo histórico', organized by the Instituto de Historia de Cuba, 13–15 October 2015 (taped).

63 Discussion with and presentation by Noemí Benítez y de Mendoza (Sociedad Cultural José Martí), 'Internacionalismo y política exterior de la Revolución Cubana', at the international symposium La Revolución Cubana. Génesis y desarrollo histórico', organized by the Instituto de Historia de Cuba, 13–15 October 2015 (taped).

64 www.ecured.cu/Colaboraci%C3%B3n_M%C3%A9dica_Cubana, accessed 12 January 2016.

65 Kirk and Erisman (2009: 8, 12).

66 Huish (2014: 188ff.).

67 Interview with Maritza González Bravo, academic vice-rector of the ELAM system (9 November 2012).

68 Interview with Yoandra Muro Valle, former vice-rector of the ELAM and chief of the medical brigade to Guatemala after Hurricane Mitch (9 November 2012).

69 Kirk and Erisman (2009: 134ff.) provide the specifics about Cuba's medical assistance in Latin America and the Caribbean. For a testimonial account of the medical missions in Africa, see López Blanch (2005).

70 The most recent example is that of Honduras, where progressive president Zelaya was ousted by a military coup. The Cuban government decided not to retire their medical personnel and the new Honduran administration continued to pay their counterpart obligations.

71 *Granma*, 12 January 2016.

72 www.unesco.org/new/en/media-services/single-view/news/education_for_all_2000_2015_only_cuba_reached_global_education_goals_in_latin_america_and_the_caribbean/, accessed 12 January 2016.

73 On this programme, see Sánchez (2005) and Artaraz (2012).

74 A previous programme, Creole Literacy by Radio, was tested in Haiti in 1999 (interview with Javier Labrada, 8 November 2012). Labrada was a senior adviser in Venezuela, Bolivia and Haiti.

75 Interview with Javier Labrada (8 November 2012).

76 For a detailed analysis, see Abendroth (2009).

77 Interview with Carlos Antelo (24 and 27 October 2011).

78 Ibid.

79 In 1992, when, after the first hours of the coup, President Carlos Andrés Pérez appeared on TV and ordered the military in Caracas to remain loyal, Chávez surrendered in order to avoid a bloodbath. He was allowed to speak on TV to convince his comrades-in-arms in the parachutist and tank units to capitulate. His speech had the following message: 'Compañeros, unfortunately, for the moment ('*por ahora*' in Spanish), the objectives that we had set for ourselves have not been achieved in the capital' (Gott 2000: 70). This '*por ahora*' clause had made him famous and was never forgotten. According to Antelo (interview 24 and 29 October 2011), Chávez told him that he had spontaneously inserted it during the transmission, without previous deliberation.

80 Interview with Carlos Antelo (24 and 27 October 2011).

81 Interview with Jorge Luis Joa (27 October 2011).

82 Historian of a city is an important official function. Leal, the Historian of Havana, is also in charge of the reconstruction of the entire historical centre of Havana (2016).
83 Interview with Carlos Antelo (24 and 27 October 2011).
84 Interview with Jorge Luis Joa (27 October 2011).
85 Interview with Carlos Antelo (24 and 27 October 2011).
86 Hernández and Giusti (2006: 416).
87 Bilbao (2002: 28–9). The interview took place on 28 December 2001 in Caracas.
88 Here I draw on Gott (2005), Bitar Deeb and Isidoro Losada (2015), Bruce (2008), Ellner (2008, 2013a) and Serbin (2010).
89 Bilbao (2002: 52).
90 Díaz Polanco (2008: 17). Also confirmed by Alberto Cabrera (interview 14 February 2012).
91 Díaz Polanco (2008: 51–3).
92 Ellner (2008: 121–7).
93 Fidel Castro quoted in Gott (2005: 285).
94 Lange quoted in Pérez Marcano and Sánchez García (2007: 176).
95 Chávez quoted in Martínez Heredia (2010: 79).
96 And six smaller Caribbean island-states between 2008 and 2014. After Honduras' affiliation in 2008, a military coup ousted President Zelaya and withdrew its membership (2009).
97 In the case of Bolivia and Nicaragua, hydrocarbon and financial resources were provided with a minimum of paperwork and at least one Bolivian cabinet member lost a ministerial position after refusing to sign 'documents authorizing disbursements without due control'.
98 See Clem and Maingot (2012), Gardini and Lambert (2011), Kozloff (2006), Lievesley and Ludham (2009), Raby (2011) and Trinkunas (2012).
99 See Lambie (2010: 216ff.).

Chapter 7: The legacy

1 Hoffmann (2009).
2 Here I draw on Alonso et al. (2001), Gratius (2008) and Mesa-Lago (2012). A recent special issue of *Latin American Perspectives* (Diaz 2014) comprises several contributions about the reform programme. I also reflect on the effects of the reforms I observed between 2009 and 2015.
3 Here I follow Piccone and Tricunas (2014).
4 Here I follow Mgr Emilio Aranguren Echeverría, bishop of Holguín, who was in charge of the episcopal Human Rights Commission (interview, 4 August 2010; I interviewed the bishop accompanied by a Dutch journalist from Radio Netherland Worldwide, RNW).
5 On 12 February 2016, Pope Francis and Patriarch Kirill, the heads of the Roman Catholic and the Russian Orthodox churches, met in Havana and issued a common statement; this time Raúl Castro was the host.

6 For the evolution of Latin America's left from the 1990s to the present, see Carr and Ellner (1993) and Ellner (2013b). For a discussion about its character, see Petkoff (2005).

7 'Cuba no exporta revoluciones, sino ideas' – Che Guevara at a press conference in the United Arab Republic on 1 July 1959 (Borrego Díaz 2013h [1966]: 46).

8 For a more recent discussion, see Lora (2011).

9 'Yo no sé cuántos ministros, miembros de gabinete, dejaron voluntariamente sus cargos para irse al monte a pelear, a hacerse guerrillero' (Alarcón de Quesada 2015).

10 The OSPAAAL also publishes the journal *Tricontinental*. I had a long interview with Lourdes Cervantes (19 November 2012), general secretary of the OSPAAAL, about the functioning of this Third World organization. In 2013, its executive secretariat consisted of representatives from Angola, Congo, Chile, Cuba, El Salvador, Guinea-Bissau, Palestine, the People's Republic of Korea, Puerto Rico, South Africa, Syria and Vietnam.

11 Cabrera, the representative, had excellent relations with José (Pepe) Mujica, who later became Uruguay's president, and with ex-bishop Fernando Lugo, afterwards president of Paraguay (interview with Alberto Cabrera, 14 February 2012).

12 Interview with Alberto Cabrera (14 February 2012). About the tense relations between the Ecuadorean government and the indigenous peoples, see Becker (2013) and Bowen (2011).

13 Guatemala has slightly less than 15 million, Haiti and the Dominican Republic have somewhat more than 10 million, and Honduras, El Salvador and Nicaragua have populations between 6 and 8 million. The two Caribbean states with relatively large populations are Puerto Rico and Jamaica, each with 3 million inhabitants (2014).

14 Zanetti (2013: 15) remarks that '[...] the natural conditions and the strategic location of Cuba have influenced [...] interpretations that are imbued with a certain geopolitical fatalism'.

15 Crandall (2008: 119, 124–8), Golinger (2010) and Corrales and Romero (2013: 48, 58–9).

16 See Raúl Castro's presidential speech (Castro Ruz 2016).

BIBLIOGRAPHY

Abendroth, M. (2009) *Rebel Literacy: Cuba's National Literacy Campaign and Critical Global Citizenship*, Sacramento: Litwin Books, LCC.

Abreu, R. (2013) *Memorias al viento*, Havana and Guatemala: Ruth Casa Editorial and Estrella Publicidad SA.

Aguilera, G. and E. Torres-Rivas (1998) *Del autoritarismo a la paz*, Guatemala: Facultad Latinoamericana de Ciencias Sociales (FLACSO).

Alarcón de Quesada, R. (2015) 'Presentación', in L. Suárez Salazar and D. Kruijt, *La revolución cubana en nuestra América: el internacionalismo anónimo*, Havana: Ruth Casa Editorial (e-book).

Alavez Martín, E. (2009) *Eduardo Chibás: clarinada fecunda (Cronología comentada: artículos, ensayos, entrevistas ...)*, Havana: Editorial de Ciencias Sociales.

Alcázar Campos, A. (2009) 'Turismo sexual, jineterismo, turismo de romance. Fronteras difusas en la interacción con el otro en Cuba', *Gazeta de Antropología*, 25(1), hdl.handle.net/10481/685625, accessed 25 December 2015.

Aldrighi, C. (2001) *La Izquierda Armada. Ideología, ética e identidad en el MLN-Tupamaros*, Montevideo: Ediciones Trilce.

Alegría, C. and D. J. Flakoll (2004) *Nicaragua: la revolución sandinista. Una crónica política, 1855–1979*, 2nd edn, Managua: Anamá Ediciones.

Almeida Bosque, J. (1987a) *Presidio*, Havana: Editorial de Ciencias Sociales.

——— (1987b) *Exilio*, Havana: Editorial de Ciencias Sociales.

——— (1988) *Desembarco*, Havana: Editorial de Ciencias Sociales.

Almorim da Angelo, V. (2009) *Luta armada no Brasil*, São Paolo: Editora Claridade.

Alonso, J. A., F. Bayo and S. Gratius (eds) (2011) *Cuba en tiempos de cambios*, Madrid: Editorial Complutense.

Alvarado, P. (2013) *Estas tardes de junio*, Havana: Editorial Gente Nueva.

Alvarado Godoy, P. F. (2003) *Confesiones de Fraile*, Havana: Editorial de Ciencias Sociales.

——— (2007) *De terroristas y canallas*, Havana: Editorial de Ciencias Sociales.

——— (2011) *Luis Posada Carriles*, Havana: Editorial de Ciencias Sociales.

Álvarez Estévez, R. (1999) *Un día de abril de 1958*, Havana: Editorial Letras Cubanas.

Amorim da Angelo, V. (2009) *Luta armada no Brasil*, São Paolo: Editora Claridade.

Anderson, J. L. (1977) *Che Guevara: A Revolutionary Life*, London: Bantam Press.

Applebaum, A. (2013) *Iron Curtain. The Crushing of Eastern Europe*, London: Penguin.

Arboleya Cervera, J. (2009) *El otro terrorismo. Medio siglo de política de los Estados Unidos hacia Cuba*, Havana: Editorial de Ciencias Sociales.

Arévalo de León, B. (2015) 'Del estado violento al ejército político. Violencia, formación estatal y ejército en Guatemala, 1500–1963', PhD thesis, Utrecht University.

Arnson, C. J. (1999) *Comparative Peace Processes in Latin America*, Stanford, CA: Stanford University Press.

Arnson, C. J. and R. Benítez Manaut (2000) *Chiapas: Los desafíos de la paz*, Mexico and Washington, DC: Instituto Autónomo de México (ITAM) and Woodrow Wilson International Center for Scholars – Latin American Program.

Arnson, C. J., J. Bermúdez, D. Echeverri, D. E. Henifin, A. Rangel Suárez and L. Valencia (2007) *Los procesos de la paz en Colombia: múltiples negociaciones, múltiples actores*, Washington, DC: Woodrow Wilson International Center for Scholars – Latin American Program.

Artaraz, K. (2012) 'Cuba's internationalism revisited: exporting literacy, ALBA, and a new paradigm for South–South collaboration', in P. Kumaraswami, *Rethinking the Cuban Revolution Nationally and Regionally: Politics, Culture and Identity*, Bulletin of Latin American Research Series, London: Wiley-Blackwell, pp. 22–37.

ASR (2012) *Reintegración, avances y logros. Informe de gestión 2011*, Bogotá: Agencia Colombiana de Reintegración.

Báez, L. (1996) *Secretos de generales*, Havana: Editorial SI-MAR SA.

—— (2005) *El mérito de estar vivo*, Havana: Prensa Latina.

Báez, L. and P. de la Hoz (2009) *Caravana de la libertad*, Havana: Casa Editorial Abril.

Bain, M. J. (2007) *Soviet–Cuban Relations 1985 to 1991. Changing Perceptions in Moscow and Havana*, Plymouth: Lexington Books.

—— (2012) 'Havana and Moscow in the post-Soviet world', in J. Loss and J. M. Prieto, *Caviar with Rum. Cuba–USSR and the Post-Soviet Experience*, New York: Palgrave Macmillan, pp. 239–49.

Balconi, J. and D. Kruijt (2004) *Hacia la reconciliación. Guatemala, 1960–1996*, Guatemala: Piedra Santa.

Barber, W. F. and N. Ronning (1966) *Internal Security and Military Power. Counterinsurgency and Civic Action in Latin America*, Ohio: Ohio State University Press for the Mershon Center for Education in National Security.

Bataillon, G. (2008) *Génesis de las guerras intestinas en América Central (1960–1983)*, Mexico: Fondo de Cultura Económica.

—— (2013) 'Los "muchachos" en la revolución sandinista (Nicaragua, 1978–1980)', *Estudios sociológicos*, XXXI(92): 303–43.

Batista, F. (1962) *Cuba Betrayed*, New York: Vantage Press.

—— (1964) *The Growth and Decline of the Cuban Republic*, New York: The Devin-Aidar Company.

Baumann, G. G. (1979) *Extranjeros en la guerra civil española: los peruanos*, Lima: Industrial Gráfica SA.

Becerra, R. (2009) 'Movimiento revolucionario "Francisco Morazán": primer foco guerrillero en Honduras', 19 February, www.cedema.org/uploads/RebecaBecerra.pdf, accessed 29 November 2015.

Becker, M. (2013) 'The stormy relations between Rafael Correa and social movements in Ecuador', in *Latin America's Radical Left in Power: Complexities and Challenges in the Twenty-First Century'*, special issue of *Latin American Perspectives*, 40(3): 43–62.

Béjar, H. (1969) *Perú 1965: Apuntes sobre una experiencia guerrillera*, Lima: Campodónico Ediciones SA.

Bell Lara, J. (2007) *Fase insurreccional de la revolución cubana*, Havana: Editorial de Ciencias Sociales.

Bell Lara, J., T. Caram León and D. L. López García (2012) *Cuba: Las mujeres en la insurrección, 1952–1961*, Havana: Editorial Félix Varela.

Bell Lara, J., D. L. López García and T. Caram León (2008) *Documentos de la Revolución Cubana. 1961*, 2nd edn, Havana: Editorial de Ciencias Sociales.

Bell Lara, J., T. Caram León, D. Kruijt and D. L. López García (2013) *Cuba: La generación revolucionaria, 1952–1961*, 2nd edn, Havana: Editorial Félix Varela.

—— (2015) *Combatientes*, Havana: Editorial de Ciencias Sociales.

Bernell, D. (2011) *Constructing US Foreign Policy. The Curious Case of Cuba*, New York: Routledge.

Bessa, J. (2009) *A contra-espionagem brasileira na guerra fria*, Brasilia: Editora Thesaurus.

Betto, F. [Carlos Alberto Libânio Christo] (1985) *Fidel Castro y la religión. Conversaciones con Frei Betto*, Havana: Oficina de Publicaciones del Consejo de Estado.

Bilbao, L. (2002) *Chávez y la Revolución Bolivariana. Conversaciones con Luis Bilbao*, Santiago de Chile: Capital Intelectual SA and LOM Editores.

Bitar Deeb, R. and A. M. Isidoro Losada (eds) (2015) 'Retos para la democracia; procesos de polarización política en Venezuela', Dossier edn of *Iberoamericana. América Latina – España – Portugal*, 59, September.

Blanco, H. (1972) *Land or Death. The Peasant Struggle in Peru*, New York: Pathfinder Press.

Bolender, K. (2011) *Voices from the Other Side. An Oral History of Terrorism against Cuba*, London: Pluto Press.

Borges, R. M., E. Córdova and E. Pérez (2004) *La lucha contra bandidos en Holguín*, Holguín: Ediciones Holguín.

Borrego Díaz, O. (2013a [1966]) 'Prólogo a la segunda edición', in O. Borrego Díaz (ed.), *Che en la Revolución Cubana*, vol. 1: *Escritos y cartas*, Havana: Editorial José Martí.

—— (2013b [1966]) *Che en la Revolución Cubana*, vol. 2: *Discursos 1959–1960*, Havana: Editorial José Martí.

Bowen, J. D. (2011) 'Multicultural market democracy: elites and indigenous movements in contemporary Ecuador', *Journal of Latin American Studies*, 43: 451–83.

Briones Montoto, N. (2008) *Esperanzas y desilusiones. Una historia de los años 30*, Havana: Editorial de Ciencias Sociales.

Bruce, I. (2008) *The Real Venezuela. Making Socialism in the Twenty-first Century*, London: Pluto Press.

Buch, L. (1995) *Más allá de los códigos*, Havana: Editorial de Ciencias Sociales.

Buch, L. M. and R. Suárez (2009) *Gobierno revolucionario cubano. Primeros pasos*, Havana: Editorial de Ciencias Sociales.

Cabarrús, C. R. (1983) *Génesis de una revolución. Análisis del surgimiento y desarrollo de la organización campesina en El Salvador*, Mexico: CIESAS (Ediciones de la Casa Chata no. 16).

Cáceres Prendes, J. (2013) 'Radicalismo político en los estudiantes de la Universidad de El Salvador durante el siglo XX. La Federación de Estudiantes Universitarios Social Cristianos (FRUSC)', in J. Juárez Ávila (ed.), *Historia y debates sobre el conflicto armado salvadoreño y sus secuelas*, San Salvador: Universidad de El Salvador and Fundación Friedrich Ebert, pp. 45–53.

Cairo, A. (2008) *Raúl Roa: Imaginarios*, Havana: Editorial de Ciencias Sociales.

Calvo González, P. (2014) 'La Sierra Maestra en las rotativas. El papel de la dimensión pública en la etapa insurreccional cubana (1953–1959)', PhD thesis, Universidade de Santiago de Compostela.

Campione, D. (2007) 'La izquierda no armada en los años setenta: tres casos, 1973–1976', in C. E.Lida, H.Crespo and P. Yankelevich (eds), *Argentina, 1976. Estudios en torno al golpe de estado*, Mexico: El Colegio de México, pp. 85–110.

Canizales Vijil, R. (2012) 'Honduras – el fenómeno de los movimientos guerrilleros en Honduras. El caso del movimiento popular de liberación "Chinchonero" (1980–1990)', *El Socialista Centroaméricano*, 12 September, www.elsoca.org/index.php/america-central/movimiento-obrero-y-socialismo-en-centroamerica/2615-honduras-el-fenomeno-de-los-movimientos-guerrilleros-en-honduras-el-caso-del-movimiento-popular-de-liberacion-cinchonero-1980-1990, accessed 29 November 2015.

Cantón Navarro, J. C. and A. Silva León (2011) *Historia de Cuba, 1959–1999*, Havana: Editorial Pueblo y Educación.

Carbonel, B. M. (2007) '"FAR" from perfect: the Cuban military and the potential for state-corporatism in post-communist Cuba', *Proceedings of the Annual Meeting of the Asociation for the Study of the Cuban Economy*, 17: 353–416.

Cardona, G. (2007) 'La guerra hispano-norteamericana', in J. Girón Garote (ed.), *Un cambio de siglo, 1898. España, Cuba, Puerto Rico, Filipinas y Estados Unidos*, Oviedo: Universidad de Oviedo, pp. 65–74.

Carmona Báez, G. A. (2002) 'Global trends and the remnants of socialism. Social, political and economic restructuring in Cuba', PhD thesis, Faculty of Social and Behavioural Sciences, University of Amsterdam.

Carr, B. and S. Ellner (eds) (1993) *The Latin American Left. From the Fall of Allende to Perestroika*, Boulder, CO, and London: Westview Press and Latin American Bureau (Latin American Perspectives Series no. 11).

Carrasco, C. A. (1997) *Los cubanos en Angola. Bases para un estudio de una guerra olvidada (1975–1990)*, La Paz: Universidad Andina – Centro de Altos Estudios Internacionales.

Castañeda, J. G. (1994) *La utopía desarmada. Intrigas, dilemas y promesa de la izquierda en América Latina*, Barcelona: Editorial Ariel.

—— (1997) *Compañero. The Life and Death of Che Guevara*, New York: Alfred A. Knopf.

Castro Fernández, S. (2008) *La masacre de los Independientes de Color en 1912*, 2nd edn, Havana: Editorial de Ciencias Sociales.

Castro Ruz, F. (1992) *Un grano de maíz*, Havana: Oficina de Publicaciones del Consejo de Estado.

——— (2009) *La paz en Colombia*, Havana: Editora Política.
——— (2010a) *La victoria estratégica*, Havana: Oficina de Publicaciones del Consejo de Estado.
——— (2010b) *La contraofensiva estratégica. De la Sierra Madre a Santiago de Cuba*, Havana: Oficina de Publicaciones del Consejo de Estado.
Castro Ruz, R. (2016) 'Discurso del General de Ejército Raúl Castro Ruz, Primer Secretario del Comité Central del Partido Comunista de Cuba y Presidente de los Consejos de Estado y de Ministros, en el VII Período Ordinario de Sesiones de la Octava Legislatura de la Asamblea Nacional del Poder Popular, en el Palacio de Convenciones, el 8 de julio de 2016, "Año 58 de la Revolución" (Versiones Taquigráficas – Consejo de Estado, 8 June)', www.cubadebate.cu/autor/raul-castro-ruz/, accessed 10 July 2016.
Ceceña, A. E., D. Barrios, R. Yedra and D. Inclán (2011) *El Gran Caribe. Umbral de geopolítica mundial*, Havana: Editorial de Ciencias Sociales.
Celesia, F. and P. Waisberg (2011) *Firmenich. La historia jamás contada del jefe montonero*, Buenos Aires: Aguilar.
Childs, M. D. (1991) 'An historical critique of the emergence and evolution of Ernesto Che Guevara's *foco* theory', *Journal of Latin American Studies*, 27: 593–624.
Clem, R. S. and A. P. Maingot (eds) (2012) *Venezuela's Petro-Diplomacy. Hugo Chávez's Foreign Policy*, Gainesville: University Press of Florida.
CNMH (2013) *¡Basta Ya! Colombia: Memorias de guerra y dignidad. Informe general*, Bogotá: Centro Nacional de la Memoria Histórica.
Corrales, J. and C. A. Romero (2013) *U.S.–Venezuela Relations since the 1990s. Coping with Midlevel Security Threats*, New York: Routledge.
Cortina Orero, E. (2014) 'Proyectos revolucionarios. Casos nacionales y coordinación regional', in V. Oikión Solano, E. Rey Tristán and M. López Ávalos (eds), *El estudio de las luchas revolucionarias en América Latina (1959–1996). Estado de la cuestión*, Zamora and Santiago de Compostela: El Colegio de Michoacán and Universidade de Santiago de Compostela, pp. 409–30.
Crandall, R. (2008) *The United States and Latin America after the Cold War*, Cambridge: Cambridge University Press.
Cuadriello, J. D. (2009) *El exilio republicano español en Cuba*, Madrid: Siglo XXI de España Editores.
Cuesta Braniella, J. M. (1997) *La resistencia cívica en la guerra de liberación de Cuba*, Havana: Editorial de Ciencias Sociales.
——— (2010) *Treinta y dos días antes y después de la victoria en Cuba*, Havana: Editorial de Ciencias Sociales.
Dávalos Fernández, R. (2012) *¿Embargo o bloqueo? La instrumentalización de un crimen contra Cuba*, Havana: Editorial Capitán San Luis.
Deere, C. D., N. Pérez Rojas, M. García and E. González (1998) *Güines, Santo Domingo and Majibacoa, sobre sus historias agrarias*, Havana: Editorial de Ciencias Sociales.
De Giuseppe, M. (2006) *Oscar Romero. Storia Memoria Attualità*, Bologna: Editrice Missionaria Italiana.
De la Rosa Valdés, L. (2011) *Fidelidad*, Havana: Casa Editorial Verde Olivo.
Del Castillo, L., M. Zaldívar and L. Villar (2005) 'Microfinanciamiento y desarrollo local. Experiencia en Cuba', in G. Beluche et al., *Microcrédito contra la exclusión*

social. *Experiencias de financiamiento alternativo en Europa y América Latina*, San José: Facultad Latinoamericana de Ciencias Sociales (FLACSO), pp. 153–71.

De Lise, L. (2007) 'De la movilización popular al aniquilamiento (1973–1976)', in C. E. Lida, H. Crespo and P. Yankelevich (eds), *Argentina, 1976. Estudios en torno al golpe de estado*, Mexico: El Colegio de México, pp. 35–58.

Del Valle Jiménez, S. (2009) *Camilo: Táctica y estrategia de una gran victoria. Diario de guerra*, Havana: Editorial de Ciencias Sociales.

Diaz, J. H. (ed.) (2014) 'Cuba in transition', special issue of *Latin American Perspectives*, 41(4), July.

Díaz Polanco, J. (2008) *Salud y hegemonía en Venezuela: barrio adentro, continente afuera*, Caracas: Universidad Central de Venezuela – Centro de Estudios del Desarrollo (CENDES).

Dilla Alfonso, H. (2005) 'Actores larvados, escenarios inciertos y guiones crípticos: ¿hacia dónde va la sociedad civil cubana?', in J. S. Tulchin, L. Bobea, M. P. Espina Prieto and R. Hernández with E. Bryan (eds), *Cambios en la sociedad cubana desde los años noventa*, Washington, DC: Woodrow Wilson International Center for Scholars – Latin American Program, pp. 37–53.

Dominguez, J. I. (ed.) (1979) *Cuba. Order and Revolution*, Cambridge, MA: Harvard University Press.

—— (1993) 'Cuba since 1959', in L. Bethell (ed.), *Cuba: A Short History*, Cambridge: Cambridge University Press, pp. 57–93.

—— (2006) *Cuba hoy. Analizando su pasado, imaginando su futuro*, Madrid: Editorial Colibrí.

—— (2009) *La política exterior de Cuba (1962–2009)*, Madrid: Editorial Colibrí.

Dominguez, J. I., O. E. Pérez Villanueva, M. Espina Prieto and L. Barberia (eds) (2012) *Cuban Social and Economic Development. Policy Reforms and Challenges in the 21st Century*, Cambridge, MA: Harvard University Press.

Domínguez Avila, C. F. (2011) 'Guerra fria na Região Amazônica: um estudo da Missão Venturini ao Suriname (1983)', *Revista Brasileira de Política Internacional*, 54(1): 7–28.

Domínguez Guadarrama, R. (2013) *Revolución Cubana. Política exterior hacia América Latina y el Caribe*, Mexico: Universidad Nacional Autónoma de México (UNAM) – Centro de Investigaciones sobre América Latina y el Caribe (CISALC).

Dreifuss, R. A. (1981) *1964: A Conquista do Estado. Ação Política, Poder e Golpe de Classe*, Petrópolis: Vozes.

Duncan, W. R. (1985) *The Soviet Union and Cuba. Interests and Influences*, New York: Praeger.

Dunkerley, J. (1988) *Power in the Isthmus. A Political History of Modern Central America*, London: Verso.

—— (1992) 'Barrientos and Debray: All gone or more to come?', Occasional Paper no. 2, London: University of London – Institute of Latin American Studies.

Eckstein, S. E. (2009) *The Immigrant Divide. How Cuban Americans Changed the US and their Homeland*, New York: Routledge.

Ellner, S. (2008) *Rethinking Venezuelan Politics. Class, Conflict, and the Chávez Phenomenon*, Boulder, CO: Lynne Rienner Publishers.

—— (2013a) *El fenómeno Chávez, sus orígenes y su impacto (hasta 2013)*, 2nd edn, Caracas: Fundación Centro de Estudios Latinoamericanos Rómulo Gallegos (CELARG) and Centro Nacional de Historia.

—— (2013b) 'Latin America's radical left in power: complexities and challenges in the twenty-first century', special issue of *Latin American Perspectives*, 40(3), May.

English, T. J. (2007) *The Havana Mob. How the Mob owned Cuba ... and then Lost it to the Revolution*, Edinburgh: Mainstream.

Escalante Font, F. (2006) *Operación Calipso: La guerra sucia de Estados Unidos contra Nicaragua*, Mexico: Ocean Sur.

—— (2009) *Nicaragua Sandinista*, Havana: Editorial de Ciencias Sociales.

—— (2010) *Operación exterminio. 50 años de agresiones contra Cuba*, Havana: Editorial de Ciencias Sociales.

Espín Guillois, V., A. de los Santos Tamayo and M. V. Álvarez Mola (2011) *Contra todo obstáculo*, Havana: Casa Editorial Verde Olivo.

Espina Prieto, M. P. (2005) 'Cambios estructurales desde los noventa y nuevos temas de estudio de la sociedad cubana', in J. S. Tulchin, L. Bobea, M. P. Espina Prieto and R. Hernández with E.Bryan (eds), *Cambios en la sociedad cubana desde los años noventa*, Washington, DC: Woodrow Wilson International Center for Scholars – Latin American Program, pp. 109–33.

Espinosa Martín, R. (2009) *Siempre en combate*, Havana: Casa Editorial Verde Olivo.

Estrada Lescaille, U. (2003) 'La muerte de Allende fue un acto de combate', Santiago de Chile: CEME – Centro de Estudios Miguel Enriquez.

—— (2005) *Tania la guerrillera y la epopeya suramericana del Che*, ed. and prologue L. Suárez Salazar, Havana: Ocean Press.

Etcheverry Vázquez, P. and S. Gutiérrez Oceguerra (2008) *Banditismo. Derrota de la CIA en Cuba*, Havana: Editorial Capitán San Luis.

Falcão, F. J. (2012) *Os homens do passo certo. O PC e a Esquerda Revolucionária no Brasil (1942–1961)*, São Paolo: Editora José Luis e Rosa Sundermann.

Feinsilver, J. M. (1989) 'Cuba as a world medical power: the politics of symbolism', *Latin American Research Review*, 24(2): 1–34.

—— (1993) *Healing the Masses: Cuban Health Politics at Home and Abroad*, Berkeley: University of California Press.

—— (2010) 'Fifty years of Cuba's medical diplomacy: from idealism to pragmatism', *Cuban Studies*, 41: 85–104.

Fernández Bastarreche, F. (2007) 'La última guerra hispano-cubana (1895–1898)', in J.Girón Garote (ed.), *Un cambio de siglo, 1898. España, Cuba, Puerto Rico, Filipinas y Estados Unidos*, Oviedo: Universidad de Oviedo, pp. 57–64.

Fernández Muñiz, Á. M. (2009) 'Repercusión de la Guerra Civil Española y del exilio republicano en la sociedad cubana', in Á. M.Fernández Muñiz (ed.), *La Guerra Civil Española en la sociedad cubana. Aproximación a una época*, Havana: Editorial de Ciencias Sociales, pp. 84–96.

Fernández Muñiz, Á. M. and A. Martín Fernández (2007) 'José Martí. Artífice de la guerra necesaria', in J. Girón Garote (ed.), *Un cambio de siglo, 1898. España, Cuba, Puerto Rico, Filipinas y Estados Unidos*, Oviedo: Universidad de Oviedo, pp. 197–206.

Ferrer Gómez, Y. and C. Aguilar Ayerra (2015) *Vilma Espín Guillois. El fuego de la libertad*, Havana: Editorial de la Mujer.

Figueroa Ibarra, C., G. Paz Cárcamo and A. Taracena Arriola (2013) 'El primer siglo de insurgencia revolucionaria en Guatemala (1957–1972)', in V. Álvarez

Áragon, C. Figueroa Ibarra, A. Taracena Arriola, S. Tischler Visquerra and E. Urrutia García (eds), *Guatemala: Historia Reciente (1954–1996)*, vol. II: *La dimensión revolucionaria*, Guatemala: Facultad Latinoamericana de Ciencias Sociales (FLACSO), pp. 27–120.

Ford González, J. (2009) *Un hombre, un partido*, Panama: Imprenta Articsa.

Fornet, A. (2007) 'El quinquenio gris: revisando el tiempo', *Casa de las Américas*, 246: 3–16.

Fournier, E. (1991) *Conociendo al MRTA para vencerlo*, Lima: Imprenta del Ejército.

Frankel, M. (2004) *High Noon in the Cold War. Kennedy, Khrushchev, and the Cuban Missile Crisis*, New York: Ballantine Books.

Fuentes, I. (2008) 'Cuentapropismo o cuentapriapismo: retos y consideraciones sobre género, auto-empleo y privatización', *Proceedings of the Annual Meeting of the Association for the Study of the Cuban Economy*, 18: 341–8.

Fulgueiras, J. A. (2009) *Víctor Bordón: El nombre de mis ideas*, Havana: Editorial de Ciencias Sociales.

Gálvez, W. (1979) *Camilo, señor de la vanguardia*, Havana: Editorial de Ciencias Sociales.

—— (1982) *Salida 19. Operación Comando*, Havana: Editorial de Ciencias Sociales.

García Frías, G. (2010) *Encuentro con la verdad*, Havana: Casa Editorial Verde Olivo (Prologue by Raúl Castro Ruz).

García Peláez, P. (2010) *Ni gallego ni asturiano: cubano y rebelde*, Havana: Editorial Capitán San Luis.

García-Pérez, G. M. (2005) *Crónicas guerrilleras de Occidente*, Havana: Editorial de Ciencias Sociales.

Garcíga Blanco, J. A. (2009) *General Tomassevich. Un heroe de la Revolución Cubana*, Havana: Editorial Política.

—— (2010) *LCB 1962: En el Escambray y más allá*, Havana: Casa Editorial Verde Olivo.

—— (2011) *Contra el terrorismo. Cerco y peine*, Havana: Editorial de Ciencias Sociales.

Gardini, G. L. and P. Lambert (eds) (2011) *Latin American Foreign Policies. Between Ideology and Pragmatism*, New York: Palgrave Macmillan.

Gellately, R. (2013) *Stalin's Curse. Battling for Communism in War and Cold War*, New York: Vintage.

George, E. (2005) *The Cuban Intervention in Angola, 1965–1991. From Che Guevara to Cuito Cuanavale*, London: Frank Cass.

Gillespie, R. (1982) *Soldiers of Peron. Argentina's Montoneros*, Oxford: Clarendon Press.

Girón Garote, J. (ed.) (2007) *Un cambio de siglo, 1898. España, Cuba, Puerto Rico, Filipinas y Estados Unidos*, Oviedo: Universidad de Oviedo.

Giuliano, M. (1998) *El caso CEA. Intelectuales e inquisidores en Cuba. ¿Perestroika en la isla?*, Miami: Ediciones Universal.

Gleijeses, P. (1978) *The Dominican Crisis. The 1965 Constitutionalist Revolt and American Intervention*, Baltimore, MD: Johns Hopkins University Press.

—— (1992) *Shattered Hope. The Guatemalan Revolution and the United States, 1944–1954*, Princeton, NJ: Princeton University Press.

—— (2002) *Conflicting Missions. Havana, Washington, and Africa* (1959–1976), Chapel Hill: University of North Carolina Press.

—— (2007) *Misiones en conflicto. La Habana, Washington y África, 1959–1976*, 3rd Cuban edn, Introduction by J. Risquet Valdés, Havana: Editorial de Ciencias Sociales.

Golinger, E. (2010) 'US interference in Venezuela keeps growing', 4 August, www.chavezcode.com/2010/08/us-interference-in-venezuela-keeps.html, accessed 10 July 2016.

Gómez Rodríguez (2011) 'Eventos de la lucha clandestina', Private publication, Havana.

González Lage, V. (2015) 'Camiño ao socialismo. A evolución ideolóxica da revolución cubana', History degree thesis, Santiago de Compostela: Universidade de Compostela – Departamento de Historia Contemporánea e de América.

Gordillo, M. B. (2007) 'Sindicalismo y radicalización en los setenta: las experiencias clasistas', in C. E. Lida, H. Crespo and P. Yankelevich (eds), *Argentina, 1976. Estudios en torno al golpe de estado*, Mexico: El Colegio de México, pp. 59–84.

Gorender, X. (1987) *Combate nas trevas. A esquerda brasileira: das illusoes perdidas à luta armada*, 3rd edn, São Paulo: Editora Ática SA.

Gott, R. (1968) 'La guerrilla en América Latina', *Mensaje*, XVII(174): 557–67.

—— (1971) *Guerrilla Movements in Latin America*, Garden City, NY: Doubleday.

—— (2000) *In the Shadow of the Liberator. Hugo Chávez and the Transformation of Venezuela*, London: Verso.

—— (2004) *Cuba. A New History*, New Haven, CT: Yale University Press.

—— (2005) *Hugo Chávez and the Bolivarian Revolution*, London: Verso.

Graña Eiriz, M. (2008) *Clandestinos en prisión*, Havana: Editorial de Ciencias Sociales.

Gratius, S. (2008) *Cuba: Entre continuidad y cambio*, Madrid: Fundación para las Relaciones Internacionales y el Diálogo Exterior (FRIDE).

Gómez Rodríguez, R. (2011) 'Eventos de la lucha clandestina', Unpublished document, Havana.

González de Cascorro, R. (1975) *Aquí se habla de combatientes y de bandidos*, Havana: Casa de las Américas.

Guerra Vilaboy, S. (2010) *Jugar con fuego. Guerra social y utopía en la independencia de América Latina*, Havana: Casa de las Américas.

Guerra Vilaboy, S. and A. Maldonado Gallardo (2005) *Historia de la Revolución Cubana. Síntesis y comentario*, Quito: Ediciones la Tierra.

Guerrero, A. (2009) *El Peronismo armado. De la Resistencia a Montoneros. De la Libertadora al Exterminio*, Buenos Aires: Grupo Norma Editorial.

Guerrero Palermo, G. (2012) *Los tupas de Tacuarembó. La izquierda, el MLN y la represión en el departamento*, Montevideo: Fin del Siglo Editorial.

Guzmán, G. (1976) *El desarrollo latinoamericano y la CEPAL*, Barcelona: Editorial Planeta.

Haberkorn, L. (2011) *Milicos y Tupas*, Montevideo: Editorial Fin del Siglo.

Harmer, T. (2011) *Allende's Chile and the Inter-American Cold War*, Chapel Hill: University of North Carolina Press.

—— (2016) 'The view from Havana: Chilean exiles in Cuba and early resistance to Chile's dictatorship, 1973–1977', *Hispanic American Historical Review*, 96(1): 109–46.

Harvey, R. (2002) *Liberators. South America's Savage Wars of Freedom, 1810–1830*, London: John Murray.

Hart Dávalos, A. (1997) *Aldabonazo*, Havana: Editorial Letras Cubanas.

Henken, T. A. (2008) *Cuba. A Global Studies Handbook*, Santa Barbara: ABC-CLIO Inc.

Henken, T. A. and A. R. M. Ritter (2014) 'Self-employment in today's Cuba: quantitative expansion amid qualitative limitation', *Proceedings of the Annual Meeting of the Association for the Study of the Cuban Economy*, 24: 288–96.

Hernández, Rafael (2005) 'Espejo de paciencia: notas sobre estudios cubanos, ciencias sociales y pensamiento en Cuba contemporánea', in J. S. Tulchin, L.Bobea, M. P. Espina Prieto and R. Hernández with E. Bryan (eds),*Cambios en la sociedad cubana desde los años noventa*, Washington, DC: Woodrow Wilson International Center for Scholars – Latin American Program, pp. 151–67.

—— (2011) 'The Cuban Revolution and the Caribbean. Civil society, culture, and international relations', in S. Puri (ed.), *The Legacies of Caribbean Radical Politics*, Abingdon: Routledge, pp. 36–46.

Hernández, Ramón and R. Giusti (2006) *Carlos Andrés Pérez: Memorias proscritas*, Caracas: Los Libros de El Nacional.

Herrera Medina, J. R. (2006) *Operación Jaula. Contragolpe en el Escambray*, Havana: Casa Editorial Verde Olivo.

Hersch, S. (1998) *The Dark Side of Camelot*, London: HarperCollins.

Hoffmann, B. (2009) 'Charismatic authority and leadership change: lessons from Cuba's post-Fidel succession', *International Political Science Review*, 30(3): 229–48.

Hoogbergen, W. and D. Kruijt (2005) *De oorlog van de sergeanten. Surinaamse Militairen in de politiek* [The Sergeant's War: The Surinamese Military in National Politics], Amsterdam: Bart Baker.

Hudson, R. (1988) *Castro's America Department. Coordinating Cuba's Support for Marxist-Leninist Violence in the Americas*, Miami: Cuban American National Foundation.

Huish, R. (2014) 'The heart of the matter. The impact of Cuba's medical internationalism in the global South', in C. Krull (ed.), *Cuba in a Global Context. International Relations, Internationalism, and Transnationalism*, Gainesville: University Press of Florida, pp. 176–207.

Ibarra Chávez, H. A. (2015) *En busca del reino de Dios en la Tierra. La Teología de Liberación durante la revolución salvadoreña*, San Salvador: Ediciones El Independiente.

Ibarra Cuesta, J. (1992) *Cuba, partidos políticos y clases sociales (1898–1925)*, Havana: Editorial de Ciencias Sociales.

—— (1995) *Patria, etnia y nación*, Havana: Editorial de Ciencias Sociales.

—— (2007) *Cuba, 1898–1921*, Havana: Editorial de Ciencias Sociales.

Ibarra Cuesta, J. et al. (1985 [1967]) *Historia de Cuba*, Havana: Editorial de Ciencias Sociales and Dirección Política de las Fuerzas Armadas Revolucionarias (FAR).

Ibarra Guitart, J. R. (2000) *El fracaso de los moderados en Cuba. Las alternativas reformistas de 1957 a 1958*, Havana: Editorial Política.

—— (2003) *Sociedad de Amigos de la República. Historia de una mediación, 1952–1958*, Havana: Editorial de Ciencias Sociales.

James, D. (2001 [1969]) *Ché Guevara. A Biography*, New York: Cooper Square Press (republication with a new introduction by H. Butterfield Ryan).

Jiménez Güethon, R. M. (2009) 'Desarrollo local y cooperativas agrícolas en Cuba: logros y desafíos', *Cuba 50 años de desarrollo humano*, special issue of *Cuadernos África – América Latina. Revista de análisis sur/norte para una cooperación solidaria* (SODEPAZ), 46: 87–101.

Jirón Miranda, P. (2007) 'La pérdida del Pacífico Español: Las Islas Marianas, Carolinas y Palaos', in J.Girón Garote (ed.), *Un cambio de siglo, 1898. España, Cuba, Puerto Rico, Filipinas y Estados Unidos*, Oviedo: Universidad de Oviedo, pp. 371–6.

Juárez Ávila, J. (ed.) (2013) *Historia y debates sobre el conflicto armado salvadoreño y sus secuelas*, San Salvador: Universidad de El Salvador and Fundación Friedrich Ebert.

Judt, T. (2006) *Postwar. A History of Europe since 1945*, New York: Penguin.

Kapcia, A. (2000) *Cuba, Island of Dreams*, Oxford: Berg.

—— (2008) *Cuba in Revolution. A History since the Fifties*, London: Reaktion Books.

—— (2014) *Leadership in the Cuban Revolution. The Unseen Story*, London: Zed Books.

Karol, K. S. (1971) *Guerrillas in Power. The Course of the Cuban Revolution*, London: Jonathan Cape.

Kaufman, M. (1985) *Jamaica under Manley. Dilemmas of Socialism and Democracy*, London: Zed Books.

Kirk, J. D. (2012) 'Cuban medical internationalism under Raúl Castro', in P. Kumaraswami, *Rethinking the Cuban Revolution Nationally and Regionally: Politics, Culture and Identity*, London: Wiley-Blackwell (Bulletin of Latin American Research Series), pp. 77–90.

Kirk, J. D. and H. M. Erisman (2009) *Cuban Medical Internationalism. Origins, Evolution and Goals*, New York: Palgrave Macmillan.

Klepak, H. (2000) 'Cuba's foreign and defence policies in the "Special Period"', FOCAL Paper 00–4, February, Ottawa.

—— (2005) *Cuba's Military 1990–2005. Revolutionary Soldiers during Counter-Revolutionary Times*, New York: Palgrave Macmillan.

—— (2009) *Raúl Castro, estratega de la defensa revolucionaria de Cuba*, Buenos Aires: Capital Intelectual.

—— (2012) *Raúl Castro and Cuba: A Military Story*, New York: Palgrave Macmillan.

—— (2014) 'A model servant. The revolutionary armed forces and Cuban foreign policy', in C.Krull (ed.), *Cuba in a Global Context. International Relations, Internationalism, and Transnationalism*, Gainesville: University Press of Florida, pp. 44–57.

Kozloff, N. (2006) *Hugo Chávez. Oil, Politics, and the Challenge to the United States*, New York: Palgrave Macmillan.

Krämer, R. (1998) 'Kuba und die DDR', in R. Krämer, *Der alte Mann und die Insel. Essays zu Politik und Gesellschaft in Kuba*, Berlin: Berliner Debatte Wissenschaftsverlag, pp. 139–60.

Kruijt, D. (1994) *Revolution by Decree. Peru 1968–1975*, Amsterdam: Thela-Publishers (Thela Latin America Series).

—— (1999) 'Exercises in state terrorism: the counterinsurgency campaigns in Guatemala and Peru', in K. Koonings and D. Kruijt (eds), *Societies of Fear. The Legacy of Civil War, Violence, and Terror in Latin America*, London: Zed Books, pp. 33–62.

—— (2008) *Guerrillas: War and Peace in Central America*, London: Zed Books.

—— (2013) 'Research on Latin America's soldiers: generals, sergeants, and guerrilla comandantes', in H. Carreiras and C. Castro (eds), *Qualitative Methods in Military Studies. Research Experiences and Challenges*, Cass Military Studies, London: Routledge, pp. 158–77.

Kumaraswami, P. (2012) *Rethinking the Cuban Revolution Nationally and Regionally: Politics, Culture and Identity*, London: Wiley-Blackwell (Bulletin of Latin American Research Series).

Lahrem, S. (2005) *Che Guevara*, Frankfurt: Suhrkamp Verlag.

—— (2010) 'Faszination Che', *Aus Politik und Zeitgeschichte*, pp. 41–6.

Lamberg, R. (1979) *La guerrilla en América Latina*, Madrid: Editorial Mediterráneo.

Lambie, G. (2010) *The Cuban Revolution in the 21st Century*, London: Pluto Press.

Laqueur, W. (2009) *Guerrilla Warfare. A Historical and Critical Study*, New Brunswick, NJ: Transaction.

Latell, B. (2003) *The Cuban Military and Transition Dynamics*, Institute for Cuban and Cuban-American Studies, University of Miami.

—— (2007) *After Fidel. Raul Castro and the Future of Cuba's Revolution*, New York: Palgrave Macmillan.

—— (2013) *Castro's Secrets. Cuban Intelligence, the CIA and the Assassination of John F. Kennedy*, New York: Palgrave Macmillan.

Latrèche, L. (2011) *Cuba et L'USSR. 30 ans d'une relation improbable*, Paris: L'Harmattan.

Le Bot, Y. (1995) *La guerra en tierras mayas. Comunidad, violencia y modernidad en Guatemala (1970–1992)*, Mexico: Fondo de Cultura Económica.

—— (2009) *La grande révolte indienne*, Paris: Éditions Robert Laffont.

Le Bot, Y. with M. Najman (1997) *El sueño Zapatista. Entrevistas con el subcomandante Marcos, el mayor Moisés y el comandante Tacho del Ejército Zapatista de Liberación Nacional*, Barcelona: Plaza & Janés Editores.

LeoGrande, W. M. (1980) *Cuba's Policy in Africa, 1959–1980*, Berkeley: University of California – Institute of International Studies.

—— (1998) *Our Own Backyard. The United States in Central America, 1977–1992*, Chapel Hill: University of North Carolina Press.

LeoGrande, W. M. and P. Kornbluh (2014) *Back Channel to Cuba. The Hidden History of Negotiations between Washington and Havana*, Chapel Hill: University of North Carolina Press.

León Rojas, G. M. (2006) *Jorge Risquet. Del solar a la sierra*, Havana: Editorial de Ciencias Sociales.

Letts, R. (América Pumaruna) (1967) 'Perú: Revolución, insurrección, guerrillas', *Pensamiento Propio*, 1: 74–128.

Lewis, P. H. (2011) *Guerrillas and Generals. The Dirty War in Argentina*, London: Praeger.

Lievesley, G. and S. Ludham (eds) (2009) *Reclaiming Latin America*, London: Zed Books.

Línarez, P. P. (ed.) (2007) *El apoyo cubano a la lucha armada en Venezuela*, Caracas: Universidad Bolivariana de Venezuela.

Livingstone, G. (2009) *America's Backyard. The United States and Latin America from the Monroe Doctrine to the War on Terror*, London: Zed Books.

López, A. J. (2014) *José Martí. A Revolutionary Life*, Austin: University of Texas Press.

López Bernal, C. G. (2015) 'Schafick Jorge Handal y la "unidad" del FMLN de posguerra: entre la memoria y la historia, El Salvador, 1992–2015', Paper presented at the 55th Congreso Internacional de Americanistas (ICA) forum 'Dimensiones transnacionales de la violencia política en América Latina, Estados Unidos y Europa', San Salvador, 12–16 July.

López Blanch, H. (2005) *Historias secretas de médicos cubanos*, Havana: Ediciones La Memoria and Centro Cultural Pablo de la Torriente Brau.

López Civeira, F., M. Mencía and P. Álvarez Tabío (2012) *Historia de Cuba, 1899–1958*, Havana: Editorial Pueblo y Educación.

López Díaz, M. (2009) 'La reconcentración: Weyler por Weyler', in M. López Díaz (ed.), *Cuba: la guerra de 1898*, San José: Facultad Latinoamericana de Ciencias Sociales (FLACSO), pp. 103–21.

Lora, G. (2011) *Revolución y foquismo. Balance de la discusión sobre la desviación 'guerrillista'*, Buenos Aires: CEICS and Ediciones RyR.

Lorenzo Castro, O. (2007) *Memorias del Capitan Pineo*, Havana: Editorial Verde Olivo.

Loveman, B. and T. M. Davies Jr (1997) *Guerrilla Warfare/Che Guevara*, 3rd edn with revised and updated introduction and case studies, Wilmington, DE: Scholarly Resources Inc.

Lust, J. (2013) *Lucha revolucionaria. Perú, 1958–1967*, Barcelona: RBA Libros.

——— (2016) 'The role of the Peruvian guerrilla in Che Guevara's continental guerrilla project', *Bulletin of Latin American Research*, 35(2): 225–39.

Macías, J. C. (1997) *La guerrilla fue mi camino (Epitafio para Cesar Montes)*, Guatemala: Piedra Santa.

Macaulay, N. (1978) 'The Cuban Rebel Army: a numerical survey', *Hispanic American Historical Review*, 58(2): 284–95.

Magalhães, M. (2012) *Marighella. O guerrilho que incendiou o mundo*, São Paolo: Companhia Das Letras.

Mallin, J. (1994) *Covering Castro. Rise and Decline of Cuba's Communist Dictator*, Washington, DC, and New Brunswick, NJ: US-Cuba Institute Press and Transaction Publishers.

Manzanhão, B. (2014) *Lenin Cerna: El hombre y sus circunstancias. Biografía no autorizada*, Managua: Instituto de Historia de Nicaragua y de Centroamérica (IHNCA).

March, A. (2011) *Evocación. Mi vida al lado del Che*, Havana: Ocean Press.

Marques Bezerra, G. H. (2010) *Brasil–Cuba: Relações político-diplomáticas no contexto da guerra fria (1959–1986)*, Brasilia: Ministério das Relações Exteriores – Fundação Alexandre de Gusmão.

Martí y Puig, S. (1997) *Nicaragua 1979–1990. La revolución enredada*, Madrid: Libros de la Catarata.

Martín Álvarez, A. (2013) 'Del partido a la guerrilla. Los orígenes de las Fuerzas Populares de Liberación Farabundo Martí (FPL)', in J. Juárez Ávila (ed.), *Historia*

y debates sobre el conflicto armado salvadoreño y sus secuelas, San Salvador: Universidad de El Salvador and Fundación Friedrich Ebert, pp. 55–62.

—— (2016) 'The long wave: the revolutionary left in Guatemala, Nicaragua and El Salvador', in A. Martín Álvarez and E. Rey Tristán (eds), *Revolutionary Violence and the New Left. Transnational Perspectives*, London: Routledge, pp. 223–45.

Martínez, J. de J. (1982) *Ideario: Omar Torrijos*, San José: Editorial Universitaria Centroamericana (EDUCA).

Martínez-Fernández, L. (2014) *Revolutionary Cuba. A History*, Gainesville: University Press of Florida.

Martínez Heredia, F. (2010) *Si breve ...*, Havana: Editorial Letras Cubanas.

Meneses, E. (1995) *Castro comienza la revolución*, Madrid: Espasa Calpe.

Mercier Vega, L. (1969) *Las guerrillas en América Latina. La técnica del contra-Estado*, Buenos Aires: Paidos (Biblioteca Mundo Moderno no. 25).

Merino, J. L. (2011) *Comandante Ramiro. Revelaciones de un guerrillero y líder revolucionario salvadoreño*, ed. R. Regalado, Mexico: Ocean Sur.

Mesa-Lago, C. (1982) 'Cuban foreign policy in Africa: a general framework', in C. Mesa-Lago and J. S. Belkin (eds), *Cuba in Africa*, Pittsburgh: University of Pittsburgh – Center for Latin American Studies and University Center for International Studies, pp. 1–12.

—— (2012) *Cuba en la era de Raúl Castro. Reformas económico-sociales y sus efectos*, Madrid: Editorial Colibrí.

Mesa-Lago, C. and J. S. Belkin (eds) (1982) *Cuba in Africa*, Pittsburgh: University of Pittsburgh – Center for Latin American Studies and University Center for International Studies.

Mesa-Lago, C. and L. Zephirin (1974) 'Central planning', in C. Mesa-Lago (ed.), *Revolutionary Change in Cuba*, Pittsburgh: University of Pittsburgh Press, pp. 145–84.

Monsanto, P. (2013) *Somos los jóvenes rebeldes, Guatemala insurgente*, Guatemala: F&G Editores.

Montgomery, T. S. (1995) *Revolution in El Salvador. From Civil Strife to Civil Peace*, Boulder, CO: Westview Press.

Mora, F. O. (2007) 'Cuba's Ministry of Interior: the FAR's Fifth Army', *Bulletin of Latin American Research*, 26(2): 222–37.

Morales Dominguez, E. and G. Prevost (2008) *United States–Cuban Relations. A Critical History*, Lanham, MD: Lexington Books.

Morello, G. (2007) 'El Vaticano II y la radicalización de los católicos', in C. E. Lida, H.Crespo and P. Yankelevich (eds), *Argentina, 1976. Estudios en torno al golpe de estado*, Mexico: El Colegio de México, pp. 111–29.

Moro Barreñada, J. M. (2007) 'La guerra de los Diez Años (1868–1978)', in J.Girón Garote (ed.), *Un cambio de siglo, 1898. España, Cuba, Puerto Rico, Filipinas y Estados Unidos*, Oviedo: Universidad de Oviedo, pp. 49–56.

Nickson, A. (2013) *Las guerrillas del Alto Paraná*, Asunción: Editorial El Lector and Portal Guarani.

Nieto, C. (2003) *Masters of War. Latin America and the United States Aggression from the Cuban Revolution through the Clinton Years*, New York: Seven Stories Press.

Noriega, M. and P. Eisner (1997) *America's Prisoner. The Memoirs of Manuel Noriega*, New York: Random House.

Nossa, L. (2012) *Mata! O Major Curió e as guerrilhas no Araguaia*, São Paolo: Companhia das Letras.

Nova González, A. (2013) *El modelo agrícola y los lineamientos de la política económica y social*, Havana: Editorial de Ciencias Sociales.

Nuiry, J. (2002) *¡Presente! Apuntes para la historia del movimiento estudiantil cubano*, 2nd edn, Havana: Editora Política.

Oikión Solano, V., E. Rey Tristán and M. López Ávalos (eds) (2014) *El estudio de las luchas revolucionarias en América Latina (1959–1996): Estado de la cuestión*, Zamora and Santiago de Compostela: El Colegio de Michoacán and Universidade de Santiago de Compostela.

Oltuski, E. (2000) *Gente del Llano*, Havana: Editorial Imagen Contemporánea.

—— (2002) *Vida clandestina. My Life in the Cuban Revolution*, New York: Wiley.

Oltuski, E., H.Rodriguez Llompart and E. Torres Cuevas (eds) (2007) *Memorias de la Revolución*, Havana: Imagen Contemporánea and Cátedra Faustino Pérez.

Ortiz, F. (2012) *La Virgen de la Caridad del Cobre. Historiografía y etnografía*, ed. J. A.Matos Arévalos, Havana: Fundación Fernando Ortiz, Instituto de Literatura y Lingüística, Sociedad Económica de Amigos del País and Oficina del Historiador de la Ciudad de la Havana.

Paíz Cárcamo, M. and M. G. Vázquez Olivera (2015) *Rosa María, una mujer de la guerilla. Relatos de la insurgencia guatemalteca en los años sesenta*, Mexico: Universidad Nacional Autónoma de México (UNAM) – Centro de Investigaciones sobre América Latina y el Caribe (CIALC).

Paszyn, D. (2000) *The Soviet Attitude to Political and Social Change in Central America, 1979–1990*, New York: St Martin's Press.

Pavlov, Y. (1994) *Soviet–Cuban Alliance: 1959–1991*, New Brunswick, NJ; North-South Center of the University of Miami and Transaction Publishers.

—— (2012) 'Socialism as the main Soviet legacy in Cuba', in J. Loss and J. Manuel Prieto, *Caviar with Rum. Cuba–USSR and the Post-Soviet Experience*, New York: Palgrave Macmillan, pp. 229–37.

Pearce, J. (1985) *Promised Land: Peasant Rebellion in Chalatenango, El Salvador*, London: Latin America Bureau.

Pécaut, D. (2001) *Guerra contra la sociedad*, Bogotá: Editorial Planeta.

Pereyra, D. (2011 [1994]) *Del Moncada a Chiapas. Historia de la lucha armada en América Latina*, Buenos Aires: Ediciones RyR.

Pérez Jr, L. A. (1993) 'Cuba, c. 1930–1959', in L. Bethell (ed.), *Cuba: A Short History*, Cambridge: Cambridge University Press, pp. 95–148.

—— (1994) 'Between baseball and bullfighting: the quest for nationality in Cuba, 1868–1898', *Journal of American History*, 81(2): 493–517.

—— (2011) *Cuba between Reform and Revolution*, 4th edn, New York: Oxford University Press.

Pérez Caso, H. (2011) *De azul y verde olivo*, Havana: Editora Política.

Pérez Marcano, H. and A. Sánchez García (2007) *La invasión de Cuba a Venezuela. De Machurucuto a La Revolución Bolivariana*, Caracas: Los Libros de El Nacional.

Pérez Prendes Muños-Arraco, J. M. (2007) 'El Tratado de Paris', in J. Girón Garote (ed.), *Un cambio de siglo, 1898. España, Cuba, Puerto Rico, Filipinas y Estados Unidos*, Oviedo: Universidad de Oviedo, pp. 85–90.

Pérez Villanueva, O. E. (ed.) (2006) *Reflexiones sobre la economía cubana*, Havana: Editorial de Ciencias Sociales.

—— (ed.) (2010) *Cincuenta años de la economía cubana*, Havana: Editorial de Ciencias Sociales.

Petkoff, T. (2005) *Dos izquierdas*, Caracas: Alfa Grupo Editorial.

Pino Santos, O. (1973) *El imperialismo norteamericana en la economía de Cuba*, Havana: Editorial de Ciencias Sociales.

Piccone, T. and H. Tricunas (2014) 'The Cuba–Venezuela alliance. The beginning of the end?', Policy Brief June 2014 of the Latin America Initiative – Foreign Policy at Brookings, www.brookings.edu/~/media/research/files/papers/2014/06/16-cuba-venezuela-alliance-piccone-trinkunas/cubavenezuela-alliance-piccone-trinkunas.pdf, accessed 7 February 2016.

Platt, W. (1957) *Strategic Intelligence Production: Basic Principles*, New York: F. A. Praeger, www.foia.cia.gov/sites/default/files/document_conversions/89801/DOC_0000606546.pdf, summary edn accessed 31 June 2015.

Polay, V. (2009) *En el banquillo. ¿Terrorista o rebelde?*, Lima: Victor Alfredo Polay Campos.

Porras Castejón, G. (2009) *Las huellas de Guatemala*, 2nd edn, F and G Editores.

Portes, A. (2007) 'The Cuban political machine: reflections on its origins and perpetuation', in B. Hoffmann and L. Whitehead (eds), *Debating Cuban Exceptionalism*, New York: Palgrave Macmillan, pp. 123–37.

Portuondo López, Y. (ed.) (1986) *30 de noviembre. El heroico levantamiento de la ciudad de Santiago de Cuba*, Santiago de Cuba: Editorial Oriente.

Pozzi, P. A. and C. Pérez (eds) (2012) *Por el camino del Che. Las guerrillas latinoamericanas 1959–1990*, 2nd edn, Buenos Aires: Imago Mundi.

Prieto, A. (2007) *Las guerrillas contemporáneas en América Latina*, Havana: Ocean Sur.

Quispe, A. (2009) *Los Tupakataristas revolucionarios*, 2nd edn, Quillasuyo: Ediciones Pachakuti.

Raby, D. (2011) 'Venezuelan policy under Chavez, 1999–2010: the pragmatic success of revolutionary ideology?', in G. L. Gardini and P. Lambert (eds), *Latin American Foreign Policies. Between Ideology and Pragmatism*, New York: Palgrave Macmillan, pp. 159–77.

Ramírez Cañedo, E. and E. Morales Domínguez (2014) *De la confrontación a los intentos de 'normalización'. La política de los Estados Unidos hacia Cuba*, 2nd, enlarged edn, Havana: Editorial de Ciencias Sociales.

Ramonet, I. (2008) *In Conversation with Fidel*, Havana: Cuban Council of State Publications.

Randall, M. (2015) *Haydée Santamaría, Cuban Revolutionary. She Led by Transgression*, Durham, NC: Duke University Press.

Reeser, P. (2015) *Desi Bouterse. Een Surinaamse tragedie* [Desi Bouterse. A Surinamese Tragedy], Amsterdam: Prometheus–Bert Bakker.

Reid-Henry, S. (2009) *Fidel and Che. A Revolutionary Friendship*, New York: Walker and Co.

Rey Tristán, E. (2005) *La izquierda revolucionaria uruguaya, 1955–1973*, Sevilla: Consejo Superior de Investigaciones Científicas (CSIC).

—— (2006) *A la vuelta de la esquina. La izquierda revolucionaria uruguaya 1955–1973*, Montevideo: Editorial Fin del Siglo.

—— (ed.) (2007) *Memorias de la violencia en Uruguay y Argentina. Golpes, dictaduras, exilios* (1973–2006), Santiago de Compostela: Universidade de Santiago de Compostela – Centro Interdisciplinario de Estudios Americanistas 'Gumercindo Busto'.

Rey Tristán, E. and P. Cagiao Vila (eds) (2011) *Conflicto, memoria y pasados traumáticos. El Salvador contemporáneo*, Santiago de Compostela: Universidade de Santiago de Compostela.

Riera Hernández, M. (1966) *Un presidente constructivo – separata del libro inédito 'Presidentes Cubanos'*, Miami: Colonial Press of Miami, Inc.

Risquet Valdés, J. (2007) 'Prólogo a la edición cubana', in P. Gleijeses, *Misiones en conflicto. La Habana, Washington y África, 1959–1976*, 3rd Cuban edn, Havana: Editorial de Ciencias Sociales, pp. vii–xlviii.

—— (2008) 'La epopeya de Cuba en Africa negra', in P. Gleijeses, J. Risquet and F. Remírez, *Cuba y África. Historia común de lucha y sangre*, Havana: Editorial de Ciencias Sociales.

Ritter, A. (2015) 'Economic illegalities and the underground economy in Cuba', *FOCAL*, 5 February, www.researchgate.net/publication/237665044_Economic_Illegalities_and_the_Underground_Economy_in_Cuba, accessed 2 January 2016.

Roa, R. (1986) *Raúl Roa, canciller de la dignidad*, Prologue by C. Rafael Rodriguez, Havana: Editorial de Ciencias Sociales.

Robben, A. (2005) *Political Violence and Trauma in Argentina*, Philadelphia: University of Pennsylvania Press.

Rodríguez, R. (2010) *La conspiración de los iguales. La protesta de los Independientes de Color en 1912*, Havana: Ediciones Imagen Contemporánea.

Rodríguez Astiazaraín, N. (2009) *Episodios de la lucha clandestina en La Habana (1955–1958)*, Havana: Editorial de Ciencias Sociales.

Rodríguez Campo, A. (2005) *Operación Fángio*, Havana: Editorial de Ciencias Sociales.

Rodríguez García, J. L. (2014) *El derrumbe del socialismo en Europa*, Havana: Editorial de Ciencias Sociales and RUTH Casa Editorial.

Rodríguez Ostria, G. (2009) *Teoponte. La otra guerrilla guevarista en Bolivia*, Cochabamba: Grupo Editorial Kipus.

Rodrigues Sales, J. (2007) *A luta armada contra a ditadura militar. A esquerda brasileira e a influencia da revolução cubana*, São Paolo: Editora Fundação Perseu Abramo.

Rodríguez V., M. A. (2008) *Sol y sombra de Omar Torrijos Herrera*, Panama: Editora Novo Art.

Rojas Nuñez, L. (2011) *De la rebelión popular a la sublevación imaginada. Antecedentes de la historia política y militar del Partido Comunista de Chile y el FPMR 1973–1990*, Santiago de Chile: Ediciones LOM.

Rollemberg, D. (2001) *O apoio de Cuba à luta armada no Brasil. O treinamento guerrilheiro*, Rio de Janeiro: Mauad.

Roopnaraine, R. (2011) 'Resonances of revolution. Grenada, Suriname, Guyana', in S. Puri (ed.), *The Legacies of Caribbean Radical Politics*, Abingdon: Routledge, pp. 1–24.

Rot, G. (2010) *Los orígenes perdidos de la guerrilla en la Argentina*, 2nd, enlarged edn, Buenos Aires: Waldhuter Editores.

Roy, J. (2009) *The Cuban Revolution (1959–2009). Relations with Spain, the European Union, and the United States*, New York: Palgrave Macmillan.

Rueda Jomarrón, H. (2009) *Tradiciones combativas de un pueblo. Las milicias cubanas*, Havana: Editora Política.

Sabino, C. (2009) *Guatemala, la historia silenciada (1944–1989)*, vol. I: *Revolución y liberación*, vol. II: *El dominó que no cayó*, Guatemala: Fondo de Cultura Económica.

Sáenz Rovner, E. (2008) *The Cuban Connection. Drug Trafficking, Smuggling, and Gambling from the 1920s to the Revolution*, Chapel Hill: University of North Carolina Press.

Sánchez, G. (2005) *'Barrio Adentro' and Other Social Missions in the Bolivarian Revolution*, Melbourne: Ocean Press.

Sánchez Cerén, S. (2009) *Con sueños se escribe la vida. Autobiografía de un revolucionario salvadoreño*, Havana: Editorial José Martí.

Sánchez Gómez, G. et al. (2013) *¡Basta Ya! Colombia: Memorias de guerra y dignidad. Resumen*, Bogotá: Centro Nacional de Memoria Histórica and Imprenta Nacional.

Serbin, A. (2010) *Chávez, Venezuela y la reconfiguración política de América Latina y el Caribe*, Buenos Aires: Siglo XXI Iberoamericana.

Servetto, A. (2010) *73/76: El gobierno peronista contra las 'provincias montoneras'*, Buenos Aires: Siglo XXI Editores Argentina.

Skierka, V. (2004) *Fidel Castro. A Bibliography*, Cambridge: Polity Press.

Solomon, D. F. (2011) *Breaking Up with Cuba. The Dissolution of Friendly Relations between Washington and Havana, 1956–1961*, Jefferson: McFarland and Company Publishers.

Spadoni, P. (2010) *Failed Sanctions. Why the U.S. Embargo against Cuba Could Never Work*, Gainesville: University Press of Florida.

Sprenkels, R. (2014) 'Revolution and accommodation. Post-insurgency in El Salvador', PhD thesis, Faculty of Social and Behavioural Sciences, Utrecht University.

Stanley, W. (2013) *Enabling Peace in Guatemala. The Story of MINUGUA*, Boulder, CO: Lynne Rienner Publishers.

Stephen, L. (2002) *Zapata Lives! History and Cultural Politics in Southern Mexico*, Berkeley: University of California Press.

Suárez Salazar, L. (ed.) (1999) *Barbarroja: Selección de testimonios y discursos del comandante Manuel Piñeiro Losada*, Havana: CIMAR-Ediciones Tricontinental.

——— (ed.) (2007) *Tania la guerrillera y la epopeya suramericana del Che*, Caracas: Editorial Ocean Press–Ocean Sur.

Suárez Salazar, L. et al. (1997) '"Mi modesto homenaje al Che", entrevista exclusiva al comandante Manuel Piñeiro Losada', *América Libre*, 11, special issue 'Ernesto Che Guevara – 30th anniversary'.

Suárez Salazar, L. and T. García Lorenzo (2008) *Las relaciones interamericanas. Continuidades y cambios*, Buenos Aires: Consejo Latinoamericano de Ciencias Sociales.

Suárez Salazar, L. and D. Kruijt (2015) *La Revolución Cubana en Nuestra América: El internacionalismo anónimo*, Havana: RUTH Casa Editorial (e-book).

Sweig, J. (2002) *Inside the Revolution. Fidel Castro and the Urban Underground*, Cambridge, MA: Harvard University Press.

—— (2012) *Cuba. What Every One Needs to Know*, 2nd edn, New York: Oxford University Press.

Taibo II, P. I. (2007) *Ernesto Guevara, también conocido como el Che*, new, corrected and augmented edn, Mexico: Planeta.

Thomas, H. (1977) *The Cuban Revolution*, 3rd, enlarged edn, New York: Harper and Row.

Timossi, J. (2011) *Los cuentos de Barbarroja. Comandante Manuel Piñeiro Rosada*, 2nd edn, Havana: Editorial de Ciencias Sociales.

Togores González, V. (2005) 'Ingresos monetarios de la población, cambios en la distribución y efectos sobre el nivel de vida', in J. S. Tulchin, L. Bobea, M. P. Espina Prieto and R. Hernández with E. Bryan (eds),*Cambios en la sociedad cubana desde los años noventa*, Washington, DC: Woodrow Wilson International Center for Scholars – Latin American Program, pp. 187–215.

Torres G., O. (2012) *Democracia y lucha armada. MIR y MLN – Tupamaros*, Santiago de Chile: Pehuén Editores.

Torres-Cuevas, E. and O. Loyola Vega (2011) *Historia de Cuba, 1492–1898*, Havana: Editorial Pueblo y Educación.

Torres Molina, R. (2011) *Las guerrillas en Argentina. Análisis político y militar*, La Plata: Campana de Palo.

Torres-Rivas, E. (2011) *Revoluciones sin cambios revolucionarios. Ensayos sobre la crisis en Centroamérica*, Guatemala: F and G Editores.

Torriera Crespo, R. and J. Buajasán Marrawi (2000) *Operación Peter Pan. Un caso de guerra psicológica contra Cuba*, Havana: Editora Política.

Toussaint, M. (2013) *Diplomacia en tiempos de guerra. Memorias del embajador Gustavo Iruegas*, Mexico: Instituto Mora, La Jornada and Universidad Nacional Autónoma de México (UNAM) – Centro de Investigaciones sobre América Latina y el Caribe (CIALC).

Trinkunao, H. A. (2012) 'The logic of Venezuelan policy during the Chávez period', in R. S. Clem. and A. P. Maingot (eds), *Venezuela's Petro-Diplomacy. Hugo Chávez's Foreign Policy*, Gainesville: University Press of Florida, pp. 17–31.

Trujillo Lemes, M. F. (2011) *El pensamiento social católico en Cuba en la década de los 60*, Santiago de Cuba: Editorial Oriente.

Uralde Cancio, M. (2009)*Voluntarios españoles en Cuba*, Havana: Editora Historia.

Uralde Cancio, M. and L. Rosado Ciró (2006) *El ejército soy yo. Las fuerzas armadas de Cuba (1952–1956)*, Havana: Editorial de Ciencias Sociales.

Urrutia, M. (1963) *Fidel Castro y compañía, S.A.*, Barcelona: Editorial Herder.

Valdés, O. (2003) *Historia de la Reforma Agraria en Cuba*, Havana: Editorial de Ciencias Sociales.

Vásquez-Viaña, H. (2012) *Del Churo a Teoponte. El traumático nacimiento del nuevo ELN*, Santa Cruz de la Sierra: Hetrodoxía and Editorial El País.

Vellinga, M. (1976) 'The military and the dynamics of the Cuban revolutionary process', *Comparative Politics*, 8(2): 245–70.

Venegas Delgado, H. (2007) 'Las transformaciones agrarias en Cuba (1979–1925)', in J. Girón Garote (ed.), *Un cambio de siglo, 1898. España, Cuba, Puerto Rico, Filipinas y Estados Unidos*, Oviedo: Universidad de Oviedo, pp. 213–20.

Vidal Felipe, Y. B. (2009) 'El Centro Gallego de La Habana durante y después de la Guerra Civil Española: crisol de pasiones', in Á. M. Fernández Muñiz (ed.), *La Guerra Civil Española en la sociedad cubana. Aproximación a una época*, Havana: Editorial de Ciencias Sociales, pp. 84–96.

Villaraga, Á. and N. Plazas (1994) *Para reconstruir los sueños (una historia del EPL)*, Bogotá: Fundación Cultura Democrática.

Walter, R, J. (2010) *Peru and the United States, 1960–1975. How Their Ambassadors Managed Foreign Relations in a Turbulent Era*, University Park: Pennsylvania State University Press.

Webber, J. R. (2011) *Red October. Left Indigenous Struggle in Modern Bolivia*, Leiden: Brill (Historical Materialism Book Series).

Weitz, R. (1986) 'Insurgency and counterinsurgency in Latin America, 1960–1980', *Political Science Quarterly*, 101(3): 397–413.

Wickham-Crowley, T. (1992) *Guerrillas and Revolution in Latin America. A Comparative Study of Insurgents and Regimes since 1956*, Princeton, NJ: Princeton University Press.

—— (2014) 'Two "waves" of guerrilla-movement organizing in Latin America, 1956–1990', *Comparative Studies in Society and History*, 56(1): 215–42.

Wolf, M. and A. McElvoy (1997) *El hombre sin rostro*, Buenos Aires: Javier Vergara Editor.

Xalma, C. (2007) *Cuba: ¿Hacia dónde? Transformación política, económica y social en los años noventa. Escenarios de futuro*, Barcelona: Icaria (Antrazyt no. 258).

Zabala Argüelles, M. del C. (1997) 'Familia y pobreza en Cuba', in R. Menjívar, D. Kruijt and L. van Vucht Tijssen (eds), *Pobreza, exclusión y política social*, San José: UNESCO and Facultad Latinoamericana de Ciencias Sociales (FLACSO), pp. 397–411.

Zanetti Lecuona, O. (2012) *Esplendor y decadencia del azúcar en las Antillas Hispanas*, Havana: Editorial de Ciencias Sociales and RUTH Casa Editorial.

—— (2013) *Historia mínima de Cuba*, 2nd, enlarged edn, Mexico and Madrid: El Colegio de Mexico and Turner Publicaciones.

Zárate, M. and D. Vargas (eds) (2011) *General Omar Torrijos de Panamá y de la Patria Grande*, Caracas: Editorial Trincheras.

Zimbalist, A. and C. Brundenius (1989) *The Cuban Economy. Measurement and Analysis of Socialist Performance*, Baltimore, MD: Johns Hopkins University Press.

INDEX

· · · · · · · · · · · · · · ·